Drawing in England from Hilliard to Hogarth

D1439356

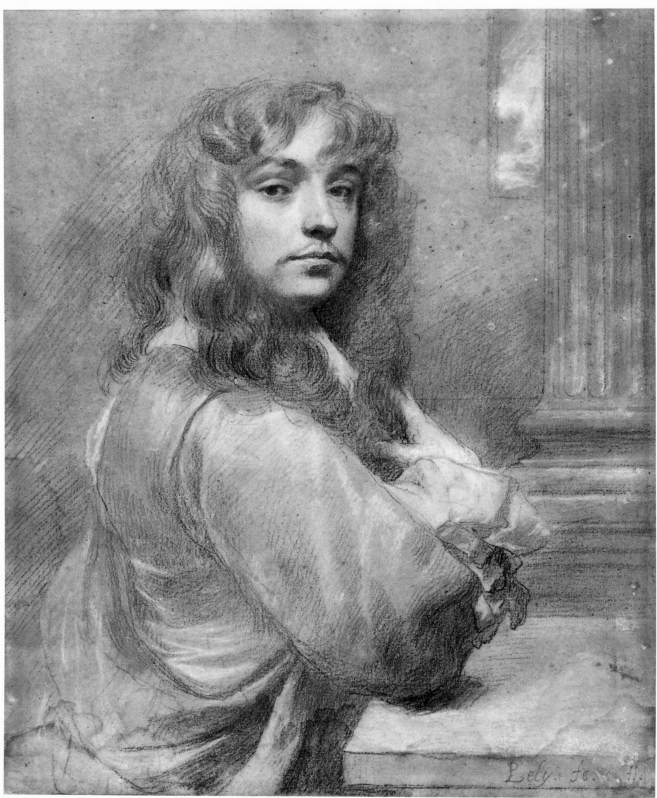

Sir Peter Lely: *Self-portrait* (no. 89)

Drawing in England
from Hilliard to Hogarth

Lindsay Stainton and Christopher White

Published for the Trustees of the British Museum
by British Museum Publications

© 1987 The Trustees of the British Museum

Published by British Museum Publications Ltd
46 Bloomsbury Street, London WC1B 3QQ

British Library Cataloguing in Publication Data

Stainton, Lindsay
 Drawing in England from Hilliard to
 Hogarth.
 1. Drawing, English—Exhibitions
 2. Drawing—17th century—England—
 Exhibitions
 1. Title 11. White, Christopher, *1930–*
 III. British Museum
 741.942'074 NC231
 ISBN 0–7141–1629–7

COVER Sir Peter Lely: *Portrait of a girl* (no. 88)

Designed by James Shurmer

Set in Baskerville, Linotron 202
by Rowland Phototypesetting Ltd
and printed in Great Britain
by Balding & Mansell Ltd

Contents

Foreword

The idea of this exhibition arose some years ago when Christopher White, then Director of the Paul Mellon Centre for Studies in British Art, London, planned a survey of drawing in England in the seventeenth century to be held at the Yale Center for British Art at New Haven. The project was later revived by the British Museum, which agreed to organise an exhibition on this theme, to be selected (chiefly from the Museum's collections) and catalogued jointly by Christopher White, now Director of the Ashmolean Museum, Oxford, and Lindsay Stainton, Assistant Keeper in this Department. The exhibition is being shown first in London, and then in New Haven, as was originally intended; this is the first collaboration on so large a scale between the two institutions, and Duncan Robinson, Director of the Yale Center for British Art, has been an enthusiastic supporter of the project from the outset.

The purpose of the exhibition is to show the variety and quality of the work both of native English artists and of Continental artists in some way associated with England during a period coinciding roughly with the Stuart era, from James I (1603–25) to Queen Anne (1702–1714), and which might be called the age of the Baroque. It ranges from the last years of Nicholas Hilliard to the very early work of Hogarth, but the main emphasis has been placed on artists working in the intervening period. The outstanding collection of seventeenth-century drawings is that of the British Museum, which has been systematically built up since the Museum's foundation in 1753, an important part of it consisting of drawings that came with the bequest of its founder, Sir Hans Sloane. The Museum's collection, then, provides the core of the exhibition, but a number of important loans have been added from other collections, both public and private. The collection of seventeenth-century English drawings in the Ashmolean Museum – the nucleus of which also goes back to the eighteenth century – is considerably smaller, but hardly of lesser quality. At least one drawing graciously loaned from the Royal Collection belonged to King Charles I, who, although best known for his collection of paintings, was also a distinguished collector of drawings. Another long-established collection is that at Chatsworth, belonging to the Dukes of Devonshire; so far as the English school is concerned, its chief glory is the magnificent representation – the finest extant – of drawings by Inigo Jones. American interest in British drawing developed only comparatively recently, but there are two outstanding collections in the USA, that of the Yale Center for British Art itself, formed chiefly by Mr Paul Mellon, and that in the Huntington Library at San Marino, California (whose constitution unfortunately forbids it to lend).

Although the arts of the Stuart period in general have been the subject of books and exhibition catalogues by such distinguished scholars as Sir Oliver Millar, Sir Roy

Strong and Dr Margaret Whinney, there have been few serious studies of Stuart draughtsmanship. John Woodward's invaluable book, *Tudor and Stuart Drawings* (1951), is still the only introduction to the subject, while the *Catalogue of XVI and XVII century British Drawings in the British Museum*, by Edward Croft-Murray and Paul Hulton (1960) provides an indispensable basis for all further study of this aspect of the art of the period. As this exhibition aims to show, this relative neglect is undeserved when compared with the attention paid to the achievements of the other Northern schools, such as the Dutch and Flemish. Even if England was to some extent weak in native talent, English patronage offered opportunities to a wide range of Continental artists, which resulted in an unparalleled intermingling of nationalities and styles. It is true that the most distinguished artists represented were foreigners; but it is to be hoped that the total effect of the exhibition will be to remind us that the English contribution to the history of European draughtsmanship at this period is less negligible than has sometimes been supposed.

The organisers of the exhibition have asked me to express their thanks to all those who have lent drawings and to the many people who have given so much assistance. Her Majesty The Queen, the Visitors of the Ashmolean Museum, Oxford, the Duke of Devonshire and the Trustees of the Chatsworth Settlement, and the Yale Center for British Art, New Haven, have been particularly generous in their support of the exhibition. We are no less grateful to all the other lenders, including a number of private collectors who wish to remain anonymous.

John Morton Morris has most generously enabled the inclusion of many more illustrations in colour than would otherwise have been possible. Professor Kitson, Director of the Paul Mellon Centre for Studies in British Art, London, kindly allowed Sheila O'Connell to assist Lindsay Stainton with a number of practical matters in the early stages of preparing the catalogue. Among the many other individuals who have given invaluable advice, we should particularly like to thank Brian Allen, Deputy Director of the Paul Mellon Centre for Studies in British Art, London; Valerie Cumming, Museum of London; Peter Day, Keeper of the Devonshire Collections, Chatsworth; Cara Denison of the Pierpont Morgan Library; Geoffrey Fisher of the Conway Library, Courtauld Institute of Art; Sir Brinsley Ford; the Rev. Tom Gibson; John Harris; Ralph Hyde of the Guildhall Library, London; Richard Jeffree; Evelyn Joll of Thomas Agnew and Sons Ltd; Mark Jones of the Department of Coins and Medals, British Museum; Leslie Le Claire of Worcester College, Oxford; Ger Luyten and A.W.F.M. Meij of the Museum Boymans-van Beuningen, Rotterdam; Sir Oliver Millar, Surveyor of The Queen's Pictures; Nicholas Penny, Keeper of Western Art, Ashmolean Museum, Oxford; the Hon. Mrs Roberts, Curator of the Royal Library, Windsor; Malcolm Rogers of the National Portrait Gallery, London; Peter Schatborn of the Rijksprentenkabinet, Amsterdam; Stephen Somerville of Somerville and Simpson Ltd; and Sue Valentine of Thomas Agnew and Sons Ltd. At the Yale Center, New Haven, Tim Goodhue, Registrar, Patrick Noon, Curator of Prints and Drawings, Scott Wilcox, Assistant Curator, and the staff of the Print Room have been consistently helpful. In the British Museum, colleagues in the Department of Prints and Drawings,

the Photographic Service and the Western Pictorial Art Section of the Department of Conservation have been more than usually forbearing. Dr White would like to thank Chris Dale-Green and Jillian Mathews for their secretarial assistance. At British Museum Publications, Teresa Francis edited the text of the catalogue.

We would especially like to thank Christopher White for writing the first essay and the entries and biographies for nos 1–61, 65–70 and 81; the remainder of the text is by Lindsay Stainton.

J. K. Rowlands, *Keeper, Department of Prints and Drawings, The British Museum*

Lenders to the Exhibition

Her Majesty The Queen 4, 77, 78, 79, 199

The Visitors of the Ashmolean Museum, Oxford 36, 41, 74, 81, 82, 92, 100, 110, 182, 193, 196

Museum Boymans-van Beuningen, Rotterdam 35, 54, 176

The Clark Institute, Williamstown 28

The Duke of Devonshire and the Trustees of the Chatsworth Settlement 8, 9, 10, 11, 12, 13, 14, 15, 16, 17, 18, 19, 20, 21, 22, 23, 24, 25, 26, 46, 57

The National Gallery of Scotland, Edinburgh 44

Sir Brinsley Ford 192

The Guildhall Library, City of London 60

The Paul Mellon Collection, Upperville, Virginia 109

Sir Oliver and Lady Millar 90

The Pierpont Morgan Library, New York 38, 53, 115

Dudley Snelgrove Esq. 152

The Victoria and Albert Museum, London 65, 148, 167, 169, 177

The Provost and Fellows of Worcester College, Oxford 27, 34

The Yale Center for British Art, New Haven 1, 3, 5, 30, 37, 67, 68, 84, 102, 116, 123, 125, 130, 132, 133, 149, 153, 157, 162, 178, 194

Private Collections 63, 64, 75, 76, 80, 87, 89, 121, 155, 156, 160a, 160b

The Theory and Practice of Drawing in Early Stuart England

The artistic achievements of the early Stuart period, momentous in themselves, are thrown into sharp relief when contrasted with what had preceded them in the previous century. As is generally recognised, the Elizabethan age was not a glorious episode in the history of the patronage of the arts in England and, with the exception of miniature painting (limning) and some highly individual domestic architecture, no branch of art either flourished or – no less significantly – kept in touch with what was happening on the Continent. Even Nicholas Hilliard, who was one of the few artists to benefit from the reign of Queen Elizabeth I, went out of his way to express what was, one cannot help thinking, a certain nostalgia when he wrote: 'Heer must I needs incert a word or two in honore and praisse of the renowned and mighty *King Henry the eight* a *Prince* of exquisit Iugment: and Royall bounty, soe that of cuning Stranger euen the best resorted vntu him, and remoued from other courts to his.'[1] It would of course have been highly inappropriate, to put it mildly, for Hilliard to draw attention to the reverse situation under Elizabeth, when Federico Zuccaro was the only 'cuning Stranger' of some international stature to pay a brief visit to the English court.

This artistic isolation meant that even the literature of art which began to flourish in Italy during the second half of the sixteenth century was not known, let alone read, in England. That fundamental source book, Vasari's *Lives of the Painters* (first published in Florence in 1550, followed by a second enlarged edition in 1568) was never mentioned by Hilliard; another writer on art, Henry Peacham, was aware that two copies existed in England, one of which belonged to Inigo Jones, but did not have occasion to read it. Only sometime after 1620, when Edward Norgate began to compose his notes on painting, did an English writer reveal direct acquaintance with this seminal account of the history and ideas of the Renaissance.

England came late to the ideas of the Renaissance, and as a result neither painting nor architecture absorbed its gradual development in correct historical sequence but caught up half-way with the events which had taken place in Italy in the sixteenth century. Thus the first contribution to the literature of art in England was Richard Haydocke's translation of Giovanni Paolo Lomazzo's *Trattato dell'arte de la pittura* (Milan, 1584), which was published in Oxford in 1598. Unfortunately publication never got further than an initial volume which included the first five books of the treatise, although Haydocke listed the remaining two books in the table of contents. (With his English audience in mind, he omitted the passages concerning Counter-Reformation art.) For students of drawing, 'the sixth booke of Practise', which included chapters on 'Drawing counterfets by the life' and 'Drawing counterfets by arte' would have provided pertinent discussion of the subject.[2]

As the few English readers of the original Italian edition would have been aware (Haydocke refers to 'the scarcities of copies'), Lomazzo's treatise was a combination of speculative art theory and practical advice to the artist. In his attitude Lomazzo was, like his contemporaries, much influenced by Vasari, for whom drawing was the foundation stone of art ('Il disegno e padre delle tre arti nostre, Architettura, Scultura e Pittura').[3] As the most immediate expression of the artistic impulse, it can be seen as representing in its purest and most intellectual form the idea in the artist's mind, 'a visible expression and declaration of our inner conception'.[4] And in describing the act of creation and the act of realisation of the image in the artist's mind, Vasari was wont to refer to drawings as '*pensieri*', or 'thoughts'.

Although he accepted drawing, with anatomy, as 'il proprio fondamento e base delle invenzioni',[5] Lomazzo nevertheless – in conformity with other late sixteenth-century writers such as Giovanni Battista Armenini, Vincenzo Borghini and Federico Zuccaro – treated it as the expression of a more intellectual idea. It was, he proposed, inspired in the mind of the artist by the mind of God, quite independently of the former's study of nature. Whereas Vasari had postulated a balance between the inner vision ('*disegno interno*') with the scrutiny of the visual world ('*disegno esterno*'), the emphasis was now placed on the former.

In addition to translating Lomazzo for his fellow-countrymen, Haydocke was responsible for encouraging Nicholas Hilliard to write his treatise entitled *The Art of Limning*, to which Haydocke refers in the introduction to Lomazzo's work: Hilliard 'by mee promiseth you a treatise of his owne Practise that way, with all convenient speede'.[6] Although this statement implies that Hilliard's treatise was intended for publication, it never went into print and may well have remained unfinished at the time of the artist's death in 1619. (Internal evidence suggests that it was written during the reign of Queen Elizabeth.) It would therefore have been known only within the artist's own circle. Unlike later writers to be discussed, Hilliard offers much more than a practical manual for the miniature painter and expresses ideas taken from late Mannerist art theory as expounded by Lomazzo.[7]

In his first paragraph Hilliard acknowledges his debt to Lomazzo, and although he also refers to 'others' and elsewhere makes particular mention of Dürer's *Four Books of Human Proportion*, it is more likely that he was dependent on Lomazzo's references to these works than on actual readings of the original texts. (As has already been said, he appears not to have known of Vasari.) Much of Hilliard's concern is directed towards elevating the status of painters and painting in England, in essence a battle which had been fought and won in Italy nearly a hundred years earlier. He devotes much attention to describing which artistic activities are fit for a gentleman, and he especially recommends the practice of miniature painting, with its demands of perfection and cleanliness.

In developing the ideas expressed by Lomazzo, Hilliard does not follow the Italian writer and his contemporaries in the transcendental meaning they give to '*disegno*'. But his debt to Lomazzo becomes evident in his remarks about the practical implications of the balance between '*disegno interno*' and '*disegno esterno*'. Where the latter writes, 'No

painter or caruer ought in his workes to imitate the proper and naturall proportion of thinges, but the visuall proportion. For (in a word) the eie and the understanding together being directed by the Perspectiue arte, ought to be a guide, measure and judge of Painting and Caruing',[8] Hilliard expresses much the same view: 'I find also that many drawers after the life for want of true Ruell or Iugment oftentimes fayles more in true proportion, theen they that without patterne drawe out of thier owne head.'[9] No less related to drawing is Hilliard's assessment of the importance of line. 'Forget not therefore', he writes, 'that the principal p[ar]te of painting or drawing after the life consisteth in the truth of the lyne . . . the lyne without shadowe showeth all to a good jugment, but the shadowe without lyne showeth nothing.'[10] Without ever defining the function of drawing, Hilliard implicitly accepts its role as a method of preparation for painting. In a passage on the 'Rulles of *Albert*' Dürer, he refers to drawing as 'the enterence the very high waye and foundation'.[11] But for the most part Hilliard's attention is devoted to the end product, the limning itself.

Henry Peacham's *The Art of Drawing with the Pen . . .* (1606), the first treatise published in England by a native, was also inspired by the desire to raise the status of the artist.[12] The author was a schoolmaster and tutor, and for a period during the brief life of Henry, Prince of Wales, was attached in some unknown capacity to his household. His book was popular, and a much enlarged edition was published in 1612 under two different titles, *Graphice or the Most Auncient and Excellent Art of Drawing and Limning . . .* and *The Gentleman's Exercise*. Addressed primarily to the gentleman (a later book was entitled *The Compleat Gentleman*, editions of which were published in 1622, 1634 and 1661), it contained much practical advice. In the dedication to the 1612 edition, Peacham wrote: 'I have drawne and collected together the most true and easie grounds of drawing, mingling and ordering all manner of watercolours for limning' as well as observations on perspective, light, annealing glass and on armoury, in a book which is primarily intended for the 'young learner'. In addition to promoting the practice of painting as a liberal art, he was keen to establish the position of the English artist, lamenting that 'our courtiers and great personages must seeke farre and neere for some Dutchman or Italian to draw their pictures, and invent their devises, our Englishmen being held for *Vaunients*'.

Peacham was acquainted with contemporary art circles, praising Hilliard and Isaac Oliver as 'inferior to none in Christendome for the countenance in small', and recommending the prints of Hendrick Goltzius for imitation in 'the true shadowing of a naked bodie'.[13] He knew Haydocke's translation of Lomazzo and recommended its purchase. Later, in *The Compleat Gentleman*, he acknowledges Carel van Mander's book 'in high Dutch', *Het Schilderboeck*, as the primary source for his account of the lives of the painters, and although he had not read it, he was aware of Vasari's *Lives of the Painters*.

As was his intention in the *Graphice*, Peacham is ready with practical advice. One chapter is devoted to 'Pencils and other Instruments necessarie for drawing', in which he counsels the artist to 'get your black lead sharpened finely'; as far as the pen is concerned, 'never be without twentie or thirtie at a time, made of Ravens and goose quils

. . . [the former] are the best of all other, to write faire, or shadow fine, your goose quils serve for the bigger or ruder lines'.[14] He then proceeds to offer a course of instruction, starting with the practice of drawing squares and circles and continuing with encouragement to the learner both to draw from life and to copy prints by such artists as Dürer and Goltzius. Although he gives no theoretical basis for his ideas, there is an underlying assumption that the function of drawing is to serve as preparation for painting. But an echo of later Mannerist theory does emerge in his section on 'How to helpe you in your Idea', in which he writes: 'hauing the generall notion or shape of the thing in your mind you mean to draw (which I doubt not but you may conceiue and remember as wel as the best painter in the world though not expresse according to the rules of art) draw it with your lead . . . [the next day] mend it according to that Idea you carry in your mind, in the generall proportion'.[15]

Whereas Hilliard followed Lomazzo in discussing both theory and practice, later writers in England tended to confine themselves to the latter. Two authors whose treatises were never published devoted much of their attention to technical matters. The manuscript treatise of Theodore de Mayerne (see no. 29) consists of notes variously dated between 1620 and 1646, recording recipes for colours and varnishes as well as instructions for painting and etching.[16] His notes are especially valuable since he had the opportunity of discussing such subjects with both Rubens and Van Dyck, as well as the young Samuel Cooper. One of his acknowledged sources was the illuminator and limner Edward Norgate, whose manuscript entitled *Miniatura or the Art of Limning* was begun about the same time.[17] In this instance the influence was reciprocal, since Norgate's treatise was inspired by De Mayerne. Norgate in fact states that the earlier version of his work was written at De Mayerne's request.

Norgate was employed by the Earl of Arundel to instruct his sons, William and Henry, in the art of limning. From his travels as a member of the Earl's household he gained the advantage of meeting a number of Continental artists. By 1617 he had been in the Netherlands, where he visited Goltzius. In 1622 he was in Rome, acting on behalf of Arundel in his search for works of art and antiquities, and ten years later accompanied the Earl as his secretary on a visit to the Netherlands. In 1639–40 he was in direct contact with Rubens in Antwerp over the proposed commission for the latter to decorate Henrietta Maria's chamber in the Queen's House at Greenwich.

Like Peacham's books, Norgate's *Art of Limning* was intended as a manual for gentlemen, a fact emphasised by its dedication to the younger of his pupils, Henry Howard. Originally written in 1620, it was subsequently extensively revised and augmented between 1648 and 1650. Although it was never published, the number of known manuscript copies suggests that it was fairly widely circulated. Norgate reveals himself to have been far better acquainted than Peacham with earlier writings such as Vasari's *Lives of the Painters*, which, for instance, he quotes on the subject of drawing. An important contemporary source was undoubtedly *The Ancient Art of Painting*, written by Arundel's librarian Franciscus Junius and published in 1638 in an English translation from the original Latin edition of the previous year. But this work would not have been of much help in treating the subject of drawing, which is little discussed apart from

being considered as one of the basic elements of painting, a categorisation which Junius borrowed from Italian writers.

Norgate's thesis is especially rewarding in the present context since he includes a section which not only describes various techniques and practices of draughtsmanship but also expresses certain attitudes towards the role of drawing. And in formulating his views he was clearly reflecting the opinions of certain contemporary artists as well as following earlier literature. But he admits that this section was only an afterthought: 'When I first began this Discourse it was noe part of my meaning . . . to speake at all of Designe, Drawing.' But 'this profound and exqueseite study of Designe, being indeed the Basis and foundation of those noble sciences, Architecture, Sculpture, Perspective, Painting, &c, should not passe by me unsaluted at least', although the author regrets that his discussion should 'bring up the reare, whose right it was to have led the van'.[18] He enumerates the various techniques of drawing with the pen, chalk and wash applied with the brush, and states a preference for the first, since 'the end of all drawing being nothing else but soe to deceave the Eyes, by the deceiptfull ingling and witchcraft of lights and shadowes, that round embost and sollid bodyes in Nature may seeme round embost and sollid *in Plano*'.[19] Like Peacham, he recommends copying prints in order to learn 'to expresse shadowes by hatching', and cites as models the engravings of Hendrick Goltzius and other named printmakers, as well as Jacopo Palma Giovane's illustrated anatomical manual, *Regole per imparar a disegnar i corpi humani*, published in Venice in 1636.

Of wider significance is Norgate's opinion about the role of drawing in artistic creation, which accords with the tradition going back to the early Renaissance: 'consider all drawing but as a servant and attendant, and as the way of painting, not the end of it.'[20] And he goes on to describe the change in Van Dyck's attitude to drawing between his earlier periods and his English years, which will be discussed later. Following Vasari, whom he quotes, Norgate conceives drawing as a combination of '*disegno interno*' and '*disegno esterno*': 'Drawing or Designe is a visible expression with the hand of the mind's Conceptions, gotten by practice, study and experience.'[21] But he is careful to warn the artist against excessive reliance on drawing from the life and after classical statues, mentioning Rubens's criticism of 'divers of his nation [who] had followed the Academy course for 20 Yeares together to little or noe purpose'.[22] The emphasis on the superiority of invention over imitation also echoes what Junius wrote in his book on painting against 'servile imitation', which takes the student no 'further then his predecessors had gone alreadie' and would result in art growing increasingly worse, 'if Phantasie had not supplied what Imitation could not performe'.[23]

The notion expressed by Junius that 'the heate of our invention' is 'preserved by continuance'[24] is taken up in the middle of the century by William Sanderson in his manual, *Graphice. The use of the Pen and Pensil. Or, the most excellent art of Painting* (London, 1658), which follows the general instructional pattern of Norgate's treatise. 'The *Commotions* of the mind, are not to be cooled by slow performance', Sanderson writes, adding the memorable image of Rubens who would 'sit musing upon his work for some time; and in an instant in the livelinesse of spirit, with a nimble hand would force out,

his over-charged *brain* into description, as not to be contained in the Compass of ordinary practice, but by a violent driving on of the passion'.[25] Although commending drawing as 'proper for any course of Life whatsoever . . . for expressing the Conceptions of the Mind', Sanderson does not question its traditional role: 'to our particular purpose of *Painting*, it is the only Consequence'.[26]

As we have seen, therefore, ideas on drawing were not developed much beyond basic instruction by English writers on art in the earlier part of the seventeenth century. Only Norgate provides something of an aesthetic, but even his arguments appear relatively down-to-earth and practical when compared with Junius's general philosophising about art, much of which reads as an expression of someone remarkably detached from works of art themselves, despite the author's place in the Arundel 'circle'.

Of more direct significance for the development of drawing in England than any of the writings mentioned above were the collections already being formed at this period. The most notable was that of the Earl of Arundel, who, his son Henry Frederick reported, despite his passion for paintings, antiquities and other works of art 'chiefly affects drawings'.[27] Arundel can be regarded as the first in the great English tradition of collecting drawings, and by the time he went into exile in 1642 he had assembled a very large holding of works collected both by himself and by his team of agents deployed throughout Europe. Sir Edward Walker describes Arundel's 'Collection of Designs' as larger than that of 'any person living'.[28] Although there is no complete record of his collection, enough evidence can be pieced together from such varied sources as the account given by Joachim von Sandrart of his visit to the Earl's house in 1627, records of purchases, and the reproductive prints Arundel commissioned from Wenceslaus Hollar and Hendrik van der Borcht after some of his drawings, to establish both its quality and quantity, as well as its range. Apart from the celebrated series of portrait studies by Hans Holbein the Younger (now at Windsor Castle), Arundel owned twenty-two drawings of the Passion by the same artist. He acquired a volume of drawings by Leonardo da Vinci, bequeathed by the artist to his pupil Francesco Melzi (probably among those now at Windsor Castle). He owned studies by Raphael and Veronese and examples by Dutch and Flemish artists. Of especial importance for contemporary artists such as Inigo Jones were the holdings of sixteenth-century Italian drawings, which included an important group by Francesco Parmigianino as well as examples by artists such as Francesco Salviati. The effect of all these drawings on living artists was made even stronger by the Earl's active patronage of them.

Whether or not Arundel was directly responsible for stimulating the interest of the King, Charles I also owned a large group of drawings.[29] But, unlike Arundel, he seems to have preferred paintings, a taste which can be inferred from the fact that he exchanged a series of Holbein portrait drawings for the Earl of Pembroke's painting by Raphael of *St George and the Dragon*. (Pembroke promptly passed the Holbein drawings on to Arundel, who was his father-in-law.) Piecing together the meagre evidence, one can deduce that Leonardo, Michelangelo and Raphael were all represented in the King's collection. A volume of portraits of the French nobility, still in the Royal

Collection, may well have included a drawing after François Clouet, as well as a group formerly attributed to Daniel Dumonstier but now thought more likely to be by François Quenel. Charles I also owned three volumes of drawings by Parmigianino and one volume by Paolo Farinato, as well as studies by Salviati and Taddeo Zuccaro.

It is highly likely that a number of drawings entered the Royal Collection through the agency of the court musician Nicholas Lanier (see no. 44), who also acted as an agent for the Earl of Arundel. With Daniel Nys he was one of the King's intermediaries in the acquisition of the Gonzaga collection in 1628. Like other agents acting on behalf of members of the court, such as Sir Dudley Carleton, Lanier took the opportunity when the occasion offered to build up a collection of his own at the same time as trying to satisfy the inexorable demands of his various masters. In his autobiography, published in 1660, Roger North wrote: 'drawings are observed to have more of the spirit and force of art than finished paintings, for they come from either flow of fancy or depth of study, whereas all this or great part is wiped out with the pencil, and acquires somewhat more heavy, than is in the drawings. These were not much esteemed in England until Nicholas Laniere was employed by Charles I to go abroad and buy pictures, which he loved. He used to contract for a piece, and at the same time agree to have a good parcel of waste paper drawings, that had been collected, but not much esteemed, for himself. This and the Arundel collection were the first in England.'[30]

Although Hilliard has left a few drawings to posterity and clearly used the medium as a means of preparation for his limning, he cannot on the basis of his extant work be described as a draughtsman of significance in the history of British art. That title more properly belongs to his pupil Isaac Oliver, who can claim to be the first artist active in England since Hans Holbein the Younger to produce a substantial body of drawings. Moreover, the fifty or so drawings by Oliver which survive today are remarkable for their variety of style, technique and subject-matter. They reveal an artist with a strong feeling for the medium and ready to exploit the different qualities of pen, chalk, wash, bodycolour and coloured paper in varying combinations to obtain the desired effect. He clearly attached importance to his drawings, and regarded them as his working capital, containing the wisdom of a lifetime to be handed on to his chosen successor. As Frans Pourbus the Elder had stipulated in his will of 1580, and as Rubens was later to do in 1640, Oliver bequeathed all his drawings to his son Peter on the condition that 'he shall live and exercise that arte or science which he and I now doe'.[31]

Oliver's surviving drawings range in finish from brief notes to elaborately executed compositions. In a number of sketches he freely records motifs taken from earlier artists such as Raphael or Giulio Romano, as in the *Holy Family with Saints Elizabeth and John*, in the British Museum (ECM & PH 10), or from contemporary art, as in the study of a *Seated woman*, also in the British Museum (ECM & PH 8), which is probably based on Jan Saenredam's engraving after Abraham Bloemart's *Vanity of Wealth*. A portrait of an impulsive recorder of everyday events or images occurring in the artist's mind is conveyed by Vertue's description of 'several leaves of Tabletts belonging to books of I Oliver that he carried in his pockett to sketch in with a silver penn'.[32] Although only one known silverpoint drawing, a *Woman with arms crossed*, in the British Museum (ECM &

PH 13), matches this description, there are other pen sketches which testify to the artist's spontaneity and freedom of execution.

By contrast there survive a number of highly finished drawings which seem to have been made as an end in themselves and which represent a very different attitude to the medium from that expressed by writers such as Norgate. It is fair to assume that since such works are mentioned in his will the artist regarded them in the same light as his limnings. It seems probable that they were appreciated by the court as works of art in their own right, since at least two drawings, *Nymphs and satyrs* (no. 4) and *Moses striking the rock*, both still in the Royal Collection, belonged to Charles I.

As Oliver reveals in his will, his drawings covered a wide range of subject-matter, and religious, mythological and allegorical subjects by him are still extant today. As a late northern Mannerist painter, he shows a characteristic receptivity to the work of other artists and styles. Study of his development is made difficult by the fact that only one drawing is dated (*The Entombment*, in the Fitzwilliam Museum, Cambridge) and only one (no. 7) can be connected with a limning. (The latter drawing can be placed late in his career.) There exist thirteen signed drawings, but the form of each signature is the same, suggesting that they were all added at the same time, presumably near the end of his life when he made his will. His stylistic sources vary from French to Netherlandish to Italian. The Franco-Flemish influence probably precedes the Italian, which presumably came to dominate as a result of his visit to Venice in 1596. But whereas the Franco-Flemish influence on Oliver derives from contemporary art, his subsequent interest in the work of Parmigianino and his immediate followers such as Girolamo Mazzola-Bedoli indicates a more antiquarian approach, seen again in the work of Inigo Jones.

Since Oliver was more than a decade older than Jones, it is reasonable to suppose in the absence of further information that he was the first British draughtsman. But it should not be forgotten that the earliest known drawings by Jones date from 1605 when the artist was already in his early thirties. Drawings from an earlier period must have existed. At this stage of his career Jones was known as a painter rather than an architect, and according to his pupil John Webb he went to Italy, probably about the turn of the century, with the expressed wish to 'study the arts of design'. (For the purpose of this survey, Jones's architectural drawings have been omitted.)

Jones's early drawings for masques performed at the Stuart court from 1605 onwards show the artist working within the Elizabethan tradition established by John White (active 1585–93). The watercolour drawing of a *Torchbearer: an Oceania* (no. 8) is comparable both in style and technique to the studies made by White of various oriental figures and Virginian Indians. Since both Oliver and Jones were in the service of Queen Anne of Denmark and Henry, Prince of Wales, they would have known one another's work and it seems likely that the older artist would have exerted some influence on the rapid development of Jones's draughtsmanship. But already in his early drawings one senses that Jones was as much concerned to record ideas from a variety of different sources as to develop a personal style. For his masques he needed a wide range of figures and costumes, and from the beginning he turned to various books

on dress, for the most part the work of late Italian Mannerist artists. Undoubtedly the most important of these was Cesare Vecellio's *Habiti Antichi e Moderni* (Venice, 1598), which Jones used as a source in his first masque, the *Masque of Blackness*, in 1605. Numerous other books and engravings by a wide range of European artists came to hand, and under pressure to produce both costume and scenery designs at what must often have been short notice, Jones freely adapted from the work of others, frequently without making any attempt to conceal his source. Such plagiarism would not have appeared unusual at the time, and it recalls the remark of Rubens who, when 'criticised by some of his competitors for borrowing whole figures from the Italians . . . answered that they were free to do likewise if they found they could benefit from it'.[33] Although working with a different purpose in mind, Jones would, one may surmise, have justified himself in a similar manner.

Gaining experience from the constant flow of commissions for designs for masques and other entertainments for the Stuart court, Jones rapidly developed his proficiency as a draughtsman. Compared with the carefully executed study of a *Torchbearer: an Oceania*, already mentioned, the drawing of a similar figure, *Torchbearer: a fiery spirit* (no. 12), done eight years later, reveals much greater freedom and assurance in the handling of the pen, with outline depending more on suggestion than precise definition. He was able to provide a rapid visualisation of his ideas, which could then be put before a patron or used as the basis for the finished design. Like Isaac Oliver with his 'tabletts', Jones's drawings show him to have been an artist of spontaneous reaction. From his reading of Vasari, he would have been aware of the definition of drawings as '*pensieri*'.

Jones was a voracious collector of prints, an activity which may have begun during his first visit to Italy. The extraordinary range of identifiable sources in his drawings gives an indication of the scope of his collection. He was not only active as a collector on his own behalf but also gave advice to patrons. He appears to have assisted Philip, 4th Earl of Pembroke, to assemble a collection of Italian Mannerist prints (the 'Wilton Album' is now in the Metropolitan Museum of Art, New York). Among Jones's favourite artists, Parmigianino stands out. Apart from his role in encouraging the Earl of Arundel to put together a collection of drawings by the Italian artist during their journey to Italy in 1613–14, Jones was, according to the Earl of Pembroke, 'so fond of Parmigiano that he bought the Prints of the Imperfect Plates, which are now here in this book'.[34] But Parmigianino was not the only artist to be sought after, and the French collector Pierre Jean Mariette stated that both Arundel and Jones were intent on acquiring as many works by Andrea Schiavone as possible.[35]

On present evidence Jones's most intense educational experience seems to have occurred during this second visit to Italy. Besides numerous sheets of studies, a sketchbook now at Chatsworth provides the most illuminating record of his work there. He kept this book beside him and continued to draw in it much later in his life. The volume, assertively inscribed with the words 'Roma Altro diletto che Imperare non trove Inigo Jones 1614' reveals the eclectic character of his interests. Drawing in pen and ink with a loose pattern of shading, Jones studies both individual details and whole figures taken from a wide range of sources. Works by both Parmigianino and Schiavone

appear frequently. Other artists such as Leonardo, Michelangelo, Raphael, Baccio Bandinelli and Polidoro da Caravaggio were also copied. As he was to do in his architecture, Jones turned foremost to artists of the early and mid-sixteenth century, but despite his pronounced antiquarian taste he intermittently paid attention to more contemporary artists such as Agostino Carracci. The album also demonstrates his interest in theory. It contains numerous notes on the antique and on human proportion, based both on observation and written sources. To improve his understanding of the human body, Jones drew on one page the bones corresponding to the legs of a figure by Bandinelli. Lomazzo was an important theoretical source for him, as for other Englishmen, and on one opening of the album he translated and illustrated the Italian writer's passage 'of the proportion of children'.

The chameleon character of Inigo Jones is as evident in his style of drawing as it is in his choice of visual sources. Both as a collector and as a copyist he appears to have been more interested in prints than in drawings. He urged Arundel to collect the drawings of Parmigianino while he collected the etchings. Following the precepts of such writers as Peacham and Norgate, his constant recourse to prints had a marked effect on his style of drawing. The finely executed penwork and elaborate shading of the *Daughter of the morn* (no. 11) are clearly the effect of such study. In general, however, it is difficult to pin down the exact sources of his manner of drawing, which, with the exception of some of his masque designs, appears to have been developed primarily as a means for expressing his ideas rapidly, rather than of producing a finished work of art. The character of his drawing can be compared with the work of the mid-sixteenth century Italian artists he studied so assiduously, but he was capable of varying his style. During his second visit to Italy he met Guercino, whose mastery of drawing in pen and wash is reflected in the three designs for *Neptune's Triumph* (nos 14–16).

Jones's workmanlike attitude to drawing is shown by the way in which, early in his career, he decided on a technique which he largely employed for the remainder of his life: drawing with pen and wash over a sketch in black lead. The only variation was that he used less wash in his later drawings of the 1630s, but otherwise he does not seem to have been tempted to try other techniques. In studying his drawings one can discern an unevenness in quality which may be attributable to haste or possibly to a lack of inspiration engendered by more pedestrian commissions. But in general Jones's learning and sophistication is brilliantly conveyed in his drawings. In a remarkable tribute, Van Dyck expressed the opinion that Jones's drawings were 'not equalled by whatsoever great masters in his time for boldness, sweetness and sureness of touch'.[36]

Apart from Hilliard, Isaac Oliver and Inigo Jones, the artistic scene during the reigns of James I and Charles I was composed largely of foreign artists who came for shorter or longer stays. Painters such as Rubens and Honthorst were in England for a matter of months rather than years, and although both executed important works connected with their visits, neither made any direct impact on the development of English drawing. (Two other artists who were resident for a longer period, namely Daniel Mytens from 1618 to 1634 and Orazio Gentileschi from 1626 to 1638, are unfortunately not known as draughtsmen.) But if Rubens made no direct impact, his

influence was to be felt through the work of Anthony van Dyck, to whom he handed on the traditional Renaissance approach to drawing. Whether recording the image in his mind in the white heat of inspiration or elaborately working up a sheet, Rubens almost invariably had an end in mind beyond the drawing itself. From early in his career Van Dyck, too, used drawing as a means both of swiftly developing his ideas on paper and of establishing a design which could serve for a finished work. Unlike Rubens, who gradually came to prefer the oil sketch, Van Dyck continued to depend primarily on drawing, even if his attitude towards the medium was modified during the latter part of his second English period. The reason for the change was undoubtedly that he became a victim of his own success. As Roger de Piles observed, Van Dyck 'was so much employ'd in drawing the portraits of the royal family, and the lords of the court, that he had no time to do any history-pieces. He did a prodigious number of portraits, about which he took great care at first; but at last he ran them over hastily and painted them very slightly.'[37] Much the same point was made by Edward Norgate, whose remarks about Van Dyck's diminishing dependence on drawing are very illuminating: 'the excellent Vandike, at our being in Italie was neat, exact, and curious, in all his drawings, but since his cominge here, in all his later drawings was ever juditious, never exact. My meaning is the long time spent in curious designe he reserved to better purpose, to be spent in curious painting, which in drawing hee esteemed as lost, for when all is done, it is but a drawing, which conduces to make profitable things, but is none it selfe.'[38] And the surviving drawings support Norgate's assertion, as is demonstrated very clearly by a comparison between the relatively worked up chalk study of Nicholas Lanier (no. 44), made during the second Antwerp period, and the schematic outline dashed on to the paper which served for his portrait of Ann Carr, Countess of Bedford (no. 52), executed near the end of his life.

With the exception of a few mythologies painted for the King, for which no related drawings exist, Van Dyck's activity in England was principally confined to portraits. Although some forty portrait drawings exist today, Vertue seems to suggest that there must have been many more. He writes: '(something) that I remember in my youth, the Name of . . . Carbonnel a Gent, who was married to . . . Mrs Carbonnel a Gentlewoman, descendant from Vandyke who livd in the same house, where I learn't to Draw at first, and somehow I got into her favour, and she showd me many drawings &c. of works that had been part of Vandykes, as they then told me, and she was so kind as to lend me some of them to draw after.'[39]

After he had settled in England, Van Dyck continued to work on his series of portraits known as the *Iconography*, adding sitters who were either English or whom he met in England. He made, for example, a carefully executed chalk drawing of Inigo Jones (no. 46), and a chalk, pen and wash portrait of the Italian artist, Orazio Gentileschi (no. 47), who was already in England when Van Dyck arrived. Made for an engraver to follow, such studies were necessarily more detailed guides than he would have required for his own painting. Such portrait studies continued the style of the earlier drawings made for the *Iconography* while he was still in Antwerp.

Far more numerous are the drawings made in connection with painted portraits. We

are fortunate in possessing two contemporary accounts of the artist's method of working during his English period. The miniaturist Richard Gibson, who was in the service of the Earl of Pembroke, described what happened when a new sitter arrived at Van Dyck's studio in Blackfriars for a sitting, which usually lasted an hour. The artist 'would take a little piece of blue paper upon a board before him, & look upon the Life & draw his figures & postures all in Suden lines, as angles with black chalk & heighten with white chalke'.[40] Everhard Jabach, the Cologne banker, who sat to Van Dyck several times near the end of the latter's life, reported to Roger de Piles a conversation he had with the artist: 'Après avoir légèrement ébauché un Portrait, il faisoit mettre la personne dans l'attitude qu'il avoit auparavant méditée, & avec du papier gris & des crayons blancs et noirs, il dessinoit en un quart d'heure sa taille & ses habits qu'il disposoit d'une manière grande, & d'un goût exquis.'[41] A number of existing studies on both blue and grey paper confirm these descriptions. Such drawings brilliantly establish in a few sure lines both the pose and fall of drapery, as well as conveying something of the psychological aspect of the sitter. In nearly contemporary inventories there are occasional mentions of studies of hands by Van Dyck, but none exist today. De Piles, reporting Jabach, says that 'Pour ce qui est des mains, il avoit chez lui des personnes à ses gages de l'un & de l'autre sexe qui lui servoient de modèle'.[42] But from this description it is not clear whether the artist made drawings from the models or painted the hands directly onto the canvas.

Both in Italy and in Flanders, Van Dyck had earlier in his life made the occasional landscape drawing, but only during his second English period did he proceed to do so with some regularity. In contrast to the increasingly schematic portrait studies of his later years, the landscapes are pre-eminent for their fineness and delicacy of execution, as if in a moment of relaxation the artist was taking lingering pleasure in recording the scene around him. Some of the drawings are in pen and ink, while others are developed with subtle layers of brown or coloured washes. Two drawings of Rye (nos 53–4) represent the only composed views complete with foregrounds. The remainder of his landscapes tend to concentrate on a single motif or on details such as a group of plants or a bunch of flowers (no. 55). They appear to have been done primarily for their own sake, and only occasionally does a recollection of a drawing recur in the foreground or background of a portrait. Once again, Van Dyck follows the practice of Rubens in the use of drawing to familiarise himself with the forms of a landscape, which could then be freely created at will in a painting. As a group, Van Dyck's drawings show a remarkably direct and sensitive response to the English landscape.

Although among the earliest and most poetic appreciations of English scenery, Van Dyck's studies were less influential on the development of English landscape drawing than the Dutch school with which Wenceslaus Hollar may be loosely associated. Constant traffic between the Netherlands and England brought various Dutch artists across the North Sea. Claude de Jongh, who was more a follower of the school of Haarlem than of painting in his native city of Utrecht, was in England on a number of occasions, as was another Utrecht artist, Cornelis van Poelenburgh (c.1586–1667), who unfortunately has left no drawings which can be connected with either what he saw

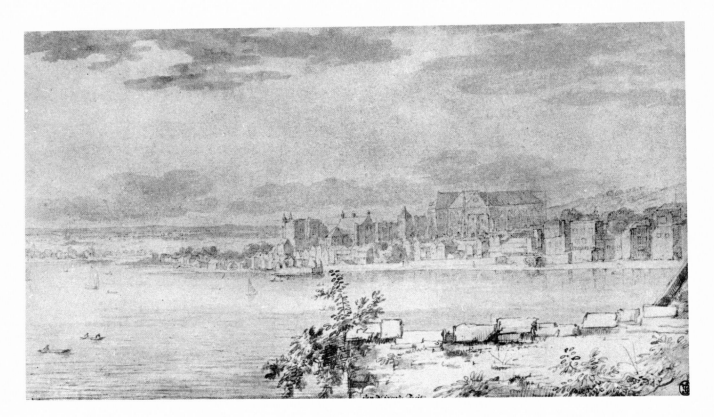

Jan Lievens:
*View of Westminster
from across the Thames.*
Pen and ink with
brown wash. Signed.
Formerly in the H. E.
ten Cate Collection

or what he painted in England. Jan Lievens (1607–74) was probably in England from 1632 to 1635, when he apparently executed a number of acclaimed portraits of the royal family and the members of the court. There is, however, a landscape drawing by his hand (above), last recorded in the H. E. ten Cate Collection, Almelo, whose subject has surprisingly not been previously recognised.[43] The view is taken from south of the Thames, looking across towards Westminster, and includes various identifiable buildings. It cannot be determined whether Lievens drew it on the spot or whether he based his view on a study made by another artist, a practice which was not uncommon at the time. If there is no proof that another Dutch artist, Bonaventura Peeters, landed on English soil, he certainly appears to have sailed close enough to the English coast to make views of Dover (no. 81) and the surrounding countryside.

Wenceslaus Hollar was undoubtedly the most influential artist for the development of English landscape, and his long periods of residence in the country both before and after the Civil War provided a continuity of practice which served to establish the English topographical style in the second half of the century. Despite his extensive etched oeuvre, Hollar can perhaps be regarded as a draughtsman first and foremost. Some of his work, such as the views along the Rhine and the Danube made for the Earl of Arundel (nos 66–7), were probably never intended to be translated into the medium of etching. For a patron such as Arundel, drawings were regarded as works of art in their own right. Vertue records that the 'Prospect of the City of Prague', presumably made on the journey of 1636, 'which being curiously and exactly done with the Pen and Pencil (no doubt) gave great Pleasure and Satisfaction to the noble Earl of Arundel'.[44]

Hollar appears to have kept all his drawings beside him throughout his life, rightly looking on them as his working capital. As an artist whose peripatetic career was affected as much by world events as by his own search for work, he must always have wondered for how long he would find a home in any one place. When he was forced into exile from England and established himself for some years in Antwerp, he clearly had his drawings with him so that he was able to work on English subjects (see no. 69), which, moreover, were intended for the English rather than the Netherlandish market.

Although Hollar's earliest drawings reflect the Mannerist style of Emperor Rudolph II's court in Prague, he soon came into contact with Dutch art during his stay in Strasbourg in 1629, when he copied landscape prints by Jan van de Velde (c.1593–1641), an artist who had also influenced De Jongh. The pervasive effect of Dutch art was increased when Hollar visited the Netherlands in 1634 and he was clearly influenced by both the art and the landscape itself. It was there that he established his precise manner of drawing which, in its understated way, successfully conveys a sense of light and atmosphere. The style of his landscape drawings can be paralleled in the work of various Dutch landscape and topographical artists of the time, notably those of the school of Haarlem. He knew Rembrandt's etchings and made copies of two of them, although at the time of his visit the Dutch master had not yet made any landscape prints.

Hollar's working procedure reveals the instincts of a natural landscapist towards his subject. As can be seen in the Rhine and Danube drawings done shortly after his Dutch visit, he started by sketching in front of the motif in black lead or with a quill pen and the addition of some wash, concentrating solely on the central point of interest. Only in the subsequent drawing executed in the studio, working in pen and brown ink with varied transparent layers of different coloured washes, did he develop the subject within a harmoniously balanced composition. In his finished drawings he introduced firmer definition of objects and space which would render, if required, their translation into etching more easily manageable. His drawings are notable for a very delicate use of watercolour, and it was only towards the end of his career, in the commissioned views of Tangier (nos 72–3) that he adopted a bolder and more assertive use of colour over line.

One suspects that by nature Hollar found most satisfaction in recording the world around him, whether he was studying a stretch of landscape or a city view, a shell, a butterfly or a muff (no. 71). But by virtue of Lord Arundel's patronage he also moved in more scholarly and antiquarian circles, which included such figures as Franciscus Junius and Inigo Jones. Aubrey states that Hollar 'spent his time in drawing and copying rarities, which he did etch.'[45] In fact, very few of the prints executed during his first English period had any connection with the subjects of Arundel's collection of works of art and antiquities, and if Aubrey is correct it seems more likely that his archaeological work was carried out in drawings, which have not survived. After the Restoration, with hardly a patron to his name, let alone one of Arundel's stature, Hollar was not called upon to continue this side of his activity in either drawings or prints.

Reflecting the character of painting and sculpture produced in England at this time, the practice of drawing during the early Stuart period cannot be said to have been

consistent in its aims and techniques, and, apart from Isaac Oliver and Inigo Jones, it depended on various visiting Continental artists. The different trends which intermittently came together in England in the early seventeenth century only started to merge and to create a sense of national artistic identity after the Restoration. But if the early history of drawing in England is necessarily piecemeal, it contains individual moments of brilliance which reach a higher peak than at any other time during the century.

CW

1. N. Hilliard, *A Treatise concerning the Arte of Limning*, ed. R. Thornton and T. Cain, Manchester, 1981, p. 68.

2. See H. and M. Ogden, 'A Bibliography of Seventeenth-Century Writings on the Pictorial Arts in English', *Art Bulletin*, XXIX (1947), pp. 196–201; L. Salerno, 'Seventeenth-Century English Literature on Painting', *Journal of the Warburg and Courtauld Institutes*, XIV (1951), pp. 234–58; M. K. Talley, *Portrait Painting in England: Studies in the Technical Literature before 1700*, London, 1981.

3. G. Vasari, *Le vite de' più eccellenti pittori, scultori ed architettori*, ed. G. Milanesi, Florence, 1878, I, p. 168.

4. Ibid.

5. G. P. Lomazzo, *Trattato dell'Arte della Pittura, Scultura ed Architettura*, Rome, 1844, II, p. 466.

6. G. P. Lomazzo, *A tracte containing the artes of curious paintinge, carvinge, buildinge*, trans. R. Haydocke, Oxford, 1598, p. ix.

7. See J. Pope-Hennessy, 'Nicholas Hilliard and Mannerist Art Theory', *Journal of the Warburg and Courtauld Institutes*, VI (1943), pp. 89–100.

8. Lomazzo, op. cit., trans. Haydocke, p. 181.

9. Hilliard, op. cit., p. 78.

10. Ibid., p. 84.

11. Ibid., p. 68.

12. See F. Levy, 'Henry Peacham and the Art of Drawing', *Journal of the Warburg and Courtauld Institutes*, XXXVII (1974), pp. 174–90.

13. H. Peacham, *Graphice or the Most Auncient and Excellent Art of Drawing and Limning*, London, 1612, p. 29.

14. Ibid., pp. 15–16.

15. Ibid., p. 20.

16. The manuscript was published by E. Berger in *Beiträge zur Entwicklungs-Geschichte der Maltechnik*, IV, Munich, 1901; see also J. van de Graaf, *Het de Mayerne MS als bron voor de schildertechniek van de barok*, Mijdrecht, 1958.

17. E. Norgate, *Miniatura or the Art of Limning*, ed. M. Hardie, Oxford, 1919. A modern edition by J. Muller and V. Murrell is in the course of preparation.

18. Norgate, op. cit., pp. 78–9.

19. Ibid., p. 80.

20. Ibid., p. 83.

21. Ibid., p. 79.

22. Ibid., p. 84.

23. F. Junius, *The Ancient Art of Painting*, London, 1638, p. 29.

24. Ibid., pp. 230–31.

25. W. Sanderson, *Graphice*, London, 1658, p. 34.

26. Ibid., p. 28.

27. M. Hervey, *The Life, Correspondence and Collections of Thomas Howard, Earl of Arundel*, Cambridge, 1921, p. 336; see also D. Sutton, 'Thomas Howard, Earl of Arundel and Surrey, as a collector of drawings', *Burl. Mag.*, LXXXIX (1947), pp. 3–9, 32–7, 75–7.

28. E. Walker, *Historical Discourses upon Several Occasions . . .*, ed. H. Clopton, London, 1705, p. 222.

29. For the collection of drawings belonging to Charles I, see A. Blunt in E. Schilling, *The German Drawings in the Collection of H.M. The Queen*, London, 1971, pp. 1–4.

30. *The Autobiography of the Hon Roger North*, ed. A. Jessopp, London, 1887, p. 202.

31. Vertue, I, p. 142.

32. Ibid., p. 68. Elsewhere (II, p. 73) Vertue describes 'a Vellum pockett book that was I. Olivers & therein are many Sketches. postures &c done with a Silver pen. by himself', which apparently included two dates, 1609 and 1610, and numerous names, including those of the Queen and Alathea Talbot.

33. S. van Hoogstraten, *Inleyding tot de Hooge Schoole der Schilder-Konst*, Rotterdam, 1678, p. 193.

34. Inscribed by the Earl of Pembroke in the Wilton Album, and quoted by H, O & S, p. 58.

35. P. J. Mariette, *Abecedario*, Paris, 1851, III; quoted by J. Sumner Smith, 'The Italian sources of Inigo Jones's style', *Burl. Mag.*, XCIV (1952), p. 204.

36. John Webb, *A Vindication of Stone-Heng, Restored*, London, 1665, p. 11.

37. R. de Piles, *The Art of Painting*, trans. and ed. B. Buckeridge, London, 1744, p. 267.

38. Norgate, op. cit., pp. 83–4.

39. Vertue, v, p. 67.

40. BL, Add. MS 22950, f.15, quoted by Talley, op. cit., p. 320, who also mentions the later evidence of Gerard Soest that, before painting the face, Van Dyck would make a summary study establishing the relative positions of the eyes, nose and mouth.

41. R. de Piles, *Le cours de peinture par principes*, Paris, 1708, pp. 291 ff.

42. Ibid.

43. D. Hannema, *Catalogue of the H. E. ten Cate Collection*, 2 vols, Rotterdam, 1955, no. 255, pl. 100; H. Schneider, *Jan Lievens*, ed. R. Ekkart, Amsterdam, 1973, cat. z no. 166, as with Douwes, Amsterdam, 1965.

44. G. Vertue, *A description of the works of . . . Wenceslaus Hollar . . . with some account of his life*, London, 1759, p. 138.

45. *Aubrey's Brief Lives*, ed. O. L. Dick, Harmondsworth, 1962, p. 323.

Drawing in Late Stuart England

Soon after Charles II was restored to the throne in 1660, Louis XIV asked his ambassador in London to send him the names of the leading English writers and artists. The ambassador replied that there were none.[1] However sweeping and characteristically chauvinist this view of the literature of the period now appears, it is impossible not to sympathise with the ambassador's assessment of the state of the visual arts in England. These were still dependent on Continental models, as they continued to be until the end of the century; and it cannot be maintained that many of the artists included in this survey would play a very significant part in a general history of European art of the period. This is at least partly accounted for by the patterns of patronage that had become established in the period of the Interregnum; the court was never entirely to regain the leading position it had enjoyed under Charles I, despite the enthusiasm for the arts that his sons Charles II and James II inherited from him. Baroque art in Europe – especially decorative painting on the grand scale – was essentially public art, whether glorifying the achievements of absolute monarchy, as in France, or proclaiming the doctrines of the Catholic Church. In Protestant England, patronage of the arts became to a great degree a private, individual concern,[2] and portraiture was the most important and characteristic branch of English painting. In 1685 William Aglionby blamed the popularity of face-painting for the dearth of history painters, a cry that was to recur in almost every account of the English school over the following one hundred and fifty years;[3] it is significant that many of the drawings surviving from this period are either studies for painted likenesses or are independent portrait drawings.

At the Restoration, the leading artist working in England was without doubt Peter Lely. He had come to prominence in the late 1640s, pursuing 'the natural bent of his *Genius* in *Landtschapes*, with *small Figures*, and *Historical Compositions*,[4] but turned to the more profitable business of portraiture. During the Interregnum he maintained a busy practice, and by 1654 was described as 'the best artist in England'.[5] By the end of the decade his style had achieved a maturity and distinction that marked him out from his contemporaries, combining something of Van Dyck's grace with his own more robust manner. With his appointment in 1661 as Principal Painter, and his naturalisation in the following year, Lely was recognised as the chief establishment artist, and was to remain unchallenged until the arrival of Kneller: his British-born contemporary, Joseph Michael Wright (no. 87), a gifted and original painter, had spent much of the Interregnum in Italy, and failed to attract consistent royal patronage in the 1660s.

Little is known of Lely's earliest work, or of the importance that drawing may have had in his training under Frans Pietersz. de Grebber in Haarlem during the late 1630s.

However, the stylistic evidence suggests that in his drawings, as in his early paintings, which reflect the influence of Poelenburgh in particular, he had absorbed the example of contemporary Dutch draughtsmanship.[6] Drawing played an important role in his work, both as part of the preparatory process for his paintings and in its own right. He was also a passionate collector of drawings, owning many that had previously belonged to the Earl of Arundel and to Charles I, as well as many by Van Dyck, which he acquired at the dispersal of his studio. The scientist Constantin Huygens went so far as to hint that Lely enriched his collection by fraudulent means, noting in his account of an interview with Queen Mary, when he was shown some of the drawings in the Royal Collection, 'Afterwards saw other books of Italian drawings in which it looked very much as if something had been stolen from them, and it was stated that Lilly, having borrowed the books from Chiffins [William Chiffinch], had gone thoroughly to work and taken originals out of them, putting in copies made by his people'.[7] This sounds unlikely, although it is very probable that Lely was, doubtless unofficially, lent such drawings to study and perhaps to copy, since the elder Charles Beale (a friend of Lely) noted in his almanac that Chiffinch arranged such a loan for the instruction of his sons Bartholomew and Charles.[8] After Lely's death, his collection was sold by auction, his executor Roger North marking all the drawings and prints that Lely had owned, as well as those by him that were still in his studio, with a stamp.[9] Later painter-collectors of drawings formerly belonging to Lely were to include Jonathan Richardson, Thomas Hudson, Sir Joshua Reynolds, Benjamin West and Sir Thomas Lawrence.

Fewer drawings by Lely survive than might be supposed, however. The catalogue of the collection of Michael Rosse, the son-in-law of Lely's friend and fellow artist Richard Gibson (see nos 62–4), which was sold in 1723, included numerous lots of working studies,[10] but these are now mostly untraced. No. 92 is a characteristic example of such a drawing: a study of arms and hands, presumably made from a model in the studio, for two of the portraits in the 'Windsor Beauties' series. Although Lely relied a good deal on his studio assistants for the production of routine portraits, this study shows that in the case of a commission as important as this he was personally responsible for the complete execution of the paintings. No. 90 is chiefly important because it is probably the only contemporary visual record of the celebrated Diana Fountain, now in Bushy Park, Middlesex, before it was altered in the early 1690s (see nos 130, 168), but it is also interesting because Lely included the fountain as a background detail in at least two paintings.

The pressure of commissions, particularly in the 1660s and 1670s, meant that Lely had to organise his studio as efficiently as possible. His practice seems to have been for sitters to choose a pose (his executors' accounts have all these numbered – 'Whole length postures No. 8 & 1', and 'Sr. Ralph Verney ½ 49', for instance), and perhaps to be shown a quick chalk sketch of the proposed composition, or occasionally, in the manner of Rubens and Van Dyck, an oil sketch. According to one account, noted down in 1673, he first 'slightly chalks out the body', laid in the face, and, 'the person sitting in his intended posture', he sketched in the hands and clothes (these were often painted later by an assistant): 'He does all this by the life presently whilst the person

stays so you have a picture in an instant.'[11] In August 1674 the Beales commissioned a portrait of their son Charles, partly so that Lely's exact method of procedure could be studied by Charles senior on behalf of his wife, the painter Mary Beale. He noted that after Lely had 'dead colour'd' the picture, he 'took a drawing upon paper after an Indian gown which he had put on his back, in order to the finishing the drapery of it'.[12]

Lely's most splendid drawings, however, are entirely different from the rapid pose sketches he used in the design of his paintings. These are the large studies (nos 93–8), drawn in black chalk on blue paper, of figures from the procession of the Order of the Garter, of which around thirty are known. Their purpose remains unclear: no contemporary reference to them has so far been discovered, and we do not know whether Lely intended to paint a series of grand full-lengths, or whether – as seems possible, to judge from the resolved quality of the drawings – he regarded them as finished works. They show Lely as a powerful draughtsman in the Continental manner, and they are arguably the fullest expression of the Dutch tradition of figure drawing to have been made in England.

Lely was probably responsible for the introduction of the coloured chalk portrait drawing into England. He seems to have made such drawings as independent works rather than as preparatory studies for likenesses painted in oils. Most of those that have survived are signed, and the posthumous inventory of his studio lists drawings of this type – described as 'Craions' – as being in ebony frames,[13] which suggests that they were for hanging on the wall in the same way as pictures. The few that are known include some of his most sensitive likenesses.[14] The wistful gaze of the young girl in no. 88, the handsome, melancholy features of Sir Charles Cotterell (no. 91) – a study that can bear comparison with Samuel Cooper's drawings (for example, no. 74) – and the supremely confident air of the artist himself (no. 89) are caught with a perceptiveness sometimes lacking in Lely's oil portraits, where the sitter is on public display. In his own time his portrait drawings were regarded as an important element of his output, and his techniques and materials were of considerable interest to his fellow-countryman Christiaan Huygens, who visited his studio on several occasions in the summer of 1663 and gave a detailed account of the artist's methods in letters to his brother Constantin.[15] On his first visit, on 22 June, he was particularly impressed by Lely's pastel portraits, and was promised technical details, noting that the artist used paper that was 'un peu griastre' (somewhat greyish), 'et n'employe de couleurs que dans le visage et cela encore légerement'.[16] He returned some days later, hoping to get the information he wanted, but, as he noted in his idiosyncratic franglais, 'Lilly ne m'a pas encore donne sa recepte pour le pastel, parce que je ne l'ay pu trouver chez luy depuis, ou bien s'il estoit, there was a Lady sitting'.[17] In mid-July, however, Huygens was able to send his brother a full account, having visited Lely's supplier of pastels to discover exactly how they were made, and enclosed a list of the different colours with each shade carefully described.[18] In a later letter, he discussed other technicalities – for example, the pastel must not be allowed to become too hard or it would become impossible to use – and noted that for 10s. he had bought a box of colours himself, 'qui a

la verité est un peu cher. mais aussi j'en ay a revendre parce que de chaque couleur j'ay deux pieces, et il y a 54 couleurs differentes.'[19]

Among Lely's followers and friends, although never his pupils, were the portrait painter Mary Beale,[20] who worked in a Lelyesque style, and her son, the younger Charles Beale (nos 169–71). He was a pupil of the miniaturist Thomas Flatman, but his most remarkable works are the sketchbooks he filled with red chalk studies from the life, depicting members of his family, their servants and children, and other visitors to his parents' house. Although as drawings they are not of the very highest order, they provide an arresting glimpse of seventeenth-century domestic life, further enhanced by the fact that the elder Charles Beale kept a journal in which he noted details of several of the people drawn by his son: for instance, he had frequent dealings with the artists' colourman Carter, who is the subject of one of the most vigorous studies (no. 170a). In their almost photographic immediacy these drawings conjure up a vivid sense of the sitters' physical presence.

Lely's immediate pupils included the talented John Greenhill (nos 133–5), whose paintings are very much in the Lely mould but whose pastel portraits show him developing an independent style. He died when he was only about thirty-two, but his proficiency as a draughtsman was rightly noted by Vertue, who records 'from the life – Heads done in crayons by Greenhill, says Mr (Thos) Gibson that he had seen with great skill and perfection equal to any master whatever'.[21] Like Lely's portrait drawings, Greenhill's were intended to be hung as if they were paintings.[22]

An obscure artist, T. Thrumten (no. 100), who is known only through a handful of pastel portraits, must have been aware of Lely's self-portrait (now in the National Portrait Gallery, London). Of those draughtsmen who specialised in pastel portraiture in the 1670s and 1680s,[23] the best are Edmund Ashfield (no. 151) and Edward Luttrell (nos 152–3), who was also a pioneer of mezzotint, sometimes using a roughened copper plate as a ground for his portraits (no. 152). Luttrell, who seems to have been the pupil of Ashfield, describes his methods in a manuscript treatise now in the Yale Center for British Art. While the influence of Lely's portrait drawings must have been a factor in the development of these more elaborate and richly textured examples, it is also probable that the pastels of French artists like Daniel Dumonstier (1574–1646) and Robert Nanteuil (1623–78) were known in England. A number of Luttrell's pastels, including both examples shown here, are copies after portraits in oils by other artists: the practice of commissioning copies or replicas was widespread at this time.

Another type of finished portrait drawing popular in England from the 1650s until the early years of the eighteenth century was the monochrome miniature, usually in black lead, a modest and cheap alternative to the painted miniature. Most of the artists who specialised in these were primarily engravers, and such drawings have much in common with portrait engraving, which reached a high standard in the work of David Loggan, William Faithorne and Robert White. At first sight, such drawings have only a very limited appeal, but closer examination reveals an unexpected degree of subtlety. No. 82, a portrait of John Aubrey by Faithorne, is a particularly fine example in its refined and sympathetic penetration of character. In contrast, a drawing by Thomas

Forster (no. 194) is characterised by the artist's lively treatment of surface texture. After his death in 1691, Faithorne was the subject of a poem by his friend Thomas Flatman, who praised his talents as an engraver:[24]

> . . . For my part I prefer, to guard the dead,
> A copper-plate before a sheet of lead.
> So long as brass, so long as books endure,
> So long as neat-wrought pieces, thou'rt secure.
> A *Faithorn sculpsit* is a charm can save
> From dull oblivion, and a gaping grave.

The finest portrait draughtsman of the period, however, was Samuel Cooper. His work as a miniature painter is beyond the scope of this survey, but established him as one of the leading artists of the period and among the few whose reputation extended beyond England: 'uno dei più famosi et accreditati pittori'.[25] Although, regrettably, only a handful of drawings by him have survived (all the known examples are included here, nos 74–80), this aspect of his work was considered significant enough to deserve specific mention by Edward Norgate in his *Miniatura*, which was written in about 1650: '. . . the very worthy and generous Mr Samuel Cooper, whose rare pencill, though it equall if not exceed the very best of Europe, yet it is a measuring cast whether in this he doe not exceed himselfe. The busines I meane is Crayon, when it speakes French, but Dry Colours in English. A kind of drawing it is when done in Chiar oscuro or light and darke upon a Colored paper.' Norgate goes on to compare Cooper's drawings favourably with those he had seen by Goltzius, 'in dry colours upon writting vellim after the life . . . exceeding well and neatly done . . . But those made by the Gentile Mr Samuel Cooper with a white and black Chalke upon a Coloured paper are for likenes, neatnes and roundnes *abastanza da fare stupire e marvigliare ogni acutissimo ingegno*'.[26] Of such drawings only those of Mrs John Hoskins (nos 75–6) and that of a dead baby (no. 80), which are on paper prepared with a coloured wash, are now identifiable. The two profile drawings of Charles II (nos 77–8) are in poor condition, but are of great interest since they were almost certainly made on an occasion later recalled by John Evelyn which gives a vivid glimpse of the King: in January 1662, he was called into the King's Closet, where Cooper was drawing his portrait by candlelight to be used in the making of dies for the new coinage: 'His Majesty was pleased to discourse with me about several things relating to painting and graving.'[27] Cooper's best-known and most beautiful surviving drawing is the study of Thomas Alcock (no. 74).

Lely died in 1680, and for the next forty years portraiture in England was dominated by the German-born Godfrey Kneller. Kneller had studied in Holland under Rembrandt's follower Ferdinand Bol, as well as in Italy. In 1676 he arrived in England, where he rapidly made a reputation for himself. A combination of considerable technical ability and complete confidence in his own talent, or – as he would have said – genius, together with the absence of any serious competition, gave him an unchallenged position, of which he took full advantage. His somewhat unsympathetic character is apparent from the quarrels that were to beset the affairs of the Great Queen Street

academy between its foundation in 1711 and 1715, when Thornhill was elected Governor in Kneller's place. 'Firm in his drawing & ready at his pencil',[28] his reputation was, however, not undeserved; and, as Horace Walpole said, 'Can one wonder a man was vain, who had been flattered by Dryden, Addison, Prior, Pope and Steele?'[29] In Pope's case, at least (see no. 147), this flattery contained an element of irony which Kneller was too self-satisfied to see.

Kneller was at the head of a large studio, and his drawings have not yet been entirely satisfactorily distinguished from those by his followers.[30] Only one hundred or so have been convincingly attributed to him, a mere fraction of the number of his paintings. He must surely have made many more drawings which have since been attributed to other hands. Contemporary interest in them is suggested by the fact that shortly after his death one of his executors brought a suit against Lady Kneller, claiming that her husband had promised all his drawings to him.[31] A number of those that survive bear a monogram inscribed by Kneller, probably in his later years when he seems to have gone through his drawings and signed some of them, suggesting that, like Lely, he thought of these not simply as preparatory studies but also as independent works (nos 141–2). Kneller's drawings are varied in type, but were mostly made in connection with painted portraits; a few studies for poses survive in which the proposed arrangement of figures is sketched out (no. 144v), but more numerous – and among his most attractive drawings – are those in which he concentrates on one element of a composition. In no. 141, drawn with almost Van Dyckian bravura, he sketches a Negro page in two positions, caught as if in slow motion; similarly in no. 144, a greyhound seen from behind. No. 142, a drawing of a doe used for the portrait of *Lord Buckhurst and his sister, Lady Mary Sackville* (Lord Sackville, Knole), is a more finished study, with delicate touches of colour.

The type of drawing most frequently associated with Kneller is the large-scale portrait head, which was to become standard practice among English portrait painters at the turn of the century: as Alexander Pope explained to Lady Mary Wortley Montagu, 'Upon conferring with Kneller I find he thinks it absolutely necessary to draw the face first, which he says can never be set right on the figure if the drapery and posture be finished before. To give you as little trouble as possible he proposes to draw your face with crayons and finish it up at your own house in a morning: from whence he will transfer it to canvas, so that you need not go sit at his house.'[32] The vapid, undemonstrative expressions in many of these studies do not commend them to modern taste, but there are exceptions, such as the vigorous likeness of the engraver Peter Vanderbank (no. 143). Among Kneller's successors, both Dahl (no. 165) and the elder Richardson made studies of a similar kind. Their purpose was as an aid in the painting of portraits, but the sitter would often pose on subsequent occasions for Kneller, as many as ten or twelve sessions sometimes being required by the artist.[33]

A number of drawings by Kneller belonged after his death to his assistant Edward Byng,[34] who also owned six sketchbooks and an album of miscellaneous studies (all now in the British Museum), consisting of drawings by several hands, which are of interest since they show something of the way in which Kneller's studio was organised. Many of the drawings are reduced and simplified copies of portraits, and were useful for

turning out replicas or to serve as models for poses when painting a new sitter. Almost without exception such drawings (and even more so, the many full-size tracings on varnished paper of various details in pictures) are uniformly uninspiring, but they served a practical purpose and were carefully preserved as the stock-in-trade of the artist. Among these stiffly drawn and repetitious studies, however, lurk a number of more interesting drawings, including a group of figure studies[35] which are probably connected with the Great Queen Street academy, of which Kneller was the first Governor and Byng a member.

In this period, portraiture was undoubtedly the dominant genre; the emergence of landscape as the distinctive English contribution to painting was a development of the later eighteenth century. The novelty of landscape as an art form in mid-seventeenth-century England may be judged from the fact that Edward Norgate could write in about 1650 that it was 'an Art soe new in England, and soe lately come a shore, as all the Language within our fower seas cannot find it a Name, but a borrowed one, and that from a people that are noe great Lenders but upon a good Securitie, the Dutch. Perhaps they will name their own Child. For to say the truth the Art is theirs.'[36] Norgate goes on to refer to the landscape paintings of a number of artists, including Brill, Elsheimer, Momper, the younger Brueghel and Coninxloo; in other words, paintings in which an ideal landscape was generally represented, rather than the features of a particular locality. This latter descriptive form of landscape – topography – was by no means new in England, but in the second half of the seventeenth century it assumed a much greater importance. Among the most notable groups of topographical watercolours dating from this period are Wenceslaus Hollar's views of Tangier (nos 72–3), drawn in 1669 when the artist accompanied a special embassy to the Moorish court with the intention of securing free trade for Tangier, a property of the British Crown since 1661. In detail, and with great clarity, relying on only the most discreet compositional aids, these drawings explain the lie of the land and its relationship to the sea, and show the placing of the various buildings, especially the fortifications and harbour installations. Certain features of this series were to become recurring characteristics of the topographical drawing. The most important, if the most obvious, was the practice of making more than one drawing of each view, a sketch executed on the spot and a finished watercolour worked up afterwards (both views of Tangier discussed here are the final versions). Hollar's drawings of Tangier are perhaps most appropriately thought of as highly sophisticated examples of military surveying, an aspect of topographical art that was to remain important well into the eighteenth century (Paul Sandby, for example, began his career as a draughtsman attached to the military survey of the Scottish Highlands carried out by the Duke of Cumberland after the defeat of the Jacobite rebellion of 1745).

Undoubtedly the most distinguished topographical artist working in England in the seventeenth century, Hollar was the primary influence on the development of this branch of landscape in England, but his immediate followers, though fairly numerous, were, with one exception, minor, if interesting, figures. They included John Dunstall, whose view of West Hampnett Place (no. 86) is in the old-fashioned medium of

bodycolour on vellum, and Thomas Johnson, with his amusingly observed drawing of the Baths at Bath (no. 85). The exception was Hollar's most notable follower, 'the Ingenious Mr Place'.[37] Although never a pupil of Hollar, as he much regretted, Francis Place knew him well (in his old age, he was to recount his recollections of Hollar to George Vertue),[38] and his own early drawings and etchings resemble Hollar's in their delicacy of line. A man of independent means, Place spent most of his life in York, where he was a member of the local Society of Virtuosi (a group of gentlemen who shared antiquarian and scientific interests). He was one of the first English artists to visit the remoter parts of the British Isles, anticipating the sketching tours of artists a century later. His drawings (see nos 148–50), which remained largely unknown until the present century, show an interest in tonal qualities, the fall of light and the texture of rocks and foliage which anticipates the naturalistic landscapes of the next generation. His later drawings suggest that he knew the work of such Dutch-Italianate artists as Thomas Wyck (nos 83–4). Place was himself a collector and owned a number of Italian views by Thomas Manby (probably including no. 125),[39] who was also influenced by the Dutch-Italianate painters Poelenburgh, Breenbergh and Asselyn.

The other significant influence on the development of a native school of landscape was that of the Dutch painters and draughtsmen who visited England from the 1660s onwards, some only for brief periods, others, including the Van de Veldes, Jan Wyck and Knyff, settling permanently. The presence of such foreigners, and the trade in their works, was much resented by the artists' guild, the Painter-Stainers' Company, who demanded that their regulations be complied with (in fact, some of those foreign-born artists who were naturalised became members of the Company); their reactionary, closed-shop attitudes can be illustrated in a direction to their clerk in 1669 to prosecute 'the man in Redcrosse Street . . . for offering Dutchy peeces for sale',[40] which was presumably thought to endanger the livelihood of native English artists.

Among the first Dutch artists to visit England after the Restoration were Jacob Esselens (nos 116–17) and Willem Schellinks (no. 120), whose journal records that he was in the country between July 1661 and April 1663, during which time he made many sketches, a number of which were worked up after his return to Amsterdam for inclusion in the great topographical collection formed by Laurens van der Hem, a member of a wealthy merchant family. No remotely comparable collection existed in England at this date, although a more modest collector, Samuel Pepys, attempted to assemble something of a similar kind. Pepys did, however, commission a group of four prospect paintings of royal palaces from another Dutch artist, Hendrik Danckerts, who lived in England from the early 1660s until 1678/9, when, as a practising Catholic, he left the country at the time of the Popish Plot. Although Pepys thought his paintings 'mighty pretty', they appear stiff and far less attractive than his drawings. He is represented here by two studies perhaps made on the spot in Wales (nos 123–4), and by a fine, large view of Badminton House (no. 122), perhaps drawn in the 1670s. This was probably the earliest of the many prospects made of the house, which were to culminate in those painted by Canaletto in 1748.

Another Dutch-born landscape artist, Leonard Knyff, specialised in painting and

drawing views of country houses and estates from a bird's-eye perspective. In the late 1690s Knyff began to make a series of drawn prospects of country houses with the intention of publishing a series of engravings, a project that resulted in the publication of *Britannia Illustrata* in 1707: no drawings survive that are directly related to any of the eighty plates that were engraved for it by Jan Kip, but no. 161, a view of Hampton Court, is probably connected with Plate 6.[41] Two particularly striking drawings by Knyff, nos 160a and 160b, are both views of the Thames at Richmond, and with their spacious, sweeping perspective achieve an astonishing sense of immediacy.

Like Knyff, Jan Siberechts (who was born in Antwerp, and came to England in about 1674, apparently at the invitation of the 2nd Duke of Buckingham) specialised in views of country houses, but his style is on the whole softer and more atmospheric, reflecting his Flemish training. Of all the Netherlandish landscapists who worked in England during the seventeenth century, Siberechts was perhaps the one who most fully responded to the English countryside: a small group of watercolours of views near Chatsworth, one of which is included here (no. 119), dated 1694, and a small study of a fallen tree trunk (no. 118), anticipate the work of watercolourists in the following century, such as William Taverner. They have a sense of atmosphere and a feeling for nature which is unusual for their date. No. 119 is also notable for its technique: the method of drawing with the brush in colour differs from the usual practice at this period of laying in the tones in grey wash and adding the tints at a subsequent stage.

Despite the Anglo-Dutch Wars, active steps seem to have been taken in the early 1670s to attract Dutch artists to settle in London,[42] the most remarkable case perhaps being that of the Van de Veldes, who were already established among the leading marine artists of the day in Holland. The elder Van de Velde had previously visited England at some time between 1660 and 1662, but settled in England with his son more or less permanently from 1672/3. They were almost immediately taken into royal service, working in a studio in the Queen's House at Greenwich and each being paid a salary of £100. The elder Van de Velde's speciality was, as the royal warrant stated, 'the taking and making Draughts of seafights', which his son would then develop in paintings. A first-hand observer of many of the most dramatic naval actions of the period, which he would sketch from a small galliot, the elder Van de Velde's services seem to have been so highly esteemed by Charles II that he was forbidden to accompany the British fleet at the Battle of Texel in August 1673: 'His Majesty was not desirous of him risking his life through cannon fire.'[43] From the work of the Van de Veldes stems the English school of marine painting and drawing in the time of Samuel Scott and Peter Monamy, and their influence can be discerned as late as the work of Turner and Constable (whose drawings of shipping have sometimes been mistaken for Van de Veldes).

One of the most important native-born artists of his generation was Francis Barlow. His paintings, drawings and engravings give the appearance of being quintessentially English, yet in fact he derived his style and even much of his subject-matter from Continental sources. His closest affinity is with a number of sporting and animal artists from the Low Countries who had settled in England, in particular Melchior Hondecoe-

ter, Abraham Hondius (no. 101) and Jan Wyck (nos 162–3). Hondius worked in a style loosely derived from Frans Snyders, but Wyck is more important for the development of sporting art in England: his followers included John Wootton, who in the next generation was to be the first English sporting painter of distinction. Like Wyck, Barlow made drawings for Richard Blome's *The Gentleman's Recreation*, published in 1686, and his designs for illustrations to various books of sport, including *Severall Wayes of Hunting, Hawking, & Fishing according to the English manner*, which he published himself in 1671 (with plates etched by Hollar), show him at his most characteristic.

In Barlow's work the influence of Hollar is evident, and like Hollar he was an accomplished etcher. His illustrations to *Aesop's Fables* (nos 103–6), first published in 1666, show him following a well-established iconography. His prototypes were Marcus Gheeraerts's etched illustrations to the *Fables*, first published in Bruges in 1567, and, more immediately, those by Francis Cleyn for the first edition of John Ogilby's *The Fables of Aesop Paraphras'd in Verse and adorn'd with Sculpture* (1651), as well as Hollar's illustrations to the second edition (1665), which were largely elegant adaptations of Cleyn's. Yet despite Barlow's dependence on these models, his illustrations are never just direct copies. There was presumably also a comparable source for his illustrations to the *Life of Aesop* (nos 107–8), but this is so far unidentified: these designs are chiefly remarkable for the elaborate Baroque interiors he depicts, in marked contrast to his usual outdoor subjects.[44] Barlow's keen sense of observation, and his robust yet graceful handling of his favoured medium, grey wash outlined in pen and ink, give all his drawings a distinctive liveliness which was often lost in the many crude engravings after his designs (compare, for example, his drawing *Manning hawks*, in the Witt Collection, Courtauld Institute of Art, with the engraving based on it by Arthur Soly for a plate in *The Gentleman's Recreation*). Barlow's reputation as an etcher was not confined to England: the introduction to the fourth edition of his *Aesop*, published in Amsterdam in 1714, speaks of 'des animaux et oiseaux dessinez d'un goût exquis et d'une touche tres savante' and of his work as 'tres utile aux peintres, sculpteurs, graveurs, et autres artistes ou amateurs de dessin'.

In the mid-seventeenth century the publisher, the artist as illustrator and the engraver brought a knowledge of literature and the arts to a far wider public than had previously been possible: this period saw a rapid increase in the number of prints and illustrated books to be published. Etching became a popular medium (in place of engraving), chiefly because it was a considerably easier and quicker method, offering a freedom and flexibility of line previously unknown. John Evelyn's *Sculptura*, published in 1662, was the first account of engraving to appear in England. It emphasised the importance of prints in spreading knowledge and in assisting those who were not able to afford original works of art: it was also in *Sculptura* that the discovery of a new engraving process – the mezzotint – was first publicised. Like his royal patron Prince Rupert (see no. 99), who brought the new technique to England, and others, including the Huygens brothers in Holland, Evelyn had an almost equal interest in science and the arts. *Sculptura* was dedicated to the physicist and chemist Robert Boyle, and among Evelyn's hopes was 'that such as are addicted to the more Noble Mathematical Sciences, may

draw, and engrave their Schemes with delight and assurance'.[45] There may seem to be a wide gulf between Evelyn's high-minded aspirations and the publication of illustrated editions of the classics in translation, such as *Virgil* (nos 30–31) or *Aesop's Fables*, but this would not have been so apparent to his contemporaries. Pepys's diary reveals some of the interest which this widening of culture evoked among an increasingly prosperous and securely established middle class. The ingenuity of publishers in devising schemes for large editions of elaborately produced books can be gauged from the careers of two of the better-known publishers of the period, John Ogilby and Richard Blome.[46] Ogilby, one of the most colourful and remarkable of characters (he had been a dancer and actor-manager before turning to publishing and translation, and twice at least lost all his money), published several important illustrated books, including his *Virgil* in 1654, the first English book in which expensive illustrations were financed by subscription, each plate bearing dedicatory lettering and the coat of arms of the 'dedicatee' who had paid for the privilege. Richard Blome's *The Gentleman's Recreation* was a similar venture. Described as 'an impudent person' who by resorting to 'progging tricks' persuaded hack writers and artists to work for him and attracted subscriptions to a bewildering variety of publications, Blome appears to have been a successful entrepreneur. Several artists, including Barlow, Hollar and Faithorne, published works on their own account, but whether this was because they hoped to make money or whether they were chiefly concerned with the possibility of themselves exercising control over their own work and the manner in which it was reproduced we do not know. Increasingly, however, in the late seventeenth century artists found book illustration a way, albeit modest, of making a living, while for some publishers there were opportunities for considerable profit: the basis of Jacob Tonson's fortune and reputation was his phenomenally successful edition of Milton's *Paradise Lost* (1688), the first to be illustrated (no. 167).

At a more popular level, a little-known aspect of Barlow's art is his work as a satirist. At this period, the majority of satires on English subjects were by Dutch engravers: few English satires published before about 1700 are of any particular visual quality, very few were signed, and even fewer preparatory drawings have survived. A handful of satirical prints by Hollar are known, and it may again have been his example that provided the stimulus for Barlow's activity in this area. Although none are signed, it is possible to identify Barlow as the designer of a number of anti-Catholic prints such as *The Happy Instruments of Englands Preservation*, for which a drawing survives (no. 115), and of playing cards also concerned with the Popish Plot of 1678–9 (nos 111–14): it is likely that Barlow was also responsible for other so far unattributed satires.

The Glorious Revolution of 1688, which ended the brief reign of James II and laid the foundations of constitutional monarchy, also ended the dependence of the aristocracy on the court and thus the pre-eminence of the court as an arbiter of taste. Neither William and Mary, nor Anne, nor the first two Georges were notably discerning patrons of the arts (although the taste for Dutch domestic architecture, interior decoration and garden design (see no. 176) favoured by William and Mary was not without influence). This was the great age of the Tory and then the Whig grandees, who formed the most powerful aristocratic oligarchy in British history. As a sign of their

expanded role in society they either rebuilt their country houses or, if they were newly rich or ennobled, built them for the first time (no. 191). Many of these houses were recorded in handsome prospect views, either painted, drawn or engraved, of the type familiar to us from Knyff's drawings as reproduced by Jan Kip in his *Britannia Illustrata*, 1707 (see no. 161). These great Baroque mansions of the 1690s sought to emulate, however remotely, the Versailles of Louis XIV, which led their owners to commission not only grand full-length portraits by Kneller or Dahl, appropriate to the large scale of the interiors, but also elaborate ceiling and wall decorations in the Continental manner. Although the vogue for such schemes was comparatively short-lived, for the Palladian style of architecture which became popular in the 1720s and 1730s gave little scope for this type of decoration, it is an interesting phenomenon in the history of British taste. Until the advent of Thornhill, the two leading decorative artists were Antonio Verrio, who settled in England in 1672, and Louis Laguerre, who, though only twenty-one when he arrived in 1684, at once became Verrio's assistant and within a few years was attracting independent commissions, the first significant one being for the decoration of Chatsworth (see no. 178). No drawings which can be attributed to Verrio with certainty are known, but one with a good claim to be by him is included here (no. 131), as well as the impressive small-scale replica in bodycolour, painted in his studio for Samuel Pepys, of the huge *James II receiving the mathematical scholars of Christ's Hospital* (no. 132).

If one person could be said to have been responsible for the introduction of decorative painting to England, it was the francophile Ralph Montagu, 1st Duke of Montagu, who had been ambassador extraordinary to France in 1669, had negotiated the secret Treaty of Dover in the following year, and was to live in exile in France between 1680 and 1685. He owned Montagu House – on the site of which the British Museum now stands (see no. 159) – and was responsible for inviting Verrio to England in 1672 to work there. Later on he also brought over a number of French artists, including Louis Chéron, who was commissioned to decorate his country house, Boughton (see no. 172).[47] Like a number of other French artists and craftsmen who left their native country after the repeal of the Edict of Nantes in 1685, Chéron was a Huguenot. So too was the designer, architect and engraver Daniel Marot, who spent most of his long life working for William III in Holland. However, he visited England in the mid-1690s (and possibly on an earlier occasion), where he seems to have advised on the design of the parterre at Hampton Court (no. 176)[48] and on the decoration of Montagu House (no. 177).[49]

The rise to prominence of James Thornhill as the leading decorative painter of his day can best be studied through his drawings. It was as a draughtsman that he was at his most baroque, and all too often the energy and gusto of his preliminary designs was lost when he came to paint on a large scale. More drawings by him are known than by any other native-born artist of the period: around four hundred survive, in addition to two travel journals (Victoria and Albert Museum) and his sketchbook (no. 184), which he began when he was twenty-three and used over a period of twenty years. It includes many of his early ideas for such major commissions as the Painted Hall at Greenwich

and the dome of St Paul's Cathedral, as well as for private commissions. His thoroughness in preparing designs is immediately apparent from the many alternative ideas he sketches out, as well as the careful annotations on literary and historical sources he has consulted.

The decoration of the Painted Hall at Greenwich, a project which spanned the greater part of his career, from 1707 until 1727, is of particular interest because Thornhill's preliminary drawings show him wrestling with a problem that was to preoccupy history painters in the eighteenth century in much the same way (nos 185–6). The chief theme of the decoration was to be the triumph of the Protestant Succession, and Thornhill had thus to depict certain episodes from recent or contemporary history, including *The Landing of William III* and *The Landing of George I*: how far was truth to real appearances consistent with the grand manner? He meticulously notes (no. 185) the objections to the representation of George I's landing as it was in fact: it was night, no ships were visible, but only small boats which would look insignificant in the composition; many of the nobles who had been present were now in disgrace; the King's dress was not 'enough worthy of him to be transmitted to posterity', and so on. Having analysed the problems, Thornhill chose to paint the subject in an idealised way, and to represent the King's dress 'as it should have been rather than as it was' (no. 186). Greenwich was Thornhill's first major commission, and one reason that he was chosen may simply have been that he would be less expensive than better-known rivals. By 1717, however, Colen Campbell's *Vitruvius Britannicus* was revelling in self-congratulatory patriotism: 'Here Foreigners may view with Amaze, our Countrymen with Pleasure, and all with Admiration, the Beauty, the Force, the Majesty of a *British* pencil.'[50] Thornhill's achievements at Greenwich and St Paul's (nos 187–90) in particular, where in both cases he wrested major commissions from foreign rivals, were the source of considerable encouragement to a younger generation of aspiring British artists, notably Hogarth.

By the last decade of the century a conscious awareness of the existence of a recognisably British school seems to have developed. This can be seen in the activities of the various clubs of artists that were formed, including the Virtuosi of St Luke and the convivial Crown and Rose Club, and in the proposals – at this stage, unsuccessful – in the late 1690s for the establishment of an academy. There was an increasing patriotic desire to encourage British artists, and the beginnings of more enlightened patronage. Although the English contribution to the theoretical literature of art was very limited until the advent of Jonathan Richardson and the Earl of Shaftesbury,[51] the first attempts at an historical survey of the British school were being made. In 1695 Richard Graham's *Short Account of the most Eminent Painters* was published with Dryden's translation of Du Fresnoy's *De Arte Graphica*, and in 1706 Bainbrigg Buckeridge's *Essay towards a British School*, a collection of brief biographical sketches of British painters, was appended to an English translation of De Piles's influential *The Art of Painting, and the Lives of the Painters*.

The establishment in 1711 of the first academy in London marks the beginning of a new era in the training of artists. Although influenced by the example of the Accademia

di San Luca in Rome and the Académie Royale de Peinture et de Sculpture in Paris, the newly formed academy in London was really more of an artists' club than a regimented institution. Essentially it was a life-class, although there was no formally appointed teacher. Several of the original members had attended academies abroad, including Kneller, Dahl, Chéron and Laguerre. The first Governor was Kneller, to whom it must have seemed a perfect opportunity to demonstrate his leadership of the British school. Although he was to be replaced by Thornhill in 1715, Kneller's influence was not without importance. His high opinion of himself and of the status due to artists was critical at a period when painting was beginning to be regarded as a liberal art rather than as a craft. In 1719 Richardson was able to write that 'Painters are upon the same level with writers, as being poets, historians, philosophers and divines, they entertain and instruct equally with them'.[52] Such a statement would have been inconceivable in an earlier generation. Besides encouraging the development of technical skills among artists, laying particular stress on the importance of drawing, the existence of this and succeeding academies[53] acted as a focus for the emergence of a native school.

In October 1720, the twenty-three-year-old William Hogarth was one of the original subscribers to a new academy founded under the direction of John Vanderbank and Louis Chéron (see nos 173–4). Although Hogarth later claimed 'it occur'd to me that there were many disadvantages . . . in even drawing after the life itself at academys . . . it is possible to know no more of the original when the drawing is finish'd than before it was begun',[54] his study of the fundamentals of figure drawing (no. 197) was to be of considerable importance. By the end of the decade he had established himself as one of the most promising younger artists, anticipating in his early prints and drawings the originality of his mature achievement. Hogarth was to be the first in a line of British artists who, in Wordsworth's phrase, set out to 'create the taste by which they are to be relished'. In his drawing *A harlot in her garret* (no. 200), he could hardly be further removed from the 'beaten subjects either from the Scriptures or from the old ridiculous stories of the Heathen gods as neither the Religion of the one or the other require promoting among protestants'[55] that he associated with the art of the Baroque era. With Hogarth we enter a new phase. He is the first truly English artist, both in his choice of vernacular, narrative subject-matter and in his overtly moralising intentions. His is an art that looks forward to the nineteenth century, rather than back to the seventeenth.

LS

1. J. Hook, *The Baroque Age in England*, London, 1976, p. 14.

2. Hook, op. cit., is a useful introduction to the period.

3. William Aglionby, *Painting Illustrated in Three Diallogues, containing some Choice Observations upon the Art. Together with the Lives of the Most Eminent Painters . . . With an Explanation of the Difficult Terms*, London, 1685, preface, n.p.

4. Richard Graham, *A short Account of the most Eminent Painters. . .*, which accompanied the English edition (*The Art of Painting . . . with Remarks*, 1695) of Du Fresnoy's *De Arte Graphica*, 1668, p. 343.

5. In a letter from James Wainwright to John Bradshaw, 6 October 1654 (Historical Manuscripts Commission, Sixth Report, Part 1, 1877, pp. 437b–438a). Quoted in O. Millar, *Sir Peter Lely*, exh. cat., National Portrait Gallery, London, 1978, no. 22.

6. Only two drawings, both landscapes, have been attributed to Lely before he left Holland. However, his later figure drawings (especially those connected with the Procession of the Order of the Garter) are very Dutch in style. See Peter Schatborn, *Dutch Figure Drawings from the Seventeenth Century*, exh. cat., Amsterdam and Washington, 1982, *passim*.

7. *Journaal van C. Huygens . . . 1688–1696*, Utrecht, 1876, p. 326 (1 September 1690).

8. Vertue, IV, p. 172.

9. Executors' Account Book of Sir Peter Lely 1679–1691, BL Add. MS 16174.

10. See catalogue of sale, Wilson, April 1723.

11. BL Add. MS 22950, f.3.

12. Vertue, IV, p. 172.

13. See 'Sir Peter Lely's Collection', *Burl. Mag.*, LXXXIII (1943), p. 188.

14. See, for example, O. Millar, *Sir Peter Lely*, exh. cat., National Portrait Gallery, London, 1978, nos 70–82.

15. *Oeuvres Complètes de Christiaan Huygens*, 22 vols, Societé Hollandaise des Sciences, The Hague, 1888–1950, vol. IV, *Correspondance 1662–1663, passim*.

16. Ibid., p. 361 (23 June 1663).

17. Ibid., p. 363 (29 June 1663).

18. Ibid., pp. 370–73 (13 July 1663).

19. Ibid., p. 389 (3 August 1663).

20. See E. Walsh and R. Jeffree, '*The Excellent Mrs Mary Beale*', exh. cat., The Geffrye Museum, London, 1975.

21. Vertue, IV, p. 86.

22. William Cartwright, who bequeathed his collection to Dulwich College in 1688, noted in his MS catalogue that he had paid Greenhill for three pastel portraits, £2 for one and £3 for each of the others, and stated that they were 'covered with glass'.

23. See Noon (1979), pp. ix–xi, for the most recent account of the development of pastel portraiture in this period.

24. Flatman's poem was published by Bainbrigg Buckeridge as part of his brief biographical notice of Faithorne, in his *Essay towards a British School*, appended to an English translation of Roger de Piles's *The Art of Painting, and the Lives of the Painters*, London, 1706, pp. 371–2.

25. A. M. Crinò, 'The Relations between Samuel Cooper and the Court of Cosmo III', *Burl. Mag.*, XCIX (1957), p. 16.

26. Edward Norgate, *Miniatura or the Art of Limning*, ed. M. Hardie, Oxford, 1919, p. 74.

27. D. Foskett, *Samuel Cooper 1609–1672*, London, 1974, pp. 47–8.

28. Vertue, IV, p. 29.

29. Quoted in L. Lipking, *The Ordering of the Arts in Eighteenth Century England*, Princeton, 1970, p. 51.

30. J. Douglas Stewart, *Sir Godfrey Kneller and the English Baroque Portrait*, Oxford, 1983, pp. 149–50.

31. Ibid., p. 149.

32. Alexander Pope, *The Correspondence. . .*, vol. II (1719–28), ed. G. Sherburn, London, 1956, p. 22.

33. Stewart, op. cit., p. 151.

34. See ECM & PH, pp. 390–95.

35. The figure studies are listed in ECM & PH under Byng, pp. 264–5, nos 68–86.

36. Norgate, op. cit., p. 42.

37. Vertue, II, p. 54.

38. Vertue, I, pp. 4, 34–5; II, p. 31.

39. The drawing by Thomas Manby (no. 125) descended to Patrick Allan Fraser of Arbroath, who also owned many drawings by Francis Place, probably through descent from Place's second daughter, Ann.

40. *The Age of Charles II*, exh. cat., Royal Academy, London, 1960–61, p. ix.

41. See J. Harris and G. Jackson-Stops, introduction to a reprint of *Britannia Illustrata*, London, 1984.

42. Charles II issued a declaration encouraging Dutch people to settle in England in June 1672. See D. Cordingly and W. Percival-Prescott, *The Art of the Van de Veldes*, exh. cat., National Maritime Museum, Greenwich, 1982, p. 14.

43. Ibid., p. 17.

44. E. Hodnett, *Francis Barlow, First Master of English Book Illustration*, London, 1978, pp. 206–20.

45. R. Godfrey, *Printmaking in Britain*, Oxford, 1978, traces the beginning of a native tradition in etching

and discusses the origins and early development of the mezzotint, pp. 19–30.

46. Hodnett, op. cit., pp. 75–8, gives a lively account of Ogilby's career.

47. J. Cornforth, 'Boughton House, Northampton-shire', *Country Life*, CXVIII (1970), pp. 624–8, 684–7.

48. A. Lane, 'Daniel Marot: Designer of Delft Vases and of Gardens at Hampton Court', *Connoisseur*, CXXIII (1949), pp. 19–24.

49. J. Cornforth, op. cit., pp. 625–6, and G. Jackson-Stops, 'Daniel Marot and the 1st Duke of Montagu', *Nederlands Kunsthistorisch Jaarboek*, 31 (1980), pp. 244–62.

50. Colen Campbell, *Vitruvius Britannicus*, 3 vols, London, 1717–25, vol. I, p. 6.

51. Notably, Shaftesbury's *Characteristicks...*, first published in 1711, and Richardson's writings, which include *The Theory of Painting* (1715), *An Essay on the Whole Art of Criticism as it relates to Painting* and *The Science of a Connoisseur* (1719), and *An Account of Some of the Statues, Bas-reliefs, Drawings and Pictures in Italy* (1722). See L. Lipking, *The Ordering of the Arts in Eighteenth Century England*, Princeton, 1970, pp. 109–26.

52. Jonathan Richardson, *An Essay on the Whole Art of Criticism as it relates to Painting*, London, 1719, p. 42.

53. See nos 146, 173–4 and 197. Besides the Great Queen Street academy, under the Governorship of Kneller from 1711 until 1715 and then Thornhill (who later transferred the academy to his own house), there were two subsequent academies in St Martin's Lane, that organised by Chéron and Vanderbank between 1720 and 1724, and, later on, that associated with Hogarth and his circle from 1734 to 1755.

54. A rejected passage from Hogarth's *Analysis of Beauty*, 1753, ed. J. Burke, Oxford, 1955, p. 184.

55. Hogarth, op. cit., p. 185.

The Catalogue

HILLIARD, Nicholas

Exeter 1547 – London 1619

Hilliard was apprenticed to the London goldsmith and jeweller Robert Brandon, whose daughter he later married, and in 1569 became a freeman of the Goldsmiths' Company. About this time he was appointed goldsmith and limner to Queen Elizabeth. His earliest dated portrait of the Queen is that of 1572 (National Portrait Gallery, London). From 1576 to 1588/9 Hilliard was in France 'to increase his knowledge by this voyage' and 'to get a piece of money from the lords and ladies'. The Duc d'Alençon, the suitor of the English Queen, was among his patrons. He met French writers and artists at the French court, including the royal medallist and limner Germain Pilon, and had the opportunity to study the work of the recently deceased François Clouet. In 1584 a draft patent reserved for Hilliard the exclusive right to paint the Queen 'in small' and in the same year he designed and engraved the Queen's second Great Seal. About 1600 he composed his *Treatise concerning the Arte of Limning*, which was the first such work to be written in English, providing information about his technique and his life. Despite growing competition from Isaac Oliver (q.v.) Hilliard's royal patronage continued under James I, who in 1617 granted him the exclusive right 'to invent, make, grave, and ymprint (and sell) any picture or pictures of our image or other representation of our Pson' for a period of twelve years. As well as a prolific portrait miniaturist of international reputation, Hilliard was an engraver and maker of woodcuts.

1 Portrait of a lady

Bodycolour on vellum laid onto card; 51 × 43 mm (2 × 1¹¹/₁₆ in)

PROVENANCE: Lady Isabella Scott (d. 1748), from whom bought by Horace Walpole (sale, Strawberry Hill, 14th day, 10 May 1842, lot 15, bought by the Earl of Derby); the Earls of Derby until 1971 (sale, Christie, 8 June 1971, lot 77)

LITERATURE: Reynolds 97; Auerbach 155; Noon (1979) 1

Yale Center for British Art, Paul Mellon Collection (B1974.2.51)

The traditional identification, recorded by Walpole, of the sitter as Elizabeth, Queen of Bohemia, is no longer accepted. Probably executed about 1605–10, this miniature relates to a group of five portraits by Hilliard in which the sitter's hair is treated to suggest cascading flames. A similar feature can be found in three portraits by Isaac Oliver, about 1610 (Reynolds 171, 173–4).

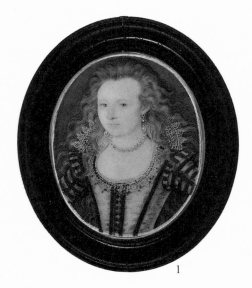

1

2 A queen and her son

Pen and black ink over black lead on two conjoined pieces of vellum; 127 × 89 mm (5 × 3½ in)

Inscribed lower left corner: *N.H.*

PROVENANCE: In the British Museum by 1837

LITERATURE: ECM & PH 2; Auerbach 190; Strong and Murrell 252

The British Museum (T 15–18)

The costume of the queen, which can be dated 1610–15, suggests that the most likely sitters are Elizabeth, Queen of Bohemia, and her infant son, Frederick Henry, who was

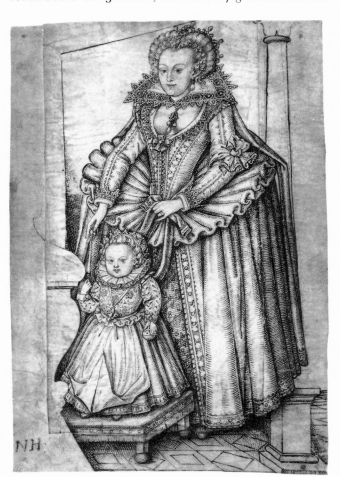

2

born in 1614. Whether the sarcophagus is that of Henry, Prince of Wales, who died in 1613, is more open to speculation.

The attribution of this drawing to Hilliard is based on the apparently contemporary inscription of the artist's initials. In view of the lack of drawings known to date from so late in the artist's life, it is difficult to assign it to him firmly, although the style is not inconsistent with his work. The precise outlines and dry manner of hatching suggest that it was done in preparation for an engraving, although no such print is known. The portrait type is very close to the double portrait of Elizabeth with her husband, Frederick, published in 1613 on the occasion of their marriage and engraved by Ronald Elstrack, probably after Hilliard (A. M. Hind, *Engraving in England*, Part I, London, 1952, p. 175, no. 22, pl. 96).

OLIVER, Isaac
Rouen? 1560? – London 1617

Remarkably little is known about Oliver's life. His father was a Huguenot goldsmith and pewterer from Rouen, who by 1568 had fled with his family to England. Isaac was apprenticed to Hilliard (q.v.) and his earliest dated portrait miniature of 1587 reveals his debt to his master. But his knowledge of Netherlandish art also makes it seem likely that at some time, possibly earlier, he travelled there. In 1596 he is recorded in Venice, and during his stay in Italy he studied Venetian and Milanese painting as well as making drawings after Parmigianino. Thereafter in his work Italian art supplanted the prior influences of the School of Fontainebleau and the Netherlands, and at the same time he developed a greater degree of naturalism. Apart from numerous portrait miniatures, there exist contemporary records of large miniatures with historical and religious subjects. He may also have painted in oils. In 1605 he was appointed 'painter for the Art of Limning' to Queen Anne of Denmark and later worked for Charles I when he was still Prince of Wales. On the basis of a drawing, a *Sheet of studies*, in the Fitzwilliam Museum, Cambridge (Finsten 188), which contains copies after details from two pictures by Guido Reni, and on the supposed resemblance of the Christ Child in the miniature of the *Madonna and Child in Glory*, in the Beaverbrook Art Gallery, Fredericton (Strong and Murrell 179) to the same figure in the 'Madonna della Vallicella' incorporated into Rubens's altarpiece in S. Maria in Vallicella, Rome, completed in 1608, it has been suggested that Oliver made a second journey to Italy about 1610.

Oliver's first wife (the mother of Peter, q.v.) died in 1599 and he married the sister of the Flemish painter Marcus Gheeraerts, who was also a Huguenot refugee in England. In 1606, the year of his third marriage (to the daughter of a court musician), he was, despite his earlier determination to remain a Frenchman, finally naturalised an English citizen. During the Stuart period he became a successful rival to Hilliard. He and Inigo Jones were the first artists working in England to leave a substantial body of drawings which in their style and subject-matter show an awareness of Continental art.

At his death, Oliver bequeathed 'all my drawings allready finished and unfinished and lymning pictures, be they historyes, storyes, or any thing of lymning whatsoever on my own hande worke as yet unfinished' to his son Peter, who completed one unfinished work.

3 Robert Devereux, 2nd Earl of Essex (1566–1601)

Bodycolour and brush and grey ink on vellum laid onto card; 51 × 42 mm (2 × 1¹¹/₁₆ in)

PROVENANCE: Sir Robert Worseley; Frances, Lady Worseley; Horace Walpole (sale, Strawberry Hill, Robins, 10 May 1842, lot 45); the Earls of Derby, by descent (sale, Christie, 8 June 1971, lot 81); Cyril Fry

LITERATURE: Noon (1979) 2; Finsten 26

Yale Center for British Art, Paul Mellon Collection (B1975.2.75)

This unfinished miniature drawing is perhaps the *ad vivum* likeness by Oliver from which the numerous finished versions of the Earl of Essex's portrait were derived. Alternatively, as Patrick Noon has pointed out, it may have been a duplicate painted by Oliver at the time of the original commission to serve as the basis of future replicas. Oliver probably never intended to complete this particular miniature, since the wispy hairs of the sitter's beard are drawn over unprimed vellum, on which the outlines of his doublet have been sketched in. The drawing was probably made about 1596: the face is not unlike that in the full-length portrait of Essex painted by Marcus Gheeraerts in that year.

The Earl of Essex was a soldier and courtier, supplanting Raleigh as Queen Elizabeth's favourite in 1588. His most celebrated campaign was the defeat of the Spanish

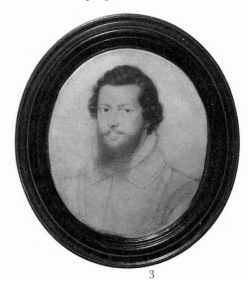

3

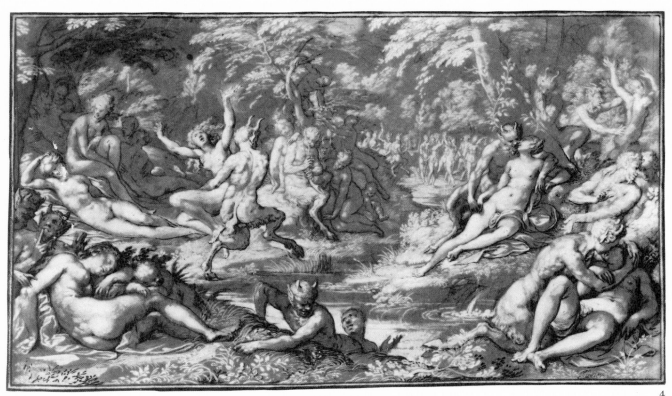

4

fleet and the capture of Cadiz in 1596, but he was later unsuccessful in crushing a rebellion in Ireland, where he was Governor-General. Removed from office, he conspired against the Queen's advisers, but with little success. Tried for treason, he was executed in 1601.

and content are related to the work of the Mannerist artists active in Haarlem from the last decade of the sixteenth century, notably Joachim Wtewael (c.1566–1638) and Cornelis van Haarlem (1562–1638). If Oliver spent some time in the Netherlands he may well have known their work at first hand.

4 Nymphs and satyrs

Black ink over black chalk, heightened with white, on discoloured brown paper; 205 × 357 mm (8¹/₁₆ × 14¹/₁₆ in)

Signed lower right: *Ollivier*

PROVENANCE: Recorded in the collections of Charles I, Charles II and James II

LITERATURE: Oppé 460; Woodward 10; Finsten 182; Strong and Murrell 180; J. Roberts, *Master Drawings in the Royal Collection*, exh. cat., The Queen's Gallery, London, 1986, no. 68

Lent by gracious permission of Her Majesty The Queen

The composition shows a group of nymphs and satyrs sporting with wanton abandon in a woodland setting. This unusually highly finished drawing was probably intended as a work of art in its own right and is unique in Oliver's oeuvre. The subject may, however, bear some relation to a large limning of Venus, Cupid and satyrs which was owned by the artist's patron, Queen Anne of Denmark (Finsten 96).

The subject-matter, with its emphasis on the nude, is unparalleled in contemporary English art and both style

5 Unidentified composition with nude figures

Pen and ink with blue wash over black lead; 80 × 145 mm (3¹/₈ × 5¹¹/₁₆ in)

Signed lower left with the artist's monogram: *IO*; inscribed by Richardson on his mount: *Isaac Oliver*

PROVENANCE: J. Richardson sen. (L 2184); Sir Thomas Lawrence (L 2445); L. G. Duke

LITERATURE: Finsten 213

Yale Center for British Art, Paul Mellon Collection (B1977.14.5095)

It is not possible to identify this subject, in which all the figures are represented in the nude. On the left, a standing female with her arm raised is supported by a group of standing and reclining figures, while on the right a mother with two children is supported by two male figures with other figures behind. Both subject and composition clearly relate to work being produced in Haarlem at the turn of the century, and this drawing is similar to that of *Nymphs and satyrs* (no. 4), for which it may, as Finsten suggests, be a preliminary idea. She also points out the

5

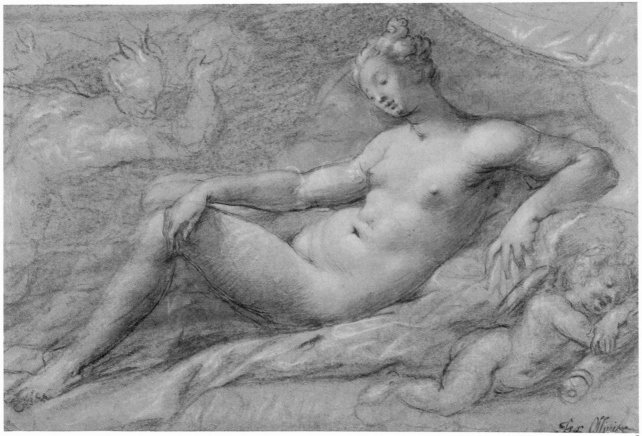

6

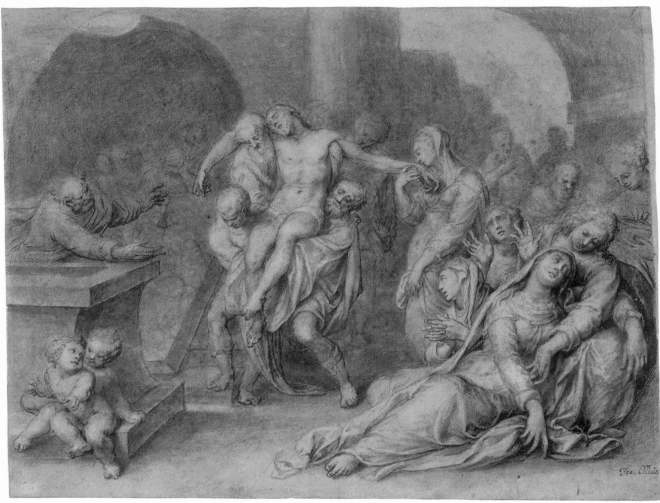

7

relationship of the unusual poses with similar figures in paintings by Primaticcio and Niccolò dell'Abbate (Finsten, I, figs R126–7).

compositions of the Fontainebleau school, which Oliver could have studied in engravings (Finsten, I, fig. R141). Both style and subject-matter suggest that it was drawn during the same period as *Nymphs and satyrs* (no. 4).

6 Antiope

Black chalk with grey wash and some indentations with a stylus, heightened with white, on buff paper; 195 × 279 mm (7⅝ × 11 in)

Signed lower right: *Isa : Ollivier*

PROVENANCE: Presented by W. B. Tiffin, 1869

LITERATURE: ECM & PH 7; Finsten 183

The British Museum (1869-6-12-295)

Antiope is represented with a cupid beside her, both figures asleep, while Jupiter, disguised as a satyr, approaches from the left. Vertue (IV, p. 28) describes a limning by Oliver in the collection of Charles I ('a naked Venus a sleepe and satyrs by her'), for which this drawing may well have been a study. The pose is related to several

7 The Entombment

Black chalk, pen and ink with brown wash, heightened with white; 295 × 377 mm (11 × 14⅞ in).

Signed lower right: *Isa: Olliuier*

PROVENANCE: Theodore Russell ?; Anthony Russell; George Vertue (sale, Ford, 19 May 1757, lot 81); Thomas Hollis sen.; Thomas Hollis jun. (sale, Sotheby, 30 April 1817, lot 1688); 11th Earl of Southesk

LITERATURE: ECM & PH 11; Finsten 187; Strong and Murrell 181; D. Cordellier, '*La mise au tombeau* d'Isaac Oliver au musée d'Angers', *Revue du Louvre*, Paris, 1983, pp. 180–83

The British Museum (1945-9-24-2)

According to two inscriptions by Vertue on the verso, one of which is on a separate piece of paper, the drawing is the

original design for a large limning by Isaac Oliver which was completed after his death by his son Peter for Charles I, who awarded the latter an annuity of £100. The joint authorship of the limning is confirmed by both Norgate (p. 55) and Van der Doort (Millar (1960), p. 103), who gives a detailed description of the work, which was last recorded in the Royal Collection at the time of Charles II, and is now in the Musée d'Angers (Cordellier, op. cit., fig. 1).

The drawing is a reworking of an earlier version of this subject in the Fitzwilliam Museum, Cambridge, the barely legible date on which is variously read as 1584 (see Cordellier, op. cit., p. 181) or 1586 (see Strong and Murrell 136). Apart from numerous other differences, the later version shows Christ supported by four of his disciples instead of resting on the ground. The French or Flemish Mannerist style of the latter, with large figures disposed within a cramped space, has as a result of Oliver's study of Italian art been transformed; attenuated Parmigianinesque figures are arranged in balanced groups within a well-defined area. Cordellier (op. cit., figs 5–7) relates the composition to designs by or connected with Michelangelo, noting especially the drawing by a follower which belonged in the early seventeenth century to Nicholas Lanier (see no. 44) and was later in the Gathorne Hardy collection, Donnington, Berkshire.

JONES, Inigo

London 1573 – London 1652

Jones was the son of a clothmaker, but little is otherwise known of his early life. He appears to have begun as a painter, and a landscape (Chatsworth) is traditionally attributed to him. From 1598 to 1601 he may have travelled in the train of Lord Roos, later 6th Earl of Rutland, to Italy, which he almost certainly visited at some point early in his career. In 1603 he may have accompanied the 5th Earl of Rutland on a diplomatic mission to Denmark to present the Order of the Garter to Christian IV. (He was described in 1605 as 'a great traveller'.) In 1604 he was in the service of Queen Anne of Denmark, and in the following year produced the first of over fifty masques, plays and court entertainments, frequently in collaboration with Ben Jonson, with whom he was to develop an increasingly bitter rivalry. In 1611 Jones became Surveyor to Henry, Prince of Wales, and after the latter's death in the following year he travelled in Italy with the Earl of Arundel from 1613 to 1614, making an intensive study of Italian art and architecture. On his return he was appointed Surveyor of the King's Works in 1615 and began his extensive career as an architect working for the Crown and the highest members of the court. Between 1619 and 1622 he built the third and existing Banqueting House in Whitehall, which was to serve as the principal setting for court entertainments (the last of these took place in 1640). From 1631 he supervised the restoration of Old St Paul's.

With the advent of the Civil War Jones's career virtually came to an end. He joined the King in Yorkshire in 1642 and in the following year lost his position as Surveyor to Edward Carter. In 1645 he was arrested with other royalists at Basing House and was subsequently fined. He appears to have had lodgings in Somerset House, where he died. Whether as architect, designer or copyist, he was an immensely prolific draughtsman, and in both style and content his drawings establish him as an international figure in contrast to earlier English artists, who remained essentially provincial.

8 Torchbearer: an Oceania

Watercolour, heightened with silver (now blackened) and gold; 285 × 187 mm (11¼ × 7⅝ in)

PROVENANCE: Probably John Webb; 3rd Earl of Burlington; by inheritance to his daughter, who married the 4th Duke of Devonshire

LITERATURE: S & B 4; A. Gilbert, *The Symbolic Persons in the Masques of Ben Jonson*, Durham, NC, 1948, p. 176; O & S 4; H, O & S 40

The Trustees of the Chatsworth Settlement

Preparatory costume study for the *Masque of Blackness*, the first court masque produced by Jones and Ben Jonson and performed in the first Banqueting House in Whitehall in 1605. The masquers (led by Anne of Denmark), who represented the black-eyed Daughters of Niger, were 'attended by so many of the Oceaniae' or torchbearers, who were described in the text as 'sea-green, waved about the skirts with gold and silver; their hair loose and flowing, garlanded with sea-grass, and that stuck with branches of coral'. They apparently imitated Oceanus, 'the colour of his flesh blue'.

9 Tethys or a nymph

Pen and ink with brown wash; 335 × 178 mm (13⅛ × 7 in)

PROVENANCE: As no. 8

LITERATURE: S & B 38; O & S 54; H, O & S 50

The Trustees of the Chatsworth Settlement

Preparatory costume study for Samuel Daniel's *Tethys' Festival*, staged in the second Banqueting House in 1610 to celebrate the installation of Henry as Prince of Wales. The role of Tethys, Queen of the Ocean and wife of Neptune, was performed by Anne of Denmark. The sea-imagery, described in the text of the masque, is seen here in all the 'maritime invention' of fish on the shoulders and 'seaweeds all of gold' and shells on the upper skirt; 'their head-tire was composed of shells and coral, and from a great murex shell in form of the crest of an helm hung a thin waving veil'.

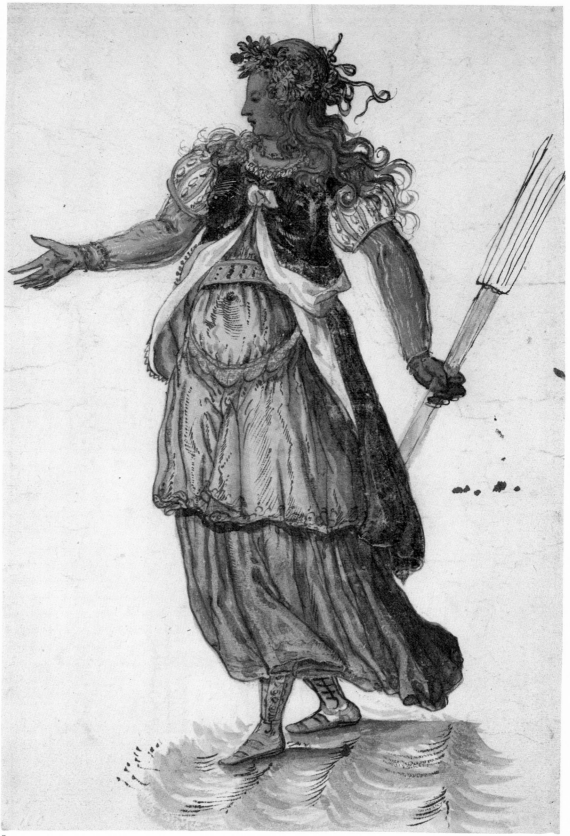

8

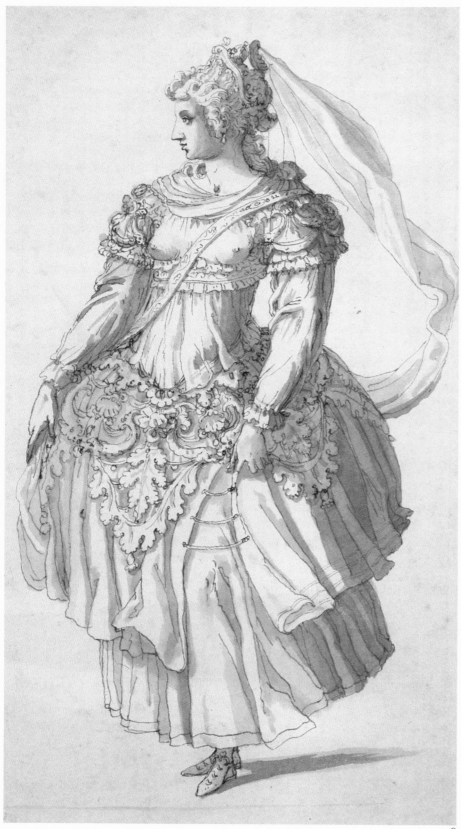

9

10 Interior of a palace

Pen and brown ink with grey wash; 470 × 388 mm (18½ × 15¼ in)

PROVENANCE: As no. 8

LITERATURE S & B 45; O & S 62; H, O & S 63

The Trustees of the Chatsworth Settlement

Probably connected with an early project for Prince Henry's Christmas masque, *Oberon, The Fairy Prince*, written by Jonson and performed in the second Banqueting House on New Year's Day 1611. At this stage the scenery was composed of a *machina versatilis*, with a vast mass of rocks on one side, which when revolved would have revealed the interior of a palace of classical architecture set within a 'frame' of rocks (see O & S 61); an *exedra*, closed by a screen of columns and decorated with statuary, leads to a corridor ending in a doorway through which the knights would presumably have entered to fight at the barriers. The concentric circles around the doorway may have been intended to indicate the effects of a central source of light.

11 Masquer: a daughter of the morn (?)

Pen and brown ink; 278 × 165 mm (11 × 6½ in)

PROVENANCE: As no. 8

LITERATURE: S & B 420; O & S 75

The Trustees of the Chatsworth Settlement

A costume study for a masquer, with the appropriate ankle-length skirt for dancing, datable about 1610, which may be connected with Anne of Denmark's Twelfth Night masque, *Love Freed from Ignorance and Folly*, written by Jonson and performed in the second Banqueting House in 1611.

12 Torchbearer: a fiery spirit

Pen and ink with watercolour; 295 × 160 mm (11⅝ × 6⁵⁄₁₆ in)

PROVENANCE: As no. 8

LITERATURE: S & B 59; O & S 81; H, O & S 74

The Trustees of the Chatsworth Settlement

Preparatory costume study for one of the pages in Thomas Campion's *The Lords' Masque*, performed in the second Banqueting House in Whitehall on 14 February 1613 on the occasion of the marriage of the Princess Elizabeth to Frederick, the Elector Palatine. The text describes 'Sixteen pages like fiery spirits, all their attires being alike composed of flames, with fiery wings and bases, bearing in either hand a torch of virgin wax'.

10

13 The entry of the augurs preceded by the poets

Pen and ink with brown wash; 230 × 376 mm (9¹⁄₁₆ × 14¹³⁄₁₆ in)

PROVENANCE: As no. 8

LITERATURE: S & B 111; Nicoll, fig. 41; O & S 117; H, O & S 234

The Trustees of the Chatsworth Settlement

Costume designs for the Twelfth Night masque, *The Masque of Augurs*, 1622, with which Jones and Jonson inaugurated the third and present Banqueting House, built by Jones. Two of the four poets in the masque, wearing garlands of bay leaves on their heads, lead two boy torchbearers in antique costume, who are followed by the 'tuneful augurs, whose divining skill' is indicated by the curved staves in their hands. Jones's source for the scenery and the augurs may have been an engraving from Onuphrius Panvinus, *De Ludis Circensibus*, Venice, 1581 (O & S, p. 341, fig. 43).

This drawing is unusual in that it represents people actually moving on the stage, and generally follows the stage directions, which describe how 'the augurs laid by their staves and danced their entry'.

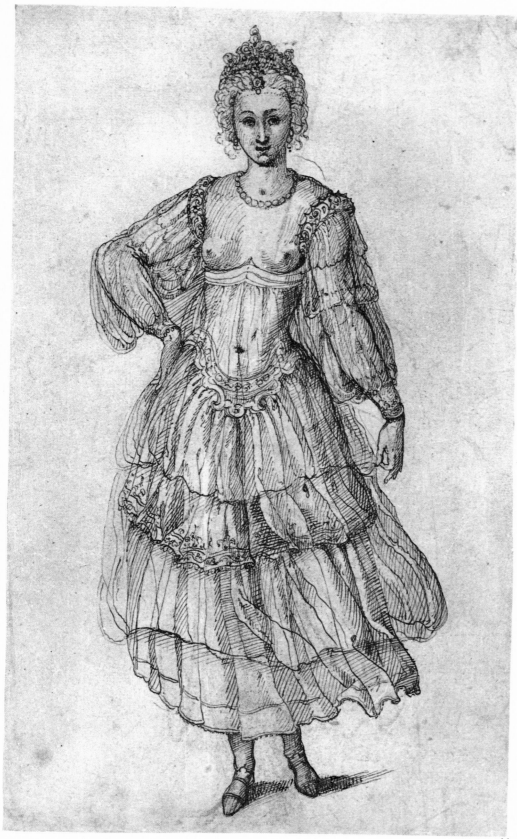

11

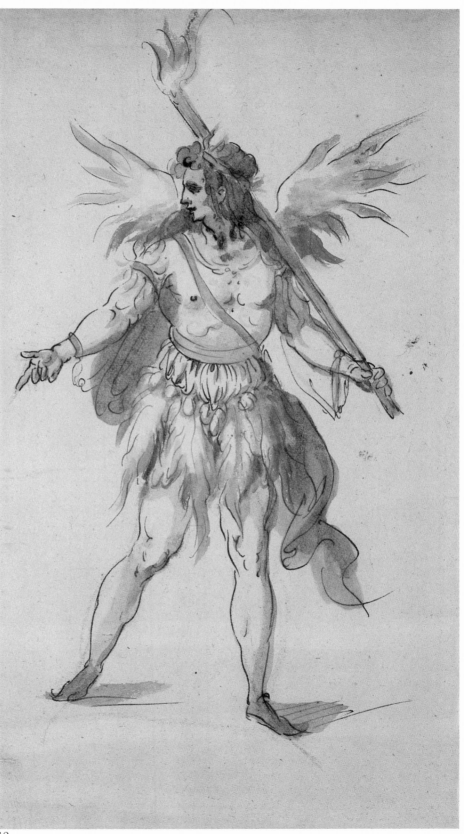

12

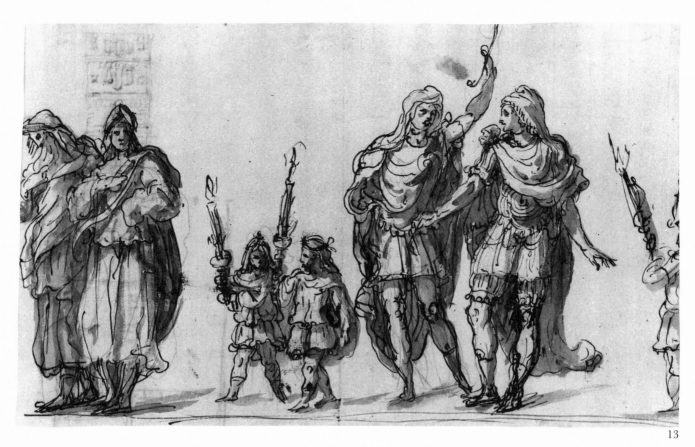

13

15

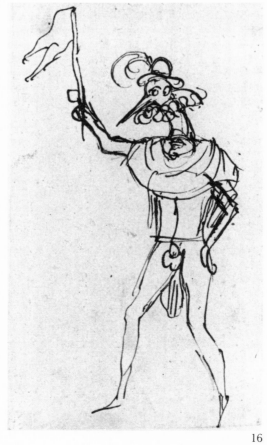

16

14

14 A turkey and an unidentified animal

Pen and brown ink; 250 × 125 mm (9⅞ × 4¹⁵⁄₁₆ in)
PROVENANCE: As no. 8
LITERATURE: S & B 458; O & S 131
The Trustees of the Chatsworth Settlement

15 A fish

Pen and brown ink; 155 × 99 mm (6⅛ × 3⅞ in)
PROVENANCE: As no. 8
LITERATURE: S & B 459; O & S 132
The Trustees of the Chatsworth Settlement

16 An unidentified bird

Pen and brown ink; 175 × 98 mm (6⅞ × 3¹⁵⁄₁₆ in)
PROVENANCE: As no. 8
LITERATURE: S & B 457; O & S 133
The Trustees of the Chatsworth Settlement

These three drawings are possibly preliminary designs for the entertainment which preceded Jonson's masque *Neptune's Triumph*, which was written in 1624 to celebrate the safe return of Prince Charles and the Duke of Buckingham from Spain, but never performed owing to disputes over ambassadorial precedence. The text refers to the Master Cook, who out of his pot produces 'persons to present the meats', including Amphibion Archy – who may have been played by the court dwarf Archibald Armstrong as a fish, in an allusion to his recent voyage to Spain with the Prince of Wales – and Captain Buz the turkey. The other animals in these drawings cannot be identified.

17 The floating island of Macaria

Pen and brown ink with grey wash; 325 × 313 mm (12¾ × 12¼ in), made up to 360 × 350 mm (14³⁄₁₆ × 13¾ in)
PROVENANCE: As no. 8
LITERATURE: S & B 65; O & S 128; H, O & S 237
The Trustees of the Chatsworth Settlement

Preparatory study for scenery for Jonson's *The Fortunate Isles, and their Union*, staged as Prince Charles's Twelfth Night masque in 1625 in the third Banqueting House (completed by Jones in 1622) and adapted from the abandoned performance of *Neptune's Triumph* of the previous year (see nos 14–16). In the centre of the floating island of Macaria, the 'prince of all the isles' which temporarily joins itself to the mainland, sits Prince Charles as Albion, holding a baton, surrounded by other masquers, the Macarii, beneath a triple-arched arbour of palm trees, symbolic of peace. In the foreground, the musician Proteus is sitting in a shell playing his lute.

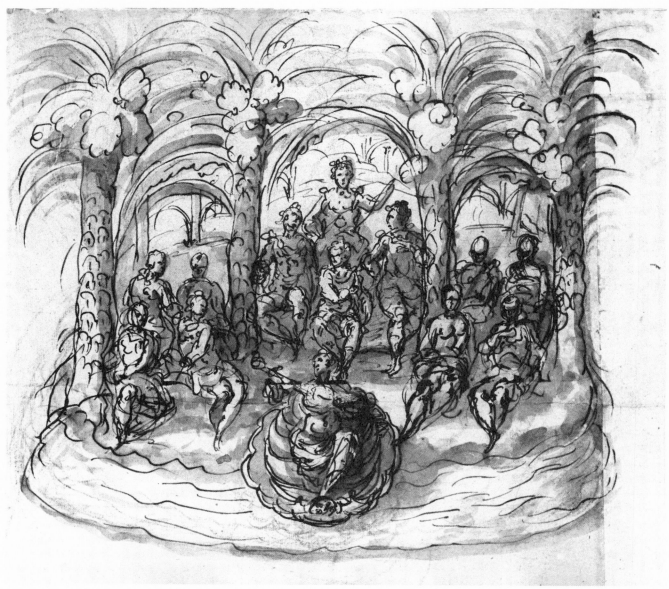

17

18 Landscape with a garden and villa

Pen and black ink, squared for transfer; 201 × 260 mm (7¹⁵/₁₆ × 10¼ in)

Inscribed in black lead at the top: *The standing sceane*, and in pen and ink on the skin above the proscenium: *The Sheperds Paradise*

PROVENANCE: As no. 8

LITERATURE: S & B 163; Nicoll, fig. 12; O & S 245; H, O & S 301

The Trustees of the Chatsworth Settlement

Design for the proscenium and standing scene in Walter Montagu's *The Shepherd's Paradise*, commissioned by Henrietta Maria and performed at Somerset House in 1633. The text of Act 1 describes the 'front of a pallas seene through trees'.

19 Atlas

Pen and black ink with grey wash, squared and numbered for transfer, with some splashes of colour; 390 × 250 mm (15⁵/₁₆ × 9¹³/₁₆ in)

PROVENANCE: As no. 8

LITERATURE: S & B 197; Nicoll, fig. 60: O & S 280; H, O & S 324

The Trustees of the Chatsworth Settlement

Preparatory study for the King's Shrovetide masque, *Coelum Britannicum*, written by Thomas Carew and performed in the third Banqueting House in 1634. After the first scene, the text describes how 'the scene changeth, and in the heaven is discovered a sphere with stars placed in their several images, borne up by a huge naked figure

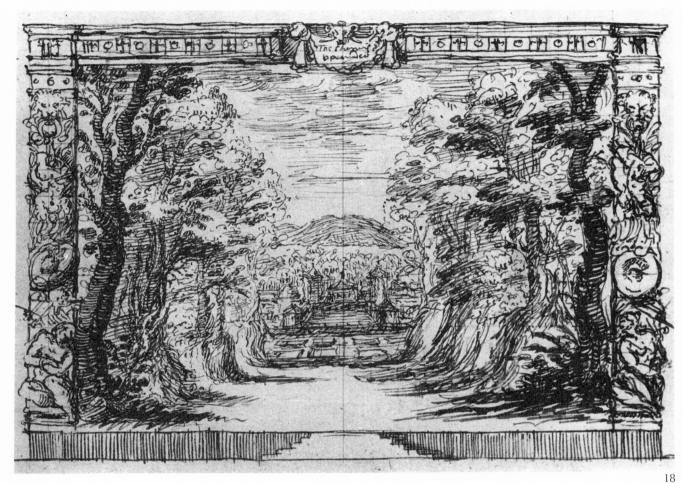

18

(only a piece of drapery hanging over his thigh) kneeling and bowing forwards, as if the great weight lying on his shoulders oppressed him; upon his head a crown; by all which he might easily be known to be Atlas'. The sphere with constellations above would have been a back shutter, whereas the figure of Atlas was either also a back shutter or a cut-out scene.

20 A garden and princely villa

Pen and brown ink, squared for transfer, and splashed with green; 437 × 565 mm (17³⁄₁₆ × 22³⁄₁₆ in)

PROVENANCE: As no. 8

LITERATURE: S & B 247; O & S 281; H, O & S 325

The Trustees of the Chatsworth Settlement

Preparatory drawing for the scenery to Scene 5 of *Coelum Britannicum* (see no. 19). The text describes 'a delicious garden with several walks and parterres set round with low trees, and on the sides against these walks were fountains and grots, and in the furthest part a palace from whence went high walks upon arches, and above them

open terraces planted with cypress trees, and all this together was composed of such ornaments as might express a princely villa'.

The garden was copied from an engraving by Antonio Tempesta (O & S, p. 587, fig. 95).

21 Two studies of Britanocles

Pen and brown ink, over corrections in white chalk; 295 × 193 mm (11⁵⁄₈ × 7⁹⁄₁₆ in)

PROVENANCE: As no. 8

LITERATURE: S & B 303; O & S 380

The Trustees of the Chatsworth Settlement

Preparatory study for the King's Twelfth Night masque, *Britannia Triumphans*, written by Sir William Davenant and performed in the temporary Masquing Room in 1638. The King played the part of Britanocles, 'the glory of the western world, [who] hath by his wisdom, valour and piety not only vindicated his own, but far distant seas infested with pirates, and reduced the land, by his example, to a real knowledge of all good arts and sciences'.

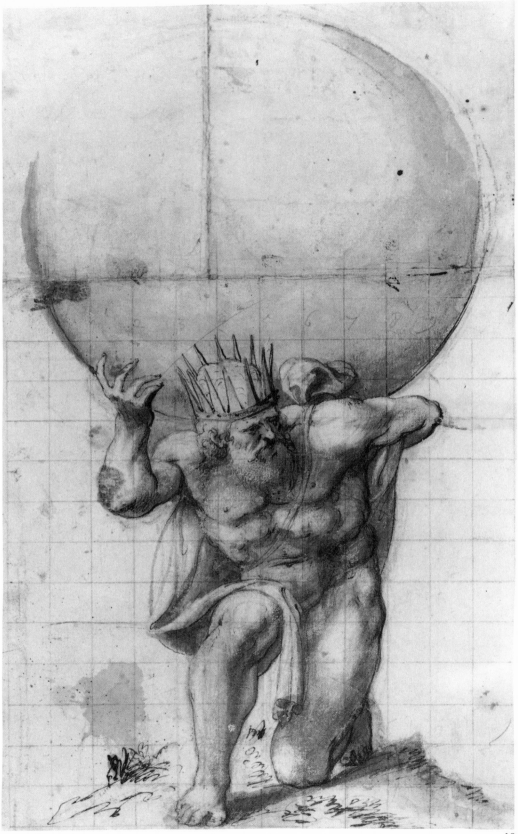

19

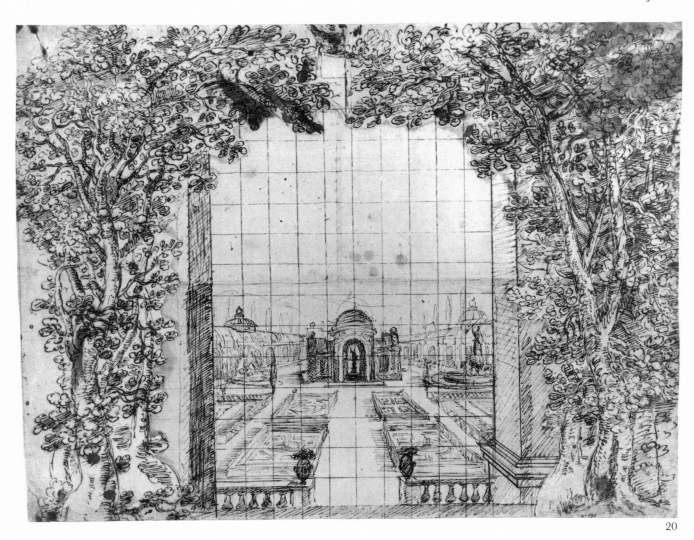

20

The masque was a political allegory on the question of the legality of Ship Money which was being tried in the courts and defended for its use in suppressing piracy.

22 A moonlit landscape

Pen and brown ink with grey wash, with splashes of green; 162 × 221 mm (6⅜ × 8⅞ in)

PROVENANCE: As no. 8

LITERATURE: S & B 309; O & S 384; H, O & S 113

The Trustees of the Chatsworth Settlement

Preparatory drawing for the back shutter for Scene 1 of *Luminalia: The Queen's Festival of Light*, presumably written by Davenant and performed as the Queen's Shrovetide masque in the temporary Masquing Room in 1638. The text describes 'a scene all of darkness, the nearer part woody [i.e. the wings], and farther off [seen here] more open, with a calm river, that took the shadows of the trees by the light of the moon, that appeared shining in the river'. The landscape is derived from an engraving of the

Flight into Egypt by Hendrick Goudt after Adam Elsheimer (O & S, p. 712, fig. 114).

23 Three studies of Furies

Pen and brown ink; 295 × 162 mm (11⅝ × 6⅜ in)

Inscribed above the upper left figure: *discorde*

PROVENANCE: As no. 8

LITERATURE: S & B 324; E. Veevers, 'Sources of Inigo Jones's Masquing Designs', *Journal of the Warburg and Courtauld Institutes*, XXII (1959), p. 373; O & S 416; H, O & S 341

The Trustees of the Chatsworth Settlement

Preparatory costume study for Davenant's *Salmacida Spolia*, performed as the King and Queen's Twelfth Night masque in the temporary Masquing Room in 1640. The text describes 'a Fury, her hair upright, mixed with snakes, her body lean, wrinkled, and of a swarthy colour. Her breasts hung bagging down to her waist, to which with a knot of serpents was girt red bases, and under it tawny skirts down to her feet. In her hand she brandished

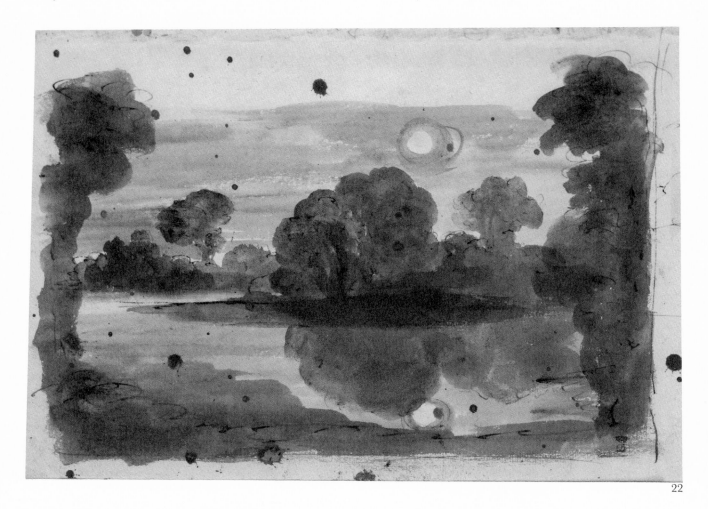

22

a sable torch, and looking askance with hollow envious eyes . . .'. The upper two studies are freely copied from the Furies in one of Callot's etchings in the *Combat à la barrière*, 1627 (O & S, p. 757, fig. 126), while the lower figure is taken from a Fury in a scene (after Tempesta) in Otto Vaenius, *Historia Septem Infantium de Lara*, Antwerp, 1612, (O & S, p. 763, fig. 127).

24 A mountainous valley

Pen and brown ink; 371 × 264 mm (14⅝ × 10⅜ in)

PROVENANCE: As no. 8

LITERATURE: S & B 402; O & S 453

The Trustees of the Chatsworth Settlement

An unidentified design, possibly for a back shutter, probably executed between 1630 and 1640. The scenery may well have been derived from one of the *Twelve Large Landscapes* engraved by Hieronymus Cock after designs by Pieter Bruegel the Elder (L. Lebeer, *Catalogue raisonné des estampes de Bruegel l'ancien*, Brussels, 1969, nos 1–12, illus.).

25 Landscape with farm buildings and a well

Pen and brown ink; 187 × 283 mm (7⅜ × 11⅛ in)

PROVENANCE: As no. 8

LITERATURE: S & B 392; O & S 465

The Trustees of the Chatsworth Settlement

This pastoral scene, which cannot be connected with any known project, shows Jones's draughtsmanship at its most accomplished. Close in style to his designs for *Florimène* (1635), it may have been intended as one layer of a scene of relieve.

26 A water deity or spirit

Black lead; 280 × 170 mm (11 × 6¾ in)

PROVENANCE: As no. 8

LITERATURE: S & B 461; O & S 476

The Trustees of the Chatsworth Settlement

This bold and free sketch, which on stylistic grounds must date from after 1630, cannot be connected with any known project for entertainment.

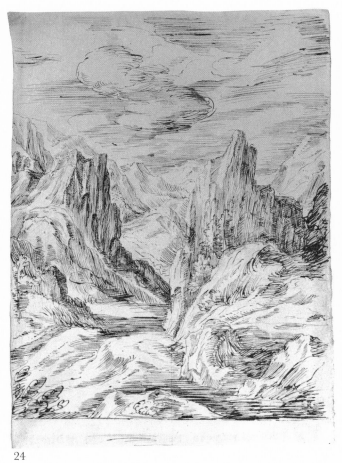

24

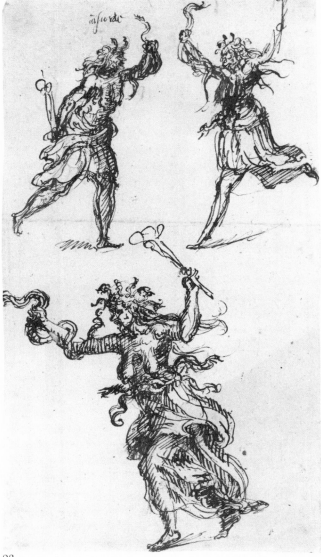

23

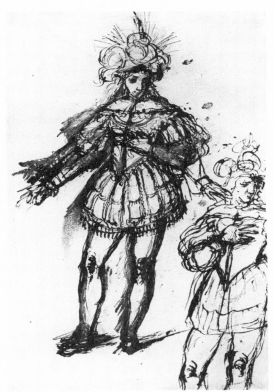

21

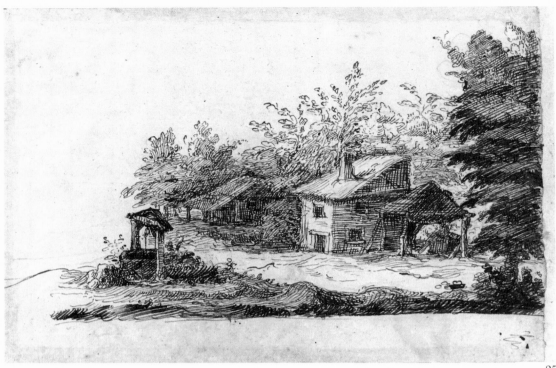

25

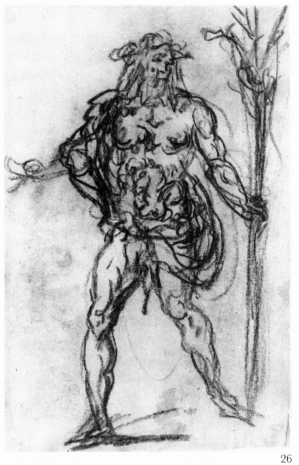

26

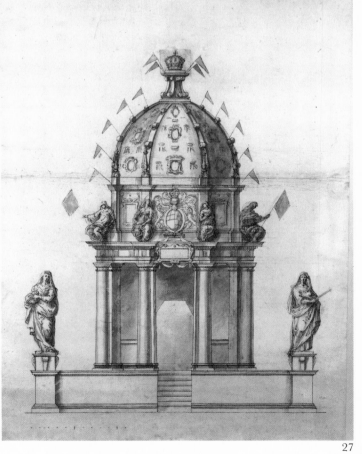

27

27 Design for the catafalque of James I

Pen and brown ink with grey wash; 610 × 430 mm (24 × 16¹⁵⁄₁₆ in)

PROVENANCE: John Webb; bequeathed by Dr George Clarke, 1734

LITERATURE: J. Summerson, *Inigo Jones*, London, 1966, p. 68; H, O & S 240; Harris and Tait 25; J. Peacock, 'Inigo Jones's Catafalque for James I', *Architectural History*, XXV (1982), pp. 1–5; C. Avery, 'Hubert Lesueur, the "Unworthy Praxiteles" of King Charles I', *Walpole Society*, XLVIII (1982), p. 141

The Provost and Fellows of Worcester College, Oxford

A preparatory study for the catafalque erected in Westminster Abbey for the lavish funeral of James I in 1625, which, according to Emmanuel de Critz (c.1605–65), was 'very ingeniously designed by Mr Inigo Jones'. Described by John Chamberlain to Sir Dudley Carleton as 'the fairest and best fashioned that hath ben seen', the 'hearse' consisted of a domed tempietto (based on Bramante's building in S. Pietro in Montorio, Rome) decorated with pennants and shields and twelve statues of Virtues in mourning carved by Hubert Le Sueur. The latter were the first of the French sculptor's works to be executed in England. A death mask taken by Maximilian Colt, who was paid for 'his journey to Theobald's for the moulding of the King's face', served for the effigy. The entire structure was painted by De Critz, who was Serjeant Painter. (Twenty-five years later De Critz gave a conflicting account of its construction; see Harris and Tait, op. cit.)

RUBENS, Sir Peter Paul

Siegen 1577 – Antwerp 1640

After training under Tobias Verhaecht, Adam van Noort and Otto van Veen in Antwerp, Rubens went to Italy in 1600. On his return in 1608 he quickly established himself both nationally and internationally, becoming the most famous painter at the courts of Europe. His work encompassed most categories of subject and different schemes of decoration.

In 1618 Rubens was involved in an exchange of works of art with Sir Dudley Carleton, and two years later, reputedly out of esteem for the Earl of Arundel, he painted the Countess and her entourage when they unexpectedly visited Antwerp. Charles I, as Prince of Wales, already owned one of his pictures by 1621, in which year the commission to decorate the ceiling of the Banqueting House in Whitehall was first mooted. Rubens's meeting with the Duke of Buckingham in Paris in 1625 led to two major commissions, an equestrian portrait and a ceiling painting for the Duke's house in the Strand (both destroyed, but sketches exist). He came to England on a diplomatic mission in 1629, and was knighted on his departure in March 1630, having executed portraits of the Earl of Arundel and the King's physician, Turquet de Mayerne, as well as an allegory known as *Peace and War*

(National Gallery, London), which he presented to Charles I. He returned home with the commission for the Whitehall ceiling, which was completed and finally installed in 1635. Shortly before his death, efforts were made, in vain, to commission him to decorate the Queen's House at Greenwich.

Rubens's method of portrait painting profoundly influenced Van Dyck (q.v.), and the Whitehall ceiling, which remained *in situ* throughout the Commonwealth, provided a source for history painters in England.

28 Thomas Howard, 2nd Earl of Arundel (1585–1646)

Brush and brown and black ink, (oil?), brown and grey wash, heightened with white, touched with red; 463 × 365 mm (18¼ × 14⅜ in)

PROVENANCE: G. H. (L 1160); J Richardson sen. (L 2184); Thomas Hudson (L 2432); Lord Selsey (sale, Sotheby, 20–28 June 1872, probably lot 2637, 'Man in Armour . . .', bought Nozeda?); R. P. Roupell (L 2234 on verso)

LITERATURE: Burchard and d'Hulst 170; Haverkamp-Begemann, Lawder and Talbot 22; Millar (1972) 44; Huemer 5ª

The Clark Art Institute, Williamstown

The sitter, 2nd Earl of Arundel and Surrey, was married to Alathea, daughter of the Earl of Shrewsbury. After a chequered and unhappy youth, owing to the execution of his grandfather for treason, he was restored in the blood in 1604 and in 1621 was made Earl Marshal. He remained an austere and aloof figure at court, and 'it was a common Saying of the late Earl of Carlisle, Here comes the Earl of Arundel in his plain Stuff and trunk Hose, and his Beard in his Teeth, that looks more a Noble Man than any of us' (Sir E. Walker, *Historical Discourses*, 1705, p. 214). Apart from his role as a statesman, he was with Charles I and the Duke of Buckingham one of the leading connoisseurs and collectors of the period, with a particular taste for classical antiquities, the drawings of Leonardo and Parmigianino and the work of Holbein. He was also an active patron of living artists (see under Inigo Jones and Van Dyck). Rubens was reported as having described him as 'one of the four evangelists and supporters of our art' (M. Hervey, *The Life of Thomas Howard, Earl of Arundel*, Cambridge, 1921, p. 175). He also praised his collection of classical sculpture at Arundel House, writing, 'I confess that I have never seen anything in the world more rare from the point of view of antiquity' (R. S. Magurn, *The Letters of Peter Paul Rubens*, Cambridge, Mass., 1955, pp. 320–21). Arundel was well travelled; for his journey to Italy in 1613–14, see under Inigo Jones, and for his embassy to the Emperor of Austria in 1636, see under Hollar. He died in Padua.

This drawing is a brilliant study, largely executed with the brush, for the three-quarter-length portrait of Arundel, now in the Isabella Stewart Gardner Museum, Boston (KdK 288), which was painted during Rubens's stay in London in 1629–30. The Earl is seen in armour, holding the golden baton of the Earl Marshal, with his

67

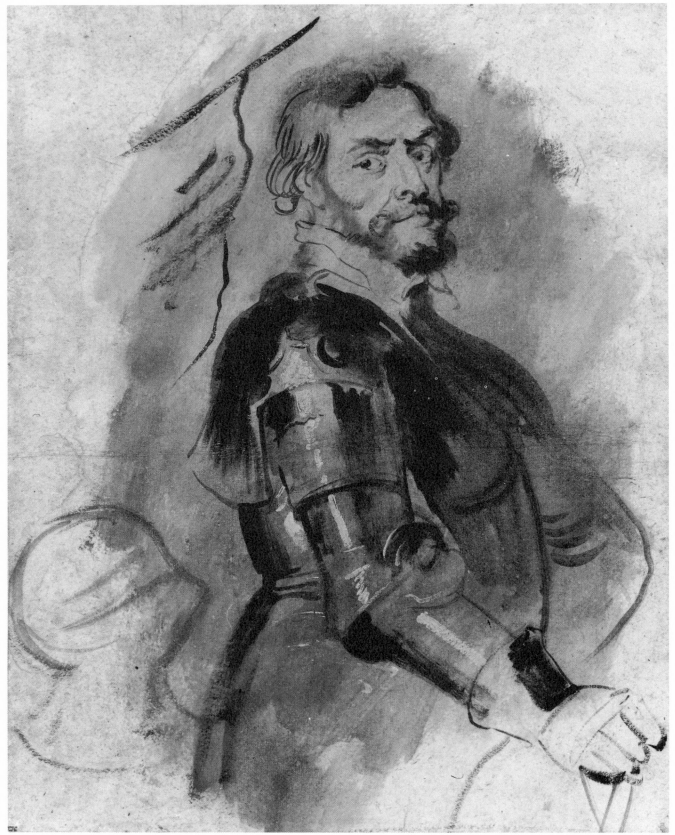

28

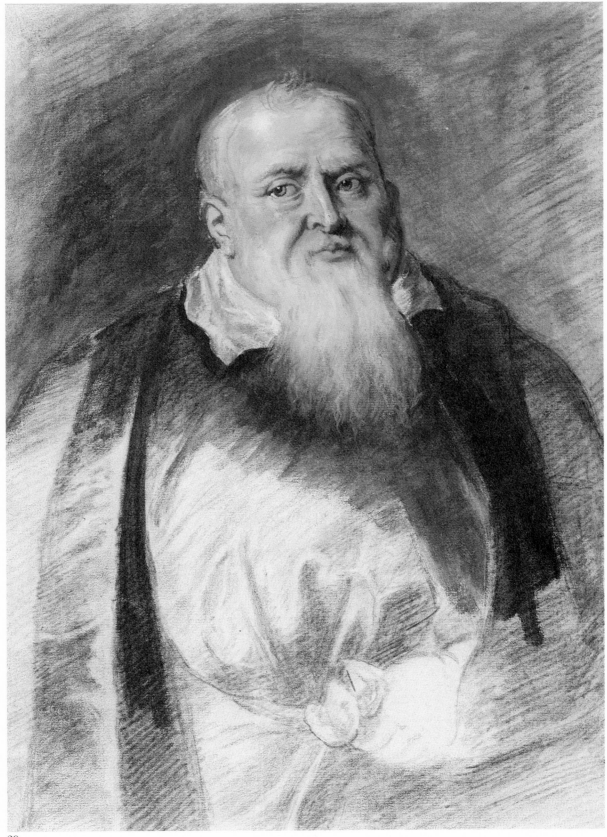

29

helmet on the table beside him. The picture shows a deep understanding of Titian's portraits and the pose may well derive from a work such as the *Duke of Urbino* (Uffizi, Florence). This drawing was clearly more concerned with establishing the composition than recording a portrait likeness, and it was probably followed by the oil study of the head and shoulders now in the National Portrait Gallery, London (Huemer, pl. 53).

29 Sir Theodore Turquet de Mayerne (1573–1655)

Black chalk with brown and grey wash, watercolour and oil-colours; 308 × 219 mm (12⅛ × 8⅝ in)

PROVENANCE: Sir Thomas Lawrence (L 2445); S. Woodburn (sale, Christie, 4 June 1860, lot 351, as by Van Dyck); W. Gruyter jun.

LITERATURE: Hind, II, 94; Burchard and d'Hulst 171; Millar (1972) 43; J. Rowlands, *Rubens Drawings and Sketches*, exh. cat., British Museum, London, 1977, no. 158; Huemer 46ª; *The Quiet Conquest: the Huguenots 1685–1985*, exh. cat., Museum of London, 1985, no. 169

The British Museum (1860-6-16-36)

The sitter was born in Mayerne, near Geneva, of a French Huguenot family. After studying medicine in France he became physician to the French king Henri IV. In 1611 he came to England and served in the same position to both James I, who knighted him in 1624, and then Charles I. He was also interested in the chemistry of pigments and apparently discovered a carnation colour made from enamel (see M. K. Talley, *Portrait Painting in England: Studies in the Technical Literature before 1700*, London, 1981, pp. 72–149). In his manuscript treatise on painting he included a number of recipes which Rubens had given him when they met in London. He was also responsible for encouraging Edward Norgate to write his treatise on miniature painting, *Miniatura or the Art of Limning*, about 1648–50. (His recipe for oil for the coronation of a monarch is still employed today.)

During the artist's stay in London in 1629–30, he made a portrait of Mayerne, which was probably of the type showing the sitter standing half-length, holding a glove, against a plain background, a (studio?) version of which is now in the New York University Art Collection (Huemer 46, pl. 126). On his return to Antwerp, Rubens painted a three-quarter-length portrait showing Mayerne seated against a view of a harbour and a statue of Aesculapius, and sent this to the sitter in 1631. On receipt of the picture, the latter wrote a warm letter of thanks. (What is possibly the original version is in the North Carolina Museum of Art, Raleigh; Huemer 47, pl. 128.) A portrait of Mayerne was listed in the artist's studio after his death.

This drawing corresponds with the first type of portrait, although it is disputed whether it is the preparatory study done from the life or a *ricordo* which the artist could have taken back with him to Antwerp as the basis of the three-quarter-length portrait. Compared with other por-

trait studies, the head is unusually highly finished, although it can be argued that, in view of the uncertainty of his movements owing to his diplomatic duties, Rubens was taking care to provide himself with all the necessary information about the sitter.

CLEYN, Francis

Rostock? 1582? – London 1658

Little is known about Cleyn's early life. He was reputedly born at Rostock in the Baltic Provinces, the son of a goldsmith. The style of his early drawings suggests that he may have been trained in the Netherlands. He was apparently in Denmark by 1611 and probably in the same year went to Italy, where he remained until 1617, spending four years in Rome. There he was able to acquire a repertory of late Mannerist forms, paying especial attention to the work of Polidoro da Caravaggio (1492–1594). He returned to Denmark, where he lived in Copenhagen and was extensively occupied in producing decorative paintings for a number of Danish royal castles. In 1623 he visited England and attracted the attention of James I, who asked Christian IV to release him from his service. But Cleyn's work for the Danish king prevented him from settling in England until 1625. He was then immediately employed by the new king, Charles I, on various commissions, including 'all manner of drawings for yᵉ Arch Triumphall' made under the supervision of Inigo Jones, probably in celebration of the arrival of Queen Henrietta Maria. He promptly received denization and an annuity of £100. Cleyn became principal designer to the Mortlake tapestry factory, for which he continued to work under the Commonwealth, producing both original designs and decorative borders for such works as the Raphael Cartoons. He also painted numerous decorative panels for country houses, examples of which can still be seen *in situ* at Ham House, near London, and was renowned for his painting in *grotesque*. In 1625 he designed the Great Seal for Charles I and in later years was a prolific book illustrator. Although not an artist of great distinction, he played an important role in introducing more up-to-date and sophisticated motifs into the vocabulary of Caroline decoration.

30

31

30 Dido and Aeneas sheltering in a cave

Brush and grey wash, indented for transfer; 260 × 197 mm
(10¼ × 7¾ in)

PROVENANCE: L. G. Duke

Yale Center for British Art, Paul Mellon Collection
(B1977.14.5222)

This and the following drawing were made as preparatory
studies for illustrations to the English edition of Virgil,
The Workes of Publius Virgilius Maro, which was published
for John Ogilby in 1654. The designs of 74 of the 101 large
plates in the volume, for the most part engraved by Hollar
and Pierre Lombart, are credited to Cleyn, and a number
of other similar drawings by him connected with the series
still exist. They represent the last of the artist's work to be
published during his lifetime (his illustrations to the *Iliad*
were published posthumously in 1660, also under the
imprint of Ogilby). Apart from these two sheets, other
drawings for the Ogilby edition of Virgil are in the
Ashmolean Museum, Oxford (Brown (1982) 105–6) and
the British Museum (1968-10-12-22 to 25).

The illustration based on this drawing, engraved in
reverse by Lombart, faces page 269, and the subject is
taken from Book IV. On the left Dido and Aeneas, fleeing
from the storm, enter the cave, while 'Fame far out-strips
all Misschiefs in her course . . . stalking on Earth, her
Head amongst the Clouds . . . so many Plumes, as many

watching Eyes lurk underneath, and what more strange
appears, so many Tongues, loud Mouths, and listning
Ears'.

31 Aeneas sleeping by the River Tiber

Brush and grey wash, indented for transfer; the verso prepared
with red chalk; 259 × 197 mm (10¼ × 7¾ in)

PROVENANCE: Lt.-Col. P. L. Bradfer-Lawrence

The British Museum (1968-10-12-23)

See the previous drawing. The illustration, engraved by
Lombart in reverse, faces page 401. The subject is taken
from Book VIII and describes the scene at night when
'Fetter'd with Sleep' and exhausted by the concerns of
war, Aeneas lay down on a bank and slept. 'The Genius of
the place, old *Tyber*, here, amongst the Poplar Branches,
did appear; of finest Linnen were his azure weeds, and his
moyst Tresses crown'd with shadie Reeds.'

VISSCHER, Claes Jansz.

Amsterdam 1587 – Amsterdam 1652

Visscher was the son of a ship's carpenter and not, as used to be thought, a goldsmith. There is no record of his master, but by 1608 he is described as a line engraver in Amsterdam. He quickly established himself as the city's most important publisher of engravings of landscapes, portraits and maps, and eventually handed over his highly successful business to his son, Nicolaes. There is no reason to believe that he ever came to England.

32 The execution of the conspirators in the Gunpowder Plot in 1606

Pen and ink with brown wash, indented for transfer; 238 × 344 mm (9⅜ × 13½ in)

PROVENANCE: Alfred Morrison; R. W. P. de Vries

LITERATURE: Hind, I, 1

The British Museum (1919-5-13-1)

Preparatory drawing for the etching in reverse, which is inscribed *N. de Visscher fecit* (*BM Satires* 69). The event takes place in an imaginary setting in a town square with a throng of spectators witnessing the various methods used for executing traitors – hanging, boiling, and drawing and quartering; other criminals are stretched out on hurdles and dragged by horse. The two angels above are identified in the print as 'Justitia' and 'Fama' while the cartouche they support is inscribed SUPPLICIUM.

The execution of eight of the conspirators in the plot took place on 30 and 31 January 1606. The previous year they had attempted to blow up the Palace of Westminster on the opening day of Parliament, when the royal family, the Privy Council and both Houses would have been assembled, as a consequence of their anger at the failure of James I to improve the position of Catholics in England.

Hind assumed that the print was contemporary with the event represented, which is certainly suggested by the style of the drawing; that neither work can be by the son Nicolaes, who was only born in 1618, and that both are by Claes Jansz. Visscher. It should, however, be noted that the latter, who abbreviated his christian name, usually signed his prints with his initials, CJV, in a monogram. The style of the drawing is very close to that of David Vinckeboons, and since his designs were engraved by Visscher he may well be its author. A similar example of possible confusion between the two artists occurs in a drawing of the *Truce between Spain and the United Provinces of 1609*, which was also engraved by Visscher (F. Lugt, *Ecole Nationale Supérieure des Beaux-Arts, Paris: Inventaire Général des Dessins des Ecoles du Nord*, I, Paris, 1950, no. 711, pl. CXII).

Other prints dealing with the Gunpowder Plot were published on the Continent, including, for example, one by Simon van de Passe (1595–1647) (*BM Satires* 71).

BOL, Cornelis

Antwerp 1589? – 1666 or later?

Several artists of this name have been recorded, but it is possible that they are all one and the same person, the 'Cornelis Bol, with his wife member of the Dutch Church London with attestation from Paris' (W. J. C. Moens, *Registers . . . of the Dutch Reformed Church, Austin Friars*, London, 1884, p. 216). An etching signed *C. Bol fecit*, showing the Spanish fleet lying off the coast of Kent, is dated 1639, and Vertue recorded three views of London from the river commissioned by John Evelyn from Cornelis Bol before the Great Fire of 1666 (IV, p. 53), which were among the earliest Restoration examples of view pictures intended for overmantels or overdoors. He is also said to have painted a picture of the Great Fire. A set of etchings by Bol after Abraham Casembrot, one of which is a view of Lambeth Palace, are similar in style to the drawing discussed below.

33 The blockhouse at Gravesend

Pen and light brown ink with grey wash; 95 × 182 mm (3¾ × 7⅛ in)

Inscribed: *CB*, and on the verso: *Het kasteel Te Schravesende door, Klots fg* [?]

PROVENANCE: Crisp

LITERATURE: ECM & PH 1

The British Museum (1859-12-10-919)

Following the old inscription on the verso, this drawing was once thought to be by Valentin Klotz (*fl.*1667–91), a Dutch topographical draughtsman and military engineer. However, there is no evidence that he visited England, and the drawing was reattributed by Binyon to Cornelis Bol on the basis of the initials *CB* and a stylistic similarity with Bol's etchings after Abraham Casembrot.

The blockhouse was one of two such forts built at Gravesend, a strategic point on the Thames, in 1539–43, during the reign of Henry VIII: it may also be seen on the right-hand side of a drawing by Van de Velde the Elder (no. 126).

32

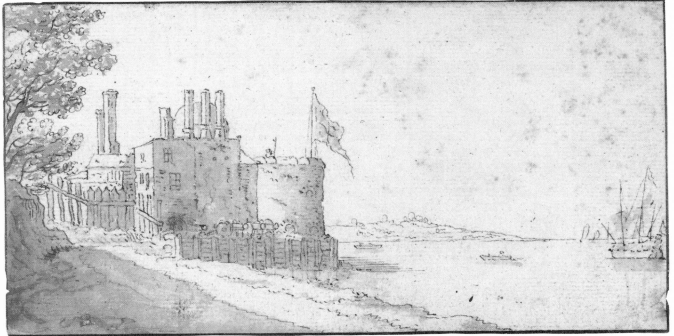

33

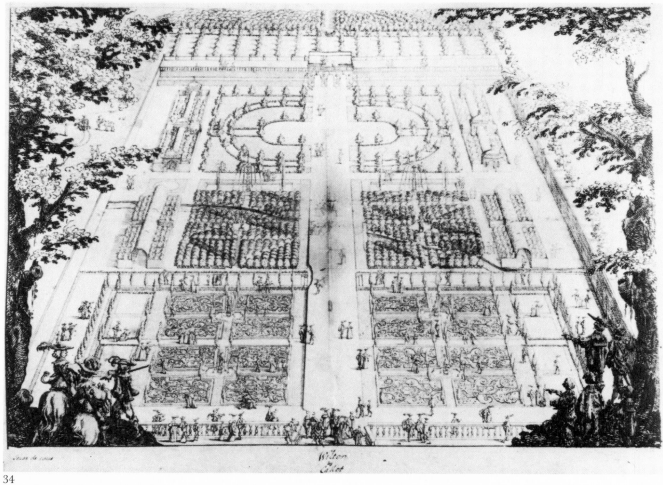

34

CAUS (CAUX), Isaac de

Dieppe? 1590 – Paris 1648

The younger brother of Salomon de Caus (b.1576), Isaac de Caus was born, probably in Dieppe, into a Huguenot family which had English connections. Like Salomon, he was primarily a garden designer and hydraulic engineer, and he is first recorded as active in the latter role on the occasion of Louis XIII's visit to Dieppe in 1617. At some point he followed the example of his brother, who for a period was in the service of both Queen Anne of Denmark and Henry, Prince of Wales, and came to England, where he is first documented in 1623–4 as the designer of the grotto in the basement of Inigo Jones's Banqueting House in Whitehall. His association with Jones (q.v.) continued in 1633–4, when he appears to have been responsible for the building of the houses designed by Jones at Covent Garden for the Duke of Bedford. He seems to have worked under Jones once again when in 1636 he was employed by the 4th Earl of Pembroke to rebuild the south front of Wilton House after he had already designed the formal gardens. In 1638 he designed a house for the 1st Earl of Cork at Stalbridge Park in Dorset, and at some unknown date thereafter he returned to France. De Caus produced two books illustrated with engravings, *Nouvelle Invention de lever l'eau* (1644) and *Le Jardin de Vuillton* (about 1645), which were later translated into English as *New and Rare Inventions of Waterworks* (1659) and the *Gardens of Wilton* (n.d.) respectively.

34 The Gardens at Wilton House

Pen and brown ink over black lead; 432 × 559 mm (17 × 22 in)

Inscribed lower centre: *Wilton by Callot*, and in another hand lower left: *Isaac de caus*

PROVENANCE: John Webb; bequeathed by Dr George Clarke, 1634

LITERATURE: H. M. Colvin, 'The South Front of Wilton House', *Archaeological Journal*, CXI (1954), pp. 181–90; H, O & S 364; Harris and Tait 110

The Provost and Fellows of Worcester College, Oxford

An elevated prospect of the formal gardens taken from the position of the house, looking south. Figures and trees in the style of Jacques Callot frame the vista. Another view, showing the south front of the house, taken from the opposite direction, is in the same collection (Harris and Tait 109).

Aubrey's remark that 'about 1633' Inigo Jones, then fully occupied at Greenwich, recommended Isaac de Caus to carry out building work for the 4th Earl of Pembroke at Wilton is supported by accounts relating to work on the gardens in 1632–3, and by the commissioning of De Caus to rebuild the south front of the house in 1636. The formal gardens were divided into parterre, wilderness, rectangular ponds, oval circus and concluding grotto, and decorated with various pieces of sculpture by Hubert Le Sueur

and Nicholas Stone, as shown here; and the drawing was probably the preparatory study for the engraved illustration to De Caus' *Le Jardin de Vuillton* (about 1645), pls 3–4. The design of the gardens, which probably owed as much to Inigo Jones as to De Caus, follows the Venetian pattern of a villa on the Brenta, and Wilton was described by Aubrey as possessing the third garden in the Italian manner to have been made in England. Its creation may well have been inspired by Charles I, who 'did love Wilton above all places, and came thither every summer'. (For details of the gardens, see R. Strong, *The Renaissance Garden in England*, London, 1979, pp. 147–64.) Since the formal gardens were destroyed by the 9th Earl of Pembroke in the 1730s, the two drawings in Worcester College remain the prime visual record of their original appearance.

HONTHORST, Gerrit van

Utrecht 1590 – Utrecht 1656

Honthorst was a pupil of Abraham Bloemart in Utrecht. Probably from 1610 until 1620 he was in Rome, where he produced a number of altarpieces in the style of Caravaggio for Italian patrons. In 1628 he was invited to England by Charles I, and during his eight- or nine-month stay he painted portraits of the royal family and the court and received the commission for *Apollo and Diana*. He developed an international reputation and worked extensively for Christian IV of Denmark and Frederick William, Elector of Brandenburg. According to Vertue, Honthorst was the favourite painter of the Queen of Bohemia. From 1635 he was working not only in Utrecht but also in The Hague, where he carried out a number of decorative paintings for the Stadholder and collaborated on the decoration of the Huis ten Bosch (see R. A. d'Hulst, *Jacob Jordaens*, London, 1982, p. 32). In 1652 he returned to Utrecht. Honthorst was one of the leading Dutch Caravaggists, painting the full range of different categories of subject picture as well as a large number of portraits in a style derived from Michiel Jansz. van Miereveld (1567–1641). He appears to have made relatively few drawings.

35 Apollo and Diana

Pen and ink with grey wash, heightened with white, over black chalk; 382 × 583 mm (15 × 22¹⁵⁄₁₆ in)

Inscribed lower centre: *G. v. Honthorst infentor 1631*, and lower left: *G. v. Honthorst inf. 1631*

PROVENANCE: Presented by Mrs Shuurmans-Ripping, 1879

LITERATURE: J. R. Judson, *Gerrit van Honthorst*, The Hague, 1959, pp. 256–7; Millar (1972) 79; C. White, *Dutch Pictures in the Collection of Her Majesty the Queen*, Cambridge, 1982, p. 56

Museum Boymans-van Beuningen, Rotterdam

A preparatory study for the large canvas, now at Hamp-

35

ton Court, representing *Mercury presenting the Seven Liberal Arts to Apollo and Diana* (right), commissioned either by Charles I or by the Duke of Buckingham and given to the King during the artist's sojourn in England in 1628. In the painting Apollo and Diana are personated by Charles and Henrietta Maria, and Mercury by Buckingham. Several other members of the court may also be identified. In the left foreground Hatred (or Ignorance) and Envy are overthrown by two boys with a trumpet and a burning brand.

In the drawing the iconographical elements are disposed as in the painting, but there are changes in the positions and attributes of some of the figures. A third boy, with a goat, seen on the left of the painting, is omitted; no attempt has been made to present the three principal figures as portraits, but the Liberal Arts can be seen more clearly as they emerge from a shadowy cave.

Very few preparatory drawings by Honthorst are known.

Gerrit van Honthorst:
Mercury presenting the Seven Liberal Arts to Apollo and Diana.
Oil on canvas, 1628.
Reproduced by gracious permission of Her Majesty The Queen

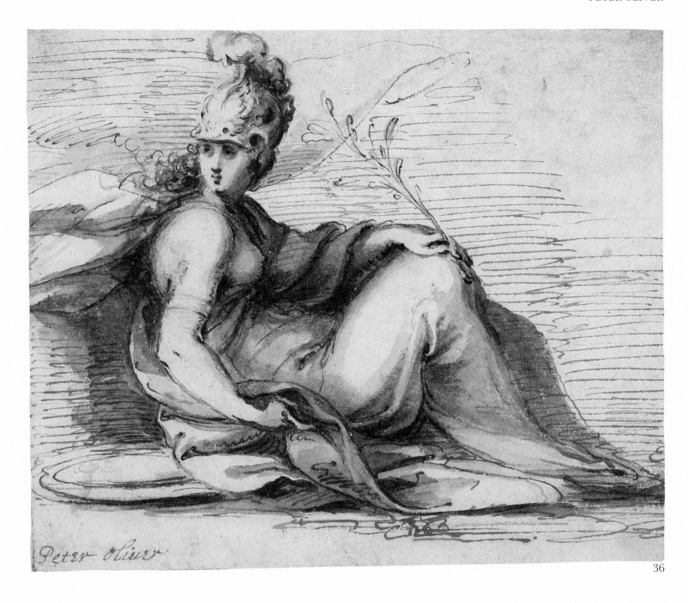

36

OLIVER, Peter

London 1594 – London 1647

The eldest son of Isaac Oliver (q.v.), by whom he was trained as a miniaturist. He assisted his father in the duplication of royal portraits and on the latter's death inherited his 'drawings and limnings', which included the unfinished *Entombment* (see no. 6). As well as continuing as a portraitist, he executed numerous history pieces in miniature which were largely copies after Italian paintings in the Royal Collection and elsewhere. His reputation equalled if not surpassed that of his father in the opinion of contemporaries such as Edward Norgate, who in praising the artist's work also mentions landscapes drawn with the point of the brush. Vertue suggests that he was also employed helping Inigo Jones (q.v.) with costume designs for masques, and states that he collaborated with Francis Barlow (q.v.) by drawing the figures in designs for etchings.

36 Allegorical female figure: Pallas Athene (?)

Pen and brown and black ink with grey wash over red chalk; 138 × 157 mm (5⁷⁄₁₆ × 6³⁄₁₆ in)

Inscribed lower left, in a nearly contemporary hand: *Peter Oliver*

PROVENANCE: Purchased 1948

LITERATURE: Woodward, pp. 20, 46, no. 13; Brown (1982) 195; Brown (1983) 6

The Ashmolean Museum, Oxford

Since the attributes could equally well fit either Minerva

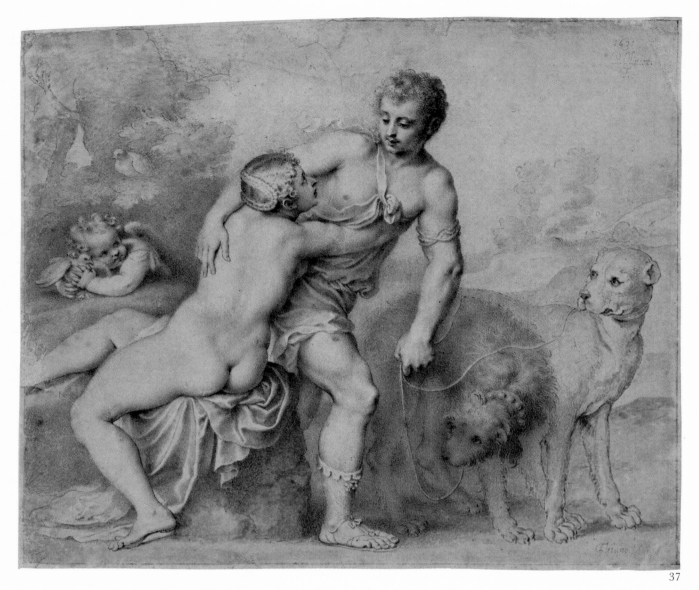

37

or Victory, the identification of the subject remains uncertain. The style of drawing can be related to both Parmigianino (1503–40) and Inigo Jones, and if, as Vertue suggests, Oliver worked on designs for masques with Jones, he would certainly have learnt to admire and imitate the Italian artist. (Oliver's only recorded etching is a half-length female figure after Parmigianino.)

37 Venus and Adonis (after Titian)

Pen and black ink with grey wash over black lead; 192 × 223 mm (7⁹⁄₁₆ × 8¹³⁄₁₆ in)

Signed and dated upper right: *1631 / P. Olivier. / F.*, and inscribed by the artist lower right: *Titiano. Inv[. . .] t.*

PROVENANCE: G. R. Barber (sale, Sotheby, 26 June 1969, lot 52)

Yale Center for British Art, Paul Mellon Collection (B1975.4.1352)

This drawing, executed in the style of a miniature, is a copy after the composition by Titian, a version of which was at the time in the collection of the Earl of Arundel (now in the Kunsthistorisches Museum, Vienna?). Oliver was employed by Charles I to copy paintings in the Royal Collection and elsewhere. As Edward Norgate wrote in his *Miniatura or the Art of Limning* (p. 54): 'Histories in Lymning are strangers in England till of late Yeares it pleased a most excellent King to command the Copieing of some of his owne peeces, of Titian, to be translated into English Lymning, which indeed were admirably performed by his Servant, Mr Peter Oliver.' Another copy by Oliver of the same composition by Titian, executed in colours, is described in Van der Doort's account of the Royal Collection as dated 1631 (Millar (1960), p. 104), and is now at Burghley House (H. Wethey, *The Mythological and Historical Paintings of Titian*, London, 1975, pl. 193).

38 Self-portrait

Pen and brown ink, point of brush and black ink, with grey wash over faint traces of black chalk; 80 × 65 mm (3⅛ × 2⁹⁄₁₆ in)

PROVENANCE: Samuel Reynolds Solly; sale, Christie (Portrait Miniatures), 8 December 1982, lot 241

The Pierpont Morgan Library, New York

This self-portrait drawing may be dated about 1625–30. It is similar in style to two drawings by Oliver in the National Portrait Gallery, London, showing the artist and his wife, Anne (4853, recto, and 4853A, verso), and to two others in the Huntington Library, San Marino, California, also of Anne Oliver (63.52.161, 162). Informal *ad vivum* studies of this type dating from the early seventeenth century are rare, and this drawing anticipates miniature drawings made later in the century by artists like Thomas Forster (nos 194–5) and David Loggan (no. 128), although Oliver's self-portrait is drawn in a much less elaborate manner.

39

38

VORSTERMAN the Elder, Lucas

Bommel 1595 – Antwerp 1675

An engraver and draughtsman, Vorsterman probably settled in Antwerp early in his life and had already made a reproductive print by 1607, when he was only about twelve years old. He was described in the registers of the Guild of St Luke as 'art dealer and engraver' and became a master in the Guild in 1620. In the same year he was taken up by Rubens (q.v.), who was in search of a competent engraver to reproduce his paintings. Vorsterman produced some important prints for Rubens but in 1622 a violent quarrel took place, in which Vorsterman is supposed to have threatened the life of his master. It is probable that Rubens's demands for both speed and

excellence were more than Vorsterman could match. At the possible instigation of the Earl of Arundel, he moved to England after April 1624, where he was employed by Arundel as well as by Charles I and the Earl of Pembroke to make engravings after paintings and drawings in their collections. He was also active as a portrait draughtsman. By the end of 1630 he had returned to Antwerp and during the following years was occupied in engraving some of Van Dyck's (q.v.) designs for the *Iconography*, production of which continued after the latter's move to England.

39 George Villiers, 1st Duke of Buckingham (1592–1628)

Brush drawing in brown and grey wash, touched with red chalk over black chalk; 198 × 170 mm (7¾ × 6⅝ in)

Signed by the artist upper right: *Bucquingam A° 1624 LVF* (*LV* in monogram)

PROVENANCE: Probably Ralph Willett (see below)

LITERATURE: H. Hymans, *Lucas Vorsterman*, Brussels, 1893, p. 153, under no. 142; Hind, II, 10

The British Museum (1862-5-24-19)

Although executed in the year the artist came to England, this drawing is more likely to be a copy from an existing portrait than an *ad vivum* study. The finished style of the sheet suggests that it was intended as a preparatory study for an engraving, although no print is known to exist. Hymans describes a very rare small oval engraving

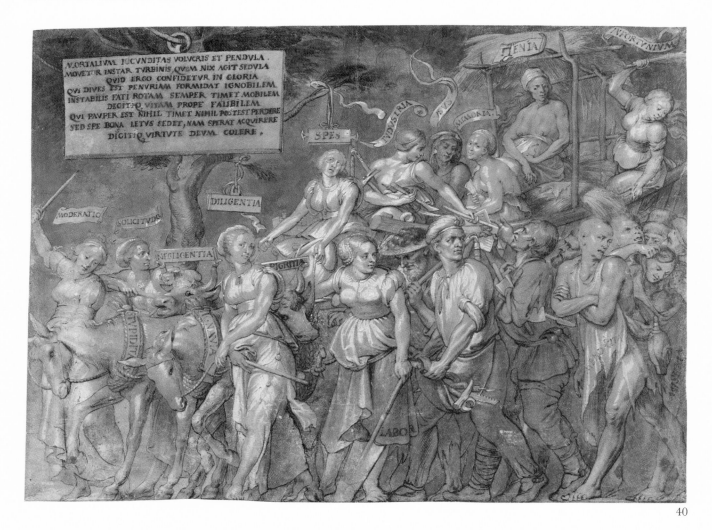

40

(45 × 36 mm), which, on the basis of the inscription in pen and ink on the impression in Paris, he accepts as by Vorsterman, and suggests that the British Museum drawing provided the point of departure for it. In 1785 William Baillie engraved what was probably this drawing as by Van Dyck, while it was in the collection of Ralph Willett.

40 The Triumph of Poverty (after Holbein)

Black and red chalk, pen and brown ink with brown and grey wash, heightened with white, the foliage green and the background blue bodycolour; 437 × 585 mm (17¼ × 23 in)

PROVENANCE: Earl of Arundel?, Sir Peter Lely; John Sheffield, Duke of Buckingham (sale, Prestage, 25 February 1763, lot 33 according to Walpole); Horace Walpole (sale, Strawberry Hill, 17 May 1842, lot 55; Sir Charles Eastlake (sale, Christie, 2 June 1894, lot 17); J. P. Richter

LITERATURE: Hind, II, 16; P. Ganz, *The Paintings of Hans Holbein the Younger*, London, 1950, p. 285; J. Rowlands, *Holbein*, Oxford, 1985, p. 224, no. L13A

The British Museum (1894-7-21-2)

The various personages are identified by inscriptions in Latin and, in one case, in Greek. Inscribed on a tablet hanging from a tree on the left are verses in Latin explaining the allegory, written, according to Vorsterman's engraving, by Sir Thomas More (a full transcription is given by Hind).

In about 1533–4, on commission from the Hanseatic merchants, Hans Holbein the Younger executed two wall paintings, between 2.22 and 2.44 m high, to decorate the hall of the Guildhall of the Steelyard. They were painted on canvas in grisaille on a blue background, heightened with gold and lightly tinted in watercolour. The subjects were the *Triumph of Riches* and the *Triumph of Poverty*, corresponding to the motto of the Hanseatic merchants, which was inscribed in Latin over the main entrance to the colony: 'Gold is the father of joy and the son of care; he who lacks it is sad, he who has it is uneasy.' Following the dissolution of the Hanseatic guild, the two paintings were eventually presented to Henry, Prince of Wales, and on his death passed to his brother, Charles I. Probably through exchange they came into the collection of the Earl of Arundel and were seen by Joachim von Sandrart hanging at Arundel House in 1627. They were later

shipped with some other parts of the Earl's collection to Antwerp and were ultimately destroyed by fire in the Bishop's Palace in Kremsier in 1752.

This copy and its companion, the *Triumph of Riches*, in the Ashmolean Museum, Oxford (Rowlands, op. cit., no. L13B, pl. 193), remain the only surviving copies in colour, and in their freedom of execution probably provide the most convincing impressions of the originals. (Other copies were made by Federico Zuccaro and Matthäus Merian in London and by Jan de Bisschop in Antwerp.) It is likely that Vorsterman, who worked for the Earl of Arundel, studied the paintings when they were in the latter's possession. The elaborate technique of the copies suggests that they were made as preparatory studies for engravings, but only the *Triumph of Poverty* was ever executed, in a print inscribed *Vorstermans*. This was attributed to Lucas Vorsterman the Younger by Vertue (v, pp. 65–6) but was accepted by Hymans as by his father (*Lucas Vorsterman*, Brussels, 1893, no. 108). Although executed in a somewhat freer style than usual, there seems no reason to doubt the traditional attribution of the two copies to Lucas Vorsterman the Elder.

DIEPENBECK (DIEPENBEECK), Abraham van

Hertogenbosch 1596 – Antwerp 1675

Diepenbeck, the son and pupil of a glass-painter, Jan Roelofsz. van Diepenbeck, moved to Antwerp about 1626, becoming a citizen ten years later. He too worked as a glass-painter and only took up oil-painting about 1630. He was dean of the Guild of St Luke in 1641, and may have visited both France and Italy. The argument that he may also have visited England, as suggested by Vertue, depends on whether his views of the various seats of the Marquess (later Duke) of Newcastle were based on drawings made by himself on the spot or on the work of other artists. He certainly worked for Newcastle during the Duke's exile in Antwerp from 1648 to 1660. Diepenbeck was a prolific draughtsman and designer for engravings, treating a wide range of subject-matter. The influence of Rubens is especially noticeable in his drawings.

41 William Cavendish, 1st Duke of Newcastle (1592–1676)

Black chalk, heightened with white, on blue paper; 277 × 165 mm (10⅞ × 6½ in)

PROVENANCE: Bequeathed by Francis Douce to the Bodleian Library, 1863; transferred to the University Galleries, 1863

LITERATURE: Brown (1982) 117; Brown (1983) 11

The Ashmolean Museum, Oxford

Formerly attributed to Lely, this drawing was recognised by Sir Oliver Millar as the preparatory study for the

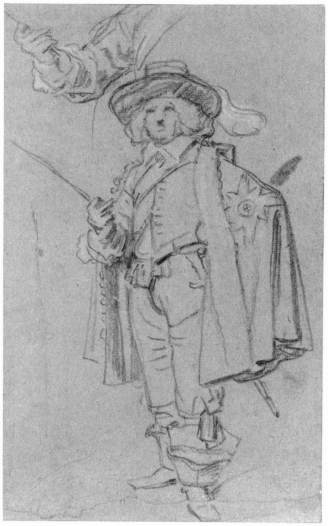
41

central part of the illustration engraved (in the same direction but on a reduced scale) by Lucas Vorsterman for the Duke of Newcastle's celebrated manual of horsemanship, *La Méthode et Invention Nouvelle de Dresser les Chevaux*, Antwerp, 1658, pl. 15, entitled 'Monseigr. le Marquis'. The alternative position of the right arm seen at the top left of the drawing was adopted in the engraving. (For the manual, see D. Steadman, *Abraham van Diepenbeeck*, Ann Arbor, 1982, pp. 41–2.)

The Duke and his family were in exile in Antwerp from 1648 to 1660, where they lived in Rubens's house. Diepenbeck's designs for the illustrations, which were engraved by various artists, were clearly carried out during this period. Apart from equestrian subjects, the volume, which contains forty-three engravings and fifty woodcut diagrams, includes family portraits and views of their homes. Following Vertue's statement (*Walpole Society*, XXVI (1937), p. 57) that Diepenbeck 'drew in England several views of his [i.e. Newcastle's] houses in the Country, in Nottinghamshire and Derbyshire', (see no. 42),

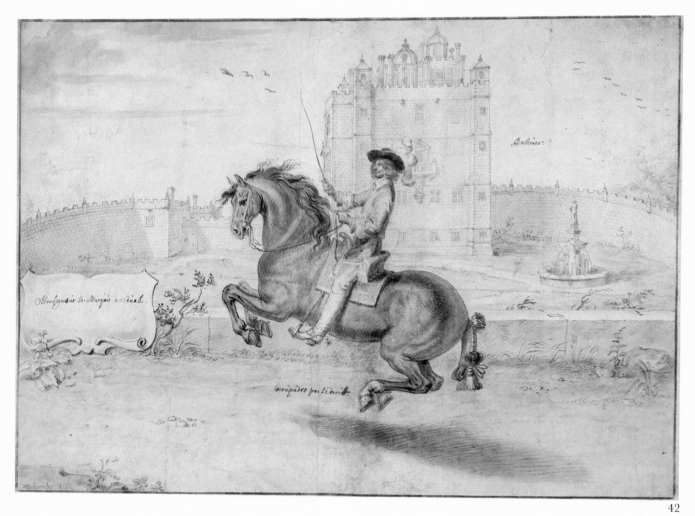

42

it has sometimes been supposed that the artist went to England either shortly before the time of publication or possibly earlier, about 1630. There is, however, no other record of such a visit and Diepenbeck may, as was common practice, have used topographical views by other artists. Despite an acute shortage of money, Newcastle maintained his passion for horses and was forced to borrow in order to finance publication of his book.

42 William Cavendish, 1st Duke of Newcastle, on horseback, with Bolsover Castle in the background

Pen and brush drawing in brown ink with grey wash and touches of white bodycolour; 395 × 520 mm (15½ × 20½ in)

Signed lower left: *A. V. Diepenbeeck.F.* (*AVD* in monogram), and inscribed in the cartouche on the left: *Monseigneur le Marquis a cheval*, beneath the horse in the centre: *Groupades par Le droict*, and to the right of the castle: *Bolsover*

PROVENANCE: Bequeathed by Sir Hans Sloane, 1753

LITERATURE: Hind, II, 20

The British Museum (5236-112)

This is the preparatory drawing for the engraved illustration of the same size and in the same direction by Petrus van Lisebetten for the Duke of Newcastle's manual of horsemanship, pl. 31 (see no. 41). The background shows the keep or little castle which was built for the Duke's father, Sir Charles Cavendish, probably by Robert Smythson between 1612 and 1621. Apart from Bolsover, several of the Duke's other seats, such as Welbeck, appear in the backgrounds of the plates. A series of paintings of managed horses at Welbeck, traditionally attributed to Diepenbeck and sometimes dated about 1630 (R. W. Goulding, *A Catalogue of the Pictures Belonging to his Grace the Duke of Portland, K.G.*, Cambridge, 1936, pp. 114–17 and 438–9), include similar views and may have served as the partial basis for Diepenbeck's designs. Of the three water-colour drawings of Bolsover Castle attributed to Diepenbeck, in a private collection (Harris (1979), pls 33 a–c), that taken from the south-east could well have been used for the background of the British Museum drawing.

43 William Cavendish, 1st Duke of Newcastle, and his family

Pen and brush drawing in brown ink, with brown and grey wash, heightened with white; 182 × 160 mm (7⅛ × 6¼ in)

PROVENANCE: Colnaghi

LITERATURE: Hind, II, 14

The British Museum (1858-4-17-1629)

Opposite an elaborate chimney-piece supported on either side by a male and female figure, the Duke and Duchess are seated beneath a canopy in conversation with a large group of men and women arranged in a circle around them in front of the fire. One servant opens or closes the window, while another stands behind the ducal couple. The style of the architecture of the small room is Flemish rather than English, and the drawing demonstrably represents the Duke and his family during their exile in Antwerp (1648–60), since the group includes the Duke's son, Henry, who was born in 1631, and his wife. It may well have been intended as one of the illustrations to the Duke's book on horsemanship (see no. 41), but, if so, was not used. (His family does, however, appear in a different arrangement in plate 42 of the book.) The drawing was engraved in the same direction by Petrus Clouet (Hollstein, IV, p. 174, no. 15), and inscribed with verses: 'Thus in this Semy-Circle, Wher they Sitt, / Telling of Tales of pleasure & of witt . . .'.

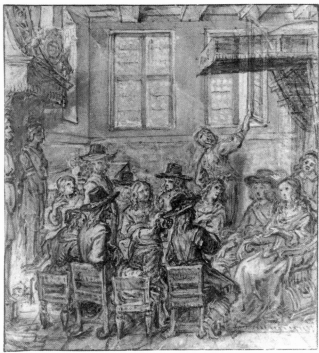

43

DYCK, Sir Anthony van

Antwerp 1599 – London 1641

Van Dyck was a pupil of Hendrick van Balen in Antwerp and later worked as an assistant to Rubens (q.v.). He came to England in 1620 to work for James I, but apart from the *Continence of Scipio* (Christ Church, Oxford), painted for the Duke of Buckingham, and a half-length portrait of the Earl of Arundel (J. Paul Getty Museum, Malibu), who may have sponsored his visit, little is known of his activity during that first stay. Within a year he had departed, ostensibly for eight months but in reality for eleven years, which were spent in Italy (1621–7) and then at home in Antwerp. With Rubens so firmly established in Flanders, Van Dyck was persuaded to return to England in the spring of 1632. Apart from a stay in Antwerp in 1634–5 and brief visits there and to Paris in 1640 and 1641, he remained in London. In February 1640 he married Mary Ruthven, a granddaughter of the 1st Earl of Gowrie.

An outstandingly able and fluent follower of Rubens, Van Dyck immediately established himself on his return to England in 1632 as the leading portrait painter to Charles I and his court, effortlessly eclipsing rivals such as Daniel Mytens. As he had demonstrated in his Genoese portraits, Van Dyck was remarkably adept at understanding the ethos of a particular society. He successfully imbued his English portraits with a seemingly indigenous vitality and an atmosphere of refinement and glamour, enhanced by his use of meaningful symbolism, which clearly appealed greatly to his sitters as well as creating an image of Caroline society. He had superb facility as a painter and his speed of execution is conveyed brilliantly in his working drawings for compositions and portraits. His influence on English portrait painting, and to a lesser extent on landscape, was paramount up to the end of the eighteenth century.

44 Nicholas Lanier (1588–1666)

Black chalk, heightened with white, on blue paper; 392 × 285 mm (15⁷⁄₁₆ × 11¼ in)

PROVENANCE: P. H. Lankrink (L 2090); J. van Haecken (L 2516) A. Ramsay?; presented by Lady Murray, 1860

LITERATURE: Vey 203; Millar (1972) 112; Millar (1982) 67; K. Andrews, *Catalogue of Netherlandish Drawings in the National Gallery of Scotland*, I, Edinburgh, 1985, p. 24, D1486

National Gallery of Scotland, Edinburgh

A preparatory study for the three-quarter-length portrait in the Kunsthistorisches Museum, Vienna (KdK 349), which was almost certainly executed in 1628, when the sitter passed through Antwerp while accompanying the most fragile pictures from the recently acquired Mantua collection to England. Apart from his assistance to the King in the acquisition of works of art, Lanier, who was of French origin, was a prominent court musician and composer, eventually becoming Master of the King's Music.

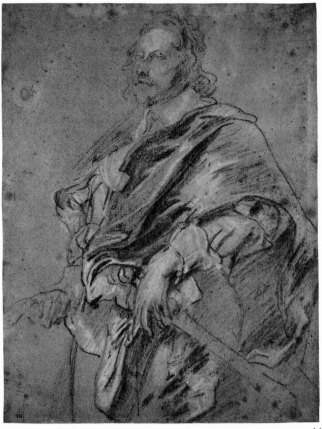

44

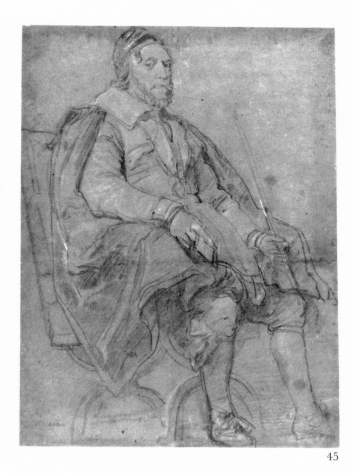

45

He played an active role in the creation of masques, and was, for example, partly responsible for the music to the *Masque of Augurs* (see no. 13).

This drawing is the first datable example of a type of preparatory study in black chalk, often heightened with white bodycolour, which Van Dyck was to use frequently for his English portraits. Here detail is more fully realised than was to become the artist's habit in later years, and the sheet is especially notable for the extensive use of white bodycolour to indicate highlights on the costume. Whereas in the drawing the right hand is held out, apparently holding a glove, in the painting it rests on the hip.

45 Thomas Howard, 2nd Earl of Arundel (1585–1646)

Black chalk, heightened with white, on brownish paper; 480 × 356 mm (18⅞ × 14 in)

PROVENANCE: Uvedale Price; Sotheby, 4 May 1854, lot 284; W. B. Tiffin

LITERATURE: Hind, II, 53; Vey 225; Millar (1972) 117; Millar (1982) 77; *Thomas Howard, Earl of Arundel*, exh. cat, Ashmolean Museum, Oxford, 1985, no. 10

The British Museum (1854-5-13-16)

For the sitter, see no. 28. In 1620, in a letter from his secretary, Francesco Vercellini, in Antwerp, Arundel was made aware of Van Dyck's rapid emergence as a rival to Rubens and was probably involved in persuading him to come to London. During his brief first visit there, Van Dyck painted the Earl's portrait, now in the J. Paul Getty Museum, Malibu (Millar (1982), 2, illus.). Arundel was also instrumental in obtaining royal permission for the artist to travel to Italy in 1621, and when Van Dyck returned in 1632 he carried out a number of widely differing portrait commissions for his patron. One, which was never realised but is possibly recorded in a watercolour of 1643 by Philip Fruytiers (Millar (1972) 134, illus.) and a drawing in the manner of Van Dyck, in the British Museum (*Burl. Mag.*, LXXIX (1941), p. 190), appears to have been for a family portrait with his grandchildren, for which this drawing may have been a preliminary study. For such a purpose the drawing is unusually fully realised and provides a powerful image of the sitter, seen from below as if raised on a dais like the Earl of Pembroke in the large family group at Wilton (KdK 405). As Millar (1982) observed, the head could have been based on the portrait of the Earl with his grandson Thomas, in the collection of the Duke of Norfolk (KdK 473), which must have been painted by 1636.

Had the dynastic image of the Earl and his descendants been executed, it would have ranked among the artist's most magnificent group portraits.

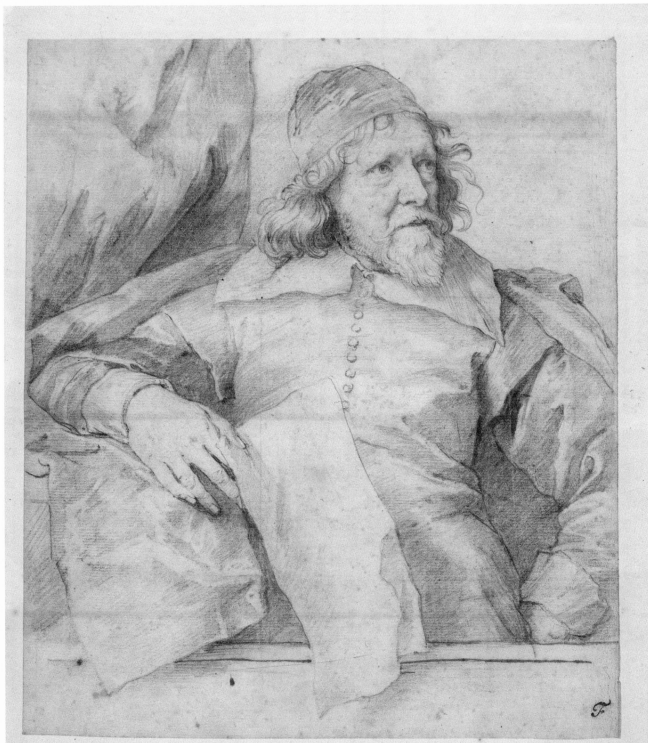

Vandyke's original Drawing, from which the Print by Van. Voerst was taken, in the Book of Vandyke's Heads. Given me by the Duke of Devonshire.

Burlington

46

46 Inigo Jones (1573–1652)

Black chalk; 245 × 200 mm (9⅝ × 7⅞ in)

PROVENANCE: N. A. Flinck (L 959), from whom acquired by the 2nd Duke of Devonshire in 1723; given by the 3rd Duke of Devonshire to the 3rd Earl of Burlington, who inscribed the mount: *Vandyke's original drawing, from which the Print by Van. Voerst was taken, in the / Book of Vandyke's Heads. Given me by the Duke of Devonshire*

LITERATURE: Vey 271; Millar (1972) 45; H, O & S 410; Millar (1982) 79

The Trustees of the Chatsworth Settlement

For the sitter, see p. 52. Like no. 47, this drawing, probably done from the life, was made in England for an engraving (by Robert van Voerst) to be included in the series of portraits of fellow-artists and other sitters designed by Van Dyck and known as the *Iconography*. It probably also served for the painted portrait, head and shoulders in an oval, the best version of which is in the Hermitage, Leningrad (M. Varsharskaya, *Van Dyck Paintings in The Hermitage*, Leningrad, 1963, no. 13, illus.). It soon became the standard portrait of the architect and was possibly the model for the bust placed on his tomb in St Benet's Church, London. Shortly afterwards Hollar used it for his engraved frontispiece (P 1428) to Jones's *Stone-Heng Restor'd* (1655).

47 Orazio Gentileschi (1563–1639)

Black chalk, with grey wash and some touches of pen and brown ink, indented for transfer; 240 × 179 mm (9⅜ × 7 in)

PROVENANCE: Thomas Hudson (L 2432); Dr R. Mead; bequeathed by the Rev. C. M. Cracherode, 1799

LITERATURE: Hind, II, 35; Vey 276; Millar (1972) 119; Millar (1982) 78

The British Museum (G.g. 2-238)

The artist Gentileschi was born in Pisa and worked in Rome, where he was in contact with Caravaggio. He moved to Paris in about 1623–4, and in 1625 met the Duke of Buckingham, who was in the French capital in connection with the King's proxy marriage to Henrietta Maria. The following year he settled in London under the protection of Buckingham, and was patronised by the King and Queen, for whom, *inter alia*, he decorated the ceiling of the hall of the Queen's House at Greenwich (later cut down and installed at Marlborough House).

This is a preparatory drawing for the engraving by Lucas Vorsterman which was to form part of the series of portraits later known as the *Iconography* (see no. 46). Van Dyck must have decided to include the present sitter when the two men met in London.

48 James Stuart, 4th Duke of Lennox and 1st Duke of Richmond (1612–1655)

Black chalk, heightened with white, on light brown paper; 477 × 280 mm (18¾ × 11 in)

PROVENANCE: Hugh Howard; the Earls of Wicklow

LITERATURE: Hind, II, 54; Vey 214

The British Museum (1874-8-8-142)

Preparatory study for the full-length portrait (see p. 89) in the Metropolitan Museum of Art, New York (KdK 411). See also no. 49.

The same formal view of the head was used in the half-length portrait – which also includes the hound but in a different pose – in the Iveagh Bequest, Kenwood (KdK 409). The Duke must have sat for Van Dyck on at least one other occasion, for the portrait with head turned to the left, now in the Louvre, Paris (KdK 410).

Stuart, who succeeded his father as Duke of Lennox in 1624, was created Duke of Richmond by Charles I, of whom he was a loyal supporter. He received the Order of the Garter in 1633, which may have occasioned this commission for a full-length formal portrait. Stylistically, both painting and related drawings must in any case date from the middle of that decade.

49 Two studies of a greyhound

Black chalk, heightened with white, on light brown paper; 470 × 328 mm (18½ × 12⅞ in)

PROVENANCE: Hugh Howard; the Earls of Wicklow

LITERATURE: Hind, II, 55; Vey 215

The British Museum (1874-8-8-141)

Preparatory studies for the hound in the full-length portrait of James Stuart, 4th Duke of Lennox and 1st Duke of Richmond (1612–55), in the Metropolitan Museum of Art, New York (see no. 48). The artist used the left-hand study in the painting. The prominence of the hound in the portrait is no doubt due to the fact that it is said to have saved its master's life, possibly in a boar hunt.

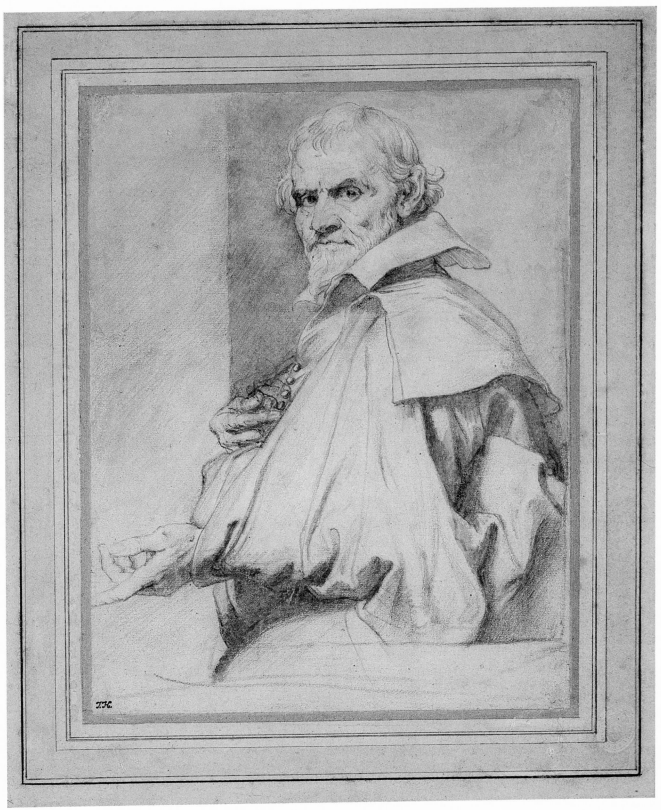

47

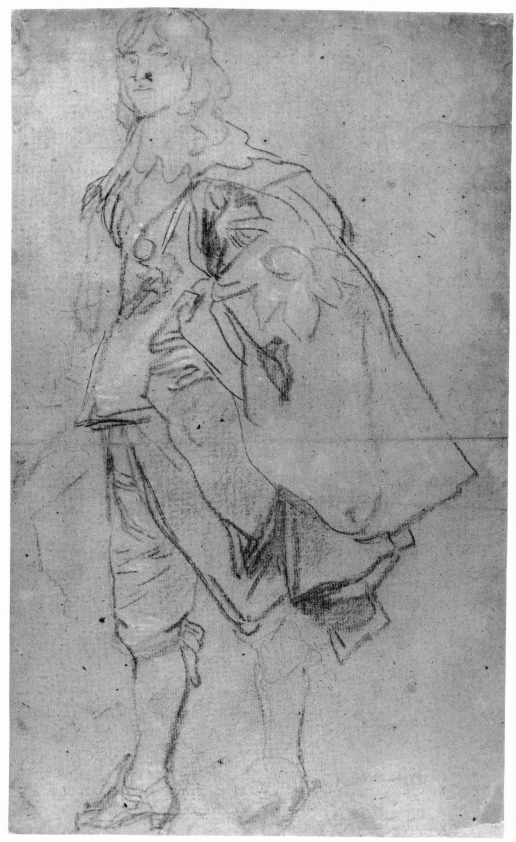

(*Right*)
Sir Anthony Van Dyck:
*James Stuart, 4th Duke of
Lennox and 1st Duke of
Richmond.*
Oil on canvas, *c.*1635.
The Metropolitan Museum
of Art, New York

48

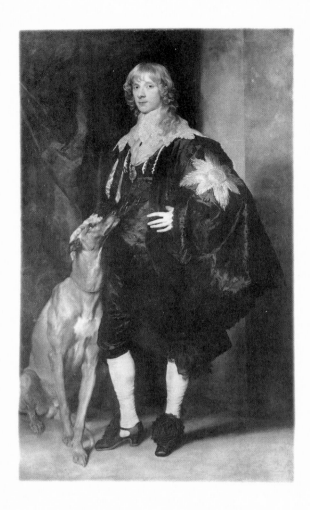

49

50 Endymion Porter (1587–1649) with his son Philip (1628–1655)

Black chalk, heightened with white, on brownish paper; 318 × 242 mm (12½ × 9½ in)

Inscribed lower left in an early hand: *A. V. Dÿck*

PROVENANCE: P. H. Lankrink (L 2090); J. Richardson sen. (L 2184); Thomas Hudson (L 2432); Uvedale Price; Sotheby, 4 May 1854, lot 278; W. B. Tiffin

LITERATURE: Hind, II, 51; Vey 210; Millar (1982) 70

The British Museum (1854-5-13-15)

Endymion Porter, who served as a Gentleman of the Bedchamber, was one of the most cultivated and widely travelled members of the Caroline court, with a particular interest in the fine arts. He was friendly with both Rubens and Van Dyck, with whom he was already in contact when the latter was in England in 1620–21. Later Van Dyck painted a self-portrait with Porter, now in the Prado, Madrid (KdK 440). Porter's son, Philip, who appears here as a spirited child, was committed for high treason during the Interregnum and died shortly after release from the Tower.

This drawing is a study for the family portrait now in

the collection of Mrs Gervase Huxley (Millar, op. cit., fig. 49), in which the father and youngest son are placed on the left of the composition, with the mother in the centre and the other two boys on the right.

51 Study of a horse

Black chalk, heightened with white, on greenish-grey paper; 429 × 366 mm (16⅞ × 14⅜ in)

PROVENANCE: Hugh Howard; the Earls of Wicklow

LITERATURE: Hind, II, 47; Vey 208; Millar (1972) 113; Millar (1982) 69

The British Museum (1874-8-8-22)

Drawn on three overlapping sheets of paper, the horse is shown with the back legs shortened, probably in order to accommodate them on the sheet. A separate study of the foreleg has been included on the right. (Another study of the foreleg (Vey 209) is also in the British Museum.) The position of the rider is only suggested.

Although the artist repeated the pose in the equestrian portrait of the *Marquis of Moncada*, in the Louvre (KdK 420), painted in Brussels in 1634–5, this study was almost

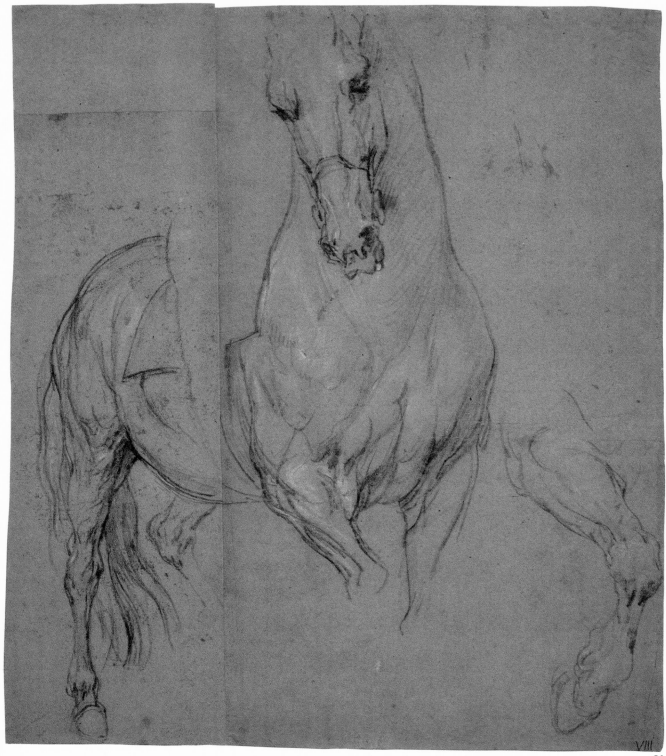

VIII

51

certainly made in connection with the equestrian portrait of *Charles I with M. de St Antoine*, in the collection of H.M. The Queen (KdK 372), executed in 1633 for the Gallery at St James's Palace. In addition to the two studies of the horse, the artist made a rapid sketch, unique in his English oeuvre, of the whole composition, which is also in the British Museum (Vey 207). The pose of the horse recurs in the portrait of *Philip IV*, in the Galleria Balbi, Genoa (*Mostra della Pittura del Seicento e Settecento in Liguria*, exh. cat., Palazzo Reale, Genoa, 1947, no. 8). The arrangement of horse and rider advancing towards the spectator derives from the type of equestrian portrait first established by Rubens in his portrait of the *Duke of Lerma* (Prado, Madrid), painted in 1603. The painting would have been seen by Charles on his visit to Spain in 1623 and may have provided the source of inspiration.

52 Ann Carr, Countess of Bedford (1615–1684)

Black chalk with some white bodycolour (rubbed) on light brown paper; 420 × 242 mm (16½ × 9½ in)

PROVENANCE: J. Richardson sen. (L 2184); Thomas Hudson (L 2432); John Thane (L 1545)

LITERATURE: Hind, II, 59; Vey 241; Millar (1972) 118

The British Museum (1846-7-9-13)

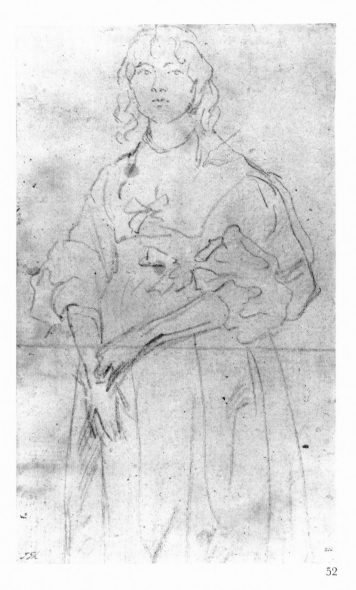

52

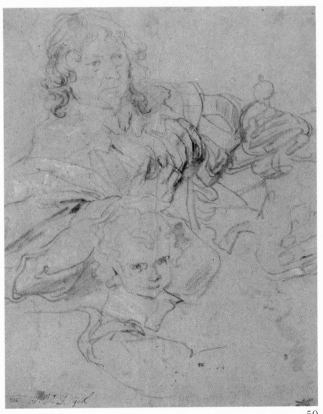

50

The sitter, daughter of the Earl of Somerset, married William, Lord Russell (later 5th Earl of Bedford and 1st Duke of Bedford) in 1637.

The drawing is a summary preparatory study for for the three-quarter-length portrait at Petworth (Millar (1982) 41), in which it can be seen that she is holding her glove in her right hand. The painting is one of a set of four portraits of Countesses – probably inspired by the European tradition of series of portraits of court beauties or famous women – which were commissioned by the Earl of Northumberland. The commission probably dates from relatively late in Van Dyck's career.

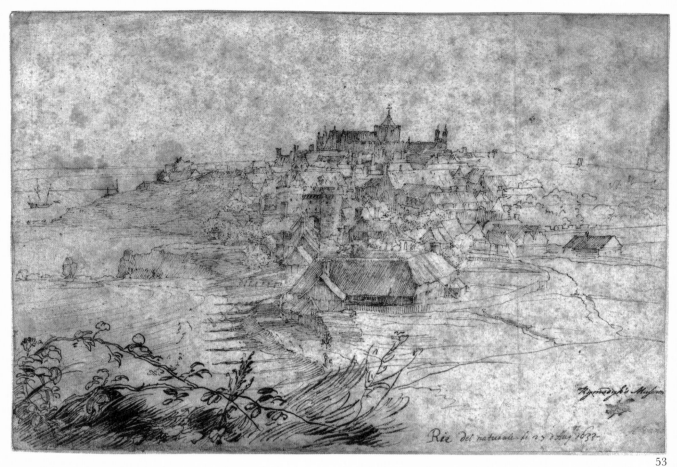

53

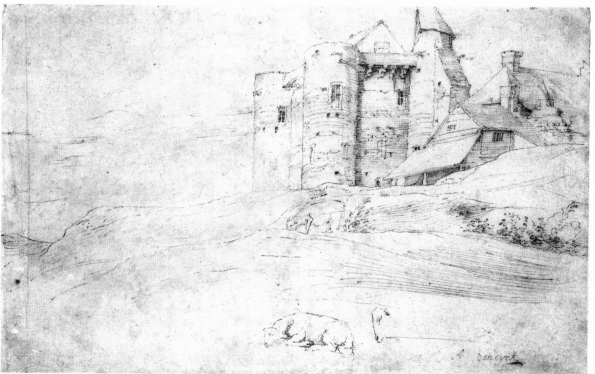

54

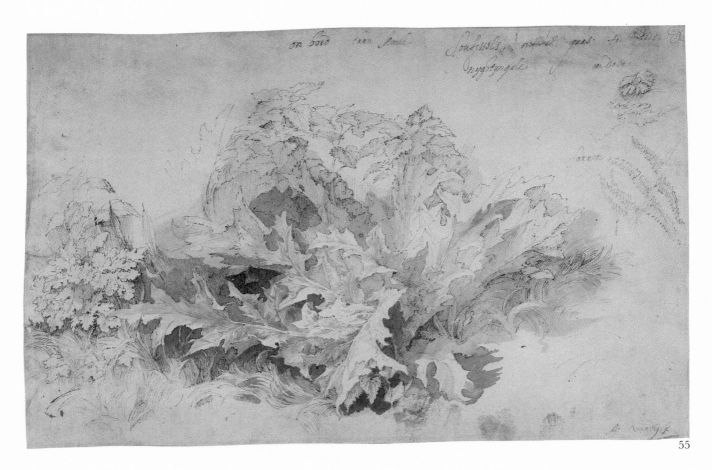

55

53 View of Rye

Pen and brown ink; 202 × 294 mm (7¹⁵⁄₁₆ × 11⁹⁄₁₆ in)

Inscribed by the artist lower right: *Rie del naturale li 27 d'Aug¹⁰ 1633 Aᵒvand[. . .]*

PROVENANCE: J. Richardson sen. (L 2183); J. van Rijmsdijk (L 2167); C. Fairfax Murray

LITERATURE: Vey 288; Millar (1972) 122; F. Stampfle, *Rubens and Rembrandt in their Century*, exh. cat., Pierpont Morgan Library, New York, 1979, no. 32; Millar (1982) 81

The Pierpont Morgan Library, New York

Rye, one of the Cinque Ports, situated on the East Sussex coast, was built on rock, and although the harbour, which can be seen in the left-hand background, was silting up by the early seventeenth century, it still served as a port for crossing to the Continent as well as for fishing boats. This view is taken from a cliff to the north-east of the town. The Norman church of St Mary appears on the horizon, and below, among the houses, is the Landgate, built in 1329, which was the entrance to the town from the London road. On the hillside to the left of the church is the Ypres Tower, one of the old fortifications, which at this period was used as a prison.

The artist made four drawings of the town, which he must have visited on at least two occasions, since that in the Uffizi, Florence (Vey 289), which depicts the church of St Mary from the seaward side, is dated 1634, the year in which he returned to Antwerp for a brief visit. For the other two drawings, see no. 54. Although in 1632 Van Dyck had made a drawing of Antwerp seen from the river (Royal Library, Brussels; Vey 287), the present drawing represents his most ambitious topographical view, the foreground cliff being established by the wild plant and grass spreading from the left. It was used by Hollar as the basis for his silverpoint drawing (Huntington Library and Art Gallery, San Marino; Sprinzels 367, fig. 234), which he later incorporated, with due acknowledgement to Van Dyck, in the upper left of his *Map of Kent* (P 665c), etched in 1659.

54 View of Rye with the Ypres Tower

Pen and brown ink; 193 × 298 mm (7⅝ × 11¾ in)

Signed lower right: *A. vandyck*

PROVENANCE: De Robiano (sale, Muller, Amsterdam, 15/16 June 1926, lot 368); F. Koenigs; given by D. G. van Beuningen, 1941

LITERATURE: Vey 291 (with previous literature)

Museum Boymans-van Beuningen, Rotterdam

See no. 53. The Ypres Tower is seen from the south-east

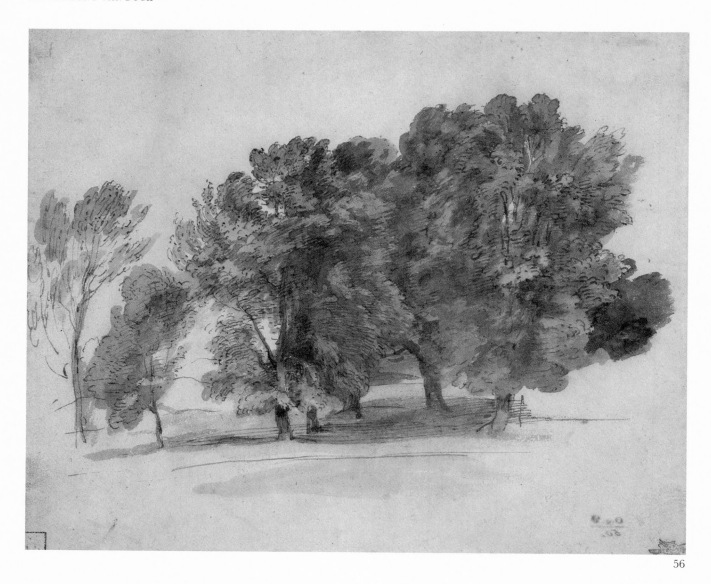

56

and was probably studied from a boat. Both the conception, including the grazing cow and sleeping sheep, and the technique are very reminiscent of Titian's landscape drawings. The artist made another drawing of the tower, taken from the south (Fitzwilliam Museum, Cambridge; Vey 290), which, unlike his other landscape studies, appears to have been used in the background of a portrait, that of *Everhard Jabach* (Hermitage, Leningrad; KdK 355).

55 Study of plants

Pen and ink with brown wash; 213 × 327 mm (8⅜ × 12⅞ in)

Inscribed by the artist upper right: *on bord cron semel. Soufissels, nettels. gras. trile gras./nyghtyngale on dasy/færren*, and probably signed by him lower right: *A vandÿck*

PROVENANCE: J. Richardson sen. (L 2184); W. Russell

LITERATURE: Hind, II, 85; Vey 296; Millar (1972) 123; Millar (1982) 84

The British Museum (1885-5-9-47)

The following plants are probably represented, from left to right: greater celandine (*Chelidonium maius*), corn sowthistle (*Sonchus arvensis*), stinging nettle (*Urtica dioica*), common quaking grass (*Briza media*), herb robert (*Geranium robertianum*), daisy (*Bellis perennis*), upper right, and lady fern (*Athyrium filix-femina*), lower right. Both the style of drawing and the English inscriptions indicate that the drawing was made during Van Dyck's second English

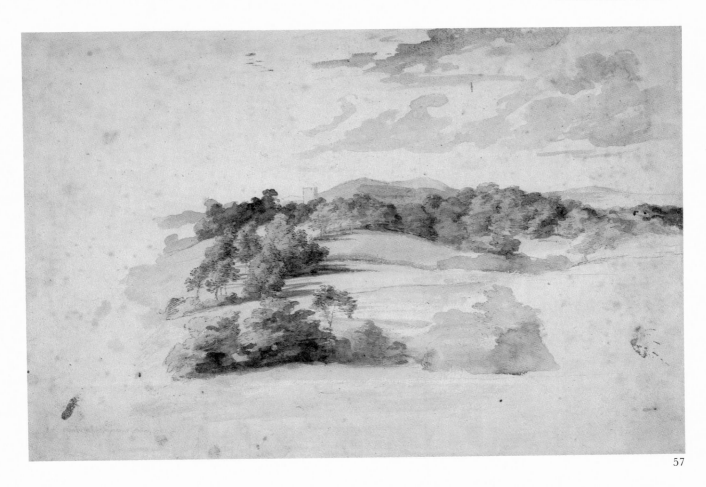

57

period, when he also probably made his only other known plant study (Institut Néerlandais, Paris; Vey 297). Plants and flowers occur in Van Dyck's pictures from an early date, and frequently appear in the foreground in works of the second English period. He may well have made a study such as this, clearly drawn from life, as a means of reference. In his drawing of a *Wild cherry with brambles and weeds* (Courtauld Institute Galleries, London; A. Seilern, *Flemish Paintings & Drawings at 56 Princes Gate London SW7*, London, 1955, pl. cxx), Rubens made, arguably at about the same time, a very similar nature study, possibly with the same purpose in mind.

56 Study of trees

Pen and ink with brown wash and watercolour; 195 × 236 mm (7⅝ × 9¼ in)

PROVENANCE: J. Richardson sen. (L 2184); Sir Joshua Reynolds (L 2364); Richard Payne Knight Bequest, 1824

LITERATURE: Hind, II, 82; Vey 303

The British Museum (O.o.9-50)

The tree on the left of the main group is not unlike that which appears in the left-hand background of Van Dyck's equestrian portrait of *Charles I* (National Gallery, London; KdK 381). This study is a very good example of the artist's characteristic combination of pen and ink with watercolour.

57 A hilly landscape with trees and a distant tower

Pen and brown ink, with grey, blue and green washes; 228 × 330 mm (8¹⁵⁄₁₆ × 13 in)

PROVENANCE: The Dukes of Devonshire, by descent

LITERATURE: Vey 306; Millar (1982) 85

The Trustees of the Chatsworth Settlement

An outstanding example of a landscape study clearly done for its own sake without any background to a portrait in mind. The method of drawing delicate pen lines to provide a framework for the free application of watercolour is characteristic of the artist.

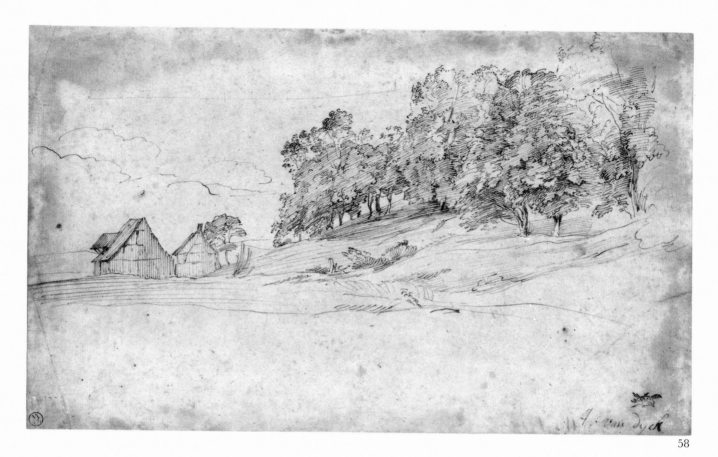

58

58 Cottages and trees on a hillside

Pen and brown ink; 189 × 299 mm (7⅜ × 11¾ in)
Signed lower right: *A: van dyck*
PROVENANCE: J. Richardson sen. (L 2184); Earl of Warwick
LITERATURE: Hind, II, 84; Vey 293
The British Museum (1897-4-10-16)

Both the style of drawing and the form of signature relate closely to a *Study of trees on a hillside* (British Museum; Vey 294), which is dated 1634 and was probably therefore made in Antwerp. In both drawings the trees are shown in full leaf, which suggests that they cannot, as has sometimes been argued, have been made in England, which the artist left in March of that year. His portrait of *Donna Anziana* (Kunsthistorisches Museum, Vienna; KdK 418, left), painted in Antwerp in 1634, contains a very similar landscape in the background. See also the portrait of *Isabella van Assche* in Cassel (E. Larsen, *L'opera completa di Van Dyck 1626–1641*, Milan, 1980, no. 817).

VAN DYCK, Circle of

59 Landscape

Bodycolour on blue paper; 240 × 388 mm (9⁷⁄₁₆ × 15⁵⁄₁₆ in)
Inscribed lower right: *A. Vandyck*
PROVENANCE: Brett; H. Oppenheimer (sale, Christie, 10–14 July 1936, lot 236)
LITERATURE: A. E. Popham, 'Acquisitions at the Oppenheimer Sale', *BMQ*, XI (1936), p. 128
The British Museum (1936-10-10-22)

The present drawing belongs to a group of attractive and unusual landscape studies executed largely, if not entirely, in bodycolour (for the most recent discussion of this group, see E. Haverkamp-Begemann and A. M. Logan, *European Drawings and Watercolours in the Yale University Art Gallery 1500–1900*, I, New Haven and London, 1970, pp. 331–2). Apart from this study, five others, including two in the British Museum (Hind, II, 86–7), bear an old ascription to Van Dyck. (It should be noted that the inscription on the present drawing gives the Flemish form of his name.) Two others in the Yale University Art Gallery (Haverkamp-Begemann and Logan, op. cit., nos 621–2) are inscribed *Wouters*, and a third, in the British Museum (1932-10-12-2; A. M. Hind, 'A Landscape Draw-

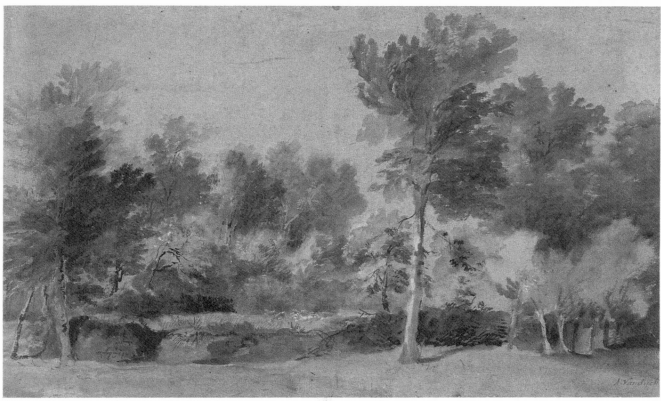

59

ing Attributed to Van Dyck', *BMQ*, VII (1932–3), p. 64), is inscribed on the old mount: *I. Rademaker fecit*.

The authorship of the group has been the subject of much discussion. Both Hind and A. P. Oppé ('Sir Anthony Van Dyke in England', *Burl. Mag.*, LXXIX (1941), p. 190) accepted them as the work of Van Dyck, given their similarity in conception and execution to undisputed landscapes by the artist. The closest parallel in the master's oeuvre is undoubtedly the *Landscape with trees and ships* (Barber Institute of Fine Arts, Birmingham; Millar (1982) 86), which is executed in watercolour and pen as well as bodycolour. However, despite the undoubted debt to Van Dyck, there is some difference in the handling of the brush as well as the absence of the penwork which invariably occurs in all accepted drawings by the master. Moreover, at least two of the drawings, one in the British Museum (1932-10-12-2) and the other in Williamstown (Haverkamp-Begemann, Lawder and Talbot 24), contain small figures more in the style of Hollar than Van Dyck.

In most recent scholarship, e.g. Vey, the attribution to Van Dyck has been rejected. The question has even been raised whether the scenery is English (see Haverkamp-Begemann, Lawder and Talbot, p. 31). The most plausible alternative, first suggested by J. Held (review of Vey, *Art Bulletin*, LXVI (1964), p. 566), is that they are by Frans Wouters, the Flemish painter (1612–59) whose name is inscribed on the two drawings in the Yale University Art Gallery. Wouters worked in England between 1637 and 1641 and came into contact with Van Dyck. Unfortunately his known work does not provide immediate parallels which would establish his authorship of this group beyond question, but some of the landscape backgrounds to his pictures, such as *Venus lamenting the Death of Adonis*, in the Royal Museum of Fine Arts, Copenhagen (W. Bernt, *The Netherlandish Painters of the Seventeenth Century*, III, London, 1970, pl. 1419), are remarkably similar. Whoever was responsible for the group, the drawings were executed under the immediate influence of Van Dyck and stand at the very beginning of the tradition of English landscape.

JONGH, Claude de

*c.*1600 – Utrecht 1663

De Jongh is first recorded in 1627 as a master in the painters' guild in Utrecht, where he appears to have spent most of his life, although his name occurs twice in Haarlem records in the early 1630s. He seems to have made a number of visits to England between 1615 and 1628, where he made topographical drawings variously dated 1615, 1625, 1627 and 1628. These formed the basis of paintings which he probably executed on his return home. In the case of his most famous picture, the *View of Old London Bridge* (Kenwood, Iveagh Bequest), he made three

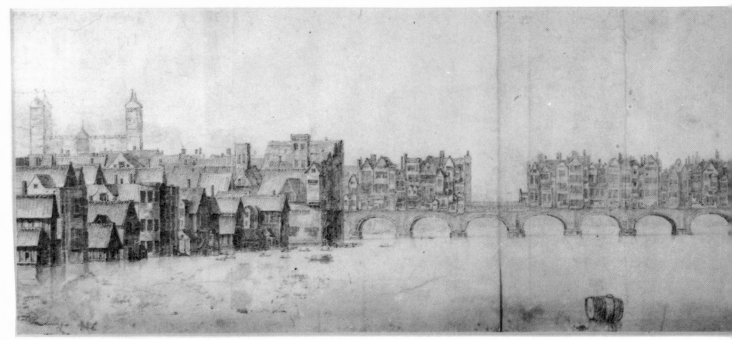

60

(*Above*) Claude de Jongh:
Old London Bridge.
Oil on panel, 1630.
The Iveagh Bequest, Kenwood (English
Heritage)

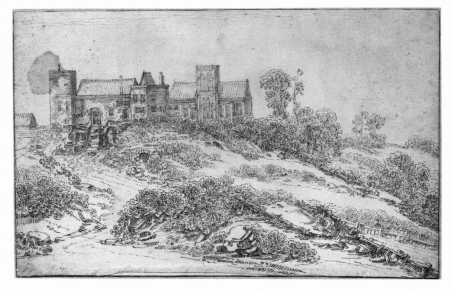

(*Right*) Claude de Jongh:
A Tudor manor house and church.
Pen and brown ink with grey wash.
Yale Center for British Art, Paul Mellon
Collection

98

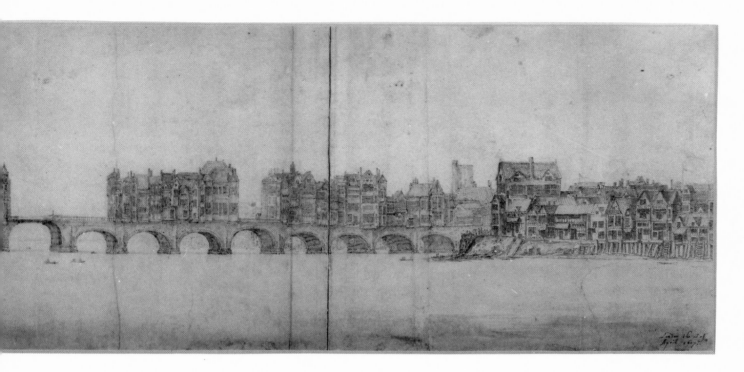

61

versions of the subject about 1650, but since these do not incorporate changes in the topography there is no reason to believe that he returned to England. The style of his paintings and drawings suggests that from an early date he was in close contact with the Haarlem school, notably with Jan van Goyen (1596–1656). Continuing the sixteenth-century landscape tradition of Pieter Bruegel the Elder, his manner of drawing with broken outlines and stippled or dotted shading creates a subtle pattern of light and atmosphere and recalls the work of his probably slightly older contemporary, Esaias van de Velde (1591–1630).

60 View of Old London Bridge

Pen and brown ink with grey wash; 229 × 991 mm (9 × 39 in)

Dated lower right corner: *London the 18 off April 1627*

PROVENANCE: Probably acquired during the nineteenth century

LITERATURE: Hayes, pp. 4, 7; Millar (1972) 60

The Guildhall Library and Art Gallery, London

Preparatory drawing for the artist's most important painting, the *View of Old London Bridge* (see p. 98), signed and dated 1630, which is in the Iveagh Bequest, Kenwood. Although generally accurate, there are a number of discrepancies in detail, which would not, however, have worried a Dutch patron. The difference in date between the drawing and the painting indicates that the former was probably made on the spot and taken back to Holland as a future subject for painting. De Jongh later repeated this view in two pictures dating from about 1650.

61 Collegiate or monastic buildings

Pen and ink with brown wash; 198 × 312 mm (7¹³⁄₁₆ × 12⁵⁄₁₆ in)

Inscribed on the verso, lower left: *hoogh 7½/ briet 12 dm*, and lower right: *The 8 off M[ay.]/.An° 1627* [?]

PROVENANCE: Baron J. G. Verstolk van Soelen (sale, Amsterdam, 22 March 1847, lot 303, as by Hollar)

LITERATURE: Hayes, p. 4; ECM & PH 4

The British Museum (1847-3-26-12)

This study belongs to a group of drawings in the British Museum (ECM & PH 1–6) which record medieval buildings or views, probably in Kent. The present buildings, which were studied again in another drawing (ECM & PH 3), have a general affinity with those of Lympne Castle and the Church of St Stephen, Kent, shown in De Jongh's drawing of 1625 (see p. 98; White (1977) 1, identified by John Newman, in Harris (1979), p. 29, no. 22).

GIBSON, Richard
London 1605 or Cumberland 1615 – London 1690

Gibson is generally thought to have been born in Cumberland in 1615 but Mary Edmond (1980) has recently suggested that he may have been the Richard, son of John Gibson 'picturemaker', who was baptised at St Dunstan-in-the-West on 7 July 1605, and John Murdoch has subsequently proposed that the artist who signed miniatures in the 1650s with the monogram *DG* was not an artist called D. Gibson but was Richard Gibson. Growing only to a height of three feet ten inches, he was known as 'Dwarf Gibson'; he also often abbreviated his name to Dick, and Vertue noted that the intertwined monogram *DG* was 'the mark of Dwarf Gibson as on a limning of his own doing' (VI, p. 10). In the 1630s Gibson was a page in the household of a lady living at Mortlake, who observed his talent for drawing and placed him with Francis Cleyn (q.v.), who was at that time designing for the tapestry works there. He was later a page at the court of Charles I and married, on St Valentine's Day 1640/41, the Queen's dwarf, Anne Sheppard, their nuptials being celebrated in a poem by Edmund Waller. Gibson's patrons came chiefly from the circle of aristocratic parliamentarians, the 'Noble Defectors'; until his death in 1649/50 the most important was Philip, 4th Earl of Pembroke, whom he perhaps met through his close friend Peter Lely (q.v.). A double portrait of Gibson and his wife was painted for Lord Pembroke by Lely in the late 1640s (Kimbell Art Museum, Texas), and Gibson was in receipt of an annuity from the Pembrokes as late as 1677. In the 1650s his chief patron seems to have been Pembroke's grandson, Charles, 2nd Earl of Carnarvon, and his wife Elizabeth Capel, to judge from the group of miniatures of members of the Capel family signed *DG*. After the Restoration, Gibson re-established himself in court circles, and was employed as a copyist of paintings in the Royal Collection and as a teacher. In 1677 he was invited to Holland to teach Princess Mary of Orange, later Queen Mary II, and lived at The Hague until 1688. This appointment, however, must cast some doubt on the suggestion that he was born in 1605, for he would have been 72 years old. To judge from the many references in Christiaan Huygens's correspondence, Gibson was also very active as a dealer and collector. He owned a number of drawings by Polidoro da Caravaggio, formerly in the Arundel collection. Gibson's children, who included the miniaturist Susanna Penelope Rosse, were all apparently of normal size.

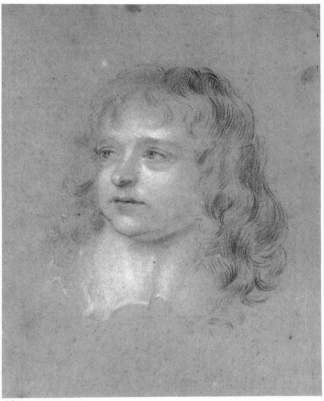

62

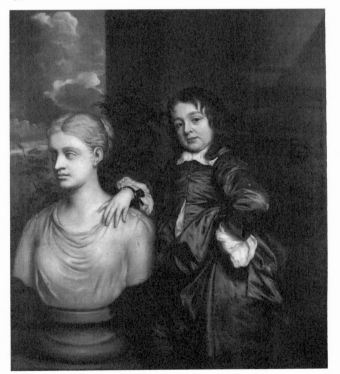

Copy after Sir Peter Lely:
Richard Gibson.
Oil on canvas.
National Portrait Gallery, London

62 Self-portrait

Red and black chalks, heightened with white, on buff paper;
225 × 178 mm (8⅞ × 7 in)
PROVENANCE: Richard Bull (sale, Sotheby, 23 May 1881, lot 65)
LITERATURE: ECM & PH 1
The British Museum (1881-6-11-157)

The identification of the subject of this drawing as
Richard Gibson is confirmed by the close likeness to
Gibson in Lely's double portrait of him with his wife Anne
Sheppard (Kimbell Art Museum, Forth Worth), prob-
ably painted about 1649–50, and in another portrait by
Lely of 1658 (the original is lost, but an early copy is in the
National Portrait Gallery, London, see below). Sir Oliver
Millar has suggested that a painting of a sleeping dwarf
(Millar (1978) 16) is also a portrait of Gibson, datable in
the late 1640s. Among the 'craions in ebony frames' in the
Lely sale of 1682 was a portrait of Gibson, but this, like yet
another painting by Lely, showing the dwarf with his
master Francis Cleyn, both dressed as archers, is un-
traced. A drawing in the Ashmolean Museum (Brown
(1982) 132), formerly attributed to Lely, has every ap-
pearance of being a self-portrait. The present drawing has
always been described as a self-portrait, but it is very
different in style from that in the Ashmolean, which (even
allowing for the fact that it has evidently been consider-
ably reworked) is much less refined in both conception
and execution.

This drawing may be dated about 1658, to judge from
its similarity to Lely's portrait of Gibson painted in that
year. Its resemblance to Lely's portrait drawings of the
late 1650s, particularly in the delicate modelling of the
face, suggests that Gibson was consciously emulating his
style, or, alternatively, that this study is in fact by Lely.

63 Portrait of a young girl

Red and black chalks on pink prepared paper; oval 138 ×
112 mm (5⁷⁄₁₆ × 4⅜ in)
Inscribed by the artist: *The Picture of a Consumtick* and [A]*eᵗ:6*
[1]*675*(?)
PROVENANCE: Mrs Richard Gibson?; William Towers (d. 1693)?;
by descent in the Tower family
Private Collection

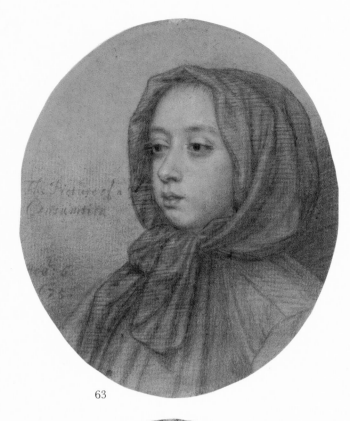

63

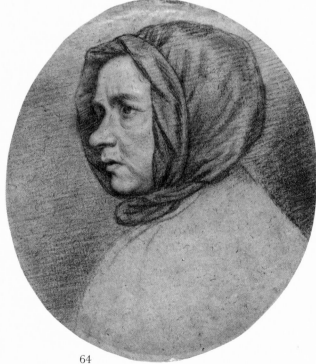

64

64 Portrait of a woman

Red and black chalks on pink prepared paper; 132 × 111 mm
(5³⁄₁₆ × 4³⁄₈ in)

PROVENANCE: As no. 63

Private Collection

Both drawings have probably been in the same collection
since the late seventeenth century. An ancestor of the
present owner, William Towers (d.1693), was a friend of
Richard Gibson, and the collection includes several other
drawings attributed to Gibson, to his daughter Susanna
Penelope Rosse and to Samuel Cooper (see nos 75–6 and
80). Neither of these drawings is signed, but the attribu-
tion to Gibson is entirely plausible and the inscription on
no. 63 appears to be consistent with his handwriting.
Nothing is known of the identity of the sitters, although
the intimate character of the drawings suggests that they
may have been members of the artist's family.

FULLER, Isaac

1606? – London 1672

Nothing is known of Fuller's early years, but according to
Buckeridge he studied in France under the history and
decorative painter François Perrier (1584 or 1590–1650).
Perrier was in Italy from 1635 to 1645 and Fuller's period
of study with him is likely to have taken place beforehand.
He is documented as working in Oxford in 1644 at the
same time as Dobson and Faithorne (q.v.). In 1650 he
designed an etched illustration of Jewish costume for
Thomas Fuller's *A Pisgah-Sight of Palestine*, and four years
later published a drawing book, *Un Libro di Designare*, with
fifteen etched plates. Although no copy is known today, it
is recorded by Vertue. In addition to painting portraits,
Fuller was commissioned soon after the Restoration to
produce a series of large historical pictures illustrating the
adventures of Charles II after the Battle of Worcester. He
was working in Oxford again by 1663, painting religious
subjects for the chapels of All Souls, Magdalen and
Wadham. By 1669 he was back in London, where besides
painting theatre scenery he also decorated rooms in sever-
al taverns, including the Mitre Tavern in Fenchurch
Street, for which, according to Vertue, he produced a
series of life-size mythological subjects, remarkable for the
'fiery colours & distinct marking of the muscles'. His
importance is difficult to assess, since certain of his large
subject paintings no longer exist. Lely is said to have
lamented 'that so great a genius should besot or neglect so
great a talent': his addiction to alcohol gave rise to the
myth that the *Self-portrait* in the Bodleian Library was
painted when he was drunk.

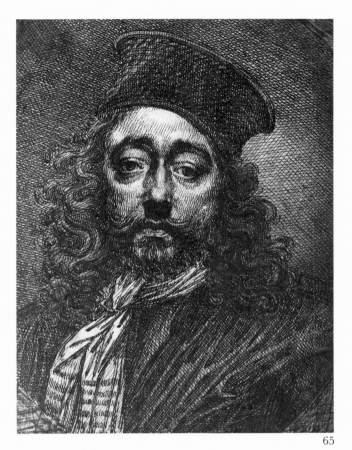

65

65 Self-portrait

Pen and black ink; 210 × 170 mm (8¼ × 6¾ in)

Inscribed on the verso: *Fuller by himself*

PROVENANCE: Bequeathed by the Rev. Alexander Dyce, 1869

LITERATURE: Woodward 21

The Victoria and Albert Museum, London

If Vertue is correct, Fuller painted a number of self-portraits. Two existing examples were executed in 1670; one, done on commission for Daniel Rawlinson of the Mitre Tavern, Fenchurch Street, London, and now in the Bodleian Library, Oxford, portrays the artist holding a drawing (E. Waterhouse, *Painting in Britain 1530 to 1790*, 3rd ed., Harmondsworth, 1969, p. 89, pl. 69); the other, omitting this detail, is now in Queen's College, Oxford. The present drawing, which appears to have been cut down, is confined to the head and shoulders within an oval, but relates to the portrait in the Bodleian Library. Although Woodward regarded the drawing as a preparatory study for the latter, the technique of elaborately hatched shading might suggest that it was done as a reduced version of the subject in preparation for a print. (It was later engraved by T. Chambers for Horace Walpole's *Anecdotes of Painting*, III, 4th ed., London, 1763, p. 4.) Similar precision and elaboration can be seen, for example, in Fuller's copy after part of Michelangelo's *Last Judgment*, in the British Museum (ECM & PH 2).

HOLLAR, Wenceslaus
Prague 1607 – London 1677

Hollar's father was a Bohemian official in the service of Rudolf II. Despite parental opposition, he was apparently attracted to miniature painting and illumination from an early age and may have been a pupil of the Flemish artist Aegidius Sadeler, engraver to the imperial court, who could have encouraged him to take up etching. His earliest etching dates from 1625. Two years later, probably for religious reasons, Hollar left Prague and went to Germany: dated drawings suggest that he worked in Stuttgart in 1627–8. In 1629 he was in Strasbourg, where he worked largely on commission for the print publisher Jacob van der Heyden. He travelled down the Rhine to Cologne late in 1629 or early in the following year. It is now thought that Hollar's stay in Frankfurt at the workshop of the Swiss engraver and publisher Matthäus Merian probably took place in 1631–2 rather than 1627–8 as was previously believed, but this dating is still unresolved. From 1632 until 1636 he was based in Cologne, where he was employed by the publishers Abraham Hogenberg and Gerhardt Altzenbach, and made a tour of the Netherlands in 1634. In 1636 the Earl of Arundel, passing through Cologne, attached Hollar to his suite on his embassy to the imperial court in Prague via Regensburg and Vienna. Hollar returned to London with Arundel at the end of the year, and was employed at Arundel House reproducing works of art in the Earl's collection. He also worked for the royal family and made some prints after portraits by Van Dyck (q.v.). About 1640 he became 'serviteur domestique' to the Duke of York, later James II, and in 1641 married a lady-in-waiting to the Countess of Arundel. Because of his royalist connections he was forced to go into exile in Antwerp in 1644, where he was obliged to work for various local publishers. In 1652 he returned to London, where he lived for a time with William Faithorne (q.v.), but suffered from a lack of patronage. Following the Restoration, however, he was eventually appointed the 'King's scenographer or designer of Prospects' in 1666. Hollar's most important project at this time was a 5 ft by 10 ft map of London with a perspective delineation of the buildings, but the Great Fire of 1666 rendered his surveys and drawings obsolete. Three years later he accompanied Lord Henry Howard on his expedition to Tangier, where he made drawings of the English settlement and its fortifications. Apart from this commission, he depended almost entirely on book illustration.

Hollar was a prolific draughtsman and his etched oeuvre amounts to nearly 2,800 plates illustrating a very wide range of subject-matter, but despite his remarkable output he died in poverty. His influence in England was particularly notable in the development of topographical art during the later part of the seventeenth century and the early years of the eighteenth: Francis Place (q.v.) is the best-known native artist directly influenced by Hollar.

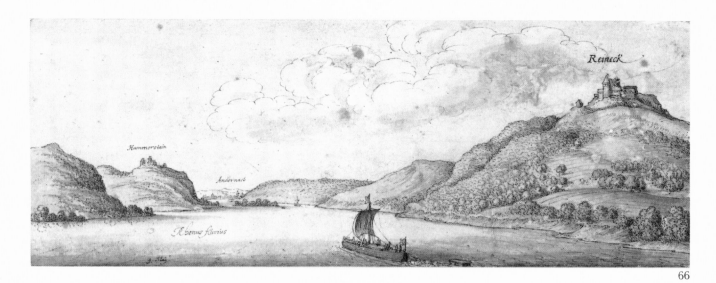

66

66 View of Rheineck and the Rhine

Pen and black ink with blue-grey wash, touched with red on the flags of the barge; 106 × 276 mm (4⅛ × 10⅞ in)

Inscribed by the artist on the three landmarks: *Reineck, Hammerstein* and *Andernach*, and on the river, *Rhenus fluvius*, and dated lower left: *9: Maij* [1636]

PROVENANCE: Bequeathed by the Rev. C. M. Cracherode, 1799

LITERATURE: Sprinzels 187 and 167; ECM & PH 23; *Wenzel Hollar: Reisebilder vom Rhein*, exh. cat., Landesmuseum, Mainz, 1987, no. 21

The British Museum (G.g.2-247)

In 1636 Hollar was commissioned by the Earl of Arundel to join his suite en route for the imperial court in Vienna, and to make a series of views recording the journey up the Rhine and Danube. In May of the same year, Arundel refers to the artist 'w^th me who drawes and eches Printes in stronge water quickely, and w^th a pretty spirit' (M. Hervey, *Thomas Howard, Earl of Arundel*, Cambridge, 1921, p. 366). Hollar produced a large number of views, for the most part in the same medium (see no. 67). This one, looking up the River Rhine, shows Arundel's barge, flying the cross of St George, in the centre foreground. He also made an etching of the Rhine near Rheineck, but seen from further downstream (P 743).

67 View of Eltville on the Rhine

Pen and brown ink with watercolour over traces of black chalk; 167 × 307 mm (6⁹⁄₁₆ × 12⅛ in)

Dated by the artist lower right: *163*[.], and inscribed by him top left: *Eltveldt im Ringauss*, and lower left: *Renus Fl.*

PROVENANCE: F. Springell (sale, Sotheby, 30 June 1986, lot 7)

LITERATURE: F. Springell, *Connoisseur and Diplomat: the Earl of Arundel's embassy to Germany in 1636*, London, 1963, no. XXXII

Yale Center for British Art, Paul Mellon Fund (B1986.26)

One of the drawings made by the artist on his journey to Vienna (see no. 66). The Earl of Arundel's party passed through Eltville on 2 May 1636. Another similar view of the town, extended on the right, is in the Kupferstichkabinett, Berlin (inv. no. 3148). Their finished character makes it unlikely that either drawing was executed on the spot; presumably the artist based his view on a now lost sketch, as seems to have been the procedure for the other drawings recording the journey.

68 View of the east part of Southwark, looking towards Greenwich

Pen and brown and black ink over black chalk; 140 × 308 mm (5½ × 12⅛ in), with an additional strip on the right added by the artist

Inscribed upper centre: *East part of South/wark toward* [crossed out] *Grinwich*

PROVENANCE: J. A. Williams; Patrick Allan Fraser (sale, Sotheby, 10 June 1931, presumably lot 147); Iolo Williams

LITERATURE: I. Williams, 'Hollar: a Discovery', *Connoisseur*, XCII (1933), pp. 318–21; Sprinzels 335; White (1977) 2

Yale Center for British Art, Paul Mellon Collection (B1977.14.4664)

A map of Thames Street and its surroundings, drawn in pencil on the verso and described by Sprinzels, is no longer visible.

The eastern part of Southwark and Bermondsey is seen from the south, with the church of St Olave, Tooley Street, on the left; on the upper left, the Thames bends downstream towards Greenwich, with the Tower of London lightly drawn in pencil on the far shore. The fourteenth-century church of St Olave, seen here, was later replaced by another church. This drawing is one of two known working studies for the seven plates which make up the *Long Bird's Eye View of London from Bankside*, and was used for the right-hand side of the composition, sheets 6 and 7

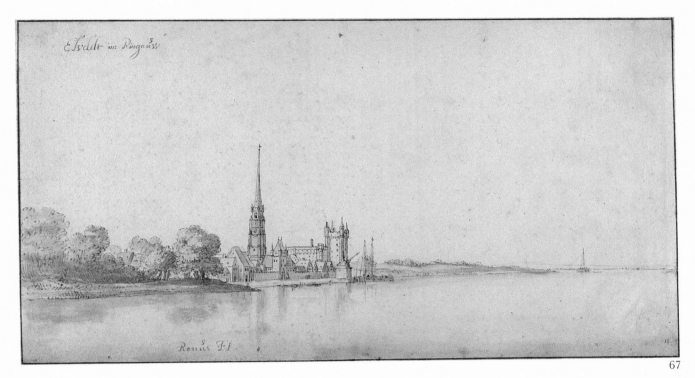

67

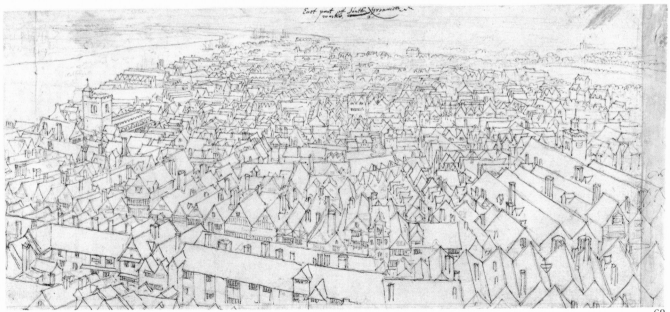

68

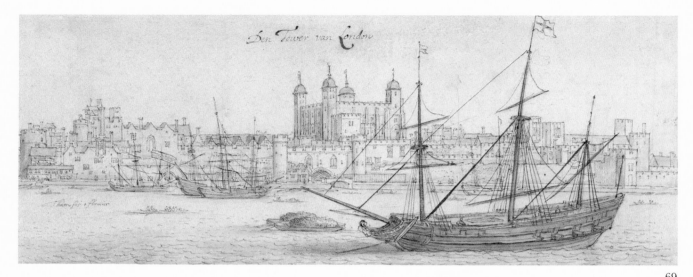

69

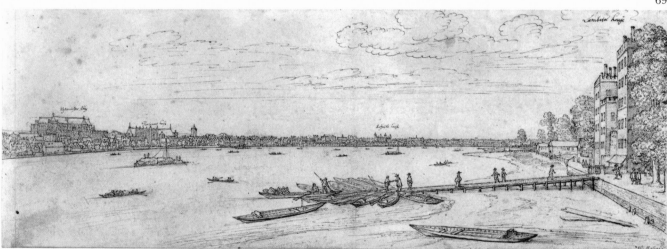

70

(Hind (1922), pls xv and xx). The other study, which shows the view on the other side of London Bridge, looking towards Westminster, is also in the Yale Center for British Art (J. Baskett and D. Snelgrove, *Drawings and the Watercolours from the Paul Mellon Collection*, Pierpont Morgan Library, New York, 1971/2, no. 4). In both drawings the north bank is drawn only in pencil, whereas the south bank has been worked over with pen and ink. Although the map was etched in Antwerp in 1647, the drawings must have been made some time between 1636 and 1644, possibly, as Hind suggests, from the tower of St Mary Overy, Southwark. They can only have served the artist as a general guide, since apart from the variation in detail, the viewpoints of the print and the drawings are different: the drawings were taken from a point farther north, nearer the river.

The present study and its companion differ from the artist's usual neatly executed pen drawings, and are relatively rare examples in the artist's oeuvre of freely drawn working studies.

69 View of the Tower of London seen from the Thames

Pen and brown ink with watercolour over black lead; 111 × 283 mm (4⅜ × 11⅛ in)

Inscribed by the artist upper centre: *Den Tower van London*, and on the river: *Thamesis fluvius*

PROVENANCE: Colnaghi

LITERATURE: Hind (1922) 22; Sprinzels 340; ECM & PH 4; Griffiths and Kesnerová 97

The British Museum (1859-8-6-389)

The view looks north-east across the river; the Traitors' Gate can be seen in the centre, with the White Tower beyond. In the foreground is a three-masted ship flying St George's flag, which was customary for merchant ships. The drawing was executed during the artist's first period in England and was presumably taken with him to Antwerp in 1644, where it was used as the basis of an

etching, published in 1647 as one of four views of London (P 908). The lettering in English on the etchings suggests that they were intended for the English rather than the Netherlandish market.

70 View of Westminster and the Thames from Lambeth House

Pen and brown ink over black lead; 151 × 401 mm (6 × 15¾ in)

Signed lower right corner, *W: Hollar, Dᵉ*[. . .], and inscribed by the artist above the appropriate buildings, *Westminster Abby, Parlament house* [i.e. St Stephen's Chapel], *Suffolke house, Lambeth house*

PROVENANCE: Messrs Hogarth

LITERATURE: Hind (1922), p. 21; Sprinzels 328 and 298; ECM & PH 5; Griffiths and Kesnerová 109

The British Museum (1882-8-12-224)

This view, which looks north and down river, was taken from near Lambeth Stairs, which can be seen in the right foreground with a number of moored wherries. It can be compared with the left half of the *Prospect of London and Westminster* (Hind (1922) 18), and was probably drawn during the same period as no. 69.

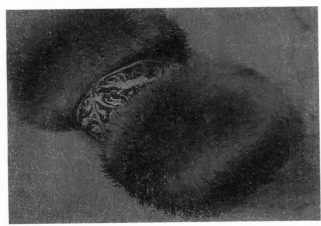

71

Wenceslaus Hollar:
Muffs.
Etching, 1647 (P1951)

71 A muff

Brush drawing in black wash on a grey prepared ground, heightened with white; 69 × 96 mm (2¾ × 3¾ in)

Verso: Part of a study of Niobe

Red chalk, strengthened with pen and ink

PROVENANCE: Bequeathed by Sir Hans Sloane, 1753

LITERATURE: Sprinzels 21; ECM & PH 47; Griffiths and Kesnerová 87

The British Museum (5214-7)

Among Hollar's most celebrated works are his etchings of muffs, which are extraordinary for the almost fetishistic delight with which he seems to have made them. This is the only known drawing by Hollar of a muff, and is a study for one of the etchings published in Antwerp in 1647, P 1946; the same muff also appears in two other etchings of groups of muffs, P 1950, published in 1645, and P 1951 (below), published in 1647.

72 'Prospect of Tangier from the Sea'

Pen and brown ink with grey wash and watercolour, on five conjoined pieces of paper; 213 × 907 mm (8⅜ × 35¾ in)

Inscribed by the artist: *Prospect of TANGIER from the Sea it being the North side, opposite to Spaine, 1669, by W. Hollar.* Various landmarks are identified. Signed: *W. Hollar fecit*

PROVENANCE: Bequeathed by Sir Hans Sloane, 1753

LITERATURE: ECM & PH 35; Griffiths and Kesnerová 117

The British Museum (5214-18)

73 'A Prospect of the Lands and Forts . . . before Tangier drawne from Peterborow Tower'

Pen and brown ink with watercolour, on nine conjoined pieces of paper; 281 × 1022 mm (11¹⁄₁₆ × 40¼ in)

Inscribed by the artist: *A Prospect of the Lands and Forts, within yᵉ Line of Communication before Tangier, now in the Possession of the English, drawne from Peterborow Tower, by Wenceslaus Hollar, his Majᵗⁱᵉˢ. designer, in September Aᵒ. 1669.* Various landmarks are identified

PROVENANCE: Bequeathed by Sir Hans Sloane, 1753

LITERATURE: ECM & PH 31; Griffiths and Kesnerová 121; Stainton (1985) 2

The British Museum (5214-20)

Tangier, part of the dowry of Charles II's queen, Catherine of Braganza, became a British possession in 1661, but was to be an almost constant source of problems. As Pepys, who was Treasurer of the Tangier Committee, noted in May 1667 when it was proposed to send an expedition to reorganise the garrison, 'I think [it] will signify as much good as everything else that hath been done about the place; which is, none at all'. In 1669 Lord Howard (grandson of Hollar's first English patron, Lord

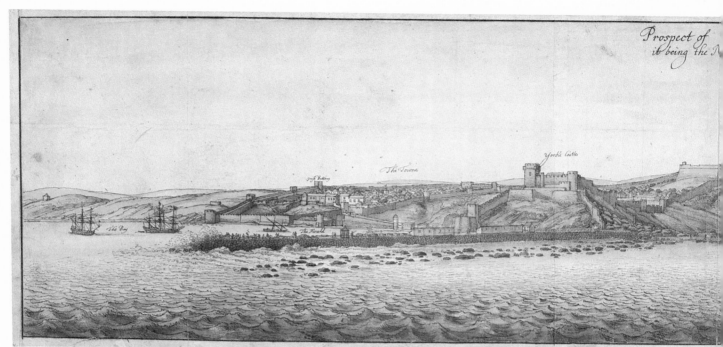

Prospect of it being the N

Yorke Castle

The Towers

South Battery

The Bay

The Mould

72

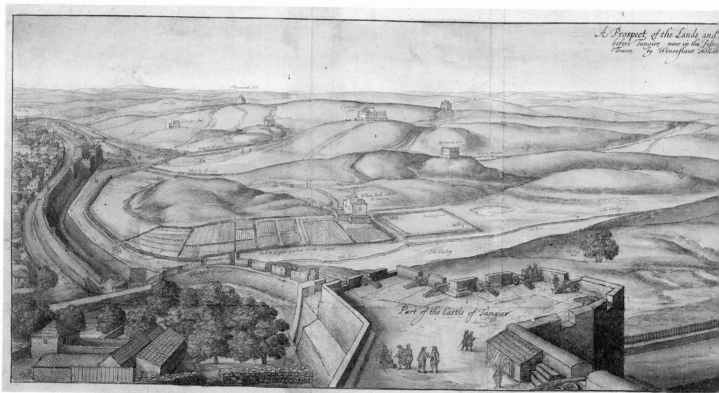

A Prospect of the Lands and
before Tangier, now in the Posse
Tower. By Wenceslaus Hollar

Part of the Castle of Tangier

73

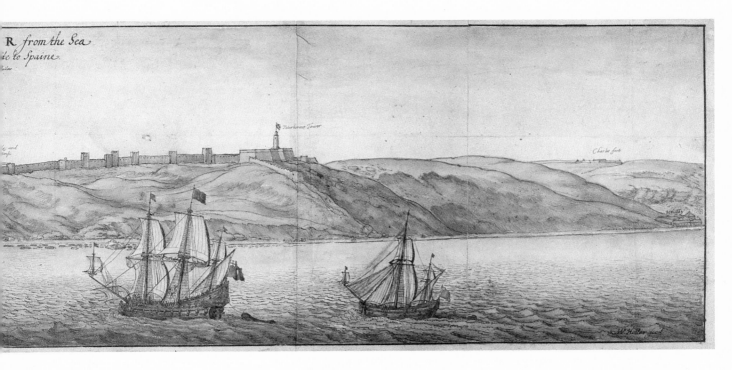

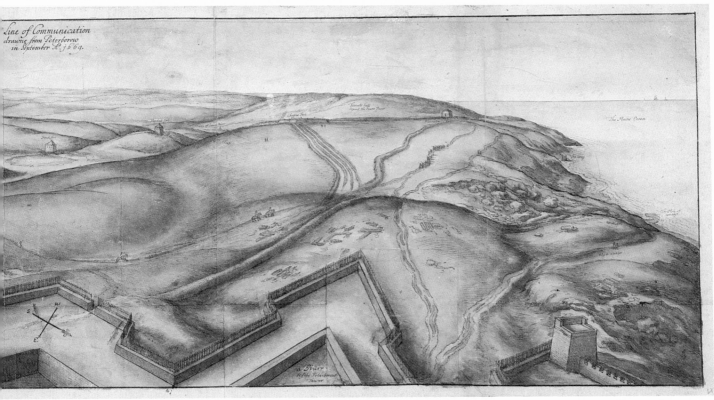

Arundel) was sent on a special embassy to the Moorish court in order to negotiate a treaty allowing Tangier free trade as well as access to the interior of Morocco for the settlement's merchants. In March 1668/9 Hollar petitioned the King to be allowed to accompany Howard, with the intention of making an accurate survey of the settlement, for which he asked to be paid £100 (see R. Pennington, *A Descriptive Catalogue of the Etched Work of Wenceslaus Hollar 1607–1677*, Cambridge, 1982, p. xlvi). The expedition arrived in Tangier in August 1669 and returned to England in December 1670, the embassy having proved a failure (see E. M. G. Routh, *Tangier: England's Lost Atlantic Outpost 1661–1684*, London, 1912, pp. 99–112). About thirty panoramic views by Hollar survive (fourteen of which are in the British Museum), which include both preliminary studies and finished watercolours: the series shows a skilful combination of the elements of military topography and pictorial landscape. After his return to England, Hollar etched fifteen views, twelve of which seem to have been published by John Overton as a set in 1673, *Divers prospects in and about Tangier*.

As can be seen from Hollar's inscriptions, the forts that defended the settlement were given incongruously English names, including Whitby, Kendal, Norwood and Monmouth, and there was a White Hall Fort and tavern, a bowling green and an English-looking kitchen garden. All were to be destroyed when the city was abandoned by the English in 1683–4. Both the drawings shown here are finished watercolours: a preliminary study for no. 67 is also in the British Museum (1932-11-3-4).

COOPER, Samuel

London 1608? – London 1672

Cooper was the greatest English miniature painter after Nicholas Hilliard (q.v.) and one of the most considerable artists working in England during the seventeenth century. He and his brother Alexander (1609?–1660?, also a miniature painter, who spent most of his career on the Continent) were orphaned when he was about sixteen, and they were then brought up and trained by their maternal uncle, the miniature painter John Hoskins (*c*.1590–1664/5). The earliest reference to Cooper is in a notebook kept by the physician and chemist Sir Theodore Turquet de Mayerne (see no. 29), in which he recorded meeting the young artist at Hoskins's house in February 1633/4: Cooper wrote down his methods of preparing various colours and gave him 'tout le secret de lenluminateur'. Cooper helped his uncle with his many miniature copies after Van Dyck (q.v.), 'which', says Buckeridge, 'made him imitate his style': it is significant that the earliest known signed work by him, of about 1637, is a miniature portrait of Van Dyck's mistress, Margaret Lemon (Institut Néerlandais, Paris). Cooper rapidly developed his own distinctive style, a vigorous and naturalistic manner which marked a significant break with the

minutely stippled technique of Isaac Oliver (q.v.), Hilliard and Hoskins. The exact date at which he set up on his own is uncertain, but he seems to have been independently established and probably married (his wife Christiana was the aunt of the poet Alexander Pope) by 1642, and from this year until his death there is a sequence of signed and dated works. He may have travelled abroad before the Civil War, but there is no firm evidence for this. What is certain, however, is his early and rapid success. By 1650 or earlier, Cooper was painting miniatures for Cromwell and his family, and was so much in demand that it was often difficult for clients to obtain sittings. His unfinished sketch of Cromwell (in the collection of the Duke of Buccleuch), one of his most powerful images, was the source for numerous finished versions and copies, perhaps including Lely's famous portrait (Birmingham City Art Gallery).

In the period following the Restoration of Charles II in 1660, Cooper enjoyed a considerable reputation and was appointed King's Limner in 1663, when he was receiving a salary of £200 per annum (the same as Lely, the King's Principal Painter). Both Samuel Pepys and John Aubrey praised Cooper's work in the highest terms. To Aubrey he was the 'prince of limners of his age', while Pepys noted in March 1668 that his 'painting is so extraordinary, as I do never expect to see the like again', and commissioned a portrait of his wife. His diary notes the progress of her sittings (Cooper usually required at least eight) and the price, £30: Cooper seems to have commanded as much as leading oil painters of the day. His reputation was equally high abroad, and in 1669 the Grand Duke Cosimo III of Tuscany sat to him during his stay in London, since, as he was told, 'no person of quality visits that city without endeavouring to obtain some of his performances to take out of the kingdom'; he described Cooper as 'a tiny man, all wit and courtesy, as well housed as Lely' (Cooper's large-scale miniature of the Grand Duke, which cost £150, is in the Uffizi, Florence). Even after Cooper's death, the Grand Duke was anxious to acquire the finest possible examples of his work (see no. 79). Among Cooper's most memorable portraits of the 1660s are those of Charles II himself (notably that in the Goodwood collection) and members of the court.

Although only a handful of drawings by Cooper are now known, he seems from Edward Norgate's *Miniatura* (*c*.1650) to have enjoyed a high reputation as a draughtsman. He was also an accomplished lute-player and a good linguist. His memorial inscription in Old St Pancras Church describes him as 'Angliae Apelles'.

74 Thomas Alcock

Black chalk heightened with white on buff paper (perhaps originally white?); 177 × 113 mm (7 × 4⁷⁄₁₆ in)

Inscribed by the sitter on the original backboard: *This Picture / was drawne / for mee / at the Earle of West / morlands house / at Apethorpe, in Northamptonshire / by the Greate, (tho' little) / Limner, the then famous / Mr. Cooper of Covent Garden: when I was / eighteen years of age / Thomas Alcock / preceptor*

PROVENANCE: Dr Richard Rawlinson, by whom bequeathed to the Bodleian Library, 1755; transferred to the Ashmolean Museum in 1897

LITERATURE: Brown (1982) 115; Brown (1983) 7

The Ashmolean Museum, Oxford

Of Samuel Cooper's few surviving portrait drawings, this is both the best known and the most beautiful. Vertue recorded that he saw the drawing at Dr Rawlinson's house in 1749 (v, p. 76). Nothing is known about the sitter apart from the details recorded in his own inscription, which notes that at the time he sat to Cooper he was a young tutor in the household of Mildmay Fane, 2nd Earl of Westmorland. Mary Edmond (see Brown (1982) 115) has found the will, dated 23 November 1699, of a Thomas

Alcock of the parish of St Margaret's, Westminster, who may or may not have been the subject of this study. The dress and hairstyle of the sitter suggest an early date in Cooper's career, perhaps in the 1640s.

75 Mrs John Hoskins

Black chalk on paper probably originally prepared with an indigo wash, of which faint traces remain; 179 × 134 mm (7¹⁄₁₆ × 5¼ in)

Signed: *SC* (in monogram) and inscribed *SC*; inscribed on the verso: *Mrs Hoskins sr: SC* (in monogram)

PROVENANCE: Mrs S. Cooper?; R. Gibson?; his widow, Mrs Gibson?; W. Towers (d. 1693)?; by descent in the Tower family

LITERATURE: *The Age of Charles II*, exh. cat., Royal Academy, London, 1960, no. 516; Millar (1972) 228; Foskett (1974a), p. 86; Foskett (1974b) 136; Edmond (1980), pp. 110, 114

Private Collection

76 Mrs John Hoskins

Black chalk on paper prepared with an ochre ground; 192 × 145 mm (7⁹⁄₁₆ × 5¾ in)

PROVENANCE: As no. 75

LITERATURE: *The Age of Charles II*, exh. cat., Royal Academy, London, 1960, no. 508; Foskett (1974a), p. 86; Foskett (1974b) 139; Edmond (1980), pp. 110, 114

Private Collection

The identification of the sitter in both of these drawings as the artist's aunt, Mrs Hoskins, is based on the inscription on the reverse of no. 75. She was the wife of John Hoskins the Elder (1595?–1665), the portrait miniaturist, who seems to have been married twice. These drawings are probably of his putative first wife, the mother of John Hoskins the Younger, born about 1630 (see no. 80v). She was portrayed by her husband in a miniature, now in the Royal Collection, which has been dated about 1645 by Mrs Foskett: both in the miniature and in these two drawings by Cooper she wears a French hood or *chaperon* which first became popular in England in the 1640s. The fact that she looks several years younger in the miniature suggests that the drawings were made about 1650. Neither her christian name nor her date of birth are known, but she probably died in the early 1650s, soon after these likenesses were drawn, as her husband had a daughter, Christiana, in 1654; by this time she would have been past childbearing age and the child's mother would therefore have been his second wife, named Sarah, who survived him, dying on 19 February 1668/9 (see Edmond, op. cit.).

Both of these portrait studies (see also no. 80r) were drawn on paper prepared with a coloured wash, which can still be clearly observed in no. 80r, although the original indigo colour used in no. 75 has now almost entirely disappeared through fading: traces of colour can just be made out along the margins of the paper. The technique used in these drawings accords with the de-

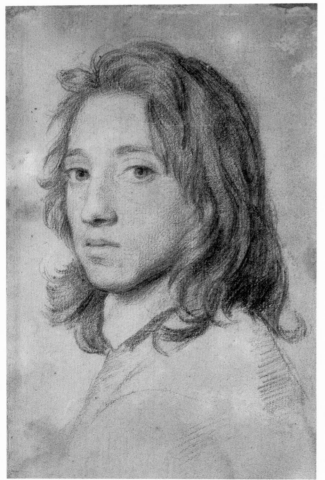

74

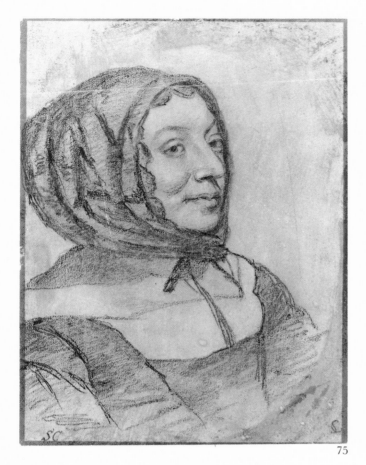

75

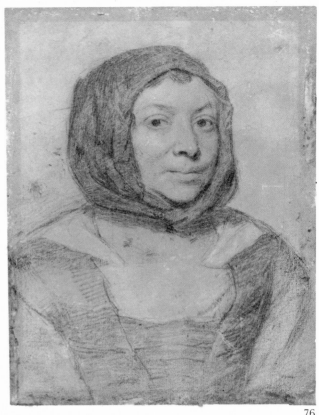

76

scription given by Edward Norgate in his *Miniatura or the Art of Limning*, written about 1648–50, which includes one of the earliest references to the artist: 'The very worthy and generous Mr. Samuel Cooper, whose rare pencill, though it equall if not exceed the very best of Europe, yet it is a measuring cast whether in this [i.e. crayon] he doe not exceed himselfe . . . Those [crayon drawings] made by the Gentile Mr Samuel Cooper with a white and black Chalke upon a Coloured paper are for likenes, neatnes and roundnes *abastanza da fare stupire e marvigliare ogni acutissimo ingegno.*'

77 King Charles II

Red and black chalks on brown paper; 175 × 140 mm (6⅞ × 5½ in)

PROVENANCE: Jonathan Richardson (father and son, L 2184 and L 2170); George, Prince of Wales; King George III and by descent

LITERATURE: See below

Lent by gracious permission of Her Majesty The Queen

78 King Charles II

Red and black chalks, heightened with white; 124 × 117 mm (4⅞ × 4⅝ in)

PROVENANCE: Bears a mark in ink, L 1753, regarded as a variant of Sir Peter Lely's, and another also in ink, an italic *W* or *JW* unknown to Lugt

LITERATURE: Oppé 133–4; Foskett (1974a), p. 87; Foskett (1974b) 140

Lent by gracious permission of Her Majesty The Queen

A note written by Jonathan Richardson the Younger, attached to the reverse of the mount of no. 77, reads: 'This Drawing is the portrait of K.Charles II for his Inauguration Medal; & for which he sate (as I have heard my Father say) the very same day that He made his Publick Entry, through London; to Loose no time in making the Dye.' This reference has usually been taken to mean John Roettier's medal, inscribed FELICITAS BRITANNIAE, commemorating the arrival of the King on 29 May 1660. However, Mark Jones (Department of Coins and Medals, British Museum) has pointed out that this medal was probably struck abroad. The portrait of the King is considerably idealised and bears little resemblance to Cooper's undoubted *ad vivum* study. It is more likely that

Richardson the Elder was referring to Charles II's coronation (i.e. 'inauguration') medal by Thomas Simon, but there is no documentary evidence that Samuel Cooper was involved in taking the King's likeness for this purpose.

In his diary for 10 January 1662, John Evelyn described how he was 'call'd into his Ma^tys closet when Mr Cooper, ye rare limner, was crayoning of the King's face and head, to make the stamps for the new mill'd money now contriving, I had the honour to hold the candle whilst it was doing, he choosing the night and candle-light for ye better finding out the shadows'. This account fits well with the strongly modelled character of no. 77, which does appear to have been done by candlelight. Also in favour of the identification of this drawing with the work described by Evelyn is the existence of the second drawing, no. 78, which seems to be an exact copy of it. Two versions of the

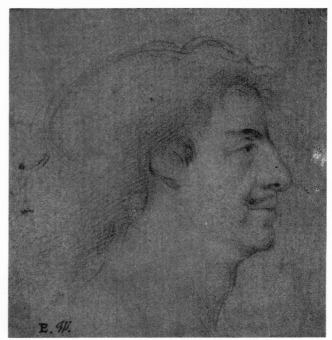

77

King's portrait would have been required for the 'contest in art' (see Sir John Craig, *The Mint*, Cambridge, 1953, p. 159) which took place between Thomas Simon and John Roettier early in 1662 and involved the production of competing patterns for the new milled coinage. The fact that Roettier's proof image of 1662 for the five-guinea piece (below left; Department of Coins and Medals, British Museum) looks closer to this drawing than does his FELICITAS BRITANNIAE medal suggests that he may have seen Cooper's likeness of the King.

No. 77 also bears a label noting that it was given to George III on 29 May (conceivably in 1810, the sesquicentenary of the Restoration) by 'his dutiful Son George P', later George IV.

79 George Monck (1608–1670), 1st Duke of Albemarle

Watercolour on vellum; 124 × 98 mm (4⅞ × 3⅞ in)

PROVENANCE Mentioned in a list of works belonging to Mrs Samuel Cooper in 1677; perhaps bought from her by Charles II; in Queen Caroline's collection, St James's Palace, 1743

LITERATURE: A. M. Crinò, 'The Relations between Samuel Cooper and the Court of Cosmo III', *Burl. Mag.*, XCIX (1957), pp. 16–21; Foskett (1974a), pp. 59–67; Foskett (1974b) 80; J. Murdoch, J. Murrell, P. Noon and R. Strong, *The English Miniature*, New Haven and London, 1981, p. 117

Lent by gracious permission of Her Majesty The Queen

One of five extant unfinished large-scale sketches in the Royal Collection which Cooper seems to have made as models from which he could subsequently paint finished versions: they seem, like his famous unfinished portrait of

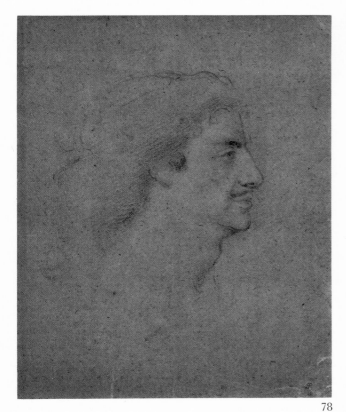

78

John Roettier:
Proof image for a
five-guinea piece of
Charles II, 1662.
The British Museum

Cromwell (in the collection of the Duke of Buccleuch), to have been painted *ad vivum*. Cooper's style in such sketches is particularly bold, and apparently impressed Cosimo III, Grand Duke of Tuscany, when he visited the artist's studio in order to have his likeness taken during his visit to London in 1669 (the portrait is now in the Uffizi, Florence). After Cooper's death, Cosimo III attempted to buy, through his London agent Francesco Terriesi, examples of Cooper's miniatures, recalling in 1674 some of the works he had seen, including one of '[il] Vecchio Generale Monk Padre del vivente Duca d'Albemarle . . . per che ho memoria che fussero condotti con molto spirito, e felicità'. Negotiations lapsed, but in February 1676/7 Cosimo III again hoped to buy a number of miniatures offered for sale by Mrs Cooper at £50 each (instead of £100, as she had originally asked), including one of General Monck. This was of particular interest to him, especially if the head was well finished, but if only sketched 'non me ne curo', and if those he was interested in were not available at the reduced price he would not have them at all. As late as 1683 Cosimo III was still in correspondence with Terriesi about a possible sale, but in the end 'unless His Highness by express command renews the commission' the idea of acquiring a large group was abandoned.

Exactly how and when the five sketches entered the Royal Collection is uncertain. The year after Samuel Cooper's death Charles II agreed to pay his widow an annuity of £200, on condition that she let him have 'several pictures or pieces of limning of a very considerable value'. No list is known, and within two years the pension was already in arrears, but it has usually been assumed that this sketch (and the four other comparable examples) were acquired by Charles II from Mrs Cooper. If, however, these are the miniatures whose sale she was negotiating with Cosimo III, they would not have entered the Royal Collection until the last years of Charles II's reign. No miniatures by Cooper were noted in the Royal Collection (with the exception of a similarly unfinished portrait of Thomas Hobbes which belonged to James II) until Vertue compiled a catalogue of Queen Caroline's collection in 1743.

Monck, a cautious royalist, had served in Charles I's army during the early stages of the Civil War, but was later to serve under Cromwell as Commander-in-Chief in Scotland. After Cromwell's death, he exercised his influence to secure the return of Charles II, determined to save the country from 'the intolerable slavery of a sword government'.

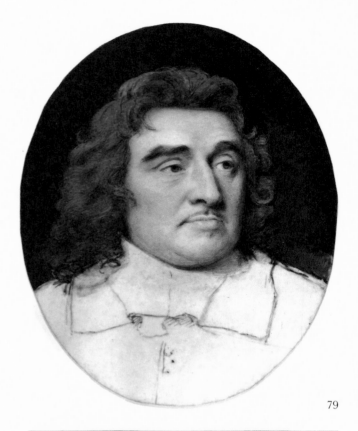

79

80v

80r

80 A dead baby

Black chalk and black lead, heightened with white and touches of black and grey wash, on paper prepared with an orange-pink wash; 148 × 186 mm ($5^{13}/_{16}$ × $7^{5}/_{16}$ in)

Verso: John Hoskins the Younger (?)

Black and red chalk, strengthened with black lead, the composition trimmed at the top; 186 × 148 mm ($7^{5}/_{16}$ × $5^{13}/_{16}$ in)

Inscribed on the verso: *Dead: child Mr S.C: child done by him NB ye son of old Mr Hoskins' Son*

PROVENANCE: Mrs S. Cooper?; R. Gibson?; his widow, Mrs Gibson?; W. Towers (d.1693)?; by descent in the Tower family

LITERATURE: *The Age of Charles II*, exh. cat., Royal Academy, London, 1960, no. 514; Millar (1972) 227; Foskett (1974a), p. 86; Foskett (1974b) 137–8; Edmond (1980), pp. 109–10, 115

Private Collection

This sheet and the two drawings of Mrs Hoskins (nos 75–6) have probably been in the same collection since the late seventeenth century. Mary Edmond (op. cit) has recently suggested that they may have been bought from Samuel Cooper's widow by the artist Richard Gibson, whose friend William Towers (d.1693) could have acquired them from Mrs Gibson. This idea is supported by the fact that the same collection, which has descended in the Tower family, also includes a number of drawings by Richard Gibson and his daughter, Susanna Penelope Rosse.

This double-sided sheet poses a number of problems. The inscription on the verso, which refers to the drawing on the recto and which Mary Edmond believes may be in the hand of Richard Gibson, has been variously interpreted. Sir Oliver Millar (op. cit) thought that the child might have been Samuel Cooper's, but he and his wife Christiana appear to have had no children. The syntax of the inscription suggests that the child was drawn by Cooper and was the grandson of John Hoskins the Elder. Mary Edmond has established that Hoskins the Younger was married to Grace Beaumont on 7 February 1669/70, and it is probable that the drawing is of their first-born

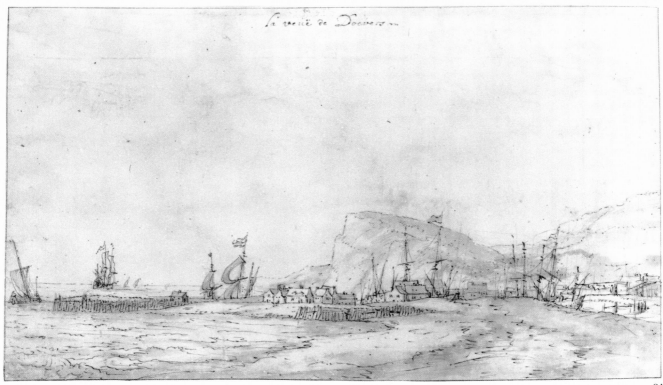

81

son, who must have died before Cooper's own death in May 1672. Drawn in a technique characteristic of a miniaturist, with the most delicate use of cross-hatching to model the baby's features and the shadows cast on his forehead by the scalloped edge of the cap, it is undeniably the most poignant of Cooper's works.

The drawing on the verso, which has been trimmed at the top, suggesting that it predates the recto, has been tentatively identified as John Hoskins the Younger (d. after 1693). His date of birth is unknown, and his career is obscure. He seems to have followed his father's calling as a miniature painter, but few works have been securely attributed to him. A miniature in the Buccleuch collection, signed and dated 1656, is inscribed *Ipse*, indicating that it was a self-portrait, but although the features are not inconsistent with those in the present drawing, the comparison is not entirely conclusive. In his diary Samuel Pepys describes a dinner party he gave in July 1668, his guests being 'Mr. Cooper, Hales [John Hayls, d.1669, painter], Harris [Henry Harris, actor], Mr. Butler that wrote *Hudibras* [Samuel Butler, 1612–80], and Mr. Cooper's cousin Jacke . . . a good dinner, and company that pleased me mightily – being all eminent men in their way.'

Drawn in broadly handled red and black chalk, the technique of the drawing on the verso is very different from the minute execution of the recto. The chiaroscuro in the face of the man suggests that, like the profile drawing of King Charles II (no. 77), this study may have been made by candlelight.

PEETERS the Elder, Bonaventura
Antwerp 1614 – Hoboken 1652

A Flemish marine painter, whose work shows the influence of Jan Porcellis (*c*.1584–1632). His master is not known. Both his brothers were painters, and the younger, Jan, who was also his pupil, produced seascapes in the same style. Peeters travelled in the Netherlands and, although there is no evidence that he worked in England, his views of Dover may have been studied from the life. Other English subjects have also been associated with him.

81 View of Dover Harbour

Pen and brown ink with grey and brown wash over black lead; 180 × 306 mm (7⅛ × 12 1/16 in)

Inscribed upper centre in a contemporary hand: *La veue de Doevers*. On the verso, a slight sketch in black lead of cliffs, beach and a town beyond, possibly Dover; inscribed in a later hand: *Bonaventura Peeters*

PROVENANCE: Sutherland

LITERATURE: Brown (1982) 199

The Ashmolean Museum, Oxford

The view is taken from the north-east, with Shakespeare Cliff rising in the background. This and another view of Dover, also bearing Peeters's name, in the same collection

(Brown (1982) 198) are the work of an artist not otherwise recorded in England, but who travelled widely as a marine painter and to whom several other English views have been ascribed. An alternative attribution to Willem Schellinks, who visited Dover in 1662, is unconvincing, since the town seen here is far less developed than it appears in Schellinks's drawing in the Hofbibliothek, Vienna (P. Hulton, 'Drawings of England in the Seventeenth Century by Willem Schellinks, Jacob Esselens and Lambert Doomer, from the Van der Hem Atlas of the National Library, Vienna', *Walpole Society*, XXXV (1954–6), no. 2, illus.) The present view probably records the aspect in the 1640s.

FAITHORNE, William

London 1616? – London 1691

Faithorne's date of birth has been inferred from Buckeridge, who supposed that he was 'near 75' when he died, but if this is so he would have been unusually old when he began his apprenticeship in 1635 to the painter William Peake (*c.*1580–1639; hitherto incorrectly transcribed from the Goldsmiths' Apprentice Register as 'William Veale'). Faithorne later attached himself to his son, Sir Robert Peake (*c.*1605–67), a staunch royalist knighted by Charles I at Oxford in 1645, under whose command Faithorne

served at the siege of Basing House. After the garrison's surrender he was imprisoned and later banished to France, where he secured the patronage of the celebrated collector the Abbé Michel de Marolles, and came into contact with the work of Philippe de Champaigne and Robert Nanteuil (Vertue, I, p. 140, and II, p. 29, states that he studied with them), whose influence, as also that of Claude Mellan, can be seen in his portrait drawings and engravings. He returned to England about 1650 and set up as an engraver, publisher and print-seller (Pepys records buying prints from him and admiring his chalk drawings). Vertue noted that he was 'the first Englishman that arrivd to any perfection [in engraving] especially in heads' (I, p. 130): he also engraved frontispieces, book illustrations and maps. Hollar (q.v.) lodged with him for some time '& did many Plates' (Vertue, I, p. 140). Faithorne's translation of Abraham Bosse's *Traicté des manieres de Graver en taille douce*, published as *The Art of graveing and etching* in 1662, was the first technical account of its kind in England, and he evolved a method of chalk drawing on a copper plate, roughened with a mezzotint rocker, that was also used by Edward Luttrell (q.v.). In about 1680 he gave up print-selling to concentrate on engraving and 'to painting in Craions [coloured chalks] from ye life with good Success' (Vertue, I, p. 140). Faithorne died of a 'lingering consumption', and was buried on 13 May 1691 at St Anne's, Blackfriars.

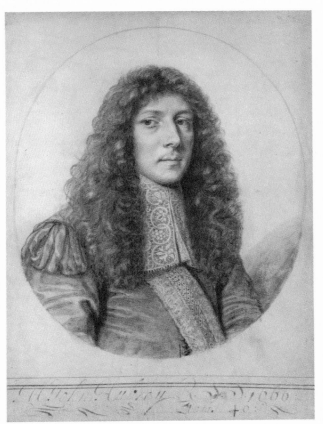

82

82 John Aubrey (1626–1697)

Black lead and wash on vellum, the face tinted with red chalk, retouched in pencil; 196 × 145 mm (7¾ × 5¹¹⁄₁₆ in)

Inscribed: *M. John Aubrey R.S.S. 1666 Aetatis 40*. A label on the back of the original frame, in Aubrey's hand, states: *Effigies Johannis Awbrey de Easton Pierse Guliel: Faythorne Amicitiae ergo adumbravit An. Dni. 1666*

PROVENANCE: John Aubrey; Old Ashmolean Museum, 1689; Bodleian Library, by whose Curators deposited in the Ashmolean, 1904

LITERATURE: Brown (1982) 123; Brown (1983) 14

The Ashmolean Museum, Oxford

John Aubrey, the antiquary and historian of Wiltshire and Surrey, is chiefly celebrated for his *Brief Lives*, a collection of vividly anecdotal biographical sketches. He was a friend of Faithorne, and this portrait was, as the inscription on the original frame records, drawn in 1666 and presented by the artist to the sitter; it was probably among Aubrey's gifts to the Old Ashmolean Museum in 1689. Although it was engraved on several occasions in the eighteenth and nineteenth centuries (notably by M. van der Gucht for the frontispiece to Aubrey's *History of Surrey*, 1719, and by C. E. Wagstaff as the frontispiece to John Britton's *Memoir of John Aubrey F.R.S.*, 1845), Faithorne did not himself etch it. The influence of Robert Nanteuil (1632?–78), the French portrait draughtsman and engraver, whom Faithorne had probably known in Paris during the late 1640s, is apparent in this drawing.

83

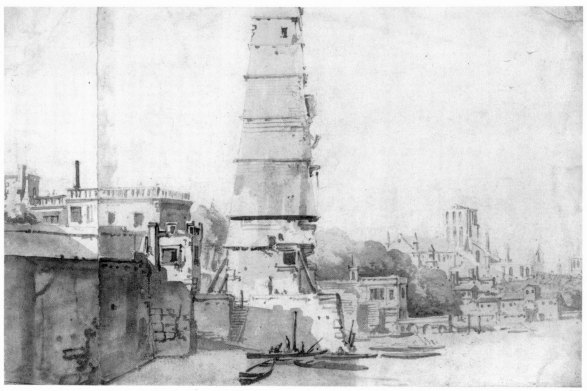

84

WYCK, Thomas

Beverwyck 1616? – Haarlem 1677

A pupil of the Haarlem artist Pieter van Laer (*c*.1592–1642), presumably at some time during the latter's stay in Italy between about 1625 and 1638: nicknamed Bamboccio (because of his deformed body), Van Laer was the principal member of a group of Dutch artists in Rome. Wyck returned to Holland, where he became a member of the Haarlem Guild in 1642 and specialised in painting, drawing and etching Italian scenes, as well as interiors in which philosophers and alchemists brood on their mysteries. Vertue noted that Wyck went to England in 1667/8 (I, p. 106), but in fact he must have been in London by 1665 (see no. 84). He continued to paint in a modified version of Bamboccio's manner, and was one of the Dutch artists employed by the Duke and Duchess of Lauderdale at Ham House. He also acquired some reputation for his views of London: Vertue states that Lord Burlington had a long prospect of London and the Thames taken from Southwark, before the Fire (v, p. 43), and that Wyck also painted views of the city on fire in 1666 (a signed painting is in the collection of the Duke of Beaufort). Vertue noted that 'Old Mr Wyke, in England' was the master of Jan van der Vaart (1653–1727), who probably came to England in 1674; but Wyck must have returned to Holland shortly afterwards, as he died in Haarlem in 1677.

83 A distant view of London from Blackheath

Brush drawing in brown and grey wash over black lead, on two conjoined pieces of paper; 300 × 795 mm (11 13/16 × 31 5/16 in)

Inscribed by the artist above the respective landmarks: *London Westminster den Toor* [?] *paules*

PROVENANCE: Paul Sandby (L 2112; sale, Christie, 17 March 1812, lot 92); presented by G. Mayer, 1897

LITERATURE: ECM & PH 6 (as by Jan Wyck); Stainton (1985) 3

The British Museum (1897-8-31-1)

This drawing was presented to the Museum as by Thomas Wyck, but has more recently been attributed on stylistic grounds to his son Jan (q.v.). However, the presence of Old St Paul's, demolished in 1668 after being damaged in the Great Fire of 1666, makes such an attribution unlikely: Jan Wyck would have been at most sixteen years old. The drawing was engraved by R. B. Godfrey in 1776, but the artist's name was noted only as 'Wyck'.

The sweeping vista of the Thames and London, seen from the top of Croom's Hill, Blackheath, lends itself to treatment in the manner of a Dutch landscape, the broadly handled foreground contrasting with the distance, where buildings are rendered with a few light strokes. The drawing was later in the collection of Paul Sandby (1730/31–1809), who owned, and was clearly influenced by, a large number of landscapes by earlier masters.

84 View of the Waterhouse and Old St Paul's

Black lead and grey wash on two conjoined pieces of paper; 229 × 343 mm (9 × 13½ in)

Inscribed on the verso: *This drawing is by Wyck & represents the Waterhouse & Old St Paul's in the distance*

PROVENANCE: Gardner; Major Sir Edward Feetham Coates; Lady Celia Milnes Coates (sale, Christie, 23 November 1971, lot 137); John Baskett

LITERATURE: White (1977) 5

Yale Center for British Art, Paul Mellon Collection (B1975.4.1446)

This drawing must have been made very shortly after the artist arrived in England in about 1663, since the Waterhouse was demolished in 1665 (to be replaced by another one) and Old St Paul's, which can be seen in the background, was ruined in the Great Fire of 1666. To the right of the Waterhouse is the Watergate at York House, built in 1626 to the design of Nicholas Stone.

Wyck's drawing style here reflects the influence of fellow-countrymen such as Jan Asselyn and Bartholomeus Breenbergh who, like him, had worked in Italy. His treatment of the subject, using soft grey wash to suggest form and the fall of light on buildings, is in extreme contrast to Hollar's linear representation of a similar view (no. 70). Where Hollar's interest is in an accurate representation of what he sees in front of him, Wyck's striking composition is almost an end in itself.

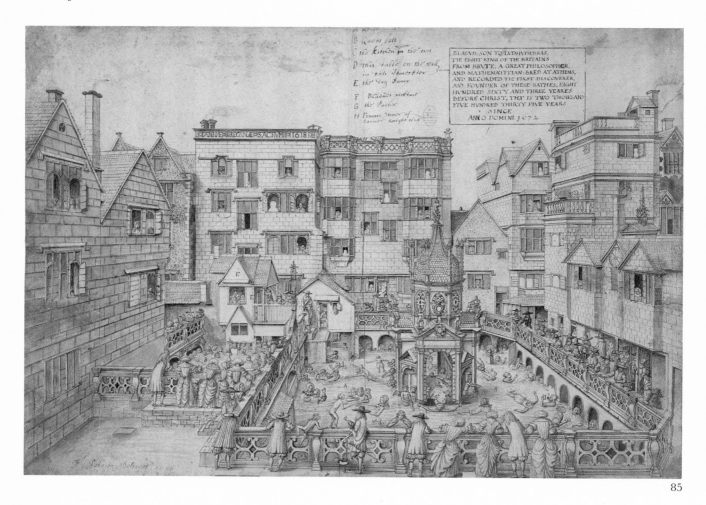

85

JOHNSON, Thomas

*fl.c.*1628 – 1685

Perhaps the Thomas Johnson recorded as living in the parish of St Andrew's, Holborn, between about 1628 and 1642 and who is noted on 15 October 1629 as having been made a freeman of the Painter-Stainers' Company (see Edmond (1980), p. 154). His name occurs frequently in the Company's minutes in the 1640s, where he is referred to as a 'picture-maker', and is last mentioned in 1652, when he was appointed Renter-Warden (a member of the governing body). In the 1650s he was working in Canterbury; views of the city by Johnson were etched by Hollar (q.v.) and Daniel King in Dugdale's *Monasticon* (1655) and King's *Cathedrall and Conventuall Churches* (1656). Johnson is recorded as having painted two religious subjects in 1657–8, but no others are known. He later worked in Bath, where he drew and etched the Baths in 1675–6, but appears to have returned to Canterbury by 1685 when as 'Mr Johnson of Canterbury' he showed members of the Royal Society 'a curious prospect of the Cathedral of that City drawn by himself in oil-colours'.

85 The King's Bath and the Queen's Bath at Bath, looking west

Pen and ink, with grey wash, indented for transfer; 335 × 470 mm (13³⁄₁₆ × 18½ in)

Inscribed by the artist with a key referring to various features of the Baths: *A Kings/B Queens bath/C the Kitchen under the Cros/D this table on the wall in this Charakter –* BLADVD, SON TO LVDHVDE-BRAS,/THE EIGHT KING OF THE BRITAINS/FROM BRUTE, A GREAT PHILOSOPHER,/AND MATHEMATITIAN: BRED AT ATHENS,/AND RE-CORDED THE FIRST DISCOVERER,/AND FOVNDER OF THESE BATHES, EIGHT/HVNDRED SIXTY AND THREE YEARES/BEFORE CHRIST, THAT IS TWO THOWSAND/FIVE HVNDRED THIRTY FIVE YEARS/SINCE/ANNO DOMINI 1672/*E the dry Pump/F Bladuds picture/G the Parlor/H Francis Stoner of/Stoner Knight 1624.* [with an oval shield of arms] and signed *T. Johnson Delineat 1675*

PROVENANCE: Messrs Ellis and White

LITERATURE: ECM & PH I; V. Cumming, *A Visual History of Costume in the Seventeenth Century*, London, 1984, p. 108, no. 115

The British Museum (1881-6-11-85)

The King's Bath, so called since at least the thirteenth century, was the oldest of the baths. The wooden pavilion in the centre, known as the Cross, was erected in 1663/4, replacing an earlier one (to be seen in Willem Schellinks's

drawing of 1662 in the Austrian National Library, Vienna). The recess within it was known as the Kitchen because of the high temperature of the water here, the point at which the hot spring rose. The supposed founder of the bath, Bladud, a mythical ancient British ruler, was commemorated by a statue and by a tablet with an inscription, here transcribed by Johnson, which was erected in 1672. The smaller adjoining New Bath was renamed the Queen's Bath to commemorate the first visit of Anne of Denmark (King James I's consort) in 1613, a date which Johnson erroneously notes as 1618.

Samuel Pepys and his wife visited Bath in June 1668, and his description is a lively visual parallel to Johnson's drawing. On Saturday 13 June he wrote: '... much company came very fine ladies ... only methinks it cannot be clean to go so many bodies together into the same water ... strange to see what women and men herein that live all the season in these waters that cannot but be parboiled and look like the creatures of the Bath'. Pepys had a sharp eye for social distinctions: 'June 15 Up ... to look into the Baths and find the King and Queen's full of a mixed sort of good and bad and the Cross only almost for the gentry'. Johnson's drawing shows lines of spectators watching the bathers and is full of humorous incident, including small boys diving off the balustrade, and a woman with two small children hanging onto her, while another child rides on an adult's back.

DUNSTALL, John

d. London 1693

Probably a native of Sussex: the name is recorded in parish registers at Cowfold and in Chichester between 1564 and 1623, and Dunstall was later to etch five views in the neighbourhood of Chichester. By the early 1660s he was established in the Strand in London, and is described by Vertue as 'a small professor & teacher of drawing'. He published several sets of etchings of natural history subjects, intended as copy-books for aspiring draughtsmen, some of the plates also being used to illustrate his autograph treatise, *The Art of Delineation* (BL Add. MS 5244). Dunstall also etched several portraits, chiefly for book illustrations, and a number of topographical subjects, all of which reflect the influence of Hollar. Only two drawings by him are known, both of which are in the British Museum.

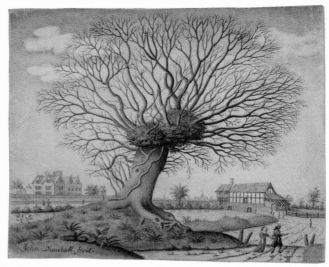

86

86 A pollard oak near West Hampnett Place, Chichester

Watercolour over black lead, touched with white on the figures, on vellum; 134 × 160 mm (5¼ × 6⁵⁄₁₆ in)

Signed: *John Dunstall fecit*

PROVENANCE: Sir Erasmus Philipps, 5th Bart; Richard Philipps, 1st Baron Milford (L 2687); Richard Grant Philipps, 1st Baron Milford of the 2nd creation; by descent in the Philipps family; H. M. Calmann, from whom acquired by the Museum in exchange for duplicate prints

LITERATURE: ECM & PH 2; M. Clarke, *The Tempting Prospect: A Social History of English Watercolours*, London, 1981, pp. 19–20; Stainton (1985) 4

The British Museum (1943-4-10-1)

The locality depicted in this charmingly naïve watercolour is established by the artist's etching of West Hampnett Place, one of a series of five views in the neighbourhood of Chichester (Bodleian Library, Gough Topography 17528, f.1b). Comparison with an eighteenth-century map of West Sussex shows that in order to frame the distant view of Chichester Cathedral more picturesquely, the artist has altered the position of the mill and the stream. West Hampnett Place, a red-brick gabled house of the late sixteenth century, built by Richard Sackville, was greatly altered in later times and destroyed by fire in 1930. The costume of the diminutive figures in the foreground suggests a date of about 1660 for this drawing.

Dunstall's use of opaque watercolour on vellum is an interesting survival of a technique which goes back to manuscript illumination of the medieval period and which continued to be used for drawing maps and semi-cartographical bird's-eye views: as late as 1658 Sir William Sanderson described exactly the same method in his *Graphice*, in the section devoted to limning landscapes.

WRIGHT, John Michael

London 1617 – London 1694

The leading native-born portrait painter of the immediate post-Restoration period, Wright's idiosyncratic style never achieved the popularity of rivals such as Lely (q.v.). According to Buckeridge, he was the son of Scots parents, who must have moved to London, where he was born, but in 1636 he was apprenticed to the portrait painter George Jamesone (1590–1644) in Edinburgh. From about 1642 until 1656 Wright (who was a Catholic) lived in Rome, and probably briefly in France. In 1648 he was elected a member of the Accademia di San Luca, and would have acquired knowledge of contemporary Baroque painting. While in Rome he began to form his own collection of paintings, drawings, prints and medals, and established a reputation as a leading antiquary. He returned to England in 1656, and established himself rapidly, being described by William Sanderson in his *Graphice* (1658) as one of the best artists in the country, and by John Evelyn in 1659 as 'the famous Mr Write'. With the Restoration of Charles II in 1660 Wright must have hoped for considerable patronage from a pro-Catholic king, but although he was commissioned to paint the ceiling of the King's Bedchamber in Whitehall Palace he held no official appointment and seems to have lost the initiative to Lely, who in 1661 was appointed Principal Painter to the King. Wright apparently had more success in attracting patronage among people far from court, who seem to have appreciated his direct but elegant style. In the early 1670s he managed to secure a major commission (possibly previously declined by Lely), painting for the City of London the portraits of those judges who had been responsible for resolving the many property disputes that arose after the Great Fire of 1666. He also painted for the City, probably in about 1676, the vast hieratical portrait of Charles II in his coronation regalia (Royal Collection). On account of the anti-Catholic hysteria aroused by the Popish Plot in the late 1670s Wright temporarily left London. He was in Dublin in 1680, where he painted one of his best-known portraits, that of Sir Neil O'Neil (Tate Gallery, London). Few paintings by Wright can be dated after about 1680: he was by then too old to be able to benefit from the death of Lely in that year. On the accession of the Catholic James II in 1685, Wright (the King apparently having 'a special fondness for him') was appointed steward to the Earl of Castlemaine's embassy to Rome, an unsuccessful attempt to enlist the Pope's support for a religious war against the Dutch. Wright, who wrote a book about the embassy, took no part in the politics of the mission, but designed the magnificent procession that escorted Castlemaine to his audience with the Pope and the banquet that followed. In 1687 James II fled from England, and the last years of Wright's life were spent in poverty. Much of his collection was sold a few months before his death.

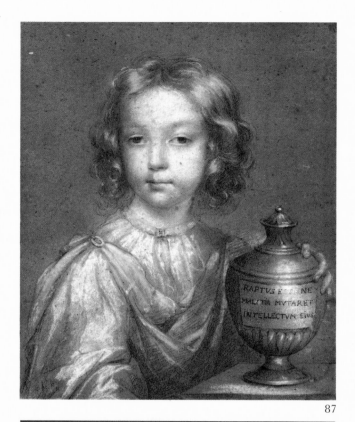

87

John Michael Wright:
Winston and Arabella Churchill.
Oil on canvas, after 1660.
The Duke of Marlborough, Blenheim Palace

87 Winston Churchill (1649–1660)

Black chalk over black lead, heightened with white, and touches of red chalk on buff paper; 240 × 195 mm (9⁷⁄₁₆ × 7¹¹⁄₁₆ in)

The urn is inscribed: RAPTUS EST NE MALATIA MUTARET INTELLECTUM EIUS

PROVENANCE: F. Carrington, New York; Lockett Collection; sale, Sotheby, 21 January 1982, lot 79 ('English School')

Private Collection

The attribution of this drawing to John Michael Wright was first suggested by Sir Oliver Millar (annotated photograph, among those placed under Lely, in the Witt Library, Courtauld Institute of Art). This attribution is strengthened by the existence of a portrait believed to be by Wright of *Winston and Arabella Churchill* (below left; Blenheim Palace), in which the figure of Winston Churchill is undoubtedly derived from the present drawing. A further portrait, signed by Wright and dated 1661 (Sotheby, 14 May 1986, lot 160, illus.) shows the two children in almost identical poses with their mother, Lady Churchill.

Winston Churchill, elder brother of the celebrated general John (1650–1722) who was later to become 1st Duke of Marlborough, died in 1660 of smallpox; hence the inscription on the urn (both in the drawing and in the painting at Blenheim), which may be literally translated 'He was taken from us lest the disease should change his understanding'. Both of the paintings were posthumous and each includes further allusions to the dead child, in the Blenheim picture an extinguished flambeau and fallen flower petals.

No drawing has hitherto been attributed to Wright, but the circumstantial evidence suggests that this study is by him. With its limpid look around the boy's eyes and overall silvery tonality it compares well with the artist's distinctive painting style.

LELY, Sir Peter

Soest 1618 – London 1680

Born Pieter van der Faes in Westphalia, of Dutch parents, he took the name Lely (often spelt and pronounced Lilly in the seventeenth century) from a family house in The Hague which had a lily carved on the gable. In 1637 Pieter Lely was listed as a pupil of Frans Pieters de Grebber in Haarlem. He arrived in England in either 1641 or 1643, according to the differing accounts of two early biographers, where he settled for the rest of his life, visiting Holland on occasion. At first Lely specialised in landscapes with figures in the manner of Cornelis Poelenburgh (1586–1667) and portraits which reflect his Dutch training. In 1647 he was made a freeman of the Painter-Stainers' Company, and began to take apprentices in 1648. His first important patrons, chief of whom was the Earl of Northumberland, were noblemen who took a moderate line in the struggle between King and Parliament, and during the Commonwealth Lely found patronage among men of a similar type. He came into his own with the Restoration of Charles II in 1660, being appointed Principal Painter to the King in 1661 and assuming something of the role played by Van Dyck (q.v., whose influence on Lely can hardly be overestimated) in the previous generation as an arbiter of taste. For the next twenty years Lely ran a large studio turning out hundreds of portraits in a decorative baroque style, exactly catching that atmosphere of sensual languor which the ladies, at least, of Charles II's court saw themselves as possessing. Drawings, both of poses and of details such as hands, were important in a practice that relied heavily on studio assistants. A more vigorous aspect of Lely's art is to be seen in the series of portraits of admirals who, under the command of the Duke of York, had fought in the second Dutch War: the heads, painted by Lely himself, are particularly fine, although in execution many of the designs are poorly painted. In the 1640s Lely began to form a large and important collection of paintings, drawings and prints (by the end of his life he owned around 10,000 drawings), the first such collection to be built up by a painter in England. It was sold by auction in 1682, 1688 and 1692, the drawings and prints being stamped with his mark by his executor Roger North. His own drawings include some of the finest to have been made in England in the seventeenth century.

88 Portrait of a girl

Black and red chalks, heightened with white, on buff paper; 281 × 196 mm (11¹⁄₁₆ × 7¾ in)

Signed: *PLely* (the initials in monogram)

PROVENANCE Sir Joshua Reynolds (L 2364); Thomas Poynder; Sir John Dickson-Poynder, later 1st Baron Islington; by descent; sale, Christie, 29 March 1983, lot 71; Thomas Agnew and Sons Ltd

LITERATURE: Woodward, p. 50, no. 39; *British Portraits*, exh. cat., Royal Academy, London, 1956–7, no. 550; Millar (1978) 73

The British Museum (1983-7-23-35)

This drawing has been dated in the late 1650s and may represent Elizabeth Seymour, later Countess of Ailesbury (1655–97), whose portrait in oils by Lely, showing her at about the same age, is at Longleat. With its delicate modelling, refined use of colour and the suggestion of a landscape background, this is one of the artist's most tender drawings and among the most beautiful English portrait studies of the period.

Like nos 89 and 91, this is one of a small group of highly finished, signed portrait drawings which Lely made as independent works of art. An inventory compiled shortly after his death records that such 'Craions' still in his studio were in ebony frames, suggesting that they were hung as if they were paintings.

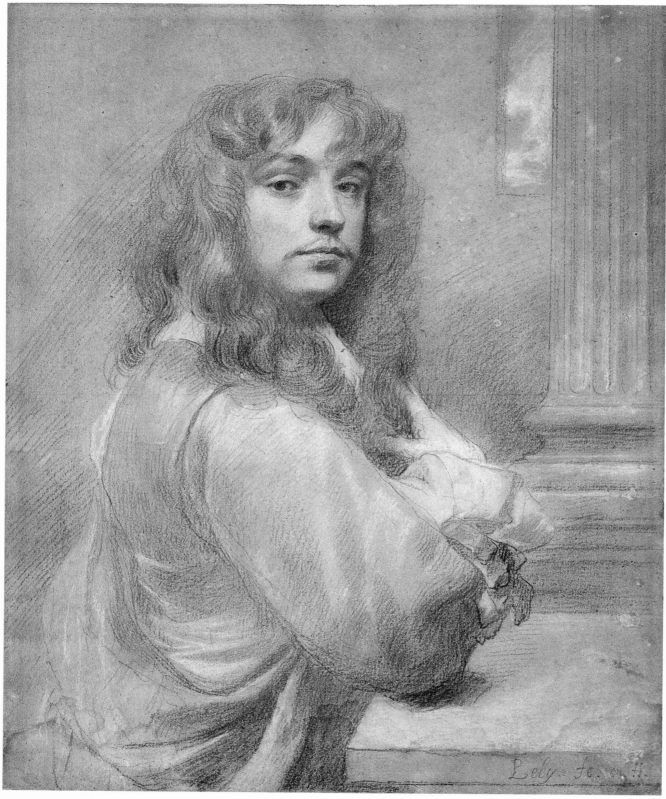

89

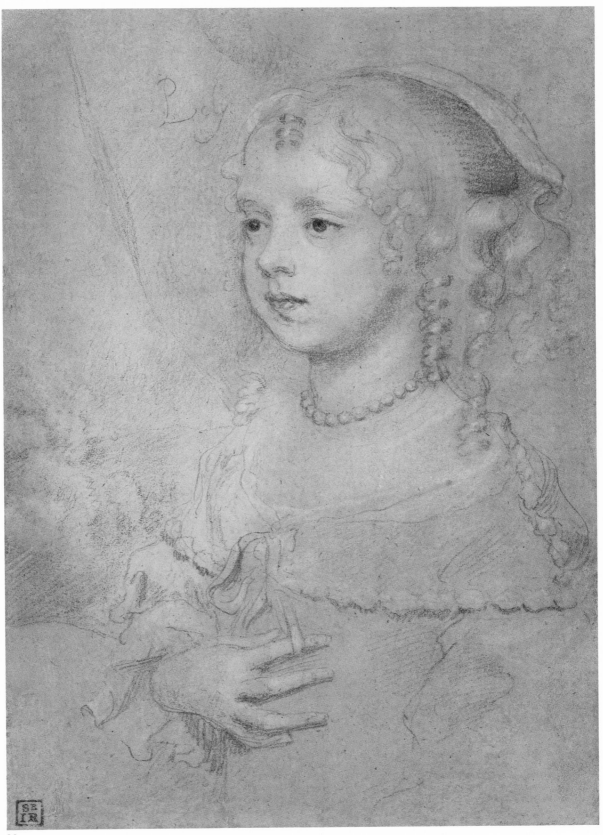

88

89 Self-portrait

Black chalk, heightened with white and touches of pink, on brown paper; 387 × 314 mm (15¼ × 12⅜ in)

Signed: *P Lely: fe: on: H* (initials in monogram)

PROVENANCE: By descent, with two other drawings by Lely of his wife, Ursula, and their son, John, in the artist's family

LITERATURE: Vertue, I, p. 143; Woodward 38; P. Hulton, 'Sir Peter Lely: Portrait Drawings of his Family', *Connoisseur*, CLIV (1963), pp. 166–70; Millar (1978) 70

Private Collection

One of the most striking of Lely's self-portraits, this drawing has usually been dated in the early 1650s. However, it compares closely with the self-portrait painted about 1660 (National Portrait Gallery, London) and probably dates from the same period. The assured pose and confident expression reflect Lely's increasing status after the Restoration: in October 1661 Charles II ordered that he be given an annual pension, as Principal Painter, of £200 'as formerly to Sr Vandyke', and by the summer of the following year he had been granted naturalisation. Lely's splendid manner of living (Pepys noted 'a mighty proud man he is, and full of state') impressed his contemporaries and was probably a conscious emulation of Van Dyck's gentlemanly existence. Lely may well have had in mind Van Dyck's self-portraits when making this drawing, in particular the *Self-portrait with a Sunflower* (below), engraved by Hollar in 1644. Although less overtly self-regarding than Van Dyck's emblematic

Wenceslaus Hollar after Sir Anthony Van Dyck:
Self-portrait with a Sunflower.
Etching, 1644 (P1393)

image, Lely's portrayal, one hand gesturing towards himself, conveys much the same message.

In this drawing (as in the National Portrait Gallery's painting) Lely shows himself wearing the dress and hairstyle of the early 1660s. The length of his hair, its fullness and the fringe are characteristic of the period after 1658, while the narrow 'pencil' moustache is also a fashion of the late 1650s and early 1660s. His clothes – a loose doublet of light material (perhaps silk), with sleeves which were open from just below the arm-hole and were tied over a billowing linen shirt – are comparable with those worn by sitters in dated portraits of the early 1660s (information from Valerie Cumming, Museum of London).

90 Study of details from the Diana Fountain

Grey wash over red chalk, heightened with white, on brown paper; 248 × 264 mm (9¾ × 10⅜ in)

PROVENANCE: Thomas Hudson (L 2432); H. S. Reitlinger (sale, Sotheby, 27 January 1954, lot 244, as by Vanderbank)

LITERATURE: J. Harris, 'The Diana Fountain at Hampton Court', *Burl. Mag.*, CXI (1969), pp. 444–8; Millar (1978) 69; C. Avery, 'Hubert Le Sueur, the "Unworthy Praxiteles" of King Charles I', *Walpole Society*, XLVIII (1982), pp. 151–3, 181; G. Fisher and J. Newman, 'A fountain design by Inigo Jones', *Burl. Mag.*, CXXVII (1985), pp. 531–2

Sir Oliver and Lady Millar

The Diana Fountain now in Bushy Park (opposite, bottom right), thought from the time of John Evelyn (who made a passing reference to it in his diary for 9 June 1662) to have been designed by the Florentine-born sculptor Francesco Fanelli, has recently been reattributed to Inigo Jones (opposite, top right). Two prints provided Jones with the essential elements of the design – an engraving by Domenico Tibaldi (1570) of Giambologna's Neptune fountain in Bologna, and another by Jan Muller (1602) of Adriaen de Vries's Hercules fountain in Augsburg. Jones was responsible for the initial design but the bronze female figure surmounting the fountain, the subsidiary figures of mermaids and putti and the four shell basins were the work of Hubert Le Sueur, who received payments in 1635, 1636 and 1637 for 'brasse and Marble worke done by him . . . according with severall bargaines made with him by Inigoe Jones Esq'. Le Sueur's work included a 'great Diana' for which he was paid £200. Other craftsmen were also engaged in the construction of the black marble basin. The fountain was set up in the Queen's Garden at Somerset House in the mid-1630s, where it was to remain until 1656.

By 1659 it had been re-erected in the Privy Garden at Hampton Court on Cromwell's orders: 'one large fountaine of black marble with a curbe of Eight cants . . . Fower scallop basins, Fower Sea-monsters, Three Scrowles, Fower boys holding Dolphins, [all] of brass [i.e. bronze] about the Fountaine. One large brasse Statue on the top of the Fountaine called Arethusa' (Commonwealth Inventory of Hampton Court, 1659). This is the first occasion on which the figure is so named: certainly

90

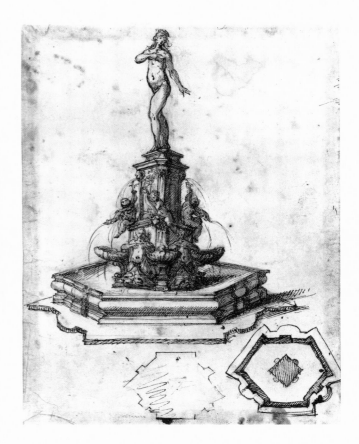

she does not have the usual attributes of Diana – the crescent moon in her hair, the bow, or a hunting dog – although her bare breast and light dress are not inconsistent with Diana's traditional image. Arethusa, nymph of the fountain at Syracuse, would, perhaps, have been an especially appropriate figure, given the watery iconography of the design. The fountain apparently caused some offence. 'A good lady named Mrs Mary Nethaway took it upon herself to write to the Protector in protest: "This one thing I desire of you, to demolish these monsters which are set up in the Privy Garden . . .", and she predicted that as long as they remained the wrath of God was liable to strike the Protector' (A. Fraser, *Cromwell our Chief Statesman*, London, 1973, pp. 460–61). In 1663, however, when the Duc de Monconys saw it (*Voyage d'Angleterre*, Lyon, 1666, p. 78) the fountain was still 'composed of four sirens in bronze, seated astride on dolphins, between which was a shell . . . Above the sirens, on a second tier, were four little children each seated, holding a fish, and surmounting all a large figure of a lady'. It is this arrangement which the present drawing documents: the shells are shown set between the sirens, presumably to receive the water spouting from the fish held by the boys above.

The fountain appears to have survived unaltered until the late 1680s, when Edward Pierce and Josias Iback began extensive modifications, Pierce supplying a new and enlarged pedestal for the figures, which were replaced in different positions. Pierce's design (no. 130) suggests that he may also have intended to substitute a figure of his

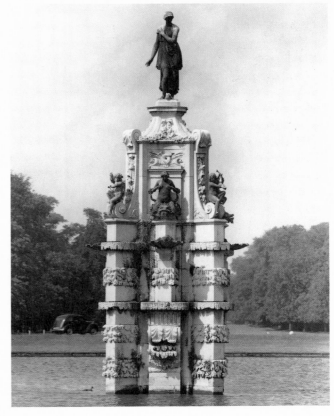

(*Right, above*) Inigo Jones:
Design for a fountain for the garden of Somerset House.
Pen and black ink with grey wash over slight black chalk underdrawing.
The Trustees of the Chatsworth Settlement

(*Right, below*)
The Diana Fountain, Bushy Park

own design for that made by Le Sueur. His work was probably completed about 1694, and may have been connected with Wren's new South Front and his replanning of the Privy Garden, where the fountain would have taken on a new importance. There is some evidence (see no. 168) that about 1700 there was a scheme to substitute a statue of William III by Nost for Le Sueur's figure, but this was never executed. In 1712 Wren decided to move the fountain to the basin in the great avenue in Bushy Park, and it was again altered.

This drawing, attributed to Lely by Oliver Millar, is of a motif that the artist was to use on several occasions in the background of portraits, including those of the Duchess of Orléans, about 1662, and of the Duchess of Cleveland, about 1670, both at Goodwood House, Sussex.

91 Sir Charles Cotterell (1615–1701/2)

Black and red chalk, heightened with white, on brown-grey paper; 227 × 194 mm (10⅞ × 7⅝ in)

Signed: *PL fe* (the initials in monogram)

PROVENANCE: Sir Andrew Fountaine (sale, Christie, 10 July 1884, lot 832)

LITERATURE: ECM & PH 28; C. Eisler, 'Apparatus and Grandeur', *Master Drawings*, VI (1968), p. 151 and pl. 47b; Millar (1978) 75

The British Museum (1884-7-26-25)

Master of Ceremonies to Charles I from 1644, Sir Charles Cotterell was a devoted royalist and went into exile in the Low Countries after the King's execution. He became Hofmaster to Elizabeth of Bohemia at The Hague and secretary to Henry, Duke of Gloucester. Oliver Millar has noted that he was in touch with Hugh May (the architect later favoured by Charles II), who acted as a royalist agent under the Commonwealth, and with Lely, chiefly in connection with the sale of the Duke of Buckingham's collection in Antwerp. May and Lely travelled together to Holland in 1656, and it is possible that Lely's involvement with the royalist exiles may have been fairly considerable.

At the Restoration, Cotterell was reinstated as Master of Ceremonies. On 22 April 1661, the day before the coronation, he was invested by the King with a gold chain and a specially designed medal of office, the appointment being made hereditary in his family. Lely's drawing shows him wearing his insignia.

An early copy of this drawing, which had been bound into an extra-illustrated set of Clarendon's *History of the Rebellion*, is in a private American collection (see Eisler, op. cit.).

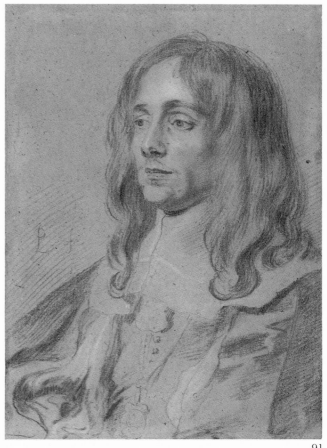

91

92 Studies of arms and hands

Black and red chalks, heightened with white, on buff paper; 381 × 267 mm (15 × 10½ in)

PROVENANCE: Sir Peter Lely (L 2092); Thomas Hudson (L 2432); M. Marignane (L 1872); purchased 1937

LITERATURE: Brown (1982) 156; Brown (1983) 8

The Ashmolean Museum, Oxford

Lely made numerous preparatory studies from the life in connection with his painted portraits; a large group of such drawings was included in the sale of Michael Rosse's collection in 1723 (Rosse was the son-in-law of Lely's close friend, the miniaturist Richard Gibson). The present sheet, one of the most graceful examples of these life studies, is related to two paintings in the series of 'Windsor Beauties' (portraits of the most beautiful women at court, commissioned by the Duchess of York). The study on the left is for the portrait of Frances Stuart, Duchess of Richmond, of about 1662 (O. Millar, *The Tudor, Stuart and Early Georgian Pictures in the Collection of Her Majesty The Queen*, London, 1963, no. 258), while the two others are for that of Mary Bagot, Countess of Falmouth and Dorset, of about 1664–5 (ibid., no. 259): both paintings are now at Hampton Court. Although the pressure of commissions made it increasingly necessary for Lely to employ assis-

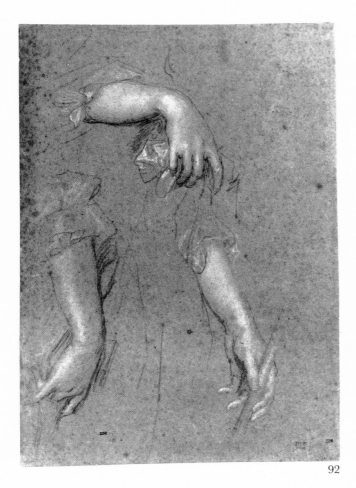

92

were included in an anonymous sale held by De Leth in Amsterdam in March 1763: they were bought by Johan van der Marck and dispersed after his death (several, including no. 98, are now in the British Museum).

Neither the dating nor the purpose of these drawings has been firmly established. Charles II revived the Order of the Garter after the Restoration, and the annual procession and related ceremonies were held with great magnificence: a new form of ceremonial dress for the Knights was introduced, to be seen at its clearest in no. 96. The earliest date for Lely's drawings is probably 1663, the year in which Captain Vaughan (no. 94) was admitted as a Poor Knight; while the latest date must be 1671, the year in which Sir Henry de Vic (c.1599–1671), Chancellor of the Order, who is the subject of another drawing from the same series, in the Ashmolean Museum, Oxford (Brown (1982) 154), died. Although, as Sir Oliver Millar has pointed out, the finished, self-contained quality of the drawings suggests that they may not have been intended as studies for a more elaborate composition, it is nevertheless significant that Lely owned a particularly beautiful oil sketch by Van Dyck (now belonging to the Duke of Rutland), originally painted for Charles I in about 1638, showing the King, Officers and Knights of the Garter 'goeing a Precessioning upon St Georgs day'. This is the only surviving evidence of a scheme described by Bellori in *Le Vite dei Pittori, Scultori ed Architetti moderni . . .*, Rome, 1672, pp. 262–3, for the decoration of a great room at Whitehall (at that period, the processions sometimes took place in London) with tapestries illustrating the history and ceremonial of the Order. It is not impossible that Lely contemplated some grand scheme – a series of life-size portraits, or a large subject-picture – devoted to the Garter, probably to be carried out at Windsor, where the Order had its Chapel and where Lely's friend Hugh May was in charge of the King's ambitious projects for rebuilding and decorating the Castle. In the post-Restoration period, the renewed veneration for the Order, combined with a new interest in medieval history, were probably the stimuli for the book by the antiquary Elias Ashmole (1617–92), *The Institution, Laws & Ceremonies of the most Noble Order of the Garter*, published in 1672 with illustrations by Hollar, and suggest that Lely was not alone in his plans to celebrate the Order. Ashmole himself was Windsor Herald, and was probably one of the figures represented in another drawing from Lely's series, formerly in the Kupferstichkabinett, Berlin, but lost during the Second World War.

The drawings illustrated here are from the group of sixteen in the British Museum (two of which are offsets); they are arranged in the order in which the figures would have walked in the procession, as shown in Hollar's etching (see p. 132). The vivid quality of movement which Lely captures with such ease, to be seen particularly in no. 95, suggests that he must himself have witnessed the event. Where Hollar gives us practical information on the exact form of dress (see p. 135) and ceremonial to be observed, but makes no attempt to depict recognisable individuals, Lely (who sometimes skimps on detail, omit-

tants, for whom drawings of this kind must have been an invaluable aid, the 'Windsor Beauties' series is almost entirely autograph and Lely must therefore himself have made use of preparatory studies. Charles Beale recorded in his notebook that when his son sat to him for his portrait, Lely made a drawing 'after an Indian gown which he had put on his back, in order to the finishing of the drapery of it'.

Figures from the procession of the Order of the Garter on St George's Day

Lely's drawings showing figures taking part in the procession of the Order of the Garter are among the most splendidly baroque to have been made in England. Although over thirty such drawings are known today, it is remarkable that there does not seem to have been any contemporary reference to them, nor do they appear to have been in any of Lely's sales. The earliest notice of any of these drawings so far discovered is in the sale catalogue of the painter Charles Jervas, in which lot 1666 on the twentieth day (the sale began on 24 March 1740) was a group of '8 of the poor Knights of Windsor, in Caricatura, S. P. Lely'. Sixteen drawings from the series

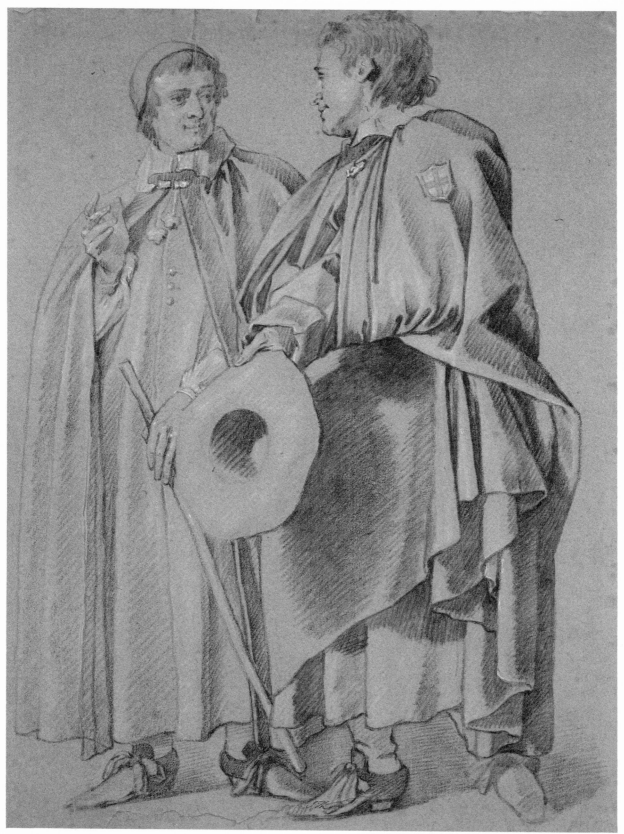

93

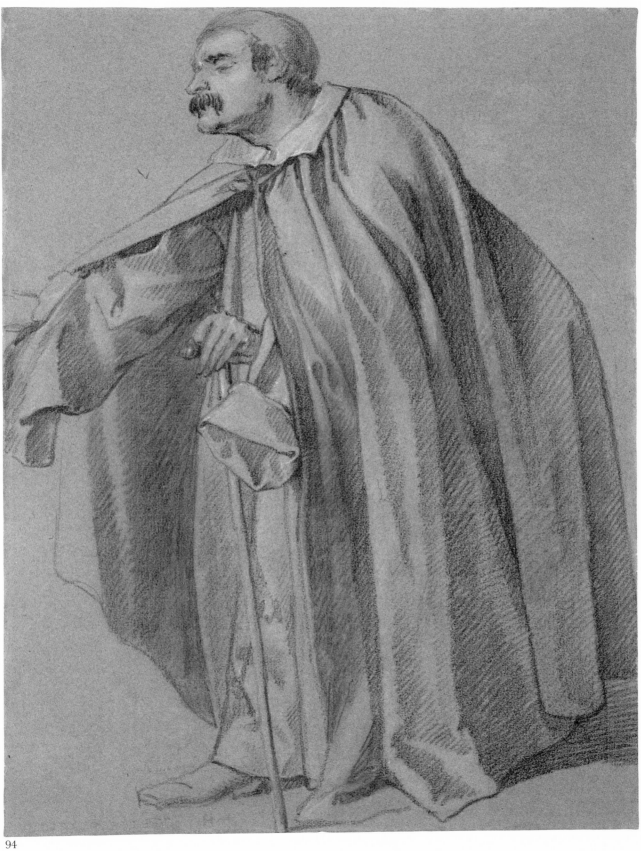

94

ting the collar of the Order or, as in no. 95, the bows by which it is attached to the mantle) does so, and at the same time suggests the splendour and swagger of the Knights, while depicting the simpler dress and mien of the Poor Knights with sympathetic gravity.

A full account of Lely's Garter drawings is to be found in Sir Oliver Millar's catalogue of the Lely exhibition held at the National Portrait Gallery, London, in 1978.

93 Two Poor Knights

Black oiled chalk, heightened with white, on blue-grey paper; 530 × 381 mm (20⅞ × 15 in)

PROVENANCE: John Thane (L 1545; cannot be identified in any of his catalogues or sales); Henry Graves & Co.

LITERATURE: ECM & PH 10; Millar (1978) 87

The British Museum (1862-7-12-649)

94 A blind Poor Knight

Black oiled chalk, heightened with white, on blue paper; 451 × 337 mm (17¾ × 14¼ in)

PROVENANCE: Anon. sale in Amsterdam, De Leth, 23 March 1763, lot 17; Dirk Versteegh (sale, Amsterdam, De Vries and Roos, 2nd part, 3 November 1823, lot 9?); Baron J. G. Verstolk de Soelen (sale, Amsterdam, De Vries, Brondgeest and Roos, 22 March 1847, lot 332)

LITERATURE: ECM & PH 12; Millar (1978) 88

The British Museum (1847-3-26-17)

The Poor Knights or Alms-Knights (predecessors of the present day Military Knights) of the Order of the Garter were veteran soldiers in needy circumstances, intended, according to Edward III's Statutes of Institution (1349) as a brotherhood to pray for the souls of the founder, succeeding sovereigns and the Knights Companion of the Order. Their dress was a red cloak, bearing the cross of St George but without the encircling Garter: this can be seen on the shoulder of one of the Knights in no. 93. On the Restoration of Charles II, the Poor Knights were chosen from soldiers who had served his father with particular distinction during the Civil War. Of those drawn by Lely, only one can be identified – Captain Richard Vaughan (1620–1700), no. 94. He was admitted as a Poor Knight on 28 July 1663, having fought with much courage for Charles I and sustained 'great sufferings in his means and hurts in his body', including the loss of his sight.

Of Lely's surviving figure drawings, those of the Poor Knights are closest to Dutch draughtsmanship of the period.

95 A Knight of the Garter

Black oiled chalk, heightened with white, on blue-grey paper; 498 × 324 mm (19⅝ × 12¾ in)

PROVENANCE: G. Morant (sale, Christie, 21 April 1847, lot 990, 'Van Dyck – two studies of Knights in their robes')

LITERATURE: ECM & PH 14; Millar (1978) 111

The British Museum (1847-5-29-11)

Wenceslaus Hollar:
The Grand Procession of the Soveraigne and Knights Companions.
Etching. Illustration to Elias Ashmole, *The Institution, Laws & Ceremonies of the most Noble Order of the Garter*, 1672 (P582)

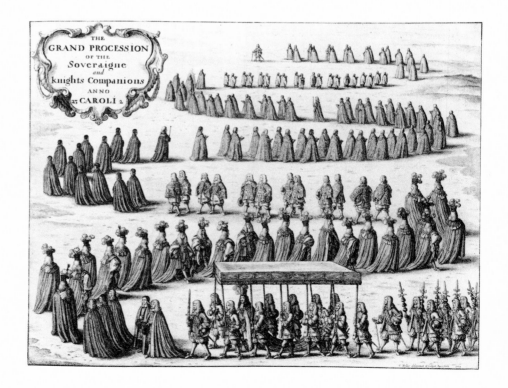

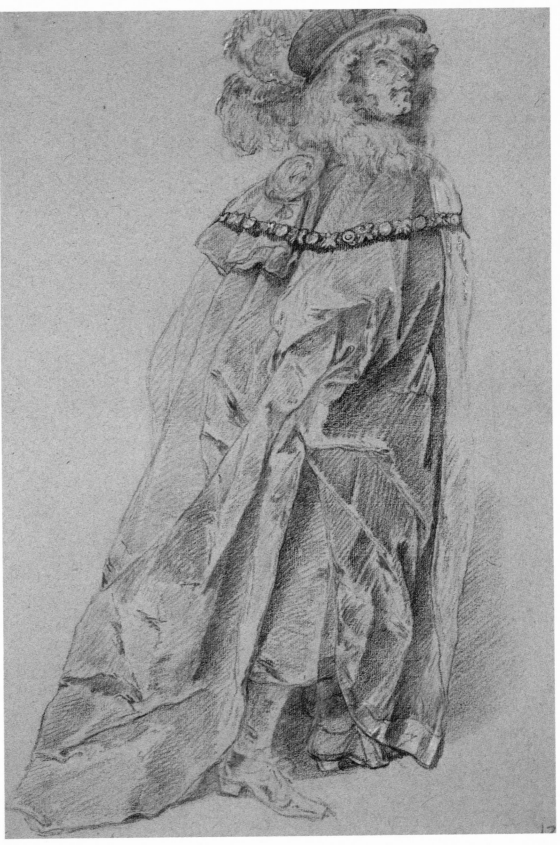

95

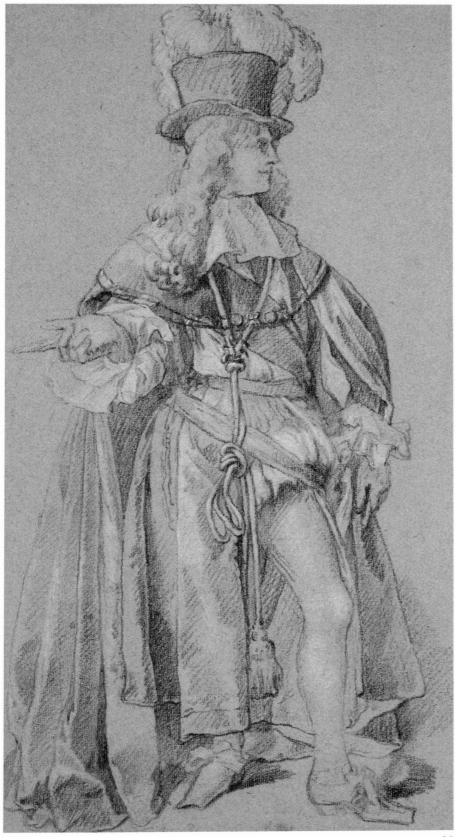

96

96 A Knight of the Garter

Black oiled chalk, heightened with white, on blue-grey paper; 504 × 267 mm (19⅞ × 10½ in)

PROVENANCE: As no. 95

LITERATURE: ECM & PH 13; Millar (1978) 108

The British Museum (1847-5-29-12)

These drawings show the full splendour of the ceremonial dress of the Knights, which – perhaps modelled on that worn by the French Knights of the St-Esprit – was redesigned after the Restoration (see fig. below). Sir Oliver Millar has suggested that the sitter in no. 96 bears some resemblance to James Butler, 1st Duke of Ormonde (1610–88), who was created a Knight of the Order in 1649.

97 The Prelate of the Order

Black oiled chalk, heightened with white, on blue-grey paper; 503 × 350 mm (19¹³⁄₁₆ × 13¾ in)

Inscribed (partly obliterated): *The Prelate of the Order*

PROVENANCE: John Thane (L 1545; cannot be identified in any of his catalogues or sales); Henry Graves & Co.

LITERATURE: ECM & PH 3; Millar (1978) 115

The British Museum (1862-7-12-647)

George Morley (1597–1684) had a distinguished ecclesiastical career; although he held strong Calvinistic opinions, he was a staunch churchman and royalist, a member of Lord Falkland's circle, a friend of the poet Edmund Waller and of Lord Clarendon. After the execution of Charles I he went into exile in France and the Low Countries, returning to England just before the Restoration to contradict rumours that Charles II was a Roman Catholic. At the coronation in 1661 Morley preached the sermon, and in the following year he was appointed Bishop of Winchester and Prelate of the revived Order of the Garter. Clarendon described him as 'of very eminent parts in all polite learning, of great wit, and readiness, and subtlety in disputation, and of remarkable temper and prudence in conversation'. He is readily identifiable in this drawing because of his distinctive short hair and close-cut beard, which may be seen in other portraits of him by Lely, although, as Croft-Murray and Hulton point out, these show him with his face much fallen in through the loss of his teeth.

98 A Canopy-Bearer

Black oiled chalk, heightened with white, on blue-grey paper (the upper corners cut off and made up); 498 × 235 mm (19⅝ × 9¼ in)

PROVENANCE: Anon. sale in Amsterdam, De Leth, 23 March 1763, lot 24 or 28; J. van der Marck (sale, Amsterdam, Hendrick de Winter and Jan Yver, 29 November 1773, lot 1439); Dirk Versteegh (sale, Amsterdam, Dr Vries and Roos, 2nd part, 3 November 1823, lot 9?); Baron J. G. Verstolk de Soelen (sale, Amsterdam, De Vries, Brondgeest and Roos, 22 March 1847, lot 332)

LITERATURE: ECM & PH 1; Millar (1978) 116

The British Museum (1847-3-26-15)

The canopy borne over the Sovereign in the Garter procession was supported by Gentlemen of the Privy Chamber, as seen in Hollar's etching *The Grand Procession* in Elias Ashmole's *Institution, Laws & Ceremonies of the most Noble Order of the Garter*, 1672 (see p. 132).

Wenceslaus Hollar:
The Regalia of the Order of the Garter.
Etching. Illustration to Elias Ashmole, *The Institution, Laws & Ceremonies of the most Noble Order of the Garter*, 1672 (P2639)

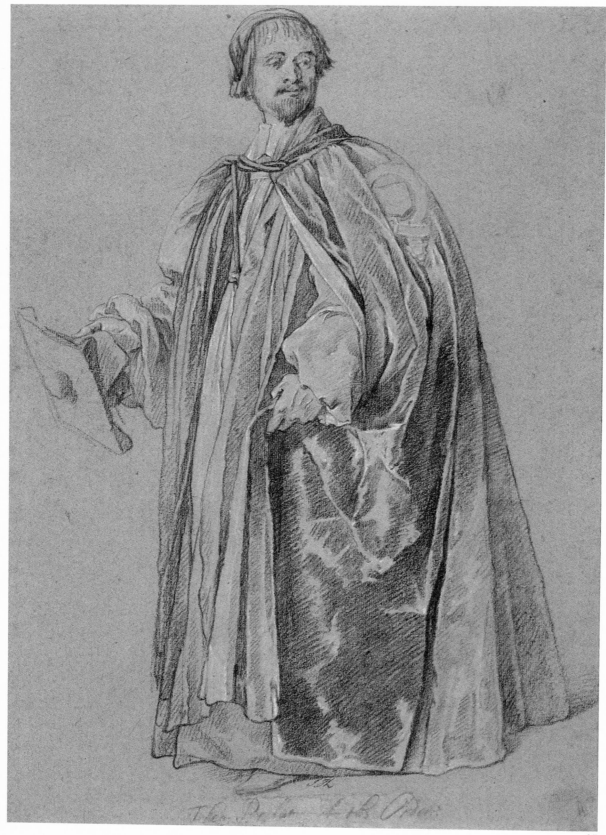

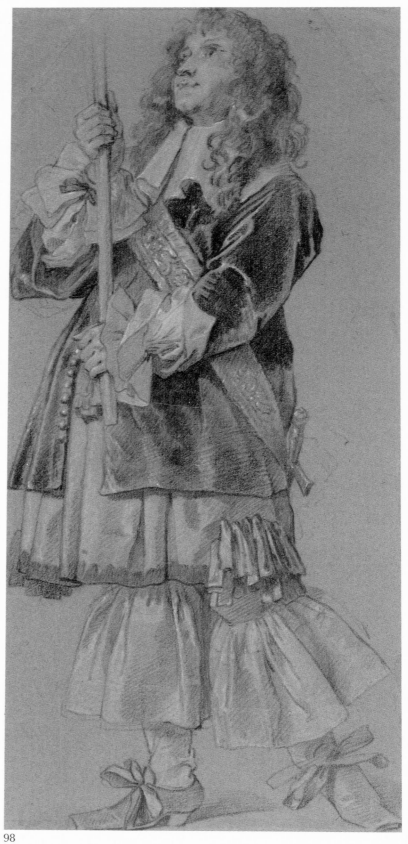

98

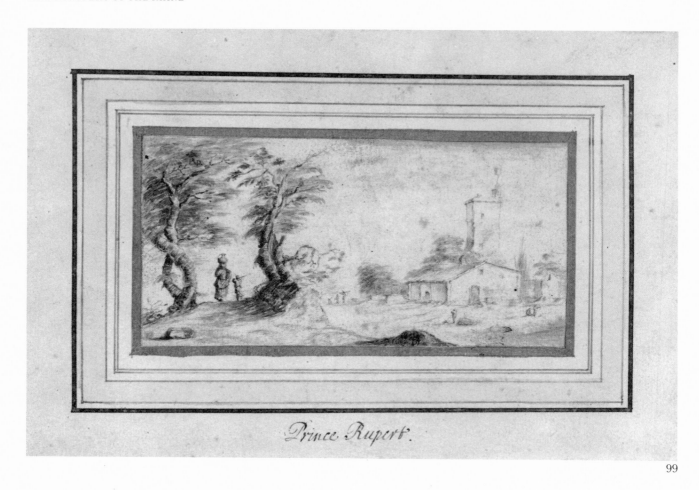

Prince Rupert.

99

RUPERT, Prince Palatine of the Rhine

Prague 1619 – Westminster 1682

The third son of Frederick V, briefly King of Bohemia and Elector Palatine, and Elizabeth, daughter of King James I of England, Prince Rupert was thus a nephew of King Charles I. He probably studied informally at the University of Leiden (his exiled mother having settled in The Hague), developing his interests in science and art from an early age. His professional career was as a soldier (after the Restoration he was more concerned with naval affairs), first on the Continent in the Thirty Years War, and then in the English Civil War, in which he fought gallantly on the side of Charles I. From 1648 until 1660 he was more or less a soldier of fortune, supporting the royalist cause and living chiefly in Holland and Germany. It was during this time that he learned the process of mezzotinting. Although the first experiments in this technique had been made by the German soldier and inventor Ludwig von Siegen (1609–80) in the early 1640s, the development of the true mezzotint – the only printmaking process in which the artist works from dark to light – required the invention of the rocker, which is attributed to Prince Rupert. This tool enables the plate to be roughened, so that, when inked, it prints a velvety black:

the engraver 'scrapes' graduated highlights with a burnisher and such areas retain less ink, so that, when printed, the design emerges from a dark background. Prince Rupert's mezzotint technique was publicised by John Evelyn in his *Sculptura* (1662), published under the auspices of the Royal Society, of which the Prince was a founder member. He seems also to have instructed a number of professional printmakers in the technique, including Wallerant Vaillant (1623–77) and William Sherwin (*fl.c.*1645–1711), who made the earliest dated English mezzotint in 1669. After the Restoration, Prince Rupert held various naval commands, achieving some success against the Dutch. He was a leading member of the intellectual establishment, with a laboratory in Windsor Castle (of which he became Constable in 1668), where he carried out scientific experiments.

99 Landscape

Black lead, the left side tinted with brown wash; 70 × 139 mm (2¾ × 5½ in), on an old mount 145 × 212 mm (5¾ × 8⅜ in)

Inscribed by the artist: *Rp.* below a coronet, and, on the old mount, by Jonathan Richardson the Elder: *Prince Rupert*

PROVENANCE: J. Richardson sen. (L 2184); sale, Cock, 10 Febru-

ary 1746/7, lot 44; Sir Edward Marsh, by whom it was bequeathed through the NACF, 1953

LITERATURE: ECM & PH 3

The British Museum (1953-5-9-1)

An important figure in the development of the mezzotint, Prince Rupert was also an amateur painter and draughtsman: this is a rare example of a drawing by him, perhaps a study for an etching in the manner of Callot. Henry Peacham, in his *Compleat Gentleman*, recommended drawing as a desirable accomplishment 'since in other countries it is the practice of Princes, as I have showed heretofore; also many of our young Nobilitie in England exercise the same with great felicitie'.

THRUMTEN, T.

fl.c.1663–1672

Nothing is known of this artist's life; he signed himself variously as Thrumten and Thrumpton and, from inscriptions on the few drawings known to be by him, appears to have worked in London between 1663 (the date of an engraving derived from the drawing on the verso of no. 100) and 1672.

100 Portrait of a young man

Black and white chalk, with touches of pastel in the face, on pale buff paper prepared with black and red chalk; 240 × 188 mm (9⁷⁄₁₆ × 7⁷⁄₁₆ in)

Verso: Mary Carleton (1642?–1673)

Black chalk heightened with white, with touches of pastel in the face; 240 × 188 mm (9⁷⁄₁₆ × 7⁷⁄₁₆ in)

Signed: *T. Thrumten feci Londini 1667* and inscribed on the verso: *Ye Jarman Prinsis* and in a later hand *Mr O 3:6*

PROVENANCE: Bequeathed by Francis Douce to the Bodleian Library, 1863; transferred to the University Galleries, 1863

LITERATURE: Brown (1982) 221; Brown (1983) 12

The Ashmolean Museum, Oxford

To judge from the few drawings known to be by Thrumten, he worked in a cruder version of Lely's style, using bright colours in place of his restrained tones. The identity of the sitter in this drawing is unknown, but it is tempting to think that he may be the artist himself. Compared with Lely's self-portrait (no. 90), Thrumten's drawing is unsubtle, but shares something of the same mood.

The drawing on the verso is of Mary Carleton, a notorious criminal who was tried for bigamy in 1663 and hanged for theft in 1673. Thrumten's inscription refers to her most celebrated imposture, her claim that she was a 'German Princess', daughter of Heinz von Wolway, Lord of Holmstein (she also claimed to be the daughter of the Duke of Oundenia), but shortly before her execution she

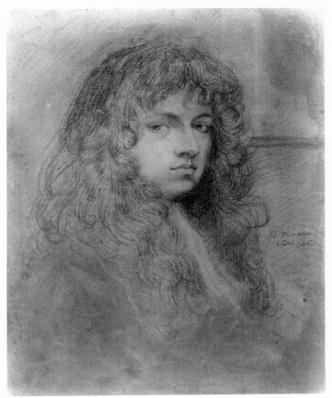

100r

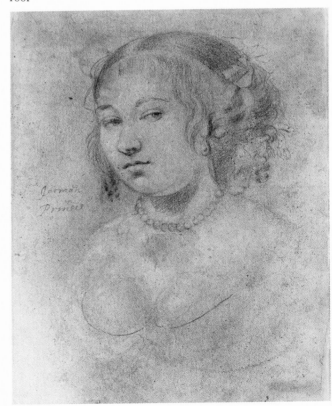

100v

101

confessed that she was the daughter of a chorister of Canterbury Cathedral. Her trials excited considerable public interest, and at the time of the bigamy case a primitive engraving of her was published by John Chantry and later prefixed to the *Memories of the Life of the Famous Madam Charlton* (1673) with the lettering 'taken by her owne order in 1663'. The present drawing appears to have been the source for this engraving, which suggests either that the drawing on the recto was made four years later, or that the date 1667 was mistakenly inscribed by Thrumten.

scenes, inspired by Frans Snyders (1579–1657); he also etched a number of similar subjects. His first wife probably died before he came to England, and according to Walpole, Hondius believed that 'the goods of other men might be used as our own; . . . finding another man's wife of the same mind, he took and kept her till she died, after which he married'. The register of St Bride's, Fleet Street, records the burial on 17 September 1691 of 'Abraham Hondiens, painter'. He left a few paintings, including a self-portrait, to his wife Sarah, and his books, prints and drawings to his son Abraham, also a painter.

HONDIUS, Abraham

Rotterdam 1625/30 – London 1691

Hondius's earliest known paintings date from the 1650s. He was living in Rotterdam, his native city, at the end of the decade, but is said to have moved to Amsterdam by 1660. To judge from the titles of several paintings, he probably visited Italy in the 1660s. A number of animal and sporting pictures, the genre for which he was to become best known in England, are recorded between 1662 and 1670. By January 1674, according to a reference in Robert Hooke's diary, he was in London. A view of the frozen Thames (Museum of London), painted in 1677, is an unusual example of a topographical subject by Hondius, who chiefly specialised in rather vicious animal

101 Two studies of a spaniel

Black chalk; 196 × 335 mm (7¾ × 13¼ in)
PROVENANCE: Presented by Edward Verrall Lucas, 1910
LITERATURE: ECM & PH 2
The British Museum (1910-12-2-49)

A drawing from a group of four studies in the British Museum, all of dogs, one of which is signed and dated 1682, about six years after the artist settled in England. Stylistically these drawings recall similar studies by other Dutch artists of the period. Although Hondius painted and etched numerous sporting and animal subjects, this lively sketch appears to be unrelated to any more elaborate composition.

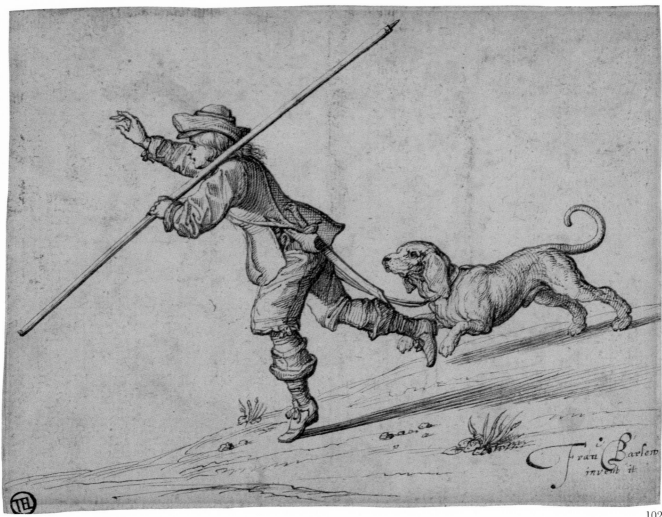

102

BARLOW, Francis

Lincolnshire? 1626? – Westminster 1704

Barlow was the first native artist to specialise in the very English genre of animal and sporting subjects. His early life is obscure, the date of his birth traditionally being given as 1626: he described himself as 'Indigenam Londinensem' on the title-page of his *Multae et Diversae Avium Species* (1671), but Vertue (perhaps repeating an earlier source) gives his birthplace as Lincolnshire and notes that he was the pupil of 'one Shepherd, a Face-Painter' (II, p. 135). This was probably William Shepherd (*fl. c.*1640–65), a member of the Painter-Stainers' Company, of which Barlow was to be made a freeman in March 1649/50. Barlow's first dated work is a drawing in the British Museum, *David slaying the lion* (1648), and within a few years he seems to have established himself as a specialist in animal painting. The antiquarian Richard Symonds noted in about 1653 that Barlow was 'living neare ye Drum in Drury Lane . . . for a quadro of fifishes

he made he had 8l'. He uses to make fowle and birds and colour them from the life.' By 1656 John Evelyn wrote of him as 'the famous painter of fowle, Beastes & Birds'. Among his paintings 'for Noblemen and Gentlemen in the Country' (Vertue, II, p. 136) would have been the magnificent group painted in the 1660s for Denzil Onslow (now at Clandon Park, Surrey). These owe a debt to Dutch Baroque farmyard scenes, for instance those of Barlow's younger contemporary Melchior Hondecoeter (1636–95), but at the same time demonstrate a close observation of nature. Barlow's drawings may in most cases be related to printmaking. His first etchings were for Edward Benlowes's *Theophila* (1652), but the plates for *Aesop's Fables*, published by Barlow himself in 1666, were his most important work in this medium. He also published a second enlarged edition in 1687. These, together with his other original etchings, place him on a level with the best of his contemporaries, although he himself rated his talents as a printmaker very modestly. He provided numerous designs for other engravers, including subjects

for Richard Blome's *Gentleman's Recreation* (1686) and other sporting books. In the second half of the seventeenth century almost every engraver of animal subjects used his work as a model, including Richard Gaywood, Jan Griffier (q.v.), Wenceslaus Hollar (q.v.), Thomas Neale and Francis Place (q.v.). An aspect of Barlow's work which has as yet been little studied is the political satire, an area in which he was again one of the earliest active English artists.

102 A boy hunting with a pointed staff and a hound

Pen and brown ink; 121 × 154 mm (4¾ × 6¹⁄₁₆ in)

Signed by the artist: *Fran^c Barlow invent it*

PROVENANCE: T. E. Lowinsky (L 2420a); J. Lowinsky, 1963

LITERATURE: J. Egerton and D. Snelgrove, *The Paul Mellon Collection: British Sporting and Animal Drawings c. 1500–1850*, London, 1978, p. 20

Yale Center for British Art, Paul Mellon Collection (B1977.14.4144)

This drawing was probably intended to be engraved as an illustration of a huntsman, but no print after it is known. The stylised, static poses of boy and dog, the emphasis on the decorative silhouette and lack of background, as well as the laborious cross-hatching and somewhat self-conscious signature, suggest that this is an early work before Barlow developed the easy naturalism of his maturity. It may date from the late 1640s, to judge from a comparison with his drawing of *David slaying the lion* (1648) in the British Museum. The almost Dutch clarity of line and concern with detail suggests, as do his pictorial compositions, that Barlow may have trained, at least partially, with one of the Dutch artists resident in England during the period.

The subject has been described as otter-hunting, but although the hound is of the same long-eared, short-legged type as in the illustration of the sport in Richard Blome's *Gentleman's Recreation*, the staff shown here has only one spike as opposed to the double prong which was normally used.

Aesop's Fables and *The Life of Aesop*

A slave in the service of Iadmon on the island of Samos in the sixth century BC, Aesop is said to have earned his freedom through telling moral animal fables. The fables, together with a Life of Aesop, are first known to have been written down about 300 BC. Two collections of about AD 40, one in Latin, the other in Greek, are the main sources for modern versions, but oriental tales and later inventions continued to be added. The order of the fables differs and there is no definitive text, but the iconography for many of the illustrations was established in medieval manuscripts and by Barlow's time was well known. His debt to these earlier illustrated versions of Aesop is not inconsiderable, in particular the etchings by Marcus

Gheeraerts the Elder (*c.*1520–*c.*1590) for *De warachtighe Fabulen der Dieren*, Bruges, 1567, reissued with additional plates as *Esbatement moral des animaux*, Antwerp, 1578. Another important source was John Ogilby's *The Fables of Aesop Paraphras'd in Verse and adorn'd with Sculpture*, London, 1651, with illustrations by Francis Cleyn (q.v.). A second edition, published in 1665, included a number of illustrations by Hollar, based on Cleyn's, as well as others of very indifferent quality by Dirk Stoop (1610?–86?).

The subjects of the fables gave Barlow the opportunity to combine his talent as an animal draughtsman with that, evident in his satirical subjects, for conveying a clear moral message. He first published his *Aesop* in 1666 with 110 plates, most of the drawings for which are in the British Museum. In 1668 he provided eighteen designs for Ogilby's *Aesopics*, an enlarged version of the 1665 edition of *Aesop Paraphras'd* In 1687 Barlow published a second edition of his own collection of the *Fables* with new illustrations to *The Life of Aesop* and verses by the playwright Mrs Aphra Behn (1640–89) beneath the plates. This edition was dedicated to William Cavendish (1640/41–1707), 4th Earl and later 1st Duke of Devonshire. The complex publishing history of these editions of Aesop is fully discussed by Edward Hodnett in *Francis Barlow, First Master of English Book Illustration*, London, 1978.

103 Fable XXI: The Cat and Mice

Pen and brown ink with grey wash over black lead; 128 × 162 mm (5 × 6⅜ in)

PROVENANCE: Miss E. Hanks

LITERATURE: ECM & PH 33

The British Museum (1867-4-13-361)

Barlow's well-fed farmyard cat is closer to that of Marcus Gheeraerts's illustration of 1567 than to Cleyn's lean mouser of 1651, who receives a sealed petition from a deputation of mice in a Gothic hall (opposite).

Barlow's 1666 edition was published in English, French and Latin, the text being provided by two professional authors and translators, Thomas Philipott, who was responsible for the English renditions, and Robert Codrington, who wrote the French and Latin versions; Philipott's couplets summing up each fable were straightforward and unambitious efforts. However, for the second edition of the *Fables*, published in 1687, Barlow engaged the well-known dramatist and author Mrs Alphra Behn to rewrite the summaries. Barlow's etching of *The Cat and Mice* follows his drawing very closely, although with the addition of two oxen in the background. It was accompanied in the 1687 edition by the following verses:

The mice consult, how to prevent their fate
By timely notice of th' aproaching Catt,
We'll hang a Bell about her neck, cry'd one,
A third replyd – but who shall putt it on.
 Morall
Good Councell's easy given, but y^e effect
Oft renders it uneasy to transact.

103

(*Above*) Marcus Gheeraerts:
The Cat and Mice.
Etching, 1567

(*Right*) Francis Cleyn:
The Cat and Mice.
Etching, 1651

143

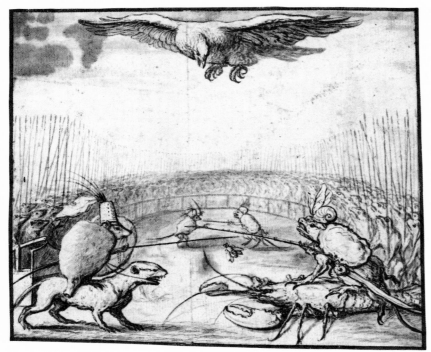

104

104 Fable xxxv: The Kite, Frog and Mouse

Brush drawing in grey wash; 129 × 154 mm (5⅟₁₆ × 6⅟₁₆ in)
PROVENANCE Henry Graves & Co.
LITERATURE: ECM & PH 43; Hodnett (1978), p. 82
The British Museum (1858-6-26-378)

Although Barlow's illustration is obviously derived from
Cleyn's design (right), his animals have a verisimilitude
which is the product of careful observation. Whereas in
his satirical drawing *The Joust* (no. 110), which appears to
have been based on this composition, the ape protagonists
have a toy-like charm, here the Frog and Mouse, their
steeds and the Kite hovering overhead share an air of
vicious menace.

The etching was accompanied in the 1687 edition by
the following verses:

> The Frog and Mouse themselves to armes betake,
> To fight for the Dominion of the Lake,
> But while in field the boasting Champions dare,
> The Kite makes both her prey, so ends the warr.
> *Morall*
> The fond aspiring youth who empire sought
> By dire ambition was to ruine brought.

The concluding moral verse by Ogilby which accompa-
nied Cleyn's illustration in the 1651 edition had a more
directly contemporary note to it:

> Thus Petie Princes strive with mortall hate,
> Till both are swallow'd by a neighbouring State;
> Thus factions with a civill War imbru'd
> By some unseen Aspirer are subdu'd.

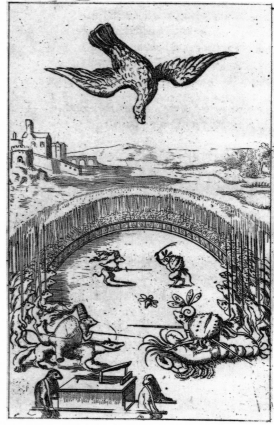

Francis Cleyn:
The Battaile of the Frog and Mouse.
Etching, 1651

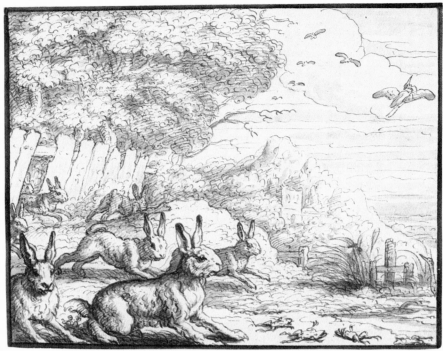

105

(*Above*) Marcus Gheeraerts:
The Hares and the Storm.
Etching, 1567

(*Left*) Francis Cleyn:
The Hares and the Storm.
Etching, 1651

145

Francis Cleyn:
The Youngman and the Cat.
Etching, 1651

106

105 Fable XLI: The Hares and Storm

Pen and brown ink with grey wash; 132 × 163 mm (5³⁄₁₆ × 6⁷⁄₁₆ in)

PROVENANCE: Henry Graves & Co.

LITERATURE: ECM & PH 49

The British Museum (1858-6-26-381)

Based again on established prototypes (Gheeraerts, 1567; Cleyn, 1651; see p. 145), the composition is nevertheless characteristic of Barlow's animal subjects where the foreground is dominated by large-scale creatures in a dark woodland setting. Various elements of the background – the ruined Italianate building beneath a mountain, and the heron flying upwards into the sky on the right – also appear in Barlow's drawing of *Hare-coursing* (no. 109).

The etching was accompanied in the 1687 edition by the following verses:

> The Hares in storms to close recesses hye,
> And thro' a scanted breach themselves convey,
> But when they find a Lake they must wade thro'
> Forward they dare not, backward can not goe.
> *Morall*
> When counsell'd thus by a more prudent Hare
> What can't be remedied with patience bear.

106 Fable LXXI: The Young Man and his Cat

Pen and brown ink with grey wash; 132 × 163 mm (5³⁄₁₆ × 6³⁄₈ in)

PROVENANCE: Henry Graves & Co.

LITERATURE: ECM & PH 76

The British Museum (1858-6-26-393)

An earlier version of this design (also in the British Museum, 1855-7-14-66) shows the young man in a flowing robe, but in this finished study Barlow has returned to a costume closer to that of Cleyn's 1651 illustration (above). He does not, however, attempt to reproduce Cleyn's delightful image of the creature who is half-cat, half-maiden.

The etching was accompanied in the 1687 edition by the following verses:

> A Youth in Love with Puss, to Venus prayd
> To change the useless Beauty to a Maid,
> Venus consents, but in the height of Charmes
> A Mouse she cry'd, and leaves his ravisht armes.
> *Morall*
> Ill principles no mercy can reclaime,
> And once a Rebell still will be the same.

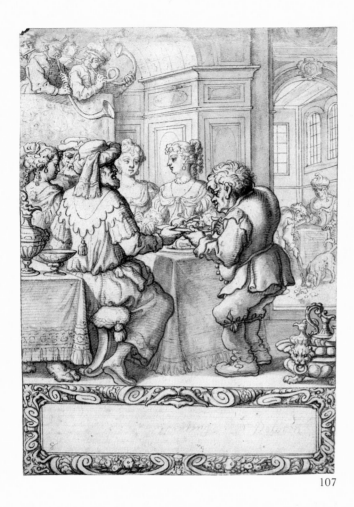

107

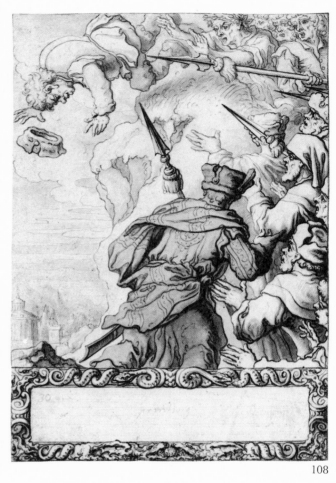

108

107 Aesop ordered by Xanthus to take a dish to her that loves him best

Pen and brown ink, with grey wash, indented for transfer; 241 × 163 mm (9½ × 6⅜ in)

Inscribed on the tablet below the drawing: *printing Mr Dolman* and *8*

PROVENANCE: Miss E. Hanks

LITERATURE: ECM & PH 111; Hodnett (1978), pp. 206–20

The British Museum (1867-4-13-327)

108 Aesop flung over a precipice by the Delphians

Pen and brown ink, with grey wash, indented for transfer; 241 × 164 mm (9½ × 6⁷⁄₁₆ in)

Inscribed on the tablet below the drawing: *30* and *printing Mr Dolman*

PROVENANCE: Miss E. Hanks

LITERATURE: ECM & PH 129; Hodnett (1978), pp. 206–20

The British Museum (1867-4-13-345)

In 1687 Barlow published a second edition of *Aesop's Fables* which included thirty-one new plates illustrating the life of Aesop: twenty-seven drawings are in the British Museum. Barlow etched five unsigned plates himself, and Thomas Dudley the remaining twenty-six. This edition must have been planned for some considerable time, since two of Dudley's plates are dated 1678 and 1679. As Hodnett (op. cit) has pointed out, the source for many of the motifs in Barlow's *Life of Aesop* is a so far unidentified edition from which both Jérôme de Marnef's *Aesopi Phrygis Fabulae* (Paris, 1585) and Christopher Plantin's *Les Fables et la Vie d'Esope* (Antwerp, 1593) had also previously been derived; but Barlow employed these prototypes

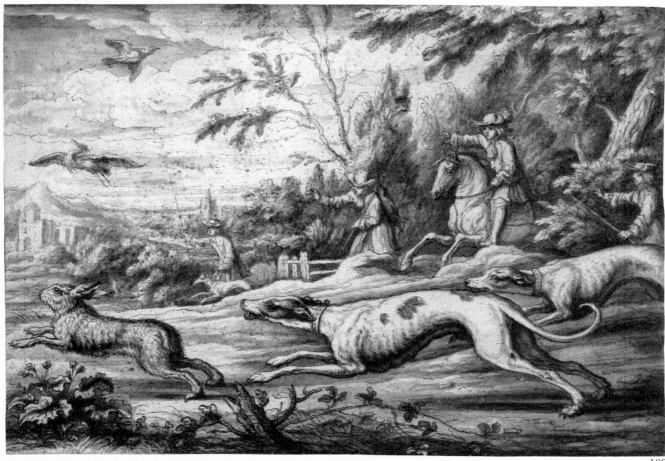

109

chiefly as a stimulus to his own imagination. His illustrations have an idiosyncratic quality, which, despite undeniable weakness in draughtsmanship (particularly of the human figure), is striking. The humpbacked figure of Aesop dominates nearly every episode, as we follow his change of fortunes from his days as a slave, who won his freedom and acted as counsellor to the Samians, solving their problems by telling moral fables so effectively that they erected a statue to him, to his end when the citizens of Delphi falsely accused him of stealing a silver cup from the temple of Apollo and killed him.

A number of the drawings are elaborate interior scenes, unlike any others by Barlow. In the first drawing illustrated here, Aesop, still in the service of his master Xanthus, has been commanded to present a 'choyce Dish . . . to Her that Affected Him [Xanthus] best'. When questioned by his master to whom he had offered it, Aesop replied '"To your Beloved". Whereupon calling the Bitch, "This is she" said he "that most constantly entitles her Affections to you; for though you load her with stripes, and discard her your house, yet still she returns both to fawn upon you, and accompany you. Your instructions ought to have directed your present to your Wife, not your Beloved".' In the background of the drawing, Aesop can be seen giving the food to the dog. The etching by Dudley,

dated 1678, was accompanied by two couplets composed by Aphra Behn:

A Wife, or Dog, as certaine reasons prove,
May faune, & wag the tayle, but never love,
Yet of the two, this story has confest
That 'tis the Dog, deserves the Present best.

The second drawing, etched by Dudley as the penultimate plate of *The Life of Aesop*, is among Barlow's most dramatic inventions. It was published with Mrs Behn's couplets:

Reader reflect upon this scene of woe,
How little faith there is in pomp below
When one so good, so great, so truely wise,
Shall find a scorn'd, tho' guiltless sacrefise.

'Mr Dolman', whose name is inscribed on several of the drawings, was perhaps the person responsible for lettering each plate; he is not otherwise recorded, however.

110

109 Hare-coursing

Pen and brown ink with grey wash; 175 × 250 mm (6⅞ × 9⅞ in)

PROVENANCE: L. G. Duke; Colnaghi, 1961

LITERATURE: J. Egerton and D. Snelgrove, *The Paul Mellon Collection: British Sporting and Animal Drawings c.1500–1850*, London, 1978, p. 19

The Paul Mellon Collection, Upperville, Virginia

This drawing is one of Barlow's most spirited sporting subjects. The emphasis is on the hounds and their prey, speeding across the foreground, their movement echoed in subsidiary details such as the disturbed birds which rise into the air. With characteristic restraint, Barlow has refrained from depicting the actual seizure of the hare. The landscape background, with its richly textured pattern of light and shade, is drawn considerably more sensitively than those in comparable illustrations for sporting manuals of the period, like Richard Blome's *Gentleman's Recreation*. The drawing was engraved in mezzotint by James Collins (who engraved several plates for Blome) as a single sheet print, rather than as a book illustration.

110 The Joust: a political satire

Pen and brown ink with grey wash; 212 × 314 mm (8⅜ × 12⅜ in)

Inscribed by the artist in the banderoles attached to the four figures, reading from left to right: (i) *we walk but slow but Aps face we be shure And these Afronts no longer shall indure*; (ii) *Come Monsure* [crossed out and altered in a different hand to *good sa*] *hust* [?] *I shall so pault your Brayne Ile make you spue my aple up agayne your Shabrone rout shall soene my Cuntrey fly Lyke Shitlecocke Ile make them mount the sky*; (iii) *Began* [crossed out and altered in a different hand to *Gadone* [?]] *you are soone of an Hure and know Ile have your countrey where de Aple grow no matter where the warre be false or right Tis for my Glory that I now doe fight*; (iv) *Sa sah along ten towsand pug me slay then turn my arse and bravely run away*. Also inscribed above the respective figures: *magiour Liktren cher* and *Captayne Suckplume*. Signed: *F. Barlow 1679*

PROVENANCE: John Thane (L 1544); Francis Douce

LITERATURE: Brown (1982) 63; Hodnett (1978), pp. 26–30

The Ashmolean Museum, Oxford

This drawing does not seem to have been engraved and its exact meaning has not been conclusively determined. The ape riding the boar, with shuttlecock fleur-de-lis on his shield and the Gallic cock on the boar's trappings, is clearly meant for Louis XIV of France, followed perhaps by Charles II of England ('Captayne Suckplume') who

was in alliance with him at the time. Above their heads, the snipe with three mushrooms (standing for three crowns) on his banner may represent Sweden, while the owl with the crossed artichokes (perhaps a reference to St Peter's keys) may stand for the Papacy. It has been suggested that the ape riding the bear may be read as Emperor Leopold I (although the bear usually represented Russia) and his attendant as Charles, Duke of Lorraine. In 1679 Louis formally ceded Lorraine (long fought over) – the apple which, according to the inscribed dialogue, is the cause of the joust – to the Holy Roman Empire but did not withdraw his troops. Barlow's patron, William Cavendish, 4th Earl and later 1st Duke of Devonshire, was an active opponent of English involvement with France.

Barlow seems to have based his composition on the established iconography for Aesop's 'The Kite, Frog and Mouse' (see no. 104). The punning use of apes to represent human figures was a commonplace of Dutch seventeenth-century satirical prints, but Barlow's skill as an animal draughtsman has lent an extra expressive dimension. The charm of these creatures must, however, soften the edge of the satire.

Designs for playing cards

The drawings described below are taken from an album containing sixty-one preliminary designs for three packs of playing cards: the *Rump Parliament*, the *Popish Plot* and the *Meal Tub Plot*. Illustrated broadsides and playing cards often depicted events of current interest and appealed to a more popular audience than contemporary newspapers. Neither the drawings nor the cards themselves are signed, but they are close in style and sentiment to other drawings by Barlow (see *The Infernall Conclave*, no. 115). Some of the events depicted date back to the days of the Commonwealth, but the majority are concerned with the alleged Catholic conspiracies of 1678 and the years immediately following, whereby King Charles II was to be assassinated and a papist state set up. Incidents are not arranged in any chronological sequence, but the latest took place towards the end of 1680. The first and most notorious of the 'conspiracies' to capture the public imagination was the Popish Plot, 'revealed' by Titus Oates, and as many as five versions of the pack illustrating this subject are preserved in the British Museum (Willshire E.186-8; Schreiber E.57-9); there is also a set of Lambeth tiles in the Victoria and Albert Museum (Schreiber Collection). Playing cards showing scenes from later alleged papist conspiracies, including Monmouth's Rebellion and the Warming-Pan Plot (BM, Schreiber E.62-3) are close in style and may also be attributed to Barlow (although no drawings are known), presumably as sequels to the subjects discussed here.

111

111 The execution of Godfrey's murderers

Pen and brown ink; 78 × 52 mm (3¹⁄₁₆ × 2¹⁄₁₆ in)

Inscribed: *The Execution of yᵉ 3 Murtherers*

PROVENANCE: Sir Andrew Fountaine; H. S. Reitlinger (sale, Sotheby, 12–13 April 1954, lot 215); F. B. Benger

LITERATURE: Willshire, pp. 251–62; ECM & PH 137 (1–61); Kenyon, pp. 151, 166–7, 302–9

The British Museum (1954-7-10-4(13))

Sir Edmund Berry Godfrey, the magistrate who heard Titus Oates's original disclosures concerning the Popish Plot, was found dead at Primrose Hill, London, on 17 October 1678. It was popularly believed that the Jesuits had arranged his death in order to suppress facts that Oates had confided in him; three men, Green, Berry and Hill, were convicted of his murder and hanged – though not together as shown by Barlow – in February 1679.

This design was engraved as the Three of Spades in the *Popish Plot* pack.

112 The devil supplying the Pope with plotters

Pen and brown ink; 78 × 51 mm (3¹⁄₁₆ × 2 in)

Inscribed: *my Paunch will never be / Emtyed* and *the Devil supplying / the pope with plotters* and on the verso: *the devil supplying the Pope wth Plotters*

PROVENANCE: Sir Andrew Fountaine; H. S. Reitlinger (sale, Sotheby, 12–13 April 1954, lot 215); F. B. Benger

LITERATURE: Willshire, pp. 251–62; ECM & PH 137 (1–61); Wayland, pp. 6–7

The British Museum (1954-7-10-4(20))

Using an image which was to remain popular among satirical draughtsmen of the following century, Barlow

112

113

114

has shown the devil excreting plotters. In his *The Cheese of Dutch Rebellion* (*BM Satires* 1045, as *The Egg of Dutch Rebellion*) the devil creates Dutch enemies of England in the same way.

This design was engraved as the Knave of Diamonds in the *Meal Tub Plot* pack.

113 'Noll's Fiddler' running from Parliament

Pen and brown ink; 77 × 50 mm (3 × 2 in)

Inscribed: *Nolls fidler runs / from the parliament* and on the verso: *Nolls fidler runs / strangle* [strangely] *from yᵉ / parliamᵗ*

PROVENANCE: Sir Andrew Fountaine; H. S. Reitlinger (sale, Sotheby, 12–13 April 1954, lot 215); F. B. Benger

LITERATURE: Willshire, pp. 251–62; ECM & PH 137 (1–61); Wayland, pp. 12, 14; Kenyon, p. 281

The British Museum (1954-7-10-4(49))

Sir Roger L'Estrange, a Tory journalist and pamphleteer (his nickname, 'Noll's Fiddler', derived from an occasion during the Protectorate when Cromwell, making an unannounced visit to a friend, came upon L'Estrange, an accomplished musician, in the course of performance) offended public opinion by publishing, in 1680, his doubts on Titus Oates's evidence concerning a papist plot, which he denounced as a hysterical fabrication. He was lampooned in broadsides (for example, *BM Satires* 1085), burnt in effigy and obliged to flee the country.

This design was engraved as the Four of Diamonds in the *Meal Tub Plot* pack.

114 Mrs Cellier in the pillory

Pen and brown ink; 79 × 51 mm (3⅛ × 2 in)

Inscribed: *Mrs Celliere disgraces / the pillory* and on the verso: *Mrs Celiere disgraces / the pillory*

PROVENANCE: Sir Andrew Fountaine; H. S. Reitlinger (sale, Sotheby, 12–13 April 1954, lot 215); F. B. Benger

LITERATURE: Willshire, pp. 251–62; ECM & PH 137 (1–61); Wayland, p. 37; Kenyon, pp. 216–17, 227–8

The British Museum (1954-7-10-4(54))

Elizabeth Cellier, 'the Popish midwife', was a central figure in the Meal Tub Plot. She was accused by one Dangerfield of hiring him to put about rumours of a Presbyterian conspiracy and supposedly incriminating papers were discovered in her meal tub. Dangerfield, a notorious character, was deemed an unreliable witness and Mrs Cellier was acquitted in June 1680. The following September, however, she was convicted of libel as a result of a pamphlet that she had written vindicating herself. She was fined £1,000 and sentenced to stand three times in the pillory. The present drawing shows her 'disgracing' the pillory by wearing armour beneath her dress and defending herself from brickbats.

This design was engraved as the Queen of Diamonds in the *Meal Tub Plot* pack.

115

115 The Infernall Conclave

Pen and ink with grey wash on two pieces of paper conjoined;
172 × 248 mm (6¾ × 9¾ in)

Inscribed by the artist: *An encouraging reward I shall doe it / For poysening the King fiwtene thowsend pounds / for Stabing the King this / for firing the City this / f[or] murding Godfrey this / Shafsbary this / To turn the plot upon the protestants / The Infernall Conclave*

PROVENANCE: Sir Robert Peel; sale, Robinson and Fisher?, London, 12–15 June 1900, part of lot 6216; H. Sotheran & Co.; J. Pierpont Morgan

LITERATURE: R. Godfrey, *English Caricature: 1620 to the Present*, exh. cat., Victoria and Albert Museum, London, 1984, no. 4

The Pierpont Morgan Library, New York

The present drawing was first identified by Richard Godfrey as a preliminary study for the lower half of *The Happy Instruments of Englands Preservation*, 1681 (*BM Satires* 1114; opposite): there are some minor differences in the composition and in the captions. The significance of the letter 'A' inscribed on many of the figures is not known. Although neither print nor drawing is signed, the style of the drawing is unmistakably Barlow's and the anti-Papist sentiments are consistent with those of his Popish Plot playing card designs (see nos 111–14). The Pope, inspired by the devil, is shown dispatching conspirators to England with the purpose of murdering the King and undermining Protestant institutions. The woman at the right of the drawing, Mrs Cellier, appears in several of Barlow's designs for playing cards illustrating episodes from the Meal Tub Plot of 1680 (see no. 114). No preliminary drawing is known for the upper part of the engraving, in which Titus Oates and other Protestant 'saviours' who exposed the Popish Plot are seated in glory. Barlow has adapted for satirical purposes the traditional device – dating back to Raphael's *Disputa* and beyond – of dividing a pictorial composition horizontally into earthly and heavenly realms.

The Happy Instruments of Englands Preservation (*BM Satires* 1114). Etching designed by Francis Barlow and published (according to the manuscript annotation) on 27 April 1681

ESSELENS, Jacob
Amsterdam 1626 – Amsterdam 1687

In his marriage contract of 1662 with Janneken Jans, Esselens was described as 'Schilder' (artist), but in a will of 1677 as 'Coopman' (merchant). He was the owner of a textile company specialising in velvets and silks, which traded throughout Europe: many of his drawings were probably made during his business travels. He was in London in 1665–6; most of his English views, like those by Schellinks (q.v.), were acquired by the Amsterdam merchant Laurens van der Hem for his vast collection of topographical material, now in the Austrian National Library, Vienna, and another small group of London views is in Copenhagen. A group of twenty-seven landscape drawings made by Esselens in France is recorded in the catalogue of Jan Pieterz. Zomer (d.1726), and he also drew Italian and Alpine views as well as Dutch landscapes. A few paintings by him are also known, including a signed *Landscape near Hampton Court* (Worsley Collection, Hovingham Hall, Yorkshire).

116 View of Chatham from the west

Pen and brown ink with brown wash over black lead; 120 × 154 mm (4^{11}/₁₆ × 6^{1}/₁₆ in)

PROVENANCE: A. P. E. Gasc (L 1131); B. Houthakker, 1971?; John Baskett, 1972

LITERATURE: P. Hulton, 'Drawings of England in the Seventeenth Century by Willem Schellinks, Jacob Esselens and Lambert Doomer, from the Van der Hem Atlas of the National Library, Vienna', *Walpole Society*, XXXV (1954–6), p. 12, under no. 12

Yale Center for British Art, Paul Mellon Collection (B1975.4.1642)

A preparatory study for a signed, finished drawing in the Van der Hem Atlas. The view is from the south bank of the Medway, looking past Chatham Ness over a thick belt of trees towards St Mary's. Below the church are buildings adjacent to the Old Dock or Ordnance Wharf: Chatham was a major naval dockyard (larger yards had been built further to the east in the 1620s). Prominent on the hill to the right is Hill House, or His Majesty's House at Chatham Hill as it was more formally called, which contained the Pay Office for the Navy. In the early 1660s it was occupied by Sir William Batten, a Commissioner of the Navy and MP for Chatham. Samuel Pepys recorded a visit to Chatham on official naval business on 8 April 1661, when he stayed with Batten, and called it a 'pretty pleasant house' in spite of being frightened in the night by seeing his pillow stand on end, his bedroom supposedly being haunted.

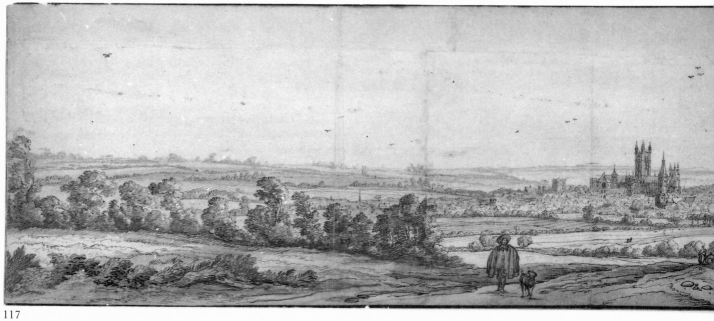

117

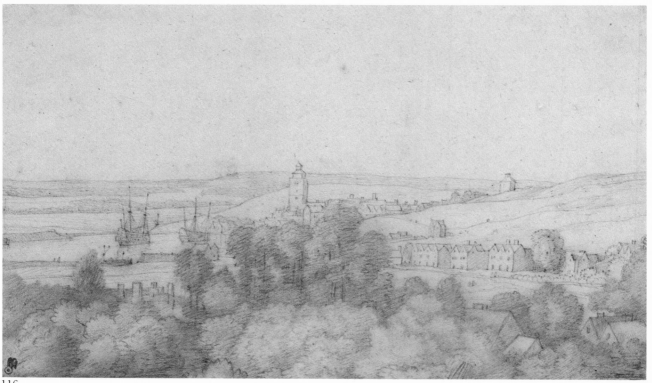

116

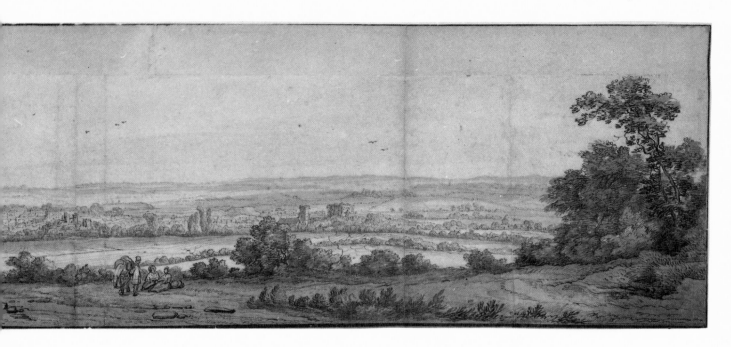

117 Canterbury from the north-west

Black lead with pen and brown ink and washes of brown and grey on four(?) conjoined pieces of paper, with an additional strip along the upper margin; 220 × 1048 mm (8⅝ × 41¼ in)

Inscribed on the verso by Willem Schellinks with a list in Dutch of the churches and gates of the city (*De Kercken en Poorten van Cantelberg*), and with the arms of Canterbury

PROVENANCE: Henry Graves & Co.

LITERATURE: Hind, IV, 11 (as by Schellinks); P. Hulton, 'Drawings of England in the Seventeenth Century by Willem Schellinks, Jacob Esselens and Lambert Doomer, from the Van der Hem Atlas of the National Library, Vienna', *Walpole Society*, XXXV (1954–6), pp. xxiii, 21; ECM & PH 1

The British Museum (1856-6-14-155)

Formerly thought to be by Willem Schellinks, who drew at least two large panoramic views of Canterbury (Austrian National Library, Vienna), this drawing contains so many passages in the distinctive style of Esselens that it is now attributed to him. However, the inscriptions on the verso are undoubtedly in Schellinks's handwriting and it has been suggested (see Hulton, op. cit.) that it may have been a collaborative effort, in which Esselens developed a sketch begun by Schellinks. Both artists worked for Laurens van der Hem and it is possible that he asked Esselens to complete an unfinished study.

The cathedral is shown with Lanfranc's tower (the Arundel Tower) intact: its steeple was removed in 1704 after being damaged in a storm and the tower itself was demolished in 1834.

SIBERECHTS, Jan

Antwerp 1627 – London *c.*1703

The son of a sculptor of the same name. Nothing is known of his early training, although he may have visited Italy between about 1645 and 1648, the year in which he became a member of the Antwerp Guild of St Luke. Siberechts specialised in painting pastoral scenes, which reflect the influence of contemporary Dutch-Italianate artists such as Berchem, Dujardin and Both and a knowledge of Rubens's landscapes. He is said to have been brought to England by George Villiers, 2nd Duke of Buckingham, who had seen landscapes by Siberechts in Antwerp in 1670. In 1672 Siberechts and his family were still living in Antwerp, but he seems to have been in England by 1674. He was to become the leading topographical painter of the period in England, merging his own style with the demands of country house portraiture. His patrons included Sir Thomas Thynne of Longleat; Henry Jermyn, 1st Lord Dover; Philip Stanhope, 1st Earl of Chesterfield, and Sir Thomas Willoughby of Wollaton Hall. He also seems to have been employed as a decorative painter, but such work was later dismissed by Vertue as 'not much esteem'd – or valued I suppose done for furniture' (V, p. 52). A few watercolours made by Siberechts in England survive (some of the earliest topographical landscapes to have been painted in this medium) and these are among his most attractive works. His date of death is uncertain: writing in 1706, Buckeridge noted that he died 'about three Years ago in *London*, and lies Bury'd in St. James's Church, being 73 Years old', but no record is to be found in the church's registers. His younger daughter, Frances, married the sculptor John Nost (q.v.).

118

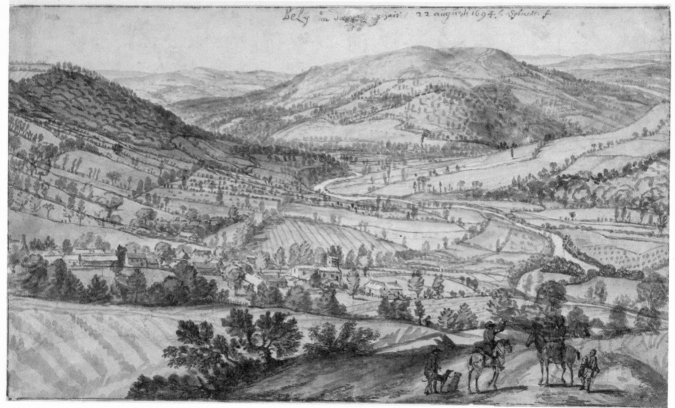

119

118 A felled tree

Watercolour and bodycolour over black lead; 166 × 401 mm (6½ × 15¾ in)

PROVENANCE: By descent in the Blofeld family, Hoveton House, Norfolk (noted in the Blofeld MS catalogue as 'A very curious drawing by Sybrecht of a cut down tree and cattle'); J. C. Blofeld

LITERATURE: ECM & PH 1

The British Museum (1909-4-6-8)

The attribution of this watercolour to Siberechts is long-standing and there seems no reason to doubt it, despite Fokker's rejection (*Jan Siberechts, Peintre de la Paysanne Flamande*, Brussels, 1931, p. 112). The subject is characteristic of Siberechts and may be compared with a *Study of a gnarled tree* in the Institut Néerlandais, Paris, and with a *Study of brushwood* in the Fitzwilliam Museum, Cambridge. Whether it was painted before Siberechts left Antwerp or after he came to England is uncertain, but the fact that it came from a collection formed in England during the eighteenth century suggests that it may date from his years in this country.

119 View of Beeley, near Chatsworth

Watercolour and bodycolour, heightened with white; 285 × 455 mm (11³⁄₁₆ × 17¹⁵⁄₁₆ in)

Signed: *Bely in darbyshair 22 Augusti 1694 J. Sybrecht. f.*

PROVENANCE: William Harris, 6th Earl of Malmesbury (sale, Christie, 21 April 1950, lot 102); H. M. Calmann

LITERATURE: ECM & PH 2; Stainton (1985) 5

The British Museum (1952-4-5-10)

This watercolour belongs to a group of hilly landscapes, two of which – this one and another inscribed *By Chatsworth in Derbyshire* (Rijksprentenkabinet, Amsterdam) – are dated 1694. Another watercolour in the same Amsterdam collection, inscribed *A View of ye Peak in Derby-shire*, is dated 1699, while a fourth (Institut Néerlandais, Paris) shows similar countryside, suggesting that it too may have been painted in 1694 or 1699. Siberechts and Knyff were called to Chatsworth in September 1699 by the 1st Duke of Devonshire to take prospects of the house, probably to record the completion of a phase of new building, but although an engraved view by Knyff was published in *Britannia Illustrata* (1707), no existing painting can convincingly be attributed to either artist.

The village of Beeley lies immediately to the south of Chatsworth: it was not acquired by the Dukes of Devonshire until 1747. Siberechts's view combines the approach of a landscape artist with that of a cartographer. Figures in the foreground are seen admiring the prospect (a suggestion that they were painted by John Wootton is unlikely). Siberechts's method of drawing with the brush in colour differs from the usual practice at the period of laying in the tones in grey wash and adding the tints later.

SCHELLINKS, Willem
Amsterdam 1627 – Amsterdam 1678

His father was perhaps the surveyor Daniel Schellinks, and he was the eldest of four brothers, of whom the second, Daniel (b.1628/9), was probably an amateur artist. After an apprenticeship to Karel Dujardin (c.1622–78), Schellinks began to travel extensively. His first documented journey (he kept a journal, now in the Royal Library, Copenhagen) was to France in 1646, where he met up with a fellow artist, Lambert Doomer (1624–1700). Together they visited north-west France, but quarrelled, and Schellinks returned alone to Amsterdam. Among Schellinks's most important commissions were the drawings he made for Laurens van der Hem (1621–78), a member of a wealthy Amsterdam merchant family who formed one of the most important seventeenth-century collections of topographical material; at the time of his death it amounted to forty-six volumes, and was sold after his daughter's death in 1730 to Prince Eugène of Savoy. Since 1737 the Van der Hem Atlas has been in the Austrian National Library, Vienna. Agatha van der Hem stated that Schellinks was expressly commissioned by her father to travel and make drawings. Doubtless many of the other well-known artists who contributed to the collection were also employed in the same way. One section of the Atlas was devoted to English views, three artists being specifically mentioned: Schellinks, Esselens (q.v.) and Doomer. Schellinks's journal shows that he visited England from 14 July 1661 to 18 April 1663. The drawings he contributed to the Atlas were probably worked up after he returned to Amsterdam late in 1665, Van der Hem presumably choosing from his sketches. After his stay in England, Schellinks and his companion Jacob Thierry (a merchant's son) went on to France, Italy, Sicily, Malta, Germany and Switzerland, records of these journeys being found in numerous drawings by both artists and in Schellinks's journal. Although some paintings by Schellinks exist, he is better known as a draughtsman. A volume of poems by him was published in Amsterdam in 1654.

120 The Dutch fleet in the Medway, June 1667

Pen and brown ink with washes of grey, brown and green, over black lead, touched with red chalk; 275 × 730 mm (10⅞ × 28¾ in)

Inscribed: *Verklaringe vande bijter[?] getallen / 1. Het gros[?] vande Hollantze vloot onder d*ᵉ*. H*ʳᵉ*. L*ᵗ*. Adm*ᵃˡ*. d*ᵉ *Ruyter leggende voor de Revier van Londen. / 2. De Mont van de Revier van Roosester, of de Medwaij. / 3. 'tEsqúaden[?] onder d*ᵉ*. H*ʳ*. L*ᵗ*. Adm*ᵃˡ *van Gent veroverende / 4. 'tFort Schirenasze, en / 5. Qúeenborow, voort het / 6. Eijlandt Shepeij / 7. De plaats alwaar den groot getal schoone masten lagen, die door de/ Hollantze bootsgezellen itz.[?] zijn aan stúkken gekapt en gereúijneert. 8. De plaats waar de Engelsche 8 Schepen, meest Branders gesanken hadde om de . . . [?]/ daar door te Stoppen. / 9. Cap*ᵗ *Brakel veroverende 't Schip de Jonathan verechende[?] 42 Stúkken / 10. Heck waer[?] de swaare ijzere keten over de Revier gespannen / 11. De 2 Batterijen tot bewaaringe van de Keten op de*

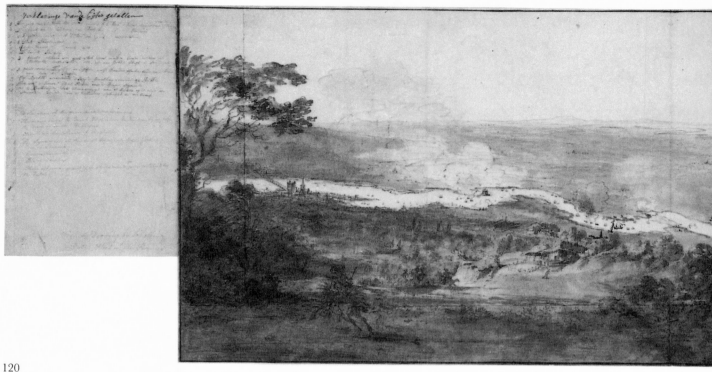

120

... [?] *een / Magazijn zijnde, door de Hollanders geplondert en verbrant,*
and annotated: *Scheppen gezonken Nota moet deze spotje wel 3 mael to
langh* ... [?] *tot Shirnasse toe.* Various landmarks are also noted.
An incomplete key in English, in a later hand, is an attempt to
translate the Dutch.

PROVENANCE: John Dillon (sale, Sotheby, 16–19 June 1869, lot
373); Messrs Holloway

LITERATURE: Hind, IV, 9; P. Hulton, 'Drawings of England in the
Seventeenth Century by Willem Schellinks, Jacob Esselens and
Lambert Doomer, from the Van der Hem Atlas of the National
Library, Vienna', *Walpole Society*, XXXV (1954–6), pp. 1–54;
ECM & PH 8

The British Museum (1869-7-10-9)

In June 1667 the Dutch fleet, under Admiral de Ruyter,
made a daring and successful raid on the Medway, setting
fire to a number of English ships and capturing the *Royal
Charles*, the fleet flagship, which was to be displayed as a
trophy at Rotterdam for several years. This drawing and
two others in the Van der Hem Atlas in Vienna (see
Hulton, op. cit.) are probably careful reconstructions
from first-hand accounts of the action, although it is
possible that Schellinks was an eye-witness of the attack.
An inscription in the artist's hand on another drawing
showing the Dutch raid (in the Ashmolean Museum; see
Brown (1982) 206) notes 'Naar't leven afgetekent door
W:S' ('Drawn from the life of W:S'). While in England
between July 1661 and August 1663, Schellinks had made
drawings of Rochester, Chatham and Dover – all strategi-
cally important – and he was later able to incorporate
comparatively accurate topographical details in the draw-
ings he made after the 1667 attack. It has been suggested
that Schellinks was working for the Dutch intelligence
services as well as for his patron Van der Hem when he
visited England, partly because of his evident predilection
for drawing fortifications, harbour installations and the
disposition of naval vessels. But it is unlikely that those
who planned the raid on the Medway could have derived
much detailed information from the drawings.

The details of the raid, as drawn and described here by
Schellinks, follow contemporary Dutch accounts very
closely. In this drawing, the viewpoint he assumes is
south-east of Rochester and is a half map- half bird's-eye-
view, with numerous inscriptions and an incomplete key
by the artist: his intention was to give a conspectus of
events. No related paintings or engravings are known,
although at least one painting by Schellinks (Rijks-
museum, Amsterdam) and two engravings, one by
Romeyn de Hooghe, are connected with one of the
drawings in the Van der Hem Atlas.

The humiliation and panic caused in England by the
Dutch attack is vividly described in the diary of Samuel
Pepys, who as a prominent naval official was closely
involved and subsequently much concerned with efforts at
Naval reform. Another diarist, John Evelyn, visited
Chatham at the end of June 1667, 'thence to view not
onely what Mischiefe the Dutch had don, but how trium-
phantly their whole Fleete lay within the very mouth of
the Thames, all from Northforeland, Margate, even to the
Buoy of the Nore, a Dreadfull Spectacle as ever any
English men saw, & a dishonour never to be wiped off'.

OVERBEEK, M. van

active *c*.1665

The drawing discussed below is one of a number of views in England, the Netherlands, France and Italy which are clearly to be attributed, by their style and inscriptions, to the same artist. Two of his views of London (Museum of London and the Louvre, Paris) show Old St Paul's before the Great Fire, and indicate that the artist was in London before 1666. Certain of the drawings are inscribed on the verso with the letters *M V O*, which have been identified as the initials of a member of the Van Overbeek family, either Matthaeus, who was recorded as buying works by Dürer and Lucas van Leyden in 1634 (Hind, IV, p. 33), or Michiel, who published views of Rome by Bonaventura van Overbeek in 1708.

121 Copper mills near Kingston, Surrey

Pen and brown wash, touched with white on brown prepared paper; 105 × 211 mm (4⅛ × 8⁵⁄₁₆ in)

Inscribed in the artist's hand: *Coper* [M]*ills. about Kingston*

PROVENANCE: Dr John Percy (listed as an anonymous drawing in the MS catalogue compiled by the collector: 'seems to have been

121

122

engraved . . . I have had it a long time before it was mounted (J.P. Sep 26 1886)'); probably in the Percy sale, Christie, 24 April 1890, lot 1434; J. P. Heseltine (sale, Sotheby, 29 May 1935, lot 306); Colnaghi; Edward Croft-Murray

LITERATURE: *Original Drawings by British Painters in the Collection of J. P. Heseltine*, London, 1902, n.p., under 'Anonymous, no. 1'; *Victoria County History of Surrey*, II, London, 1907, part 2, pp. 254–5, 275, 327, 414; *The Shock of Recognition*, exh. cat., Tate Gallery, London, 1971, no. 79

Private Collection

The present drawing is typical of those attributed to Overbeek. Its precise subject has not been identified, but since all the English views by the artist are in the south-eastern part of the country it may be assumed to be in the vicinity of Kingston, Surrey. From as early as 1589, when George Evelyn, the grandfather of the diarist, established his gunpowder manufactories, there were a number of industrial mills (driven by water-wheels as shown here) along the Hogsmill Stream which ran into the Thames just to the south of Kingston. No copper mills are recorded there in the seventeenth century but there are known to have been both copper and brass mills nearby in Esher, Sheen and Wandsworth. It appears that the trade was carried on by the Dutch in particular, and for many years Dutchmen in Wandsworth held the secret of the manufacture of brass frying-pans.

The drawing's provenance can only be traced back for a little over one hundred years, but during that period it has belonged to three distinguished collectors: Dr John Percy (1817–89), a metallurgist and amateur artist who also owned the portrait by Thomas Forster of George St Lo (no. 195); J. P. Heseltine (1843–1929), stockbroker, collector and trustee of the National Gallery; and Edward Croft-Murray (1907–80), Keeper of Prints and Drawings at the British Museum.

DANCKERTS, Hendrik

The Hague *c*.1630 – The Hague? after 1679

Trained first as an engraver, Danckerts took up landscape painting on the advice of his brother Johan (*c*.1615–*c*.1661), who was Dean of the Guild of St Luke at The Hague, of which Danckerts himself became a member in 1651. He probably visited England briefly in the summer of 1650, perhaps at the invitation of Lely (q.v.) (see Whinney and Millar, p. 263): in 1653 he travelled to Italy, later using drawings he had made there for his large classical landscapes. Shortly after the Restoration Danckerts returned to England, where his first documented works were five prospects (including three of Rome) commissioned in the autumn of 1666 for the Earl of Clarendon's new house in Piccadilly. He subsequently became popular as a painter of decorative overmantels and overdoors, his patrons including the Earl of Berkeley, for whom he painted views of Whitehall Palace and Nonsuch Palace, and the Earl of Sandwich, who commissioned views of Plymouth and Tangier (where he had established an English garrison in 1661/2) in 1669. Sandwich's protégé Samuel Pepys commissioned four prospects of royal palaces – Whitehall, Hampton Court (for which he later substituted a view of Rome), Greenwich and Windsor – in 1668/9, perhaps as symbols of his respect for the Crown, and described the finished paintings as 'mighty pretty'. Buckeridge noted that Danckerts was 'employed by Charles II to paint all the sea-ports in England and Wales; as also the Royal Palaces; which he performed admirably well'; views of Hampton Court (about 1665–6), Tangier (about 1669), Falmouth (1674) and Portsmouth (about 1675) are in the Royal Collection, as are a number of classical landscapes. The attribution to Danckerts of the celebrated picture in which Charles II is shown being presented with a pineapple by the gardener John Rose (about 1675; Houghton Hall, Norfolk) is doubtful. A payment of £34.5*s*.6*d*. to 'Henry Dankart for several prospect pictures and landscapes by the King's command' in 1678/9 is the last reference to him in Eng-

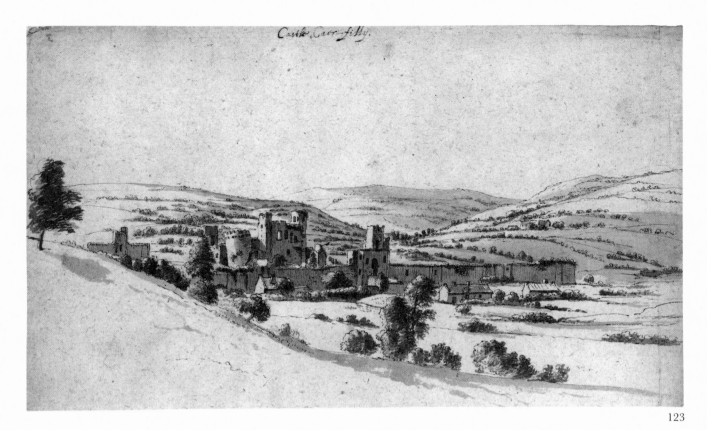

123

land: a Catholic, he was forced to leave the country during the anti-Catholic hysteria aroused by the Popish Plot, and returned to Holland.

122 Badminton House, Gloucestershire, from the east

Pen and brown ink with brown and grey wash on three conjoined pieces of paper; 283 × 827 mm (11⅛ × 32⁹⁄₁₆ in)

Inscribed with colour notes on the horizon by the artist and, in a later hand: *42* and *Country House 72* and on the verso: *No. 10, No 61* and *No 41 Prospect of two Country houses by Dankers*

PROVENANCE: Lt. Gen. William Skinner, RE; J. Skinner; Lt. Monier Skinner, RE; War Office; transferred to the British Museum, Dept of Manuscripts, 1887; transferred to Dept of Prints and Drawings, 1948

LITERATURE: ECM & PH 4; Harris (1979), p. 57, no. 47

The British Museum (1948-11-26-11)

One of two views of Badminton by Danckerts in the British Museum: the other shows the house from the north. The seat of the Dukes of Beaufort, Badminton was rebuilt largely in its present form during the second half of the seventeenth century by Henry Somerset (1629–99), 3rd Marquess of Worcester, created 1st Duke of Beaufort in 1682, but the identity of the architect is not known. Danckerts's views were probably made in the 1670s, but there are no related paintings; in this drawing, the propor-

tions of the cupola above the central block of the house have been exaggerated. The beginnings of the axial tree-planting in the park can be seen here: by about 1705, Thomas Smith's paintings of the house (see Harris, op. cit., p. 125) show avenues of mature trees.

Although primarily a house portrait, Danckerts's drawing reveals a sensitivity to landscape and a freshness of mood that contrasts with his more formal oil-paintings.

123 Caerphilly Castle

Pen and black and brown ink with grey wash; 250 × 423 mm (9¹³⁄₁₆ × 16⅝ in)

Inscribed by the artist: *Castle Caer-filly*, and on the verso: *5*

PROVENANCE: Iolo Williams; Colnaghi, 1964

LITERATURE: White (1977) 6

Yale Center for British Art, Paul Mellon Collection (B1977.14.4676)

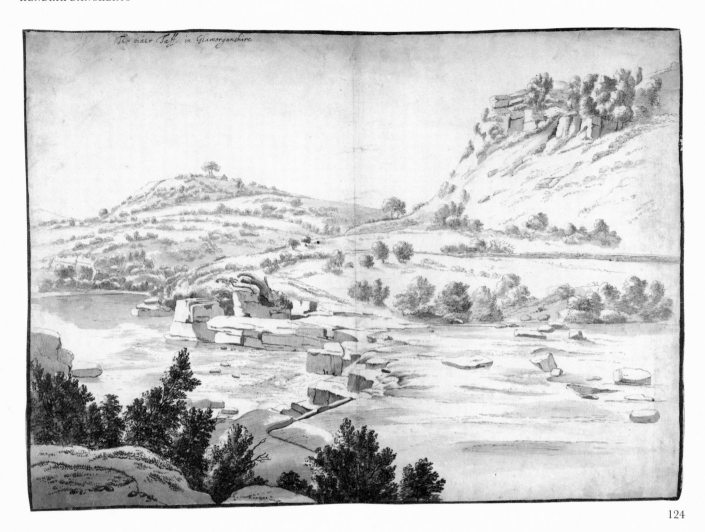

The river Taff. in Glamorganshire

124

124 View on the River Taf

Pen and grey ink with grey wash and touches of black; 420 × 560 mm (16½ × 22¹⁄₁₆ in)

Inscribed by the artist: *The river Taff. in Glamorganshire*

PROVENANCE: William James Harris, Viscount FitzHarris (sale, Christie, 21 April 1950, lot 100); Colnaghi

LITERATURE: ECM & PH 6

The British Museum (1957-7-13-1)

Danckerts travelled extensively in Britain in connection with topographical commissions. Most of his paintings, though greatly admired by his contemporaries, including Charles II and Samuel Pepys, who thought his work 'mighty pretty', are stiff and almost primitive in handling. By contrast, his surviving drawings have an immediacy and a feeling for place which are very striking.

These drawings, perhaps dating from the early 1670s, and a second view of Caerphilly Castle in the Yale Center for British Art (B1977.14.5651) are similar in style and may well, to judge from the number inscribed on the verso of no. 123, have been intended as part of a series of views in the surrounding area. Caerphilly Castle, in Glamorganshire, originally built about 1270 and subsequently extended, was the largest in Wales, covering thirty acres. Danckerts's view is taken from the south-east, looking towards the so-called Grand Front, with the Leaning Tower to the left of the central Keep, and the North Platform to the right. The view on the River Taf, also in Glamorganshire, anticipates similar drawings by Francis Place.

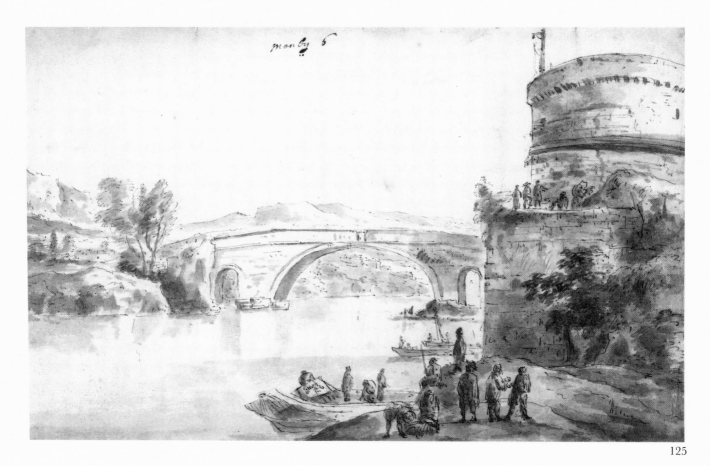

125

MANBY, Thomas

London? 1633 – London 1695

Perhaps the Thomas Manby whose baptism is recorded at St Martin-in-the-Fields on 30 May 1633. Little is known about his life or career, but Buckeridge, writing in 1706, described him as 'a good *English* Landskip-Painter, who had been several times in Italy, and consequently painted much after the *Italian* manner': Manby was among the earliest British artists to have worked in Italy. The dates of these visits are unrecorded, but he probably returned finally to London before 1685, as Buckeridge states that 'he was famous for bringing over [from Italy] a good Collection of pictures, which were sold at the *banqueting-*house about the latter end of king Charles IId's Reign'. He seems to have continued his activity as a picture dealer in partnership with the sculptor Edward Pierce (q.v.), and after their deaths their 'curious Collection of Books, Drawings, Prints, Models & Plaster Figures' was auctioned on 4 February 1695/6 'at Mr. John Cocks, the Golden Triangle in Long Acre, to be continued daily till sold'. The only other contemporary references to Manby occur in Charles Beale's notebooks; in 1676 Manby painted the landscape background for Mary Beale's copy of a Lely portrait, for which he was paid in kind with '2 ounces of very good Lake. of my makeing – & 1 oz ½ pink'.

In the same year, Beale sent him a copy of Antonio Doni's *Disegno . . . partito in piu ragionamenti, ne quale si tratta della Scoltura et Pittura* (1549) and in 1681 lent him 'my Leonardo da Vinci trattato della Pittura'. Manby died in November 1695, and was buried at St Martin-in-the-Fields on 24 November.

125 The Ponte Lucano, near Tivoli

Pen and brown ink with grey wash; 235 × 363 mm (9¼ × 14¼ in)

Inscribed: *Manby 6*

PROVENANCE: Francis Place?; by descent to Patrick Allan Fraser of Arbroath (sale, Sotheby, 10 June 1931, lot 149); Iolo Williams; Colnaghi, 1964

LITERATURE: I. Williams, 'Thomas Manby, a 17th Century Landscape Painter', *Apollo*, XXIII (1936), pp. 276–7; I. Williams, *Early English Watercolours*, London, 1952, p. 6; *Early English Watercolours from the Collection of I. A. Williams*, exh. cat., Graves Art Gallery, Sheffield, 1952, no. 5; D. Bull, *Classic Ground*, exh. cat., Yale Center for British Art, New Haven, 1981, no. 113

Yale Center for British Art, Paul Mellon Collection (B1977.14.5699)

A group of eleven drawings, formerly in the collection of Patrick Allan Fraser of Arbroath, comprises Manby's

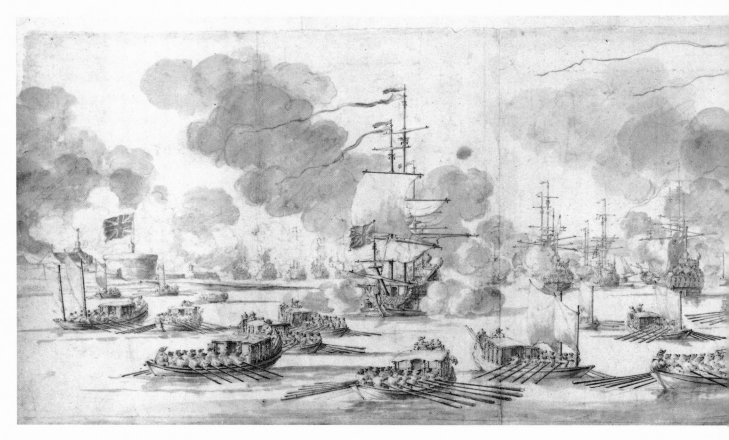

126

known oeuvre. They are all views in Italy, chiefly in the Roman Campagna, and show the influence of the Dutch-Italianate tradition of draughtsmanship, in particular the wash drawings of Poelenburgh, Breenbergh and Asselyn. This drawing is a view of the twelfth-century Ponte Lucano, on the River Anio below Tivoli, with the Tomb of Plautius, built in AD 2 by the consul M. Plautius Silvanus and one of the best-preserved examples of Roman sepulchral architecture. Manby's view was almost certainly not made on the spot, since he has drawn the bridge inaccurately and has altered its relationship to the tomb.

VELDE the Elder, Willem van de

Leiden 1611 – London 1693

VELDE the Younger, Willem van de

Amsterdam 1633 – London 1707

The work of these artists, father and son, was so closely interdependent that they are here treated together. Van de Velde the Elder was the son of a sea-captain of Flemish origin. Nothing is known of his training, but he seems to have begun his career as a marine artist in the mid-1630s:

he must have been making drawings for some time before the earliest dated example in 1638. From the 1640s he was frequently employed in an official capacity by the Dutch navy, and in 1653 was described as 'Draughtsman of the fleet', with the use of an official galliot from which to observe naval engagements. He was present at many of the most important battles of the Anglo-Dutch Wars, including Scheveningen in 1653, Lowestoft in 1665, the Four Days in the following year, and Solebay in 1672, as well as witnessing the Battle of the Sound in 1658, when the Dutch, in support of the Danes, fought the Swedes. Many of his surviving drawings were made during the battles and lightly worked up with wash afterwards; subsequently he would develop subjects into finely detailed grisailles, drawn with pen and brush on a panel prepared with a white ground.

Van de Velde the Younger was his parents' eldest son, and he was the brother of the artist Adriaen van de Velde (1636–72). For a short time he seems to have been the pupil of Simon de Vlieger (c.1600–1653), whose atmospheric style was very different from the meticulous ship portraiture of Van de Velde the Elder and must have influenced him considerably. From the outset of his career he worked closely with his father, frequently using his drawings as the basis for paintings. In the winter of 1672–3 the Van de Veldes moved to England, where they

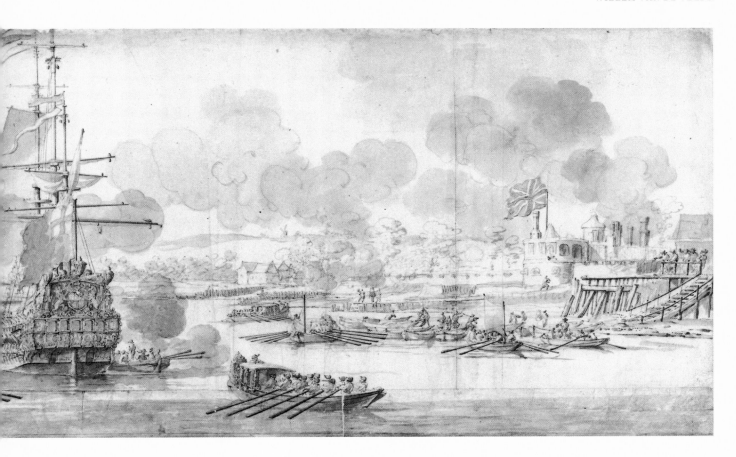

were to be based for the rest of their lives. (Van de Velde the Elder had already made an extended visit to England in 1660–62, after accompanying the squadron that escorted the restored King Charles II.) Their decision to settle in England while the Third Anglo-Dutch War was still in progress was largely due to the French invasion of the Netherlands. A Dutch contemporary, Pieter Blaeu, wrote that Van de Velde the Elder 'as a result of the bad conditions here during these wars, can not do his work'. In May and June 1673, he was present at the Battle of Schooneveld, but this time accompanying the English fleet and including their ships, rather than the Dutch, in the foreground. In January 1674, a warrant from Charles II specified a salary of £100 'unto William Van de Velde the Elder for taking and making Draughts of seafights, and the like Salary . . . unto William van de Velde the Younger for putting the said draughts into Colours for our particular use', and they apparently had a studio in the Queen's House at Greenwich. With the end of the Anglo-Dutch War, their official commissions were chiefly connected with peacetime events: naval reviews, the launchings of ships, and other royal events such as the arrival of Mary of Modena in England in 1673 and the journey of Princess Mary and William of Orange to Holland in 1677.

Van de Velde the Elder continued working into his old age. The son spent less time at sea than his father, although following the latter's death in 1693 he is recorded in 1694–5 as accompanying the English fleet under Admiral Edward Russell to the Mediterranean. He revisited Amsterdam in 1686, where he painted a large picture of shipping on the River IJ for the City of Amsterdam. William Gilpin, the writer on the Picturesque, recorded in 1791 that an old Thames waterman remembered taking Van de Velde on the river to study the sky: 'Mr Vandervelt took with him large sheets of blue paper, which he would mark all over with black and white . . . These expeditions Vandervelt called in his Dutch manner of speaking *going a skoying*'. His last drawing is dated 1707, the year of his death. Both artists, more especially the son, influenced the English school of marine painting and draughtsmanship, in particular Peter Monamy (1681–1749), Samuel Scott (1701/2–72) and Dominic Serres (1722–93).

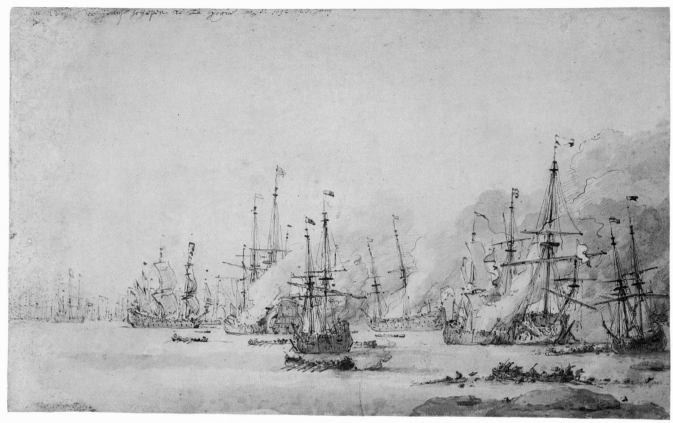

127

126 The arrival of King Charles II at Gravesend to receive Mary of Modena (1658–1718), 26 November 1673

Black chalk and grey wash with pen and black ink, on five conjoined pieces of paper (made up at the top); 327 × 1103 mm (12⅞ × 43⁷⁄₁₆ in)

Inscribed: *No 2*

PROVENANCE: Samuel Woodburn (sale, Christie, 27 June 1854, lot 2459?); W. B. Tiffin

LITERATURE: ECM & PH 35

The British Museum (1854-6-28-80)

One of four drawings in the British Museum connected with the arrival in England of Mary, daughter of Alfonso IV, Duke of Modena, in November 1673; another four drawings are in the National Maritime Museum, Greenwich (M. Robinson, *A Catalogue of the Drawings in the National Maritime Museum made by the Elder and the Younger Willem van de Velde*, Cambridge, 1958, nos 411–14).

The marriage of Mary and the widowed James, Duke of York, later James II, was promoted by Louis XIV and Pope Clement X. The ceremony took place in Modena on 30 September 1673, the Earl of Peterborough standing proxy for the Duke. After travelling overland through France, the Princess and her party embarked at Calais for England on board the royal yacht, the *Cleveland*, landing

at Dover on 21 November. Here she was met by her husband and travelled with him by road to Gravesend, where they were received by the King on 26 November; from here the royal party proceeded by barge up the Thames to Whitehall.

127 The destruction of the French ships in the Bay of La Hogue, May 1692

Pen and brown and black ink, with grey and brown wash, over black chalk; 299 × 467 mm (11¾ × 18⅜ in)

Inscribed: *het brunden der franse schepen te La Hogue no 5:1.2.3.junij* [here burn the French ships at La Hogue no 5:1.2.3. June (according to the New Style calendar used on the Continent)] and *W.V.V.J. 1692*. Inscribed on the verso: *N76 Vandervelde A:D:1779–*

PROVENANCE: Marseille Holloway

LITERATURE: ECM & PH 50

The British Museum (1872-7-13-443)

In 1692, misled by the advice of the exiled James II, Louis XIV planned an invasion of England, which was to be led by James. In preparation for this, the French admiral the Comte de Tourville was ordered to engage the combined English and Dutch fleet, from which it was believed that many desertions could be expected from disaffected Eng-

lish officers still loyal to James and that the French would thus achieve victory. In fact the French fleet was outnumbered, and was defeated on 19 May off Cap Barfleur, although Tourville's tactical ability saved his ships from immediate disaster. The French retreated towards the Channel Islands, pursued by the allied fleet, twenty ships returning safely through the Race of Alderney (a dangerous tidal passage) to St Malo. Before the remaining fifteen could follow, the tide changed and they were swept eastwards and leeward of the English. Three ships sought refuge at Cherbourg, while the twelve others made for the bay of La Hogue. Here, on 23–24 May (Old Style) they were burned by an English squadron under the command of Vice-Admiral Rooke.

This drawing is one of three in the British Museum which show the same incident. Although it is inscribed 1692, its companion (1872-7-13-445) is dated 1701, and it is probable that they were both drawn at this later date. Van de Velde may perhaps have been present, although unlike his father he did not regularly spend time at sea. While his father's talent lay chiefly in his ability to make rapid and accurate on-the-spot sketches, the son transformed such information into dramatic paintings. His drawing style is spirited but more summary, characterised in later years, as here, by the use of pen and brown ink outline.

128

LOGGAN, David

Danzig 1634/5 – London 1692

If the inscription *aet. 20 1655* on a self-portrait noted by Vertue is correct (I, p. 105), Loggan was born in 1634/5, the son of an Oxfordshire merchant of Scottish descent living in Danzig. He studied first in Danzig under Willem Hondius (c.1597–c.1658) and later in Amsterdam under Crispin de Passe the Younger (c.1589–c.1677). By about 1658 Loggan was living in London, where he collaborated with Hollar (q.v.), engraving some of his drawings, and worked for several publishers. In 1665 (perhaps to escape the Plague in London) he moved to Oxfordshire, and was appointed 'public sculptor' (engraver) to the University in 1669 at a stipend of 20 shillings per annum. His friendship with the antiquary Anthony Wood probably provided the stimulus for the publication in 1675 of his famous series of engraved plates, *Oxonia Illustrata*, a companion to Wood's *History and Antiquities of the University of Oxford* (1674). From about 1676 until 1690 Loggan was engaged on a similar project, *Cantabrigia Illustrata*, and was appointed engraver to Cambridge University, continuing, however, to hold his Oxford appointment until his death. With William Faithorne (q.v.), he was one of the first artists in England to specialise in miniature portraits drawn in black lead, his likenesses being characterised by great delicacy of touch and elaborate treatment of decorative detail. According to Vertue, Loggan brought a number of Dutch engravers to England, includ-

ing the mezzotinter Abraham Blooteling (1632–98). Robert White (q.v.) was one of his pupils.

128 John Wilmot, 2nd Earl of Rochester (1647–1680)

Black lead, tinted with light brown wash, on vellum; 136 × 116 mm (5⅜ × 4⁹/₁₆ in)

Signed: *D. L. delin 1671*

PROVENANCE Miss Warre (sale, 1874, bought by Miss Adair, by whom presented in 1903)

LITERATURE: ECM & PH 10; Graham Greene, *Lord Rochester's Monkey*, London, 1974, p. 91

The British Museum (1903-3-9-1)

Although this drawing is not inscribed with the sitter's name, there is no reason to doubt the traditional identification that it is a portrait of Lord Rochester, the poet and intimate of Charles II, celebrated for his wit and profligacy. The appearance of the sitter in this drawing corresponds closely with the portrait of Rochester crowning his monkey, about 1670 (Lord Warwick), attributed to Jacob Huysmans, and with a portrait by Lely, about 1677 (Beckett 444). According to the date inscribed on it, this drawing must have been made when Rochester was about 24. It is one of Loggan's most accomplished portrait studies, the features being drawn with great sensitivity, while the differing textures of the sitter's wig, face and elaborate costume are brilliantly depicted.

Designed by Edwd Pierce for ye Duke of Buckingham to be set up in Westminster Abby.

129

PIERCE, Edward

London c.1635 – London 1695

The first recorded event in Pierce's career is his admission to the freedom of the Painter-Stainers' Company by patrimony in 1656 (his father Edward Pierce (1598–1658) was, as Vertue noted, a well-known decorative painter); in 1693 he was Master of the Company. However, he in fact became a sculptor, mason-contractor and architect. Nothing is known of his training, but before 1660 he had modelled busts of Milton (conceivably *ad vivum*) and Cromwell, and from 1663 to 1665 he was working as a mason under Sir Roger Pratt at Horseheath, Cambridgeshire. After the Great Fire, Pierce secured a number of masonry contracts for City churches, notably St Paul's, and, as Vertue observed, 'was much employed by Sʳ Chr. Wren in his Carvings and Designs (v, p. 9). As a sculptor, he is best known for his fine portrait busts of Cromwell (1672) and Wren (1673), both in the Ashmolean Museum, Oxford; his equal facility in wood-carving has resulted in the misattribution of some of his work to Grinling Gibbons (q.v.). Pierce was occupied with decorative carving up to the end of his life, working at Hampton Court in the 1690s (see no. 130). As an architect, his most important commission was the Bishop's Palace at Lichfield, built to his design in 1686–7. His last work was probably the design and erection of the Seven Dials column, Covent Garden, in 1694 (the drawing for which is BM 1881-6-11-177). Pierce was also a collector; after his death, his friend the architect William Talman (1650–1719) was 'to have the choise and picking of what shall seeme to make up the worthy colection he intends' from his 'Clositt of Books, prints and drawings'. The remainder of his collection was sold by auction with that of Thomas Manby (q.v.) in 1696.

129 Design for a monument to George Villiers, 2nd Duke of Buckingham (1627/8–1687) and Mary, Duchess of Buckingham (d. 1704)

Pen and brown ink over black lead, with washes of grey and brown (perhaps indicating the parts to be carried out respectively in marble and gilded bronze); 505 × 495 mm (19⅞ × 19½ in)

Inscribed (in William Talman's hand): *Designed by Edwd. Pierce for ye Duke of Buckingham to be Set up in Westminster Abby.*

PROVENANCE: William Talman; John Talman (L 2462; sale, 4–10 April 1728, lot 23 or 132?); Richard Bull (sale, Sotheby, 23 May 1881, lot 106); purchased at the Bull sale through A. W. Thibaudeau

LITERATURE: ECM & PH 1; Whinney (1964), p. 47

The British Museum (1881-6-11-176)

While there is no contemporary evidence to suggest that Pierce was commissioned to design a monument to the 2nd Duke of Buckingham, there is no reason to doubt the inscription on this drawing, which is in the hand of the architect and collector William Talman (1650–1719),

Comptroller of Works to King William III from 1689 to 1702, to whom Pierce bequeathed his drawings. This monument was never erected, however, perhaps because the Duke's estate was seriously impoverished.

George Villiers, 2nd Duke of Buckingham, son of the murdered favourite of James I and Charles I (see no. 39), was brought up with the royal children and afterwards became notorious for his unscrupulous politics and profligate way of life. He was the 'B' in 'Cabal', the notorious group of informal advisers to the King which took its name from the initial letters of its five members and which wielded considerable and somewhat sinister power between 1667 and 1673. Buckingham was memorably satirised as Zimri by Dryden in *Absalom and Achitophel*:

> Stiff in Opinions, always in the wrong;
> Was everything by starts, and nothing long:
> But in the course of one revolving Moon
> was Chymist, Fiddler, States-Man and Buffoon.

He died in 1687 – as Alexander Pope later wrote, 'in the worst inn's worst room' – his Duchess (Mary, daughter and heiress of Lord Fairfax, the Parliamentarian General) surviving until 1704. The representation of the Duchess beside her husband on the sarcophagus might suggest that the present design was made after her death, but this is impossible since Pierce died in 1695. The monument may have been commissioned by the Duchess after her husband's death, or perhaps even during his lifetime. The inclusion of a dead infant in the foreground of the drawing, shown with a coronet beside him as if to indicate that he was the Duke's predeceased heir, is mysterious: it may be that there was an unrecorded stillborn baby. Buckingham had no legitimate issue and the title became extinct on his death (although by his mistress Lady Shrewsbury he had an illegitimate son who died young and was interred in Westminster Abbey under the spurious title of the Earl of Coventry).

Pierce's grandiose design is in the form of a pavilion, in the centre of which a cupola, crowned by a figure of Fame, rises above a canopy hung with drapery and decorated with a shield encircled by the Garter and surmounted by a ducal coronet. The Duke and Duchess stand as in life, pointing towards their recumbent figures on the sarcophagus. Seated along the lower step are figures symbolising Faith, Hope, Wisdom and Fortitude, and in the centre an infant with a coronet beside him, lying on drapery supported by two weeping cherubs.

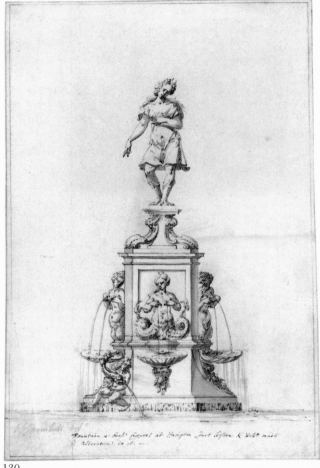

130

Sutton Nicholls:
The South Front of Hampton Court.
Etching, about 1699

130 Design for the Diana Fountain

Pen and brown ink over pencil with grey wash; 381 × 243 mm
(15 × 9⁹⁄₁₆ in)

Inscribed: (in pencil) *Sr Js Thornhill delt* and (in pen, in William
Talman's hand) *Fountain w: brass figures at Hampton Court before
K. Willm made ye alteration to it. –*

PROVENANCE: Sabin Galleries, London, 1969; Private Collection,
London

LITERATURE: J. Harris, 'The Diana Fountain at Hampton
Court', *Burl. Mag.*, CXI (1969), pp. 444–8; G. Fisher and J.
Newman, 'A fountain design by Inigo Jones', *Burl. Mag.*, CXXVII
(1985), pp. 531–2

Yale Center for British Art, Paul Mellon Collection
(B1975.4.1707)

The original Diana or Arethusa Fountain, designed by
Inigo Jones in the mid-1630s (see no. 90 and fig. on p. 127)
and originally set up in the garden of Somerset House, was
moved to Hampton Court in 1656. It survived unaltered
until about 1690, when Edward Pierce and Josias Iback,
perhaps in connection with Wren's reconstruction of the
South Front and his replanning of the Privy Garden,
carried out extensive modifications. The present drawing
seems to be Pierce's first design for altering the fountain:
the shell basins are shown beneath the sirens, and the boys
holding dolphins have been moved from their original
positions above the sirens. Surmounting the fountain is a
figure intended, to judge from the emblematic crescent
moon in her hair, as a representation of Diana. This
suggests that Pierce may have been planning to replace
the original figure with one of his own design, but
although he did alter the arrangement of the subsidiary
elements, Le Sueur's Arethusa/Diana remained un-
touched. Pierce charged £1,262.3s.0d. for 'carving done
about the ffountain in P.G. [Privy Garden] carving 8
scrowles & 4 festoons with shells & sevll foot of supp. in
the gt. stones under the cornish' and Iback £321.19s.0d.
'for Brasseworke done about the ffountaine, & for 4 large
brasse shells. new casting & repairing'. These alterations
are recorded in a crude engraving by Sutton Nicholls
(left), about 1699, which shows Le Sueur's figure on a
pedestal that matches Pierce's description of the work he
carried out. This rearrangement of the fountain has re-
mained substantially unaltered, although when it was
re-sited in Bushy Park in 1712 a new high rusticated base
was added to Pierce's pedestal (see no. 168).

131

VERRIO, Antonio

Lecce 1639? – Hampton Court 1707

Verrio is said by his early biographer De Domenici to have studied in Venice. By 1655, however, he was living in his native town, where his first patrons were the Jesuits, who also commissioned him to paint a ceiling in their college in Naples (1661). For the next five years Verrio seems to have travelled widely in Italy, but in 1666 he arrived in France, settling in Toulouse, where he established a reputation as a distinguished artist. By 1671 he was in Paris, where he became *agréé* at the Académie, submitting his *morceau de réception* in June 1672. Later in the same year he left for England, probably at the invitation of Ralph Montagu, 1st Earl and later 1st Duke of Montagu, who was himself returning home after three years as Ambassador Extraordinary to the French court.

Verrio's first English patron was Henry Bennet, 1st Earl of Arlington, for whom he worked at Euston Hall and at his London house. His knowledge of the Baroque style and his Catholicism recommended him both to Charles II and James II, his most important patrons. In 1675 he was naturalised, and embarked on his most ambitious commission, which was to be his chief occupation until about 1684, the decoration of the newly constructed north range at Windsor Castle: most of his work was to be destroyed in George IV's reconstructions. Less important commis-

Antonio Verrio:
The Sea Triumph of Charles II.
Oil on canvas, about 1674.
Reproduced by gracious permission of Her Majesty The Queen

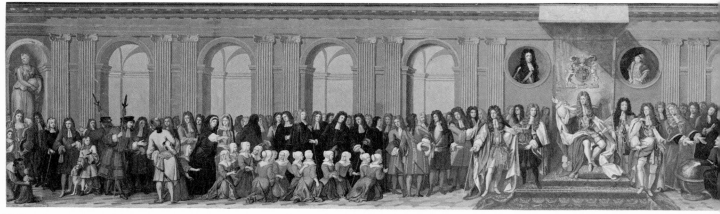

132

sions in the 1680s included the decoration of the staircase and Great Room at Montagu House, 1682–3, destroyed by fire in January 1685/6 (see no. 159). On the accession of James II, Verrio collaborated with Grinling Gibbons in the decoration of the Catholic chapel at Whitehall and was appointed principal Gardener and Surveyor to the King. When the Revolution took place in 1688, Verrio chose to retire from royal service: his post as Principal Painter was taken by John Riley (1646–91) and Godfrey Kneller (q.v.), and his loyalty to the exiled king (his son fought in James II's army in Ireland and was briefly imprisoned) caused him to look elsewhere for patronage. His most notable commission in the 1690s was the decoration of six rooms at Burghley for John Cecil, 5th Earl of Exeter, where the Heaven Room is the most brilliant example of a Baroque illusionistic interior in England. Perhaps persuaded by Lord Exeter, Verrio returned to royal service under William III, working at Windsor and at Hampton Court until 1704. Failing eyesight resulted in several less than successful paintings, notably the King's Staircase and the Queen's Drawing Room, for Queen Anne.

131 Design for an allegorical composition

Pen and brown ink with brown wash over red chalk, the original composition extended and modified by the addition on the left of two strips of paper; squared for transfer; 283 × 428 mm (11⅛ × 16⅞ in)

PROVENANCE: Bequeathed by Sir Hans Sloane, 1753

LITERATURE: ECM & PH 1

The British Museum (5214-249)

One of only a handful of drawings attributed to Verrio: the ascription to him of this sheet dates back to Sir Hans Sloane. Although the drawing has been squared for transfer, no related painting or engraving is known. The subject has not been identified, but bears some similarity to Verrio's painting *The Sea Triumph of Charles II* (about 1674) at St James's Palace (see p. 171). This drawing was perhaps intended as a preparatory study for a painting

celebrating the King as peacemaker: a prince or king holding an olive branch, attended by three female figures symbolising Royal Power, Justice and Humility, is borne forward on clouds, while three more female figures welcome him, one of them kneeling to offer a crown. Behind them is a throne, over which is a canopy supported by putti, one of whom is holding a laurel wreath.

VERRIO, Antonio, Studio of

132 King James II receiving the mathematical scholars of Christ's Hospital

Bodycolour on five conjoined sheets of paper laid down on canvas; 459 × 2356 mm (18¹⁄₁₆ × 92¾ in)

PROVENANCE: Samuel Pepys; by family descent to Samuel Pepys Cockerell (sale, Sotheby, 1 April 1931, lot 10, bought by H. Freeman); Edward Bullivant; Mr and Mrs Eric Bullivant (sale, Sotheby, 28 November 1974, lot 49); John Baskett

LITERATURE: Noon (1979) 17

Yale Center for British Art, Paul Mellon Collection (B1977.14.6307)

Christ's Hospital was founded in 1553 by King Edward VI for the education of London orphans, and in 1673, on the advice of Samuel Pepys, the diarist and senior naval administrator, King Charles II established a Royal Mathematical School within the Hospital. The intention was to ensure the supply of properly trained naval recruits with a thorough grasp of mathematical and navigational skills, a pressing need for the navy, which had been proved unprepared during the Anglo-Dutch Wars. Pepys, Secretary to the Admiralty, was a governor of the Hospital and seems to have been the prime mover in the scheme to commemorate Charles II's benefaction; in October 1677 he was charged with the selection of an appropriate 'statue, inscription or painting', and was subsequently asked 'to get some historian painter to draw a fair Table

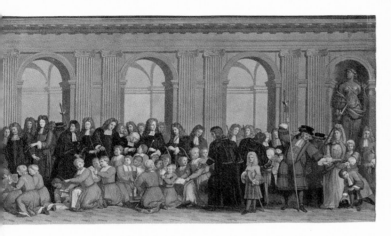

representing his Majesty and some Chief Ministers of State, The Lord Mayor, The President and some Governors, and the Children of his Majesty's Royall Foundation: a Ship, Globes, Maps, Mathematicall Instruments, and such other things as may well express his Majesty's Royall Foundation and bounty to this Hospitall'. The artist selected by Pepys was Verrio, but it was not until December 1681 that he received a formal commission, the Hall of the Hospital having been rebuilt in the meantime. In addition, a large portrait of Charles II, posed with a cannon and navigational instruments, and ships in the background, was commissioned in 1684 from Marcellus Lauron, also to be hung in the Hall. Verrio produced a *modello*, which was approved, but work on the immense canvas – it measures 16 × 87 feet – which he painted in collaboration with Louis Laguerre, progressed slowly, and was further delayed by the death of Charles II in 1685, necessitating the substitution of a portrait of James II as the principal figure in the composition: the painting was not completed until February 1687/8. As originally conceived, it consisted of three separate canvases. The central group showing the enthroned King set between portraits of Edward VI and of his brother Charles II, to whom he gestures, and surrounded by his courtiers (who include, on the King's right, George Jeffreys, 1st Baron Jeffreys (see no. 152), who had been appointed Lord Chancellor in 1685) occupied the end wall of the Hall. It was flanked on either side by the left and right sections of the composition, which show the Governors (including Pepys, who is depicted holding a scroll in his right hand and looking at a navigational map of the British Isles), the pupils and officers of the school and children of the foundation, the girls being shown with their matrons. In 1902 the paintings were rehung in one continuous frieze in the dining-hall of the Hospital's present building in Horsham, Sussex, losing much of the original effect: Verrio had carefully adjusted the background architectural perspective to allow for the way in which the panels were hung.

The present picture is a reduced copy of the composition, somewhat modified in the treatment of the architecture so that it makes sense as a continuous image,

and was doubtless painted by a member of Verrio's studio especially for Pepys. It is still in the original frame, which is surmounted by the intertwined *C* monogram of Charles II. Although it has been suggested that this is Pepys's concealed acknowledgement that it was Charles II, not James II, who founded the school, such an interpretation is unlikely, since Pepys regarded himself as a particularly devoted subject of King James II, who as Duke of York had been Lord High Admiral and a supporter of his plans for naval reform. Pepys and Verrio became friends, and in July 1688 Pepys arranged for Verrio's son to become a volunteer (a preliminary step to obtaining a naval commission) on the *Bonadventure*.

GREENHILL, John

Salisbury 1640/45 – London 1676

The eldest son of John Greenhill, a merchant and later registrar of the diocese of Salisbury. Nothing is known of his early training, but by the time he moved to London in 1662 he had apparently begun to paint portraits. He entered Lely's (q.v.) studio as an assistant, remaining with him until about 1667: Vertue described Greenhill as Lely's 'most excellent disciple'. He established a considerable reputation as a painter, working in a style that was technically dependent on Lely (with whose work his own has often been confused). As a draughtsman, his portrait drawings in chalks are nearer in style to the richly coloured drawings of artists like Ashfield (q.v.) or Luttrell (q.v.) than to Lely's essentially monochrome studies. Greenhill's crayon portraits were highly esteemed: Vertue quotes Thomas Gibson's opinion that they were 'done . . . with great skill and perfection equal to any Master whatever'. Although reputedly industrious at first, Greenhill 'fell into a debauched course of life', the result, it was said, of his association with actors, and died from injuries caused by a fall when drunk in Long Acre, Covent Garden.

133 Philip Woolrich

Pastel and black chalk; 319 × 256 mm (12⁹⁄₁₆ × 10¹⁄₁₆ in)

Inscribed on a label attached to the back of the frame: *Phillip Woolrich Esq of Dinsdale He also scraped a fine mezzotinto from this drawing which is a very scarce print. see Walpole's Anecdotes of Painting Mr Woolrich married 8th July 1676 Anne Killinghall of Middleton St George – see Granger's Biog Hist*

PROVENANCE: George Allan of Blackwell Grange by 1794; probably his son, George Allan; Mrs W. Spooner (sale, Christie, 22 November 1977, lot 102)

LITERATURE: Noon (1979) 9

Yale Center for British Art, Paul Mellon Fund (B1978.3.4)

An eighteenth-century label mistakenly attributed this drawing to Francis Place. However, although Place made a mezzotint after it, published states of the print bear

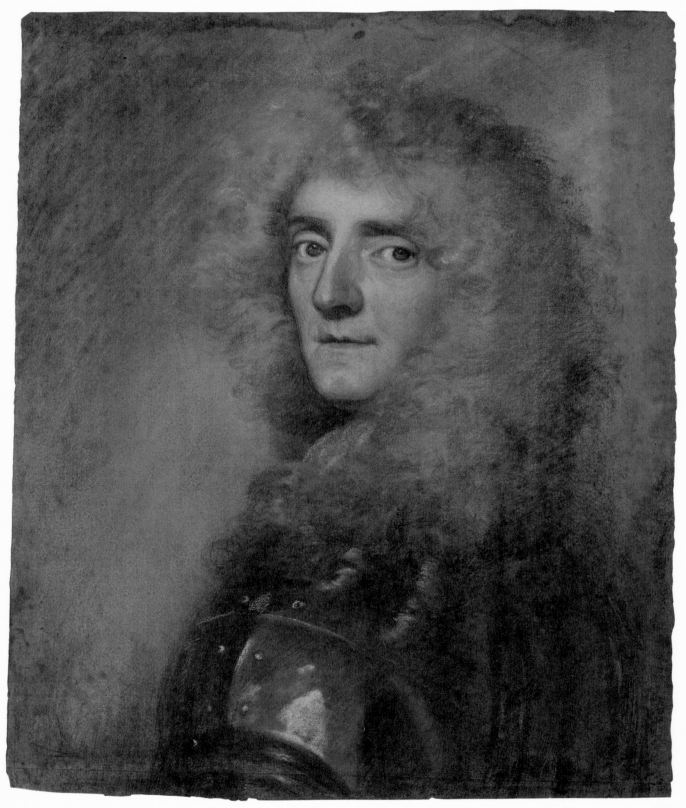

133

inscriptions clearly identifying John Greenhill as the artist and Place as the engraver. Another mezzotint thought to be by Place, of about 1667, is also after a drawing by Greenhill, *Mr Harris as Cardinal Wolsey* (1664; Magdalen College, Oxford). Little is known about the sitter, but in 1676 he married one of Place's relations, which suggests that this mezzotint may have been made at about that time.

Although it has been damaged by rubbing and staining, this portrait is one of Greenhill's finest works. In composition it closely resembles his half-length oil portrait of the Hon. Thomas Herbert (1656–1733), later 8th Earl of Pembroke (a version of which is at Wilton House), painted in about 1676, the year of Greenhill's death. Both are indebted in their design to Lely.

134 Sir Thomas Twisden (1602–1683)

Coloured chalks on buff paper; 281 × 209 mm (11 1/16 × 8 3/16 in)

PROVENANCE: Thomas Agnew and Sons Ltd

The British Museum (1986-3-1-1)

135 Lady Twisden (c.1610–1702)

Coloured chalks on buff paper; 280 × 202 mm (11 × 7 15/16 in)

PROVENANCE: Thomas Agnew and Sons Ltd; presented by the British Museum Society

The British Museum (1986-3-1-2)

Although neither is signed, these portrait drawings may confidently be attributed to Greenhill on stylistic grounds. The sitters are Sir Thomas Twisden and his wife, Jane. Called to the Bar in 1626 and elected a Bencher of the Inner Temple in 1646, Twisden was a loyalist and on the Restoration was made a Justice of the King's Bench and knighted; he was created a baronet in 1666. Political divisions in mid-seventeenth-century England were not always so clear-cut as is often supposed: Twisden seems to have benefited from the political connections of his brother-in-law Matthew Tomlinson (see below) during the Commonwealth and Protectorate, when he increased his legal practice. He was later to be the judge who, in 1661, when many prisoners were freed at the time of Charles II's coronation, refused to allow Bunyan (see no. 138) to be released from Bedford gaol.

Jane Twisden was the sister of Matthew Tomlinson (1617–81), a supporter of the Parliamentary and Cromwellian cause, in whose custody Charles I had been placed during the last weeks of his life. After the King's execution, Tomlinson recovered his George and Ribbon, which Jane Twisden sent to the exiled Charles II (see Sir J. R. Twisden, *The Family of Tysden and Twisden*, London, 1939, p. 347). He later maintained that he had treated the King well, although Clarendon wrote that he 'pretended to pay much more respect and duty to the King in his outward demeanour, yet his majesty was treated with much more rudeness and barbarity than he had ever been

before' (*The History of the Great Rebellion*, XI, London, 1888, p. 230). As A. W. McIntosh has shown ('The Numbers of the English Regicides', *History*, LXVII, no. 220 (1982), pp. 195–216), far from declining – as he later claimed – to sit as a member of the *ad hoc* High Court of Justice that tried the King in 1649, Tomlinson in fact sat several times, notably on the crucial occasion on 27 January when sentence of death was passed, and was one of the ten non-signing regicides. He was therefore on a list of prime culprits for whom no pardon was intended after the Restoration. In order to escape prosecution, he had to be exempted by name in the Act of Oblivion, which was passed on 29 August 1660, and this he managed by denying his presence at the trial. Tomlinson's unmerited exemption meant that Sir Thomas Twisden narrowly missed sitting in judgement on him, for Twisden was a member of the Commission of Oyer and Terminer which on 9 October 1660 began the trial of the regicides and others (at which Tomlinson himself was a witness) under the exceptions to the Act of Oblivion.

This pair of drawings must date from the last year or so of Greenhill's brief career. A portrait of Lady Twisden was painted by Mary Beale (related by marriage to the Twisdens) in 1677, its progress being documented in Charles Beale's notebook for that year. In both this drawing and Mary Beale's portrait (below), Lady Twisden is wearing a very similar dress and exactly the same black lace veil, although her commanding features are

Mary Beale:
Lady Twisden.
Oil on canvas, 1677.
Richard Jeffree

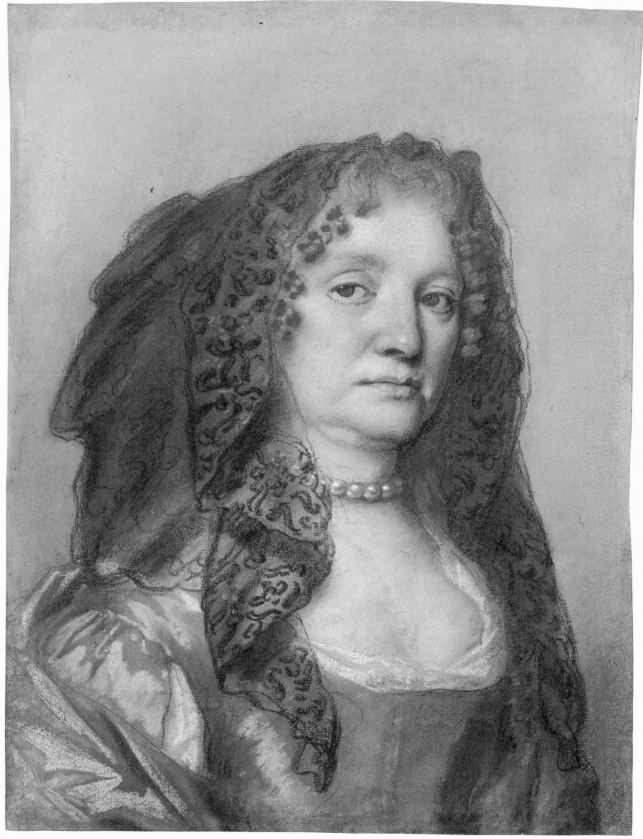

135

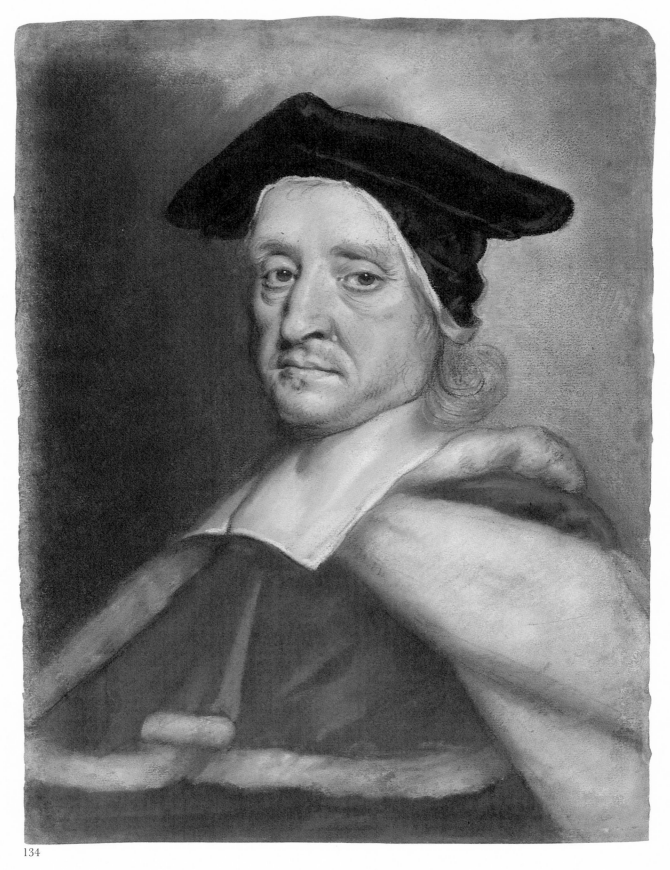

134

perhaps slightly softened in the painting. Sir Thomas is shown, as in other portraits of him, wearing his judge's robes. In technique, these richly coloured chalk drawings are close to those by Ashfield and Luttrell. A second pair of drawings by Greenhill of the same sitters is in a private collection in Yorkshire, having descended through Sir Thomas's sister.

KNELLER, John Zachary
Lübeck 1644 – London 1702

An obscure and undistinguished artist, John Kneller was the elder brother of Godfrey (q.v.), in whose company he is said to have studied under Ferdinand Bol (1616–80). His earliest work is a Rembrandtesque *Young Scholar*, painted in 1668 as a pendant to his brother's *Aged Philosopher* (St Annen Museum, Lübeck). He accompanied Godfrey Kneller on his travels in Italy in the early 1670s; according to Vertue, while there they jointly painted 'the Roman amphitheatre dated. 1677' (II, p. 68), but this date is impossible, since Godfrey Kneller arrived in England in 1676. A letter of April 1677, written in Italian, from Godfrey Kneller in London (describing his successful progress) is addressed to John Kneller in York, and enquires how much he is being paid for his work. By 1684, he was apparently charging £5 for the small-scale portraits in which he specialised (*A List of Pictures at Kingsweston taken July 1695*, MS in the Paul Mellon Collection, Yale Center for British Art). He later painted miniature portraits in watercolours, including copies of his brother's works. Vertue noted also that he achieved some success as a still-life painter (II, p. 146). He was buried in St Paul's, Covent Garden, on 31 August 1702.

136

136 A hog

Black chalk on blue-grey paper; 205 × 267 mm (8 1/16 × 10 1/2 in)
Inscribed by Godfrey Kneller: *JK f*.

PROVENANCE: Edward Byng; by descent to Mrs E. A. Roberts

LITERATURE: ECM & PH I

The British Museum (1888-7-19-76)

The attribution of this drawing to John Kneller is based on the inscription, which is in his brother's hand. It appears to be the only extant example of John Kneller's draughtsmanship.

GYLES, Henry
York 1645 – York 1709

Gyles came from a family of York stained-glass makers, inheriting a tradition that stretched back several generations, and he became a leading exponent of the art in the Restoration period. He experimented in the manufacture of vitreous enamels for use on the surface of plain glass, a technique that was largely to replace the use of coloured glass (which until the late 1630s had traditionally come from Lorraine). Most of his work was for churches and houses in Yorkshire, and he became a leading figure in the circle of York Virtuosi, an informal society of antiquaries and gentlemen who shared interests in scientific developments, local history and art: his friends Ralph Thoresby and Francis Place (q.v.) were fellow-members. His later years were dogged by ill-health and extreme poverty. He described himself in his will as a glass-painter, this apparently being the earliest use of the term in connection with the craft in York. Few drawings by him have survived, although there are some designs for window glass in the City Art Gallery, York.

137 Self-portrait

Red and black chalks, with watercolour, on buff paper; 313 × 227 mm (12 5/16 × 7 7/8 in)
Inscribed in Ralph Thoresby's hand: *ye effigies of Mr Hen: Gyles the celebrated Glass-Painter at Yorke*

PROVENANCE: Ralph Thoresby; George Vertue (cannot be identified with any particular lot in his sales); Horace Walpole (sale, Robins, 28 June 1842, lot 1270); A. E. Evans

LITERATURE: ECM & PH I

The British Museum (1852-2-14-372)

While there is no doubt that this is a portrait of Henry Gyles (the inscription is in the hand of the antiquary Ralph Thoresby, who was a close friend), it is less certain that it is by Gyles himself. It was first described as a self-portrait in Walpole's sale catalogue, perhaps recording an earlier attribution. Gyles is not known to have made portrait drawings, and Croft-Murray and Hulton

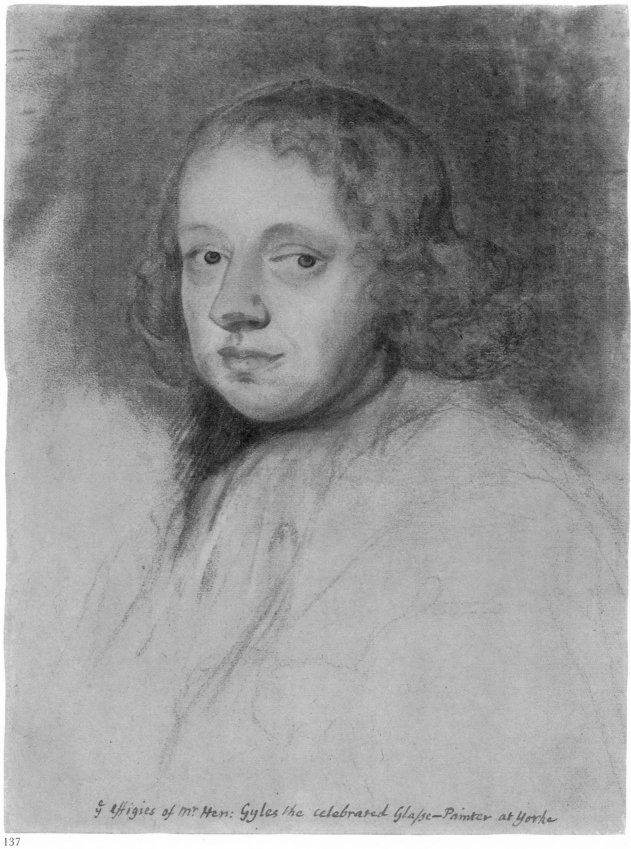

ỹ effigies of mr Hen: Gyles the celebrated Glaſſe-Painter at Yorke

137

therefore suggested that this study might be by another artist associated with the York Virtuosi, perhaps John Lambert (d. 1701), son of the Parliamentarian general and described by Thoresby as 'a most exact limner', Jacques Parmentier (1658–1730), the French decorative artist who settled in Yorkshire and painted some portraits, or Francis Place, who engraved a mezzotint portrait of Gyles for his trade card, probably in the mid-1670s. The present drawing is probably slightly later in date.

WHITE, Robert

London 1645 – London 1703

A pupil of David Loggan (q.v.), White likewise specialised in miniature portrait drawings in black lead touched with wash, which, although generally less refined in style, are sometimes confused with those by his master. White was a prolific portrait engraver: over four hundred plates are known to be by him, dating between 1666 and 1702. He contributed illustrations to a number of publications associated with Loggan, probably assisting him with some of the drawings for *Oxonia Illustrata* (1675) and *Cantabrigia Illustrata* (1688). He also drew and engraved other topographical subjects and illustrated the first *Oxford Almanack* (1674).

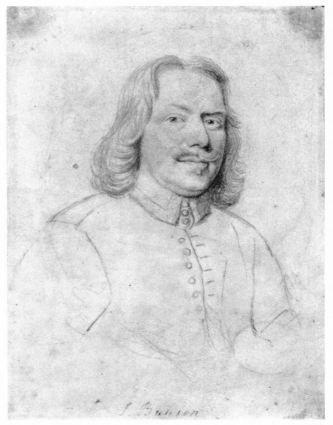

138

138 John Bunyan (1628–1688)

Black lead on vellum, the face finished in metal-point; 122 × 90 mm (4^{13}/₁₆ × 3^9/₁₆ in)

Inscribed: *I. Bunion*, and on the verso, probably not by the artist, *R. White*

PROVENANCE: James West? (sale, Langford, 26 January 1773, lots 39–42, or 27 January, lots 34–8); bequeathed by the Rev. C. M. Cracherode, 1799

LITERATURE: ECM & PH 9; D. Piper, *Catalogue of Seventeenth Century Portraits in the National Portrait Gallery 1625–1714*, London, 1963, pp. 44–5

The British Museum (G.g.1-493)

One of the few *ad vivum* portraits of John Bunyan, the famous nonconformist preacher and writer, chiefly celebrated for his book *The Pilgrim's Progress* (1678), an allegory of the Christian life. This drawing was used by Robert White for the engraved portrait of Bunyan which formed the frontispiece to another of his allegorical epics, *The Holy War* (1682). White may, however, have made the drawing some years earlier as the basis for his famous engraving of Bunyan dreaming, first used for the 1679 edition of *The Pilgrim's Progress*.

139

GRIFFIER, Jan

Amsterdam 1646 or 1652 – Westminster 1718

The records of the Leiden Academy for 1700 note a 'Joannes Griffier' aged forty-eight, but Vertue states that he was seventy-two when he died in 1718 (I, p. 51), and he would therefore have been born in about 1646. Often referred to as 'Old Griffier' (two of his sons were artists), he was apprenticed to a carpenter, a tile painter and a flower painter before studying with the landscapist and etcher Roeland Roghman (*c.* 1620–86) as well as (according to Walpole) informally with Adriaen van de Velde (1636–72), Jacob van Ruisdael (1628/9-82) and, more improbably, Rembrandt. He settled in London soon after the Great Fire of 1666, which he depicted in several paintings, and was admitted a 'free-brother' of the Painter-Stainers' Company in 1677. He was also a competent etcher and mezzotinter, engraving subjects after Barlow (q.v.), Lely (q.v.) and Godfrey Kneller (q.v.). In 1695 he returned to Holland, apparently travelling in his own yacht, which was shipwrecked off the Dutch coast. For the next decade or so he remained in Holland, returning to London in about 1705-7. Walpole noted that 'mixed scenes of rivers and rich country were his favourite subjects', and paintings such as his prospects of *Hampton Court Palace*, about 1710 (Tate Gallery, London) and *Syon House*, about 1710 (The Duke of Northumberland, Syon House) are capriccios, combining real views of the houses with fantastic craggy landscapes. According to Vertue, 'in [the] latter part of his time a great mimick of other masters both Italian & flemish. in which succeeded & deceived very well. livd somewhat retird towards his latter end & died (at his house on millbank Westminster)' (I, p. 51).

139 Study of willows on the banks of a river

Black chalk heightened with white on blue-grey paper; 390 × 575 mm (15⅜ × 22⅝ in)

PROVENANCE Messrs Goupil

LITERATURE: ECM & PH 1

The British Museum (1878-7-13-17)

This drawing entered the British Museum collection with the attribution to Griffier. Although in complete contrast to his known paintings, which are often capriccios, this naturalistic study seems to show the influence of Ruisdael, from whom Griffier is said to have received informal instruction.

KNELLER, Sir Godfrey

Lübeck 1646 – London 1723

According to the inscription on his monument in Westminster Abbey, Kneller was born in 1646, although Vertue noted his year of birth as 1649: the former date is now generally accepted. He was the third son of the City Surveyor of Lübeck and was apparently intended for a military career, being sent to Leiden to study mathematics and fortification. However, he decided instead to become a painter and moved to Amsterdam, where he trained under Ferdinand Bol and perhaps also with Rembrandt himself. In 1672 Kneller travelled to Italy (an early biographer suggests that he may have made a previous visit in 1663) with his brother John (q.v.), to study history painting and develop his talent for portraiture, first in Rome and then in Venice. He was back in Germany in 1675, and probably arrived in London in the following year, where his first English patron was John Banckes, a Hamburg merchant. Kneller's reputation soon reached the court, and he painted his first portrait of Charles II in 1678. He continued to paint royal likenesses through three reigns, and in 1692 he was knighted and in 1715 created a baronet. Much of his time was taken up with official commissions: in 1684 he was sent by the King to paint Louis XIV, and in 1697 he travelled in the suite of William III to Holland for the signing of the Treaty of Ryswick – commemorated in his huge canvas at Hampton Court, which celebrates William III's triumph as peacemaker in Europe – and then to Brussels, where he painted an equestrian portrait of the Elector of Bavaria. Commissions came in such quantity that he employed numerous assistants to paint draperies and backgrounds, and in consequence his portraits are uneven in quality. However, in those where he was personally interested in the sitters – such as Alexander Pope, Matthew Prior or the members of the Kit-Cat Club – he shows considerable brilliance of handling. Succeeding Lely (q.v.) as the most fashionable portraitist of the day, he set a standard that was not surpassed, in the eyes of contemporaries, until the time of Reynolds. His arrogance and conceit were legendary, but his notion of the status due to artists may well have helped to raise the dignity of his profession in England. In 1711 he was a founder of one of the first formalised academies for the training of young painters and his importance lies not least in the fact that he was above all a practical, rather than a theoretical, artist. He died in the year in which Reynolds was born.

140

140 Copy of the 'Diane de Versailles'

Black and red chalks on brown paper; 306 × 200 mm (12 × 7⅞ in)

Inscribed by the artist: *G Kneller. desinyé a Verlalie* [Versailles] *aprée La Statue dan La Gallerie d'Roy*

PROVENANCE: Hugh Howard; the Earls of Wicklow

LITERATURE: ECM & PH 26; Stewart (1971) 55; Stewart (1983), p. 175, no. 78

The British Museum (1874-8-8-2261)

A drawing after the antique made by Kneller during his visit to France in 1684–5, where he was commissioned by Charles II to paint Louis XIV. The statue, known as the *Diane de Versailles* or *Diane à la biche*, is a Roman copy of a fourth-century BC Greek original. It was brought to France from Rome in the reign of François I, where it was placed successively in the châteaux of Meudon and Fontainebleau, the old Salle des Antiques in the Louvre, and the Grande Galerie at Versailles, where Kneller saw it; during the Revolution it was returned to the Louvre (see W. Fröhner, *Notice de la Sculpture Antique du Musée Imperial du Louvre*, I, Paris, 1869, pp. 122–5).

141

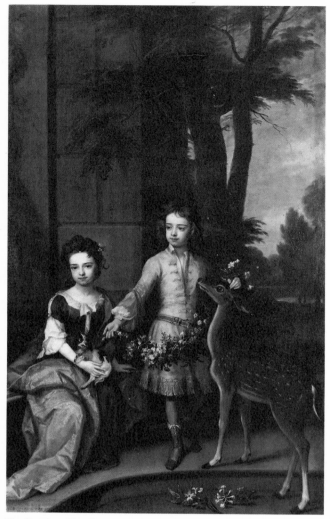

Sir Godfrey Kneller:
Lionel Sackville, Lord Buckhurst, later 1st Duke of Dorset, and Lady Mary Sackville, later Duchess of Beaufort.
Oil on canvas, about 1695.
Lord Sackville, Knole

141 A Negro page

Black chalk heightened with white on blue paper; 281 × 225 mm (11 1/16 × 8 7/8 in)

Signed: *GK* and inscribed *32* [?] *16 42*

PROVENANCE: Edward Byng; by descent to Mrs E. A. Roberts

LITERATURE: ECM & PH 14; Stewart (1971) 20; Stewart (1983), p. 159, no. 2

The British Museum (1888-7-19-77)

Two studies of the same pose, one of Kneller's most graceful drawings, presumably made in connection with a portrait, although no exactly similar figure appears in any of the artist's paintings. Stewart dates this drawing about 1685–90. It may perhaps have been a first idea for the page in the large equestrian portrait of *Marshal Schomberg*, about 1689 (Brocklesby Park), who appears in a similar though reversed pose.

142 A doe

Black, yellow and white chalks on buff paper; 314 × 255 mm (12 3/8 × 10 in)

Signed: *GK*

PROVENANCE: Edward Byng; by descent to Mrs E. A. Roberts

LITERATURE: ECM & PH 22; Stewart (1971) 23; Stewart (1983), p. 160, no. 7

The British Museum (1888-7-19-75)

A study for Kneller's portrait of Lionel Sackville (1687–1765), Lord Buckhurst, later 1st Duke of Dorset, and his sister Mary (1687–1705), who married the 2nd Duke of Beaufort in 1702. In the painting (left), which probably dates from the mid-1690s, the children are shown with the doe, which Kneller must have drawn *ad vivum*, presumably at Knole, where herds of deer roam the park. In the drawing Kneller shows the legs in alternative positions, but chose the first version for the portrait.

143 Peter Vanderbank (1649–1697)

Black chalk, heightened with white, on buff paper; 392 × 271 mm (15 7/16 × 10 11/16 in)

Inscribed (over an early repair): *R. Wilson*. A later hand has added *Drawn by* before the 'signature' and *R.A.* after, and has noted: *This drawing is mentioned in Edwards' account of Wilson as being in the possession of John Richards, R.A.*

PROVENANCE: William Esdaile; John Inigo Richards (sale, Squibb's, 12 March 1811, lot 133); Woodburn sale, Christie, 20 June 1854, lot 998

LITERATURE: E. Edwards, *Anecdotes of Painters*, London, 1808, p. 80; L. Binyon, *Catalogue of Drawings by British Artists and Artists of Foreign Origin working in Great Britain . . . in the British Museum*, IV London, 1907, p. 352, no. 1 (as by Richard Wilson); B. Ford, *The Drawings of Richard Wilson*, London, 1951, no. 1A; W. G. Constable, *Richard Wilson*, London, 1953, pp. 151–3; Stewart (1971) 42; Stewart (1983), p. 166, no. 35

The British Museum (1854-6-28-18)

142

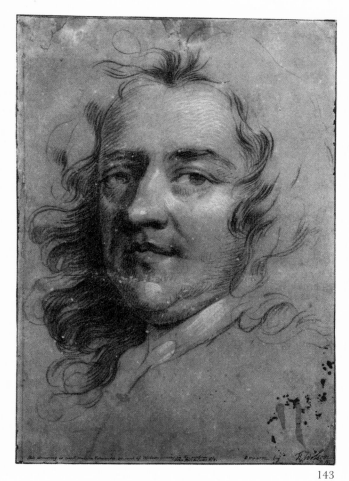

143

144 A greyhound

Black chalk on blue paper; 284 × 225 mm (11 3/16 × 8 7/8 in)

Verso: Richard Boyle (1695–1753), Lord Clifford, later 3rd Earl of Burlington and 4th Earl of Cork, with his sisters Lady Elizabeth and Lady Juliana Boyle(?)

Signed: *GK*

PROVENANCE: Edward Byng; by descent to Mrs E. A. Roberts

LITERATURE: ECM & PH 21; Stewart (1971) 24; Stewart (1983), p. 161, no. 9

The British Museum (1888-7-19-73)

Both recto and verso are connected with Kneller's portrait of Lord Burlington as a child with three of his sisters and a greyhound (Stewart (1983), p. 96, no. 117), painted about 1700. Burlington was to become a notable patron of the arts, an architect and the leading propagator of the Palladian movement in England; his collection of drawings by Inigo Jones descended through his daughter Charlotte, who married the 4th Duke of Devonshire (see nos 8–26). Stewart has noted that this sheet was probably drawn at a fairly early stage in Kneller's development of the composition, since the verso shows only two of the Earl's sisters, probably Elizabeth and Juliana; by the time he painted the portrait, their younger sister Jane was also included. A mezzotint by John Smith, published in 1701 (Chaloner Smith 53), is related to the painting, and shows (in reverse) the Earl and his sister Jane with their dog.

145 Lebeck

Black chalk, heightened with white, on blue-grey paper; 280 × 213 mm (11 × 8 3/8 in)

PROVENANCE Edward Byng; by descent to Mrs E. A. Roberts

LITERATURE: ECM & PH 12; Stewart (1971) 21; Stewart (1983), p. 162, no. 13

The British Museum (1888-7-19-68)

Lebeck was the proprietor of a London tavern in the early years of the eighteenth century. This drawing is a study for a portrait (present whereabouts unknown), datable about 1710, of which a mezzotint was engraved by Andrew Miller in 1739 (Chaloner Smith 29). Another drawing connected with the painting is of a hand holding a glass (BM 1897-8-13-9(67)), and the complete composition is recorded in one of the sketchbooks owned by Kneller's assistant Edward Byng (BM 1897-8-13-8(46v)).

Although believed since at least the early years of the nineteenth century to be a drawing of Admiral Smith by Richard Wilson, this drawing is in fact a study by Kneller of the engraver Peter Vanderbank. Brinsley Ford doubted the attribution to Wilson (op.cit., p. 15), and W. G. Constable pointed out that the so-called signature was dubious. Douglas Stewart has shown (op.cit., 1971) that Kneller must have made the drawing for a portrait of Vanderbank now known only through the mezzotint by George White (Chaloner Smith 50): the painter is not identified in any of the known states of the print, but Stewart is clearly correct in stating that it was Kneller.

Vanderbank, an engraver, was born in Paris, and was a pupil of François Poilly (1622–93). He is said to have moved to London in about 1674, and he engraved many of Kneller's portraits. Vertue recorded that he died in poverty, his widow being forced to sell his engraved plates and their sons to go to sea 'or shifted about being not otherwise provided for'. He noted that Vanderbank's portrait by Kneller (presumably that for which this drawing was the study) was in 1743 in the possession of Mrs Vanderbank's sister-in-law (v, p. 19).

144

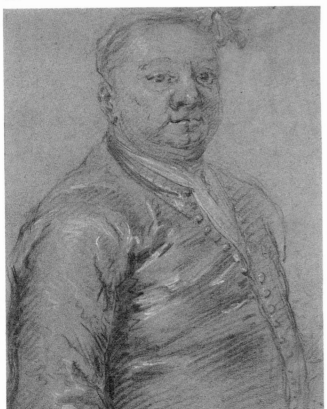

145

146 Life study

Black chalk, heightened with white, on blue paper; 445 × 238 mm (17½ × 9⅜ in)

PROVENANCE: Edward Byng; Elizabeth Wray (née Byng); Charles Wray; Sir Charles Wilkins; C. W. B. W. Roberts; G. R. Harding

LITERATURE: ECM & PH (under Byng 8) 71: Stewart (1971) 57; Stewart (1983), p. 170, no. 58

The British Museum (1897-8-13-9(68))

Many of the Kneller drawings in the British Museum were originally in the collection of his studio assistant Edward Byng (d.1753), who is referred to in Kneller's will as having 'for many years faithfully served me' and as then living in his master's house. This study comes from an album of drawings made in Kneller's studio, which include copies after portraits, together with tracings of portrait heads and a number of miscellaneous subjects, by a variety of hands. There are also nineteen academic figure studies, of which four, including the present sheet, have been attributed to Kneller himself. In 1711 the first English academy was opened in a rented house in Great Queen Street. It consisted of sixty members, each subscribing a guinea a year, and included a number of amateurs as well as professional artists. Kneller was elected as the first Governor, a post he held until dissension led to his replacement by Thornhill in 1715, and there were twelve directors. Unlike the French Académie, which was its inspiration, the London academy was not a formalised channel for state patronage, and had no regulatory powers: it was a privately organised, unofficial association, which existed to satisfy the practical needs of artists, in particular offering facilities for life drawing, which were nowhere else to be found in England. Studies of the kind illustrated here would have been made at meetings of the academy. Although in existence for only nine years or so, this academy was the forerunner of the two subsequent academies in St Martin's Lane, that organised by Chéron and Vanderbank between 1720 and 1724, and, later on, that associated with Hogarth and his circle from 1734: the Royal Academy, founded in 1768, although closer to the French model in terms of organisation, nevertheless had its origins in these earlier informal bodies.

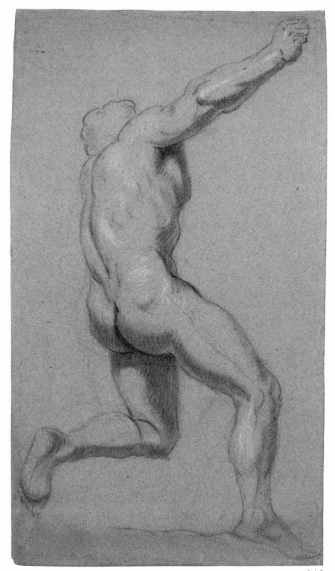

146

epitaph for his monument ('as if to gratify an extravagant vanity dead, which he had ridiculed living', wrote Horace Walpole), recorded: 'I paid Sir Godfrey Kneller a visit but two days before he died; I think I never saw a scene of such vanity in my life. He was lying in his bed, and contemplating the plan he had made for his own monument. He said many gross things in relation to himself, and the memory he should leave behind him. He said he should not like to lie among the rascals at Westminster.' According to Vertue (III, p. 43), Kneller had hoped to have the monument set up in his local church at Whitton, near Twickenham, but the conspicuous place he wished it to occupy was already taken up by a memorial to Pope's father 'which he [Kneller] could not prevail to get remov'd'. Before his death, Kneller approved a *modello* by Rysbrack (whose sale in 1766 included a terracotta model for the monument), rejecting a design by Francis Bird. As executed, the monument was very close to Kneller's drawing, with one notable difference. In his own design, Kneller shows himself bare-headed and short-haired, in vaguely classical style. Rysbrack's bust, which was probably derived from a self-portrait (perhaps a chalk drawing formerly in the Painter-Stainers' Company, see Stewart (1983), pl. 110a) is *en negligé* with a loose cap, the head thrown up and back in a commanding manner.

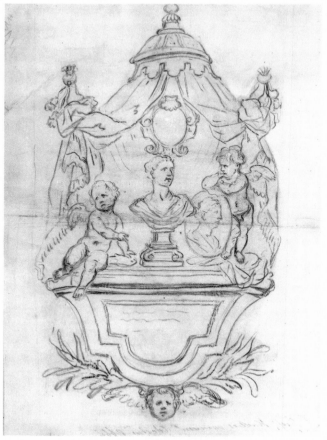

147 Design for the artist's own monument

Black chalk over black lead; 465 × 333 mm (18⁵⁄₁₆ × 13⅛ in)

Inscribed on the verso: *Sr Godfy Knellers monumt Westmr Abby*

PROVENANCE: Edward Byng; by descent to Mrs E. A. Roberts

LITERATURE: ECM & PH 27; Whinney (1964), pp. 84–5, 256, note 10; Stewart (1971) 59; J. D. Stewart, 'New Light on Michael Rysbrack: Augustan England's "Classical Baroque" Sculptor', *Burl. Mag.*, CXX (1978), pp. 215–16; Stewart (1983), p. 170

The British Museum (1888-7-19-81)

A study by Kneller for his own monument, which was executed by Rysbrack and erected at the west end of the North Aisle of Westminster Abbey in 1730. Alexander Pope, who knew the artist well and was to compose the

147

Nathaniel Parr after Hubert-François Gravelot:
Monument to Sir Godfrey Kneller.
Engraving for the 1742 edition of John Dart's *Westmonasterium*,
II, pl. 128

The monument originally had looped-up drapery falling from a canopy and a coat of arms (above), as indicated in Kneller's design, but these were discarded in 1848 when the monument was removed to its present position in the South Aisle, high up above Grinling Gibbons's tomb of Sir Cloudesley Shovell.

PLACE, Francis

Dinsdale 1647 – York 1728

Born in Durham, into a long-established county family: his father was appointed High Sheriff of Durham in 1653. Place was sent to London to study law, but the Plague of 1665 gave him an excuse to cut short an uncongenial career, and he returned to his family home. While in London he had met Hollar (q.v.), whose work was to have a lasting influence on his style. He later bought Hollar's sketchbooks and many of his prints from his widow. In 1716 Vertue corresponded with him about his recollections of Hollar, and in 1727 went to see him in York. However, as Place told Vertue '[Hollar] was a person I was intimately acquainted withal. but never his disciple nor any bodys else. which was my misfortune' (I, p. 34). Place returned to London in 1666 or 1667 and Hollar introduced him to fellow artists and to the leading publishers and print-sellers, notably Pierce Tempest and John Ogilby, for whom, in collaboration with Hollar, Place helped to illustrate the English edition of Jan Nieuhoff's *Embassy from the East India Company to the . . . Emperour of China* (1669). Besides other illustrations of topographical subjects and birds and animals (some in collaboration with Barlow, q.v.), Place was also one of the pioneers of mezzotint. His first independent topographical drawings date from about 1670, when he began to travel extensively in England, basing himself in York. He was the first native artist whose main interest was landscape, and his journeys to the Isle of Wight and France in 1677, Northumberland and South Wales in 1678, France in 1681, Ireland from 1698 to 1699 and North Wales in 1699, Scotland in 1701 and possibly the Low Countries, as well as within Yorkshire, anticipate the sketching tours of artists a century later. Place's later drawings show the influence of Dutch-Italianate artists like Bartholomeus Breenbergh and Thomas Wyck (q.v.), and instead of Hollar's linear pen and ink style, display a greater concern with tonal textures. He was a leading member of the York Virtuosi, an informal society composed chiefly of antiquarians, scientists, medical men and local gentlemen, including Henry Gyles (q.v.), the antiquarian Ralph Thoresby and the physician and zoologist Martin Lister, FRS. Place shared the tastes of such men, illustrating Lister's publications and assembling his own rather motley collection of curiosities, which he gave to Thoresby. His interests also included the chemistry of pottery, in particular the glazing of stoneware and the manufacture of porcelain; a few examples of pieces attributed to him survive. Although he was from time to time engaged professionally on book illustration, Place was essentially an amateur; as Vertue noted, he had 'means enough to live on' and 'passed his time at ease. being a sociable & pleasant Companion much belovd' (II, p. 54).

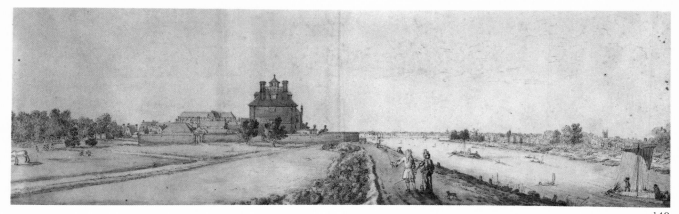

148

149

148 Peterborough House and Lambeth from Millbank

Black chalk, pen and ink and watercolour; 162 × 464 mm (6⅜ × 18¼ in)

Inscribed by the artist below the drawing: *Peterborough House Lambeth and the Strand as they apeared from Mill bank A: 1683*

PROVENANCE: Patrick Allan Fraser of Arbroath (sale, Sotheby, 19 June 1931, lot 132)

LITERATURE: I. Williams, *Early English Watercolours*, London, 1952, p. 10; M. Hardie, *Water-colour Painting in Britain*, I, London, 1966, p. 61; R. Tyler, *Francis Place 1647–1728*, exh. cat., City Art Gallery, York, 1971, no. 33; Harris (1979), p. 107, no. 96; L. Lambourne and J. Hamilton, *British Watercolours in the Victoria and Albert Museum*, London, 1980, p. 292

The Victoria and Albert Museum

A finished drawing (E.1507-1931) based on two sketches also in the Victoria and Albert Museum (E.1508 and 1509-1931); the two foreground figures appear also on a sheet of figure studies in an American private collection. Place's style as a topographical artist was largely derived from Hollar, whose panoramic compositions such as the *View of Westminster and the Thames from Lambeth House* (no. 70) must have influenced him. In this drawing, Place's viewpoint is just across the river from Hollar's. The large

house in the foreground is Peterborough House (demolished in 1809 to make way for the Millbank Penitentiary), and on the left is Westminster Abbey, before the addition of Hawksmoor's towers (1735–9); across the river is Lambeth.

149 Dunbar Castle and the Bass Rock

Pen and black ink over black lead with grey wash, on two conjoined pieces of paper; 175 × 573 mm (6⅞ × 22⁹⁄₁₆ in)

PROVENANCE: Thomas Agnew and Sons Ltd, 1966

LITERATURE: White (1977) 8

Yale Center for British Art, Paul Mellon Collection (B1977.14.4647)

Place seems to have made a tour of Northumberland and Scotland in 1701; views of Bamburgh Castle (Leeds City Art Galleries) and Glasgow Bridge (Patrick Allan Fraser sale, Sotheby, 10 June 1931, part of lot 134) are both dated in that year, and other drawings (see R. Tyler, *Francis Place 1647–1728*, exh. cat., City Art Gallery, York, 1971, nos 54–8) seem to belong to the same journey. The present drawing and a watercolour of almost exactly the same view appear to have been based on a sketch made on the spot (both in Glasgow City Art Gallery). On the left

150

are the ruins of Dunbar Castle and to the right is the Bass Rock. A comparison with Hollar's *'Prospect of Tangier from the Sea'* (no. 72) shows Place adopting a similar panoramic viewpoint, but using a less linear style.

150 The Dropping Well, Knaresborough, Yorkshire

Grey wash partly outlined with pen and brown ink; 324 × 408 mm (12¾ × 16¹⁄₁₆ in)

Inscribed by the artist: *The Droping Well Knaisborough F:P* and on the verso in another hand: *F. Place delin* and *92 Perrott*

PROVENANCE: Frances (Place) Wyndham; Wadham Wyndham; Parrott family ?; W. and G. Smith

LITERATURE: ECM & PH 18; M. Hardie, *Water-Colour Painting in Britain*, I, London, 1966, p. 62; R. Tyler, *Francis Place 1647–1728*, exh. cat., City Art Gallery, York, 1971, no. 73

The British Museum (1850-2-23-822)

From about 1700 Place increasingly abandoned the prac-tice of detailed drawing in pen and ink in favour of wash and watercolour, with which he could achieve broader tonal effects, perhaps influenced by the drawings of Netherlandish artists such as Thomas Wyck and Hendrik Danckerts (see nos 83 and 124). His concentration in this drawing on the effects of light and shade on the rocks and foliage is very different from his earlier preoccupation with linear exactness. Both this drawing and another view of the Dropping Well (where water from the River Nidd with a high limestone content flows over a rocky crag, and objects suspended from the overhang gradually become petrified), together with three views of Knaresborough Castle, dated 1711 (also in the British Museum, 1850-2-23-818–820), were probably all made on the same tour. Like most of the drawings by Place in the British Museum, these formerly belonged to the artist's son-in-law, Wadham Wyndham (1700–1783).

ASHFIELD, Edmund

fl. c. 1669 – 1690?

With Luttrell (q.v.), who was his pupil, Ashfield was one of the most accomplished pastellists of the late seventeenth century. Little is known of his life: the antiquary Thomas Hearne described him as 'a sober person & suspected to be Catholic'. According to Buckeridge, he was 'a Gentleman well descended', perhaps, from the coincidence of names, related to Sir Edmund Ashfield of Chesham, Buckinghamshire, to whom Henry Peacham dedicated his discourse on drawing and limning, *The Gentleman's Exercise*, in the 1634 edition. The earliest reference to him as an artist is in a collection of poems by Sir Thomas Lawrence (1645–1715), which includes 'Verses sent with the Musick Speech to my Cousin Edward [*sic*] Ashfeild an Ingenious Painter', the speech being delivered in Oxford in July 1669. Buckeridge noted that Ashfield studied with the painter John Michael Wright (q.v.), but although he is known to have copied a number of paintings, no original composition in oils is recorded. He seems to have started working in crayons in the early 1670s (all his dated works are from that decade) and to have established a reputation for his skill. According to Buckeridge, he 'multiply'd the number and variety of tints, and painted various complexions in imitation of oil; and this manner has been so much improved among us, that there is no subject which can be express'd by oil, but the crayons can effect it with equal force and beauty'. He may have been the Mr Ashfield who appears in the list of Roman Catholics living in the parish of St Paul's, Covent Garden, in 1678. His date of death is uncertain, but he is perhaps the 'Mr E.A. lately deceased' whose collection of paintings was advertised for auction on 5–9 March 1690/91.

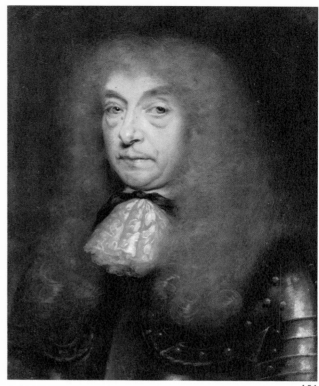

151

151 A gentleman

Coloured chalks; 282 × 225 mm (11⅛ × 8⅞ in)

PROVENANCE William Anderson

LITERATURE: ECM & PH 1

The British Museum (1908-7-14-47)

Although it is neither signed nor dated, the attribution of this drawing to Ashfield is long-standing; indeed C. H. Collins Baker ('Notes on Edmund Ashfield', *Walpole Society*, III (1914), p. 86) considered it his masterpiece.

The identity of the sitter is uncertain. Croft-Murray and Hulton discounted Collins Baker's tentative suggestion that it might represent John Maitland (1616–82), 1st Duke of Lauderdale, of whom a portrait by Ashfield, dated 1674/5, is at Ham House, Surrey. However, a comparison between that drawing, Lely's portraits of Lauderdale (notably that in the Scottish National Portrait Gallery, Edinburgh, painted in about 1665, and the double portrait of about 1673 with his wife, at Ham House) and the present drawing shows a considerable resemblance. Lauderdale, at first a Covenanter in opposi-

tion to Charles I, later supported the King, and was imprisoned after the Battle of Worcester in 1651 until the Restoration. He became Secretary for Scotland, wielding considerable power and patronage, and was the 'L' of the 'Cabal' (see also no. 129): Sir Oliver Millar has described him as 'a formidable, well-educated, unprincipled and unattractive man'. He married in 1672 Elizabeth Murray, Countess of Dysart, with whom he undertook extensive rebuilding and redecoration at Ham House.

A description of Lauderdale by Bishop Burnet is vivid, if unappealing: 'a very ill appearance; he was very big; his hair red, hanging oddly about him: his tongue was too big for his mouth, which made him bedew all that he talked to.'

LUTTRELL, Edward

*fl. c.*1680 – 1724

The artist referred to himself both as 'Lutterell' and 'Luttrell', and the latter spelling has been adopted here because it is likely, according to the researches of Patrick Noon (1979, pp. 11–12), that he was connected with the Luttrell family of Saunton Court, Devon, to which the famous diarist Narcissus Luttrell belonged. Accounts of his origins and early life are confusing: he is said to have been born in Dublin, but there is no evidence for this. Vertue noted that he originally studied law in London, abandoning this calling for art, in which he had 'no regular teaching from a Master but from a small knowledge of drawing by practice for his Pleasure' (1, p. 42). Buckeridge states that he studied under Edmund Ashfield (q.v.), and this is to some extent borne out by a deferential reference to Ashfield in a manuscript treatise, *An Epitome of Painting Containing Breife Directions for Drawing Painting Limning and Cryoons . . . And How to lay the Ground, and work in Mezzo Tinto all by Edward Luttrell. 1683*, dedicated to his 'much Honoured and most Ingenuous Kinswoman Maddam Dorothy Luttrell' (Yale Center for British Art). Luttrell specialised in crayon, or pastel, portraiture in a style close to that developed by Ashfield but characterised by reddish-brown flesh tones: a number of his works are copies after other artists, both contemporary and old masters, the British Museum having a series after prints by Rembrandt and one after Otto van Veen. He was a pioneer of mezzotint engraving (Vertue gives a lively account of how he acquired the secret of the technique, 1, p. 43), and worked for a while in partnership with Isaac Beckett, Luttrell 'being very quick & drew better'. He later combined his knowledge of drawing and engraving by using copper plates roughened as if for mezzotinting as a ground for pastel, claiming that he was the first person to do this, although William Faithorne (q.v.) has also been credited with the discovery.

Almost nothing is known of Luttrell's life; he seems to have lived in Westminster, but there is no record of the date or place of his death. He provided some of the portraits for Kennet's *History of England* (1706) and is mentioned by Vertue as one of the twelve original directors in 1711 of the Great Queen Street academy (see no. 146). He is also included in Vertue's list of 'Living painters of Note in London'. Noon (op.cit.) mentions that two pastels dated 1724 and inscribed with his name were on the art market in 1971, but thinks that they may be after Luttrell.

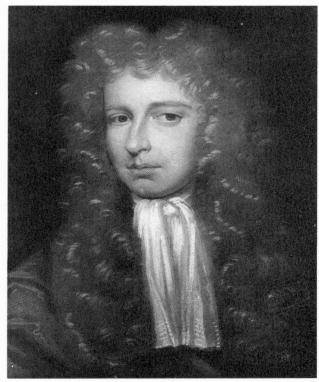

152

152 Judge Jeffreys (1645–1689)

Pastel on copper, the surface prepared with a mezzotint rocker; 305 × 255 mm (12 × 10 in)

Inscribed: *E. Lutterell*, scratched on the plate

PROVENANCE: Christie, 2 March 1971, lot 75

Dudley Snelgrove

Luttrell seems to have been the inventor of a technique closely related to the early development of the mezzotint, that of drawing in crayons (pastel) on copper plates roughened with a rocker as if for the preparation of a mezzotint. The present portrait is a characteristic example of his method. Like the majority of his known works, this is a copy (in reverse) after a painting by another artist – a portrait of Judge Jeffreys, painted about 1678–80 and attributed to William Claret (National Portrait Gallery, London). Claret's portrait is a three-quarter length, showing Jeffreys in his robes as Recorder of London, an appointment he held from 1678 to 1680.

Judge Jeffreys, one of the most notorious lawyers of the period, was an ambitious and clever advocate (though his legal learning was held to be rudimentary). He was appointed Lord Chief Justice in 1683, despite Charles II's reservations, and came into his own on the accession of James II in 1685. Among his first judgements of the reign was that on Titus Oates (see nos 111–15), when he took the opportunity of paying off an old grudge by concurring in a particularly harsh sentence. But he is best known for

his part in suppressing Monmouth's Rebellion later in the same year, conducting the so-called 'Bloody Assize' in the West Country, where an alleged 320 sympathisers were convicted and executed (these numbers are, in fact, probably exaggerated). As his reward, James II created him Lord Chancellor. However, at the Revolution of 1688 Jeffreys was almost lynched by the London mob as he failed in his attempts to flee England, and he was forced to take refuge in the Tower of London, where he died in 1689.

153 Samuel Butler (1612–1680)

Pastel; 327 × 248 mm (12⅞ × 9¾ in)

PROVENANCE: L. G. Duke

LITERATURE: Noon (1979) 10; D. Piper, *Catalogue of Seventeenth Century Portraits in the National Portrait Gallery 1625–1714*, London, 1963, p. 50

Yale Center for British Art, Paul Mellon Collection (B1977.14.6092)

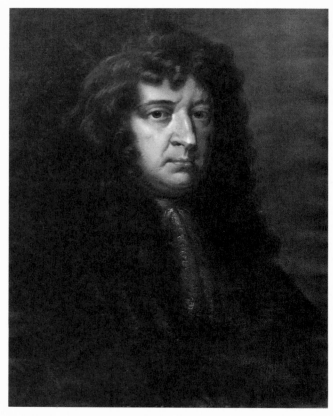

153

Formerly attributed to Ashfield, this drawing is a version of Luttrell's signed portrait of Butler in the National Portrait Gallery, London, drawn in bodycolour and pastel on panel, and dated by Piper (op. cit.) very late in the sitter's life or perhaps posthumously: another version of this likeness is in the Bodleian Library, Oxford. In his manuscript treatise of 1683 (Yale Center for British Art), Luttrell describes the different techniques of crayon drawing, the first, which he has used here, being pure pastel on paper: 'it will not only have the freedome and strength of a painting but the neatness and beauty of Limning. And with free and soft Cryoons any thing that is or can be painted may be expressed whatever the Ignorant say to the Contrary'.

Samuel Butler is best known as the author of *Hudibras* (see no. 198), published between 1662 and 1678, a satire on Puritanism as a way of life that enjoyed enormous popularity (although many of its allusions escape the modern reader). He never received a court appointment, despite Charles II's admiration for *Hudibras*, and seems to have died an embittered man. As he lived in obscurity until the sudden fame occasioned by the publication of *Hudibras*, there are no known portraits of him before about 1670.

GIBBONS, Grinling

Rotterdam 1648 – London 1721

Gibbons was born in Holland, where his father, an English merchant, was living. It is not known exactly when he came to England, but he perhaps had some training in Holland; his style both as a carver and sculptor has affinities with the Quellin family workshop, and the fact that Arnold Quellin (1653–86) later worked with Gibbons perhaps confirms this earlier connection. According to Vertue, Gibbons worked in York before moving to London. The diarist John Evelyn claimed to have discovered him in 1671 and to have brought him to the attention of Charles II. But Vertue noted that it was Lely (q.v.) who recommended him to the King. Certainly it was Lely's close friend Hugh May, Comptroller of the Royal Works, who gave Gibbons his first major commissions in the late 1670s, at Windsor and at Cassiobury. Gibbons was a virtuoso craftsman, his forte being the carving in wood of swags of flowers, fruit, foliage, game and trophies (not unrelated to Dutch flower and still-life painting), fine examples of which survive. He also had a large workshop, his practice expanding to include major sculptural works. The best of these, in a modified Baroque style, were carried out in collaboration with Quellin, including the elaborate altar for the Catholic chapel in Whitehall Palace, 1685–6 (later dismantled), the statue of James II, 1686 (Trafalgar Square), and several monuments. After Quellin's death, Gibbons's figure sculpture became stiffly classicising, though no less ambitious, as can be seen in his design for a monument to William and Mary (no. 154) and in his monument to Sir Cloudesley Shovell (d. 1707) in Westminster Abbey. From the late 1680s until Queen Mary's death in 1694, and then again from 1698 until 1701 Gibbons was much employed at Hampton Court, and was appointed Master Carver to the Crown in 1693. Other notable commissions included the choir stalls and some of the stone carving at St Paul's in the late 1690s, and, between 1708 and 1712, much of the architectural ornament and figure sculpture for Blenheim Palace.

154 Design for a monument to King William III and Queen Mary II

Pen and brown ink with washes of grey, yellow and pink; 419 × 312 mm (16½ × 12¼ in)

PROVENANCE: Richard Bull (sale, Sotheby, 23 May 1881, lot 72); purchased at the Bull sale through A. W. Thibaudeau

LITERATURE: ECM & PH 1; D. Green, *Grinling Gibbons: his Work as Carver and Statuary 1648–1721*, London, 1964, pp. 74, 164; Whinney (1964), pp. 57, 249 (note 47)

The British Museum (1881-6-11-164)

Among Gibbons's most important patrons was Queen Mary, who employed him first at Kensington Palace and then at Hampton Court, where Wren and Talman began an extensive rebuilding programme in 1689. In 1693 he was appointed Master Carver to the Crown, but the death of the Queen in the following year put an end to all the Hampton Court works. With Wren and Hawksmoor, Gibbons was responsible for the Queen's elaborate catafalque and, probably shortly afterwards, again with Wren, designed a marble memorial to her, intended to be placed above her tomb in Henry VII's Chapel, Westminster Abbey: Gibbons's drawing for this monument is at All Souls, Oxford. The King decided, however, that the money should be devoted to Greenwich Hospital, which was considered a more fitting memorial to the Queen. The project was revived, probably after the death of the King in 1702, as a joint memorial to William and Mary. Had Gibbons's design been executed it would have been the most elaborate Baroque monument in England. On either side of the central group of the King and Queen, attended by a mourning Britannia and two other females, stand four figures of Virtues – Hope, Justice, Prudence and Charity – on pedestals between coupled Corinthian pillars. Overhead, angels with trumpets draw back the hangings of a baldachin, while putti descend holding a wreath, a palm and a celestial crown.

Although this ambitious project was unrealised, Gibbons thriftily made use of various elements in it elsewhere. His monument to the 1st Duke of Beaufort (1629–1700), originally erected in St George's Chapel, Windsor Castle, but moved to Badminton in 1875 (see p. 197), is a simpler version of the royal design. The full-length female figures standing in front of the twin Corinthian columns are Justice and Prudence; on the plinth below the sarcophagus is the group of St George and the Dragon which occurs in the entablature in the present drawing. Above the recumbent figure of the Duke, two putti proffer a celestial crown. (The figures of Virtues were removed some years ago, but are still at Badminton, and it is hoped that they will eventually be replaced.) Gibbons must have been particularly proud of the figures, for they reappeared in about 1707 as part of a design for the decoration of the Saloon at Blenheim.

154

Grinling Gibbons: Tomb of the 1st Duke of Beaufort
(1629–1700), at Badminton, Gloucestershire (photographed
about 1964)

LAURON, Marcellus

The Hague 1648/9 – London 1701/2

The son of a minor French-born artist who had settled in
The Hague, Lauron went to England when young. He is
said to have lived for some time in Yorkshire, and Vertue
láter recorded the story (otherwise entirely uncorrob-
ated) that Rembrandt visited York in 1661, where Lauron
knew him. By 1674 Lauron was living in London, and was
a member of the Painter-Stainers' Company. He seems to
have attempted most branches of painting, including
copying pictures and working in Kneller's studio as a
drapery and flower specialist. Vertue had a low opinion of
his character, after seeing some of his bawdy genre sub-
jects: 'his thoughts in his pictures shew him to be a Man of
levity. of loose conversation & *morals* suteable to his birth
and education. being low & *spurious*'. The earliest known
portrait by Lauron is the full-length of Charles II painted
for the Mathematical School at Christ's Hospital in 1684–
5, and in a similarly grand style, though less impressive, is
his portrait, dated 1689, of John, 3rd Lord Lovelace, a
loyal supporter of the new king, William III (Wadham
College, Oxford); Lauron also drew the coronation pro-
cession of William and Mary. He also appears to have
painted staffage figures and animals for other painters; a
sale catalogue of 1713 lists 'A large Stag-Hunting by
Lauron and Vandest' (presumably Adriaen van Diest, a
landscapist who worked in England from about 1678 until
his death in 1704). Lauron is best known, however, for his
Cryes of London, a series of engravings after his drawings,
published in 1687/8 (see nos 155–6). Another group of
drawings by Lauron, of fencing scenes, were engraved in
1699 as *The Art of Defence* (see nos 157–8). Among his
pupils was his son Marcellus Laroon (1679–1772), a
soldier, who retired from the army in 1732 and became
well known as a painter and draughtsman of conversation
pieces and genre subjects.

155 'Buy my fat chickens'

Black lead and grey wash, indented for transfer; 215 × 156 mm
(8⁷⁄₁₆ × 6⅛ in)

PROVENANCE: R. E. Alton (sale, Sotheby, 10 July 1986, lot 43);
Martyn Gregory

LITERATURE: R. Raines, 'Drawings by Marcellus Lauron – "Old
Laroon" – in the Pepysian Library' in 'Notes on British Art',
Apollo, LXXXII (1965), n.p.; R. Raines, *Marcellus Laroon*, London,
1966, pp. 13–16; M. Webster, *Francis Wheatley*, London, 1970, p.
82; K. Beall, *Kaufrufe und Strassenhandler*, Hamburg, 1975, pp.
113, 126–33

Private Collection

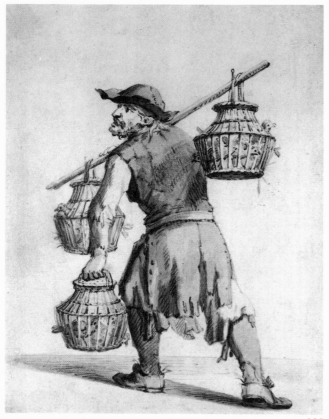

155

and in subsequent editions many of the plates were re-engraved with alterations after Louis-Philippe Boitard, chiefly to bring the costumes up to date.

Lauron almost certainly knew Jean-Baptiste Bonnart's *Cris de Paris*, published about 1676 (see Beall, op. cit., p. 224), with which the *Cryes* share some similarities, but Lauron's designs were above all realistic representations of the people he saw in the streets of London. The title-page to the series noted that the subjects were 'Drawne after the Life', and the robust individuality of his depictions is perhaps Lauron's chief innovation. For the first time, some of the criers' own names or nicknames are recorded, including Colly Molly Puff, a baker; Madam Creswell, probably a procuress; Poor Jack, a fishmonger, and Merry Andrew, a clown or jester. In this attempt to portray individuals rather than types, Lauron anticipates Hogarth. As Robert Raines noted (op. cit., 1966, p. 14), Hogarth's *Shrimp Girl* of about 1750–55 (National Gallery, London) is in the same tradition as *'Six pence a pound fair Cherryes'*.

156 'Six pence a pound fair Cherryes'

Pen and grey wash over black lead, indented for transfer; 215 × 156 mm (8⁷⁄₁₆ × 6⅛ in)

PROVENANCE: As no. 155

LITERATURE: As no. 155

Private Collection

Two of the drawings made by Lauron for *The Cryes of London*, the series published by Pierce Tempest (1653–1717), which was probably first issued in 1687, according to a contemporary advertisement, although no copy of an edition before 1688 is known to exist. A number of engravers seem to have been employed, although only two plates are signed, those being by John Savage (*fl.c.*1680–1700). The popularity of the series is demonstrated by the number of times that it was reprinted during the following seventy-five years. Further editions were issued by Tempest in 1689 and 1709, when Lauron's name was mentioned for the first time. The number of engravings varied from edition to edition, and the plates passed to another publisher, H. Overton, in about 1709–11, being reissued in 1711. During the eighteenth century, the series carried captions in French and Italian as well as in English, and ten subjects were copied in reverse in Holland by Jacob Gole, who added Dutch inscriptions. In about 1750, the *Cryes* were republished by Robert Sayer,

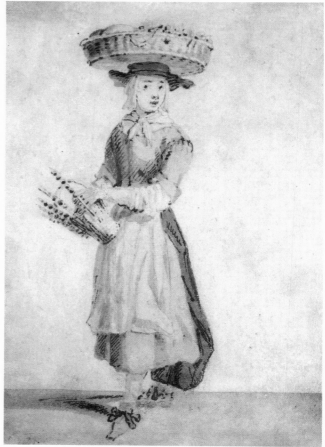

156

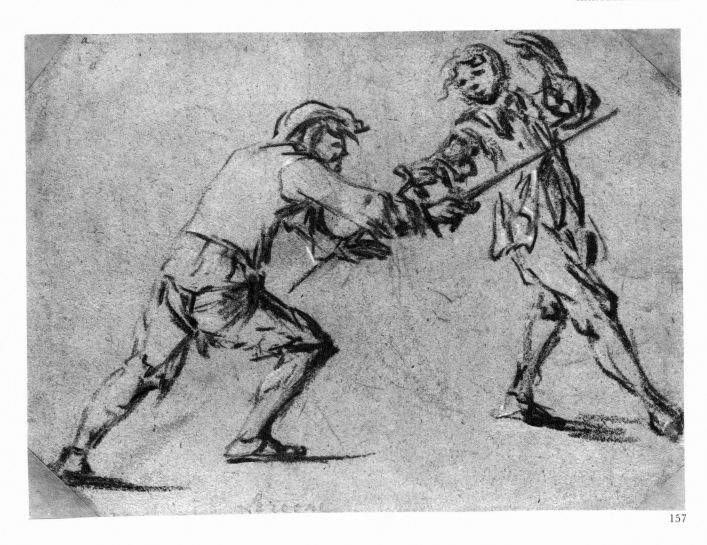

157

157 A fencing scene

Black and brown chalks, heightened with white, on buff paper (the corners have been trimmed and made up); 192 × 257 mm (7⁹⁄₁₆ × 10⅛ in)

Inscribed: *Laroone*

PROVENANCE: L. G. Duke; Colnaghi, 1961

LITERATURE: J. Egerton and D. Snelgrove, *The Paul Mellon Collection: British Sporting and Animal Drawings c.1500–1850*, London, 1978, p. 61

Yale Center for British Art, Paul Mellon Collection (B1977.14.5303)

158 A fencing scene

Brush drawing in brown wash, over black lead, indented for transfer; 179 × 296 mm (7⁷⁄₁₆ × 11⅝ in)

The recto bears traces of lettering cut away at the foot

PROVENANCE: Hugh Howard; the Earls of Wicklow

LITERATURE: ECM & PH 1; R. Raines, *Marcellus Laroon*, London, 1966, p. 13

The British Museum (1874-8-8-2262)

Vertue noted that Lauron's 'most considerable work. besides paintings are designs he made for a book of ye London Cryes another for fencing...' (I, p. 147). Twenty-four plates, engraved by William Elder, were published in 1699 as *The Art of Defence; in which the several sorts of Guards, Passes, Encloses and Disarmes &c are represented by proper Figures with their respective Explications* (there were two issues, one published by Phillip Lea and another by G. Beckett); Lauron's name does not appear on the plates of any of the known copies of the book. No. 157 was not engraved, but it depicts the same manoeuvre as that in plate 5: 'Here a Tierce is cutt off by a Cart by turning

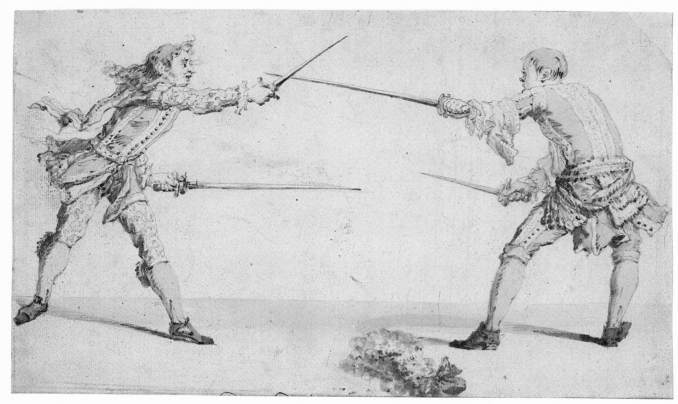

158

about the left foot (with the Body) in makeing the Pass'. Both this drawing and another similar example in the British Museum (1897-8-13-9r and v) were probably preparatory studies, sketched from the life. No. 158, however, is a finished drawing, in a style more closely related to his designs for *The Cryes of London* (nos 155–6), which was engraved as plate 8: 'The Sword and Dagger Guard: The Sword that offers first is Defended by ye Dagger'.

GASSELIN, Francois(?)

*fl. c.*1683 – 1703

The drawing illustrated is by the same hand as those in an album at Chatsworth – one of which is inscribed *par Gasselin* – which show that the artist was working in the environs of Paris between 1683 and 1692 and in London in 1693. A sheet of views of Windsor Castle in the Royal Library is dated *12-19 d'ous* [août] *1703*. Anthony Blunt suggested that the artist might be identified with a Noël Gasselin who was active in Paris in 1677. Most of the drawings atributed to Gasselin are in pen and brown ink with grey wash on narrow strips of paper and bear inscriptions in an idiosyncratic form of French. The artist may have been a Huguenot: a François Gasselin is recorded in the Baptism Register of the French Church, Glasshouse Street, as godfather to the son of Corneille François Gole in June 1701, and a François Gaslin in that

of St Martin Orgar as godfather to the son of Etienne Billon in September 1701.

159 Montagu House from the north-west

Pen and brown ink, touched with grey wash; 100 × 336 mm (3¹⁵⁄₁₆ × 13¼ in)

Inscribed: *veuee de montay gutant* [Montagu House] *du Costay qui re garde sur son jardin et sur la Coste ou est amesetet* [Hampstead] *et ayguet* [Highgate] *desynay a pres natures –*

PROVENANCE: Sir Henry Ellis

LITERATURE: ECM & PH 2; J. Mordaunt-Crook, *The British Museum: A case-history in architectural politics*, Harmondsworth, 1972, pp. 54–6; G. Jackson-Stops, 'The Building of Petworth', *Apollo*, CV (1977), pp. 327–8

The British Museum (1860-7-14-4)

The first Montagu House, much the grandest house built in London in the second half of the century (1675–80), was designed by Robert Hooke (1635–1703) for the francophile Ralph Montagu (1638–1709), 1st Earl of Montagu and later 1st Duke of Montagu. Markedly French in style, with elaborate interiors decorated by Verrio, it was gutted by fire in January 1685/6. The house was rebuilt shortly afterwards, and it is this second building that is shown in Gasselin's drawing. Colen Campbell illustrated the reconstructed house in *Vitruvius Britannicus*, I, 1715, pls 34–6, ascribing the design to a 'Monsieur Pouget', who

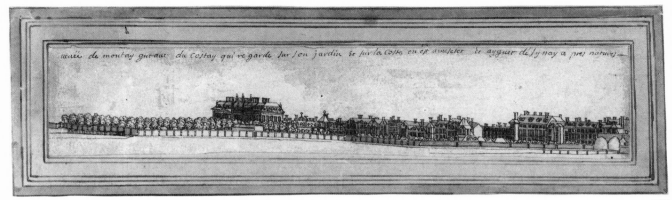

159

has been identified with the sculptor and architect Pierre Puget (1622–94). For several reasons, however, it is unlikely that Puget was the architect responsible for the new Montagu House. Recently a number of drawings in the style of Daniel Marot by an otherwise unidentified 'Mr Boujet' have come to light, and it seems possible on stylistic grounds that he may have been the architect not only of Montagu House, but also of the remodelled North Front of Boughton House, Northamptonshire, also built for Ralph Montagu, and of Petworth, Sussex, rebuilt by the 6th Duke of Somerset (1662–1748), whose wife was Montagu's stepdaughter.

Gasselin's view is taken from near the present Tottenham Court Road looking east towards Montagu House: Robert Hooke's forecourt and cupola-topped entrance (which had survived the fire) are also visible, with, on the right, the backs of the houses facing onto Great Russell Street. The British Museum was established in Montagu House in 1754, but with the construction of Sir Robert Smirke's Greek Revival building between 1841 and 1848 the old house was gradually demolished.

KNYFF, Leonard

Haarlem 1650 – Westminster 1722

The son of Wouter Knyff, a landscape painter from whom he probably received his training. His elder brother Jacob (1639–81) went to England in 1673, and Leonard followed sometime after 1676. By 1681 he was living in Old Palace Yard, Westminster, and apart from two visits to Holland in 1693 and 1695 he settled in England, applying for naturalisation in 1694. He began to hold picture auctions from 1695. However, no documented painting is known before 1697. In Holland he had specialised in bird and animal subjects, which he occasionally painted in England, but he became best known for his topographical pictures, often bird's-eye views, of country houses and their estates. He was the populariser of such prospects, but it seems to have been his brother Jacob who first painted this type of view. In the late 1690s Knyff began to

draw prospects of country houses with the intention of publishing engravings, a project that culminated in *Britannia Illustrata or Views of Several of the Queens Palaces also of the Principal Seats of the Nobility and Gentry of Great Britain* (1707), a collection of eighty plates of views drawn by Knyff and engraved by Jan Kip; a second volume, which included the plates that Kip had drawn for Sir Robert Atkyns's *Gloucestershire* (1712), was published in 1715. In the same year, David Mortier's five-volume *Nouveau Théâtre de la Grande Bretagne* was published, a work which reprinted the whole of *Britannia Illustrata* as well as including a miscellany of other topographical plates (many sets vary in their contents and the work as a whole is thus very difficult to collate). Knyff (and probably also Kip) had sold out their interests in the venture some years earlier. No drawings have survived of the subjects that were engraved for *Britannia Illustrata*, but they must have been very similar to the view of Hampton Court, no. 161. Of Knyff's painted prospects, the finest is the pair showing *Hampton Court, Herefordshire*, dated 1699, in the Yale Center for British Art.

160a View of Richmond Hill and the Thames at Petersham Eyot

Pen and brown ink over black chalk and grey wash; 226 × 782 mm (8⅞ × 30¾ in)

PROVENANCE: Jeremy Maas, 1962

LITERATURE: L. Herrmann, *British Landscape Painting of the Eighteenth Century*, London, 1973, p. 16; Harris (1979), p. 117, no. 113

Private Collection

This drawing is a study for a painting of the same view (whereabouts unknown; see Harris, op. cit.), a characteristic example of Knyff's panoramic prospects. The view is taken from Richmond Hill, looking up river, with the Roebuck Inn on the far left. The village of Petersham is in the centre, and the Earl of Rochester's house, New Park, built about 1692–1700, is partly hidden by the trees at the bottom of the hill. The roofs of Ham House can be seen in the distance. Another painting by Knyff (Ionides Bequest, Orleans House) is a bird's-eye view from the

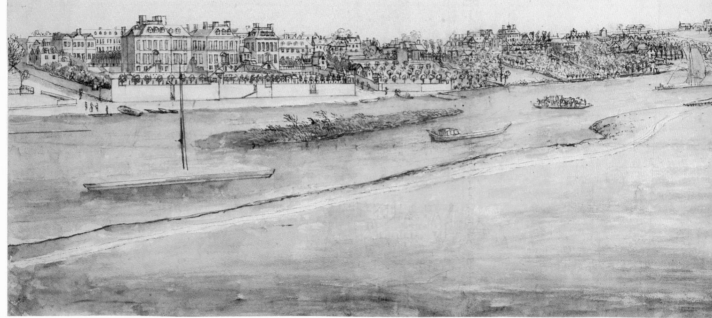

160b

160a

terrace in front of the Roebuck, near the entrance to Richmond Park, looking down river towards Richmond. This drawing and the two paintings can probably be dated about 1700–1702, when Knyff was engaged in making drawings for the eighty engraved plates in *Britannia Illustrata*, published in 1707, which included a view of New Park.

160b View of Richmond Hill

Pen and brown ink with grey wash and touches of black lead; 208 × 727 mm (8³⁄₁₆ × 28⅝ in)

Inscribed by the artist: *Sir Jame's Ash*

LITERATURE: Harris (1979), p. 114, no. 107 (mistakenly said to be in the British Museum)

Private Collection

Like no. 160a, which shows in more detail and from

another viewpoint the right-hand section of this prospect, the present drawing can probably be dated in the early years of the eighteenth century. Knyff's view here is taken from the Middlesex bank of the Thames, looking across to Richmond. The horse-ferry (there was no bridge until 1777) can be seen in midstream, loaded with a coach and horses. The house in the trees on the right, built in the early seventeenth century, was, as Knyff notes, known by its owner's name, Sir James Ash; by 1726 it was called Twickenham Meadows and later Cambridge House after the dilettante Richard Owen Cambridge who lived there from 1750 to 1802. The houses whose gardens back onto the river at Richmond include one later known as Hotham House, to the left, which was built by 1695 and owned by Nathaniel Wood from 1695 to 1707 (it collapsed in 1960), and Heron House (Mr J. Cloake, Chairman of Richmond Local History Society, has kindly communicated this topographical information).

This view was not used as the basis for a painting or an

engraving, and is unfinished, but is a handsome example of Knyff's draughtsmanship. A painting by Tillemans, *Richmond from Twickenham Park*, painted about 1720–25 (Department of the Environment), shares a similar viewpoint.

161 Hampton Court from the south

Pen and brown ink with grey wash; 413 × 585 mm (16¼ × 23 in)

Inscribed with annotations in Knyff's hand, which include the names of the statues in the Privy Garden and indicate areas of 'gravel' and 'grass'

PROVENANCE: F. Sabin

The British Museum (1961-4-8-1)

This bird's-eye view is probably connected with Knyff's series of prospects engraved by Jan Kip for *Britannia Illustrata*, published by David Mortier in 1707, in which, however, that of Hampton Court is from the west. It is remarkable as a contemporary view made soon after Wren's additions to the palace (1689–94) for King Wil-

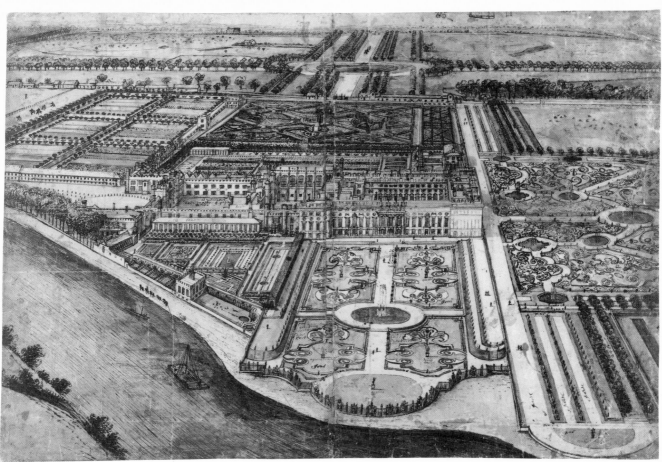

161

liam III and Queen Mary, showing the elaborate layout of the gardens in Franco-Dutch taste which were begun at that time and completed during the next phase of works after fire destroyed Whitehall Palace in January 1698, causing the King, in the words of Defoe, 'to revive his good liking for Hampton Court'. The drawing can probably be dated about 1702; in January 1703 Knyff reported that he had drawn 'a great many of Hampton Courte . . . which are not yett engraved'. A painting by Knyff in the Royal Collection (O. Millar, *Tudor, Stuart and Early Georgian Pictures in the Royal Collection,* London, 1963, no. 423), showing the palace from the east, can be dated a little later.

On the south side of the palace is the Privy Garden, stretching to the river and enclosed by Jean Tijou's baroque concave-convex ironwork screen; the so-called Diana Fountain, designed by Inigo Jones and Hubert Le Sueur (see nos 90, 130 and 168), which had been altered by Edward Pierce about 1690 and placed in the centre of the redesigned Privy Garden (see p. 170), is not readily visible. To the east is part of the Fountain Garden, with the layout of parterres and fountains designed by Daniel Marot (see no. 176), and running north-south is the Long Walk created by Henry Wise about 1700. North of the palace can be seen the Wilderness with the Labyrinth or Maze, laid out about 1699. Beyond the Maze is the entrance to Bushy Park, with the Chestnut Avenue and the Great Basin, constructed in 1699–1700. On the west side of the palace were the former Tiltyard Gardens, which William III turned into kitchen gardens.

WYCK, Jan

Haarlem 1652 – Mortlake 1700

The son and pupil of Thomas (q.v.), Jan Wyck was born in Haarlem. The inscription on Faber's mezzotint after Kneller's portrait of him (1685; untraced), published in 1730 (Chaloner Smith 397), notes his date of birth as 29 October 1652, although a marriage licence issued in November 1676 describes him as 'Jan Wick of St Paul's Covent Garden, gent., widower, about 31', thus suggesting that he was born about 1645. Jan Wyck accompanied his father to England soon after the Restoration, but the exact date is not known. The first documented reference to him is on 17 June 1674, when he appeared before the court of the Painter-Stainers and promised to pay his own and his father's 'quarterage'. Among his first British patrons were the Duke and Duchess of Lauderdale, who employed a number of Dutch as well as English artists at Ham House in the 1670s; Wyck's signed *Cavalry Skirmish* in the Duke's Closet is one of the first of a genre in which he specialised, working in a style influenced, as Vertue noted, by Wouwermans (1619–68) and by Jacques Courtois, Il Borgognone (1621–76). Among his battle-pieces at Drumlanrig is one of *Bothwell Brig* (1679), probably painted for the Duke of Monmouth, and in something of

the same manner were his military equestrian portraits, such as that of William III (1692) at Blenheim, which were to become prototypes for early eighteenth-century artists. Wyck played an important part in the development of sporting painting in England, 'his Hunting Pieces are also in grate Esteem among our Country-Gentry, for whom he often drew Horses & Dogs by the Life' (Vertue, II, p. 141). John Wootton (1682–1764), the first native-born sporting artist of distinction, was a pupil of Wyck's in the late 1690s, and many of his hunting and racing scenes were indebted to his master's compositions. Wyck also made drawings of sporting subjects for Blome's *Gentleman's Recreation* (1686). He died in Mortlake, Surrey, where he had lived since his third marriage in 1688.

162 A stag hunt: full cry

Brown and grey wash with bodycolour on grey-green paper; 475 × 333 mm (18¾ × 13 in)

Inscribed on the old mount: *539-2 John Van Wycke* and on the verso: *R. Willett coll. 1808 WE P. 118 No. 539*

PROVENANCE: Ralph Willett, 1808; William Esdaile (L 2617); E. Horsman Coles; F. R. Meatyard; A. P. Oppé; Miss A. and Mr D. Oppé; S. Gahlin, 1965

LITERATURE: *The Paul Oppé Collection*, exh. cat., Royal Academy, London, 1958, no. 410; J. Egerton and D. Snelgrove, *The Paul Mellon Collection: British Sporting and Animal Drawings c.1500–1850*, London, 1978, p. 102

Yale Center for British Art, Paul Mellon Collection (B1977.14.4170)

A spirited example of a hunting subject, a genre in which Wyck specialised. He was important in the growth of sporting painting in England, and in the late 1690s John Wootton was his pupil. Wyck's fluent style and his sense of colour and movement are particularly apparent in works such as this decorative drawing.

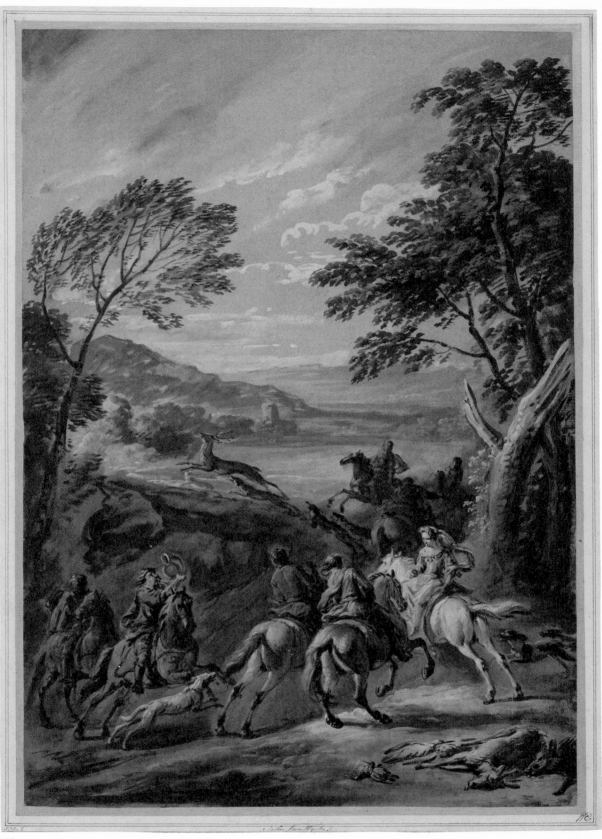

162

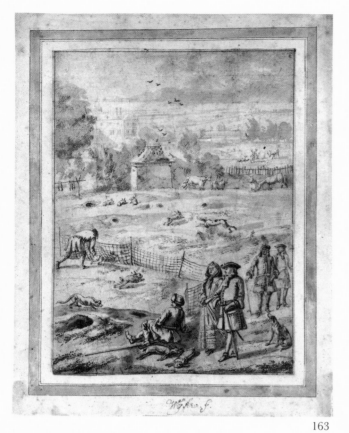

163

163 Rabbit-catching

Pen and brown ink, with washes of grey and brown; 298 × 214 mm (11¾ × 8⁷⁄₁₆ in)

Inscribed: on the old mount (perhaps by the artist) *Wyke fe*, and on the verso: *John Wyck or Wyke B. 1640 D. 1702 (signed) Purchased at the Strawberry Hill Sale 1842*

PROVENANCE: Horace Walpole (sale, Robins, 23 June 1842, lot 1266, no. 35); purchased by Henry Graves & Co.; Dr B. Delany (L 350; apparently not in his sale, Sotheby, 5 June 1872); E. H. Coles; A. H. Coles

LITERATURE: ECM & PH 8

The British Museum (1950-10-14-2)

This drawing was intended as an illustration to Richard Blome's *The Gentleman's Recreation* (1686), but was not engraved. It corresponds with Chapter XIV of Part III of the book, 'Hunting', pp. 98–9, '*Of Takeing and Hunting the CONEY or RABET, with* Dogs, Nets *and* Ferrets . . .'. Blome describes the manner of hunting, using dogs (in Wyck's drawing, a tumbler, noted as 'a Creature of great craft and subtilty', p. 69) and ferrets to drive the rabbits out of their burrows and, as shown here, into the nets pitched for the purpose. Another drawing by Wyck in the British Museum, *The death of the hart*, was engraved by Arthur Soly as an illustration for the passage on stag-hunting.

WISSING, Willem

Amsterdam 1656 – Stamford 1687

Of the pupils of Sir Peter Lely (q.v.), only Wissing and Greenhill (q.v.) developed independent styles, but both died in their thirties, just as they were beginning to establish themselves. Wissing trained in The Hague under Willem Doudijns (1630–97) and Arnoldus van Ravestyn (1615–90), and perhaps also in Paris: the inscription on his monument notes 'Quem Batava tellus educavit, Gallia aliquandiu fovit'. By July 1676 he had arrived in England and had been admitted as a member of the Dutch Reformed Church in London. He seems to have entered Lely's studio almost immediately, according to one source as a servant but more probably as a pupil and assistant, being described as such in Lely's will. After Lely's death, he was temporarily Godfrey Kneller's (q.v.) chief rival, painting Charles II and finding particular favour with James II, who sent him to Holland in 1685 to paint William, Prince of Orange (later William III) and Princess Mary. His compositions became widely known through mezzotints. In the last years of his life, Wissing's chief patrons were the Brownlows of Lincolnshire and the nearby Earl of Exeter, whose sons he painted at Burghley House, Stamford, shortly before he died there.

164 A seated woman

Black chalk; 474 × 317 mm (18⅝ × 12½ in)

PROVENANCE: Bequeathed by Sir Hans Sloane, 1753

LITERATURE: ECM & PH 1

The British Museum (5214-68)

The attribution to Wissing dates from the mid-eighteenth century, when the drawing was in Sir Hans Sloane's collection, and is recorded in the manuscript inventory of the Sloane Bequest compiled in 1845. Vertue noted that 'Wissing learnt of Sr. Pet. Lely. & was at first only his *livery man* [servant] . . . but haveing a strong inclination to drawing without his Masters knowledge. made such a progress that he [Lely] was surpriz'd when he first saw his drawings. & took off his livry & sett him forward in his studies of painting' (II, p. 26). Surprisingly, in view of this account, only one other drawing, a study for a portrait of Lady Brownlow, about 1686 (Witt Collection 949), has been attributed to Wissing, and is quite different in style from the present sheet.

This type of intimate portrait study, almost photographic in its immediacy, was common in Holland, but is found only rarely in England, the drawings of Charles Beale being the nearest in approach (see nos 170–71). The informal mood of the drawing suggests that perhaps the sitter was a member of the artist's family rather than one of his clients.

The sitter's dress presents some problems in dating the drawing, and hence casts some doubt on its attribution. She is shown wearing a style of dress newly fashionable in

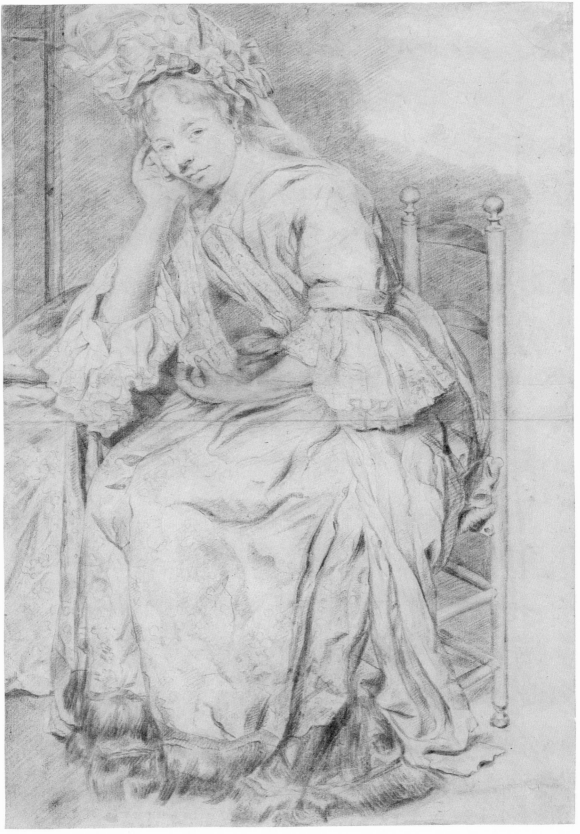

164

the late 1680s, the mantua, which the artist has drawn in unusually informative detail: the silk brocade petticoat with a heavy fringe, a contrasting stomacher or decorated stays-panel, delicate lace sleeve-ruffles and lappets to her *cornette* head-dress, all of great stylishness (though she is seated on a simple ladderback chair). Wissing died in 1687, but the dress depicted compares most closely with French fashion plates of 1688–9. Allowing for a lapse of time before the latest French fashions were copied in other European cities, this suggests that the present drawing is not by Wissing.

DAHL, Michael

Stockholm 1659? – London 1743

Dahl was trained in Stockholm as a history and portrait painter, and was appointed assistant court artist. In 1682 he went to London, where he soon became a protégé of Godfrey Kneller (q.v.). In 1685 he travelled with Henry Tilson (1659–95) via Paris to Italy, where they stayed for three years, Dahl painting a portrait of Queen Christina of Sweden (Grimsthorpe Castle). Both artists left Rome in 1687, returning via Frankfurt to London in March 1688/9. Dahl soon became a rival to Kneller, Vertue noting that 'the Great business and high carriage of Kneller gave a lustre to the actions or workes of Mr Dahl . . . being a man of great Modesty and few words – joynd to his excellent skill' (III, p. 118). He attracted influential patrons, notably the 6th Duke of Somerset, for whom he painted the 'Petworth Beauties' in the 1690s. At about the same time he was taken up by Prince George of Denmark ('his Royal Patron – and great Promoter of his fortune', Vertue, III, p. 118) and his wife Princess Anne, and after her accession as Queen in 1702 painted a series of Admirals at Greenwich, in competition with Kneller. After the Queen's death in 1714, Dahl's royal patronage ceased – it has been suggested that as a Tory he fell out of favour with the Hanoverians – although he was considered for appointment as Principal Painter to the King on Kneller's death in 1723. In fact George I appointed Charles Jervas, partly, according to contemporary rumour, in a fit of pique because Dahl refused to paint a royal baby (*Diary of the 1st Earl of Egmont*, Hist. MS Commission, III, 1920, p. 275). In the decade after Kneller's death, Dahl was much employed; he retired from painting in about 1740. His chief pupil was a fellow Swede, Hans Hysing (d. 1753).

165 Edward Harley, 2nd Earl of Oxford (1689–1741)

Black chalk, heightened with white, on blue paper, the corners trimmed; 370 × 260 mm (14⁹⁄₁₆ × 10¼ in)

Inscribed: *Ld Oxford*

PROVENANCE: Edward Cheney (sale, Sotheby, 4 May 1885, lot 907); Colnaghi

LITERATURE: L. Binyon, *Catalogue of Drawings by British Artists and Artists of Foreign Origin working in Great Britain . . . in the British Museum*, IV, London, 1907, p. 298, no. 22 (as by George Vertue); Stewart (1971) 51; D. Stewart, 'Some Portrait Drawings by Michael Dahl and Sir James Thornhill', *Master Drawings*, XI (1973), p. 38 and p. 42, no. 5; J. Kerslake, *National Portrait Gallery: Early Georgian Portraits*, I, London, 1977, p. 206

The British Museum (1885-5-9-1670)

This drawing is related to the half-length portrait of Lord Harley (now at Welbeck Abbey), seated and holding a medal of Queen Anne, which was painted before 1719 (in which year it was copied in an enamel miniature by Zincke) and engraved by Vertue in 1746. Until recently the drawing was attributed to George Vertue, but Stewart has suggested (op. cit., 1971) that it is an *ad vivum* study by Dahl in preparation for the painting. The identification of this sheet has made it possible to attribute a number of other similar studies to Dahl, many of which were previously thought to be by Kneller. Both Dahl and, slightly later, Jonathan Richardson the Elder seem to have adopted from Kneller the practice of making such life-size studies of heads as an aid in painting portraits.

Edward Harley, who became the 2nd Earl of Oxford in 1724, was a noted collector; his great library, started by his father and described by Dr Johnson as excelling any offered for sale, was dispersed in 1742, but the celebrated Harleian collection of manuscripts was one of the founding collections of the British Museum in 1753. He was also a patron of contemporary writers, including Pope, Swift and Prior, and of artists and architects such as Rysbrack, Gibbs and Vertue. Dahl seems to have been his favourite portrait painter, as Vertue noted in 1737: 'My good Lord Oxford. has at heart the promoteing of . . . Mr Dhal [*sic*] for face painting' (III, p. 79), and in the sale of parts of Lord Oxford's collection after his death there were eighteen portraits by Dahl.

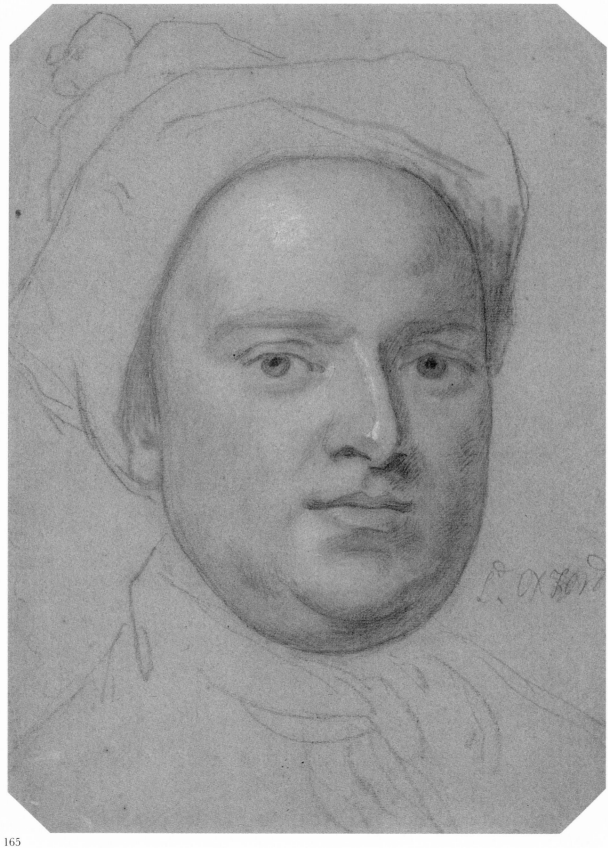

165

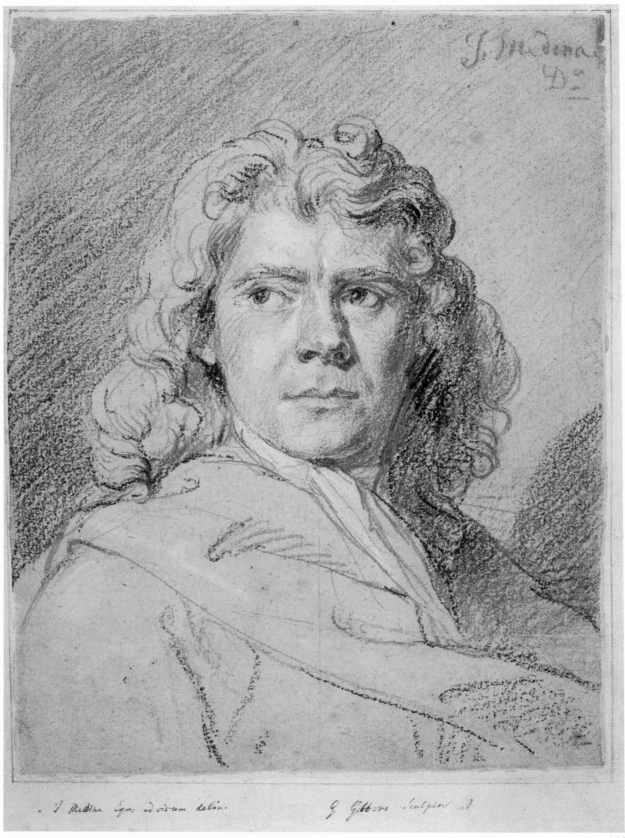

166

MEDINA, Sir John Baptist

Brussels 1659/60 – Edinburgh 1710

The son of a Spanish officer who settled in Brussels, Medina studied painting there under François de Chatel; he went to England in 1686, practising in London as a portrait painter in the manner of Kneller (q.v.). In 1688 he went to Scotland, where his patron, the 5th Earl of Leven, helped him to secure commissions. He settled in Edinburgh, where he enjoyed considerable success, and his series of portraits in the Surgeons' Hall, painted between 1697 and about 1708, are perhaps his best works. Vertue noted that 'he drew and painted historical subjects very well and had a fine taste in landscape and would have made a good history painter had he lived where suitable encouragement were to be met with' (I, p. 49), but the only surviving history picture by Medina is an *Apelles and Campaspe* (Gosford House, East Lothian). Tonson's 1688 edition of Milton's *Paradise Lost* included eight illustrations by Medina, the only known examples of his work as an illustrator (see no. 167); Vertue states that he also made designs for an Ovid, but these were never published. Medina was knighted in 1707, the last person to receive this honour in Scotland before the Union in May of that year.

166 Grinling Gibbons (1648–1721)

Red and black chalks, heightened with white, on buff paper; 227 × 172 mm (8¹⁵⁄₁₆ × 6¾ in)

Verso: Study of a pair of legs

Red chalk; 227 × 172 mm (8¹⁵⁄₁₆ × 6¾ in)

Signed: *J. Medina De* and inscribed on the old mount, by George Vertue, *J Medina Eques ad vivum delin.* and *G Gibbons Sculptor &* [not completed]

PROVENANCE: George Vertue (cannot be identified with any specific lot in his sales, Ford, 16 March and 17 May 1757); Horace Walpole (probably in his sale, Robins, 28 June 1842, lot 270, but not specifically listed); A. E. Evans

LITERATURE: ECM & PH 1; D. Piper, *Catalogue of Seventeenth Century Portraits in the National Portrait Gallery 1625–1714*, London, 1963, pp. 136–7; D. Green, *Grinling Gibbons: his Work as Carver and Statuary 1648–1721*, London, 1964, p. 33

The British Museum (1852-2-14-375)

As an *ad vivum* portrait of the celebrated wood-carver and sculptor this drawing is of particular interest. It can probably be dated about 1686–8, when Medina was working in London: Gibbons would have been in his late thirties. He was painted by Kneller about 1690 (Hermitage, Leningrad) and, with his wife Elizabeth, by John Closterman, perhaps a little later. A contemporary description of Gibbons comes from the diarist John Evelyn, who claimed to have 'discovered' 'that incomparable young man' in 1671, working on a large copy in wood-relief of Tintoretto's *Crucifixion*. Recalling their first meet-

ing he noted: 'I found he was likewise *Musical*, & very Civil, sober & discreete in his discourse'.

This drawing belonged to George Vertue (1684–1756), the first historian of the arts in England, and then to Horace Walpole (1717–97), whose *Anecdotes of Painting, Engraving, Architecture &c &c in England* (1765–71) were based on Vertue's notebooks.

167 Illustration for Book III of Milton's *Paradise Lost*

Pen and brown ink with brown wash; 298 × 184 mm (11¾ × 7¼ in), set in a decorative border, perhaps by Francesco Pellegrino

PROVENANCE: Bequeathed by the Rev. Alexander Dyce, 1869

LITERATURE: M. Pointon, *Milton and English Art*, London, 1970, pp. 1–20; S. Boorsch, 'The 1688 *Paradise Lost* and Dr Aldrich', *Metropolitan Museum Journal*, 6 (1972), pp. 133–50

The Victoria and Albert Museum

Milton's *Paradise Lost*, published in 1667, first appeared in an illustrated edition in 1688, issued by Jacob Tonson (who chose in 1717 to be painted by Kneller for the Kit-Cat series holding a copy of it). It was one of the first examples of a book published by subscription (a list of the

167

five hundred backers appears at the end of the volume), and Tonson's first great success. The poem was illustrated with twelve engravings, one for each of the books into which the epic was divided. All the plates save one were engraved by Michael Burghers (*fl.*1676–1720); seven are signed 'Medina invenit' and one 'Medina delineavit', one is signed by Bernard Lens (1659–1725), and four are anonymous. It has usually been assumed that these four unsigned designs should also be attributed to Medina, but Suzanne Boorsch has shown (op. cit.) that they were almost certainly by Dr Henry Aldrich (1647–1710), Dean of Christ Church, Oxford, an amateur architect of distinction and a collector of books, manuscripts and prints, as well as author of a treatise on grammar and a book on logic. These four compositions – which include the most striking design of the twelve, *Satan and his angels* – were probably derived from engravings in Aldrich's collection.

Additional confirmation that Medina was responsible for only eight of the illustrations is to be found on a manuscript title-page accompanying the drawings, which are in the Victoria and Albert Museum. This states: 'Original Drawings, Eight in Number, Being All that were ever Designed for Mr Milton's Poem of Paradise Lost, By Sr John Baptist of Medina'. Each drawing is surrounded by a decorative border, presumably added by the Francesco Pellegrino who signed the title-page. The drawing shown here is for Book III, and makes use of the well-established convention of continuous narrative, in which several episodes are represented: Christ is adored by angels, while in the foreground Satan alights upon the earth; his passage to the sun is shown, as well as his arrival on Mount Niphates; and Adam and Eve are seen in Paradise. Medina's knowledge of seicento religious painting is apparent in his designs for *Paradise Lost*, if only in dilute form.

NOST, John

Mechelen before 1660 – London 1711/12

Nost was the proprietor of one of the famous statuary yards which flourished near Hyde Park Corner during the eighteenth century, supplying a range of sculpture from lead figures for gardens to grand tombs for noble patrons. His style owes more to that of Grinling Gibbons (q.v.) than to his Flemish background, suggesting that he was perhaps barely out of his apprenticeship in 1679 when he is recorded at Windsor Castle. By 1686 he was foreman to his fellow-countryman Arnold Quellin (1653–86), whose widow he married. In later years his work tended to become mannered, characterised by jaunty poses and swirling drapery. This is to be seen particularly in much of the garden sculpture for which he is best remembered, for instance the figures at Rousham (1701) and the Perseus at Melbourne Hall, Derbyshire (1699–1705), although other figures in that garden are derived from Continental models as diverse as Giambologna, Annibale Carracci

and François Duquesnoy. There are only three documented tombs: those of Sir Hugh Wyndham (1692, Silton, Dorset), the 3rd Earl of Bristol (d. 1699, Sherborne, Dorset) and the Duke of Queensberry (1711, Durisdeer, Dumfriesshire), but several others may be confidently attributed on stylistic grounds and it would appear that Nost attracted many commissions for monuments. He worked for William III at Hampton Court around the turn of the century, providing not only the fountain design discussed below but figures and vases for the gardens and several fine marble chimney-pieces, including one with a relief showing the Triumph of Venus for which he was paid £235. The fact that the yard remained in the family until 1739, when it was taken over by John Cheere (1709–87), has led to a certain amount of confusion over the attribution of individual pieces to Nost himself (who until recently was thought to have died in 1729), to his nephew Gerard (d. 1729), his assistant Andrew Carpenter (*c.*1677–1737) or his son John Nost II (*c.*1711/12–1780) (information from Sheila O'Connell).

168 Design for a fountain, with a statue of King William III

Pen and ink with grey wash, on two pieces of paper; 517 × 318 mm (20 × 12½ in)

PROVENANCE: Michael Angelo Rooker; Thomas Agnew and Sons Ltd

LITERATURE: J. Physick, *Designs for English Sculpture 1680–1860*, London, 1969, pp. 24, 56 and fig. 56; J. Harris, 'The Diana Fountain at Hampton Court', *Burl. Mag.*, CXI (1969), p. 447 and fig. 37

The British Museum (1964-12-12-7)

A design connected with one of several schemes to alter Inigo Jones' and Hubert Le Sueur's Diana Fountain, moved in 1656 from Somerset House to the Privy Garden at Hampton Court (see no. 90). The fountain was first altered by Edward Pierce between 1689 and 1694 (see no. 130) but there is evidence to suggest that in about 1700 the figure of Diana was to be replaced by one of William III. Two designs by Nost have survived which are connected with this project: one drawing (Victoria and Albert Museum 9145) shows a statue of William III on a simple pedestal with boys representing the continents at each corner, while the other, exhibited here, is not only more elaborate but shows a clear relationship with the Diana Fountain as remodelled by Pierce. Of Jones' and Le Sueur's original design only the figure surmounting the fountain, the boys holding dolphins and the scallop-shell basins remain: the carved stone pedestal is that designed by Pierce and recorded in Sutton Nicholls's engraving of about 1699 (see p. 170). The upper parts of both the present drawing and that in the Victoria and Albert Museum are separate sheets of paper pasted down, suggesting that they were alternative proposals. Nost also made a model of a proposed fountain, incorporating the same elements, for which he submitted an account in

168

BEALE, Charles

London 1660 – London 1714?

The younger son of Charles Beale (1631–1705) and his wife, the painter Mary Beale (1632/3–99), one of the better-known women artists of the period. Most of her portraits reveal the influence of her friend Lely (q.v.), who gave her advice and allowed her to study his collection. Her husband, who for a time held an official post as Deputy Clerk of the Patents, helped her in her professional work by becoming an expert in artists' colours, and kept notebooks which provide an unparalleled account of a seventeenth-century painter's life, recording details of clients' sittings, the progress of paintings and the family's frequently troubled financial affairs. Both Charles and Mary Beale came from well-connected families, their social contacts providing a nucleus of sitters, many of whom were distinguished churchmen and other well-known professional men. Their elder son, Bartholomew, became a doctor, but both he and his brother had helped in the studio from an early age in the routine business of drapery painting. They also copied drawings by Italian masters, apparently borrowed from the Royal Collection through William Chiffinch, who seems to have acted as keeper of them.

As a boy, Charles contracted smallpox and (clearly accident-prone) was once badly injured by a blow on the head from a falling brick: perhaps this contributed to his later poor sight. In 1677 he was apprenticed to his parents' friend the miniaturist, barrister and writer Thomas Flatman (1637–88). Miniatures by Charles Beale (chiefly copies of paintings by other artists) are dated between 1679 and 1688, but in the latter year he gave up this work because of failing eyesight and changed to full-scale portraiture, probably assisting his mother. His most notable works, however, are the red chalk studies from the life preserved in three sketchbooks dating between 1679 and 1681: the earliest is in the Pierpont Morgan Library, New York; the second, originally containing 175 drawings, was broken up and the sheets separately mounted after it entered the British Museum in 1799 (see no. 171), while the third, dated 1680, is also in the British Museum (no. 170). Charles Beale was still painting in 1712, but the date and place of his death are confused. The date 1721 inscribed in his '3rd Book' led Croft-Murray and Hulton to suppose that he might have been the 'Charles Beale' who was buried at St Martin-in-the-Fields on 26 December 1726; but the inscription is probably not in his hand. One of Vertue's accounts of his death states that he 'dyd in Longacre where he lodged 1714' (V, p. 14).

August 1701. The death of William III in 1702 (while riding in Bushy Park), however, put an end to any plans for the work. In November 1712, under Wren's direction, the Diana Fountain was re-sited in Bushy Park, with a new high rusticated base to Pierce's pedestal (see p. 127), perhaps made to the design of Nost, who had recently died. Alternatively, it may have been designed by William Talman, who had been responsible for the layout of the grounds: he had submitted an estimate for a 'pedestall of Portland stone for a Diana in brass' in December 1699, but was dismissed as Comptroller of Works in 1702.

Although Nost's scheme for the fountain was not carried out, he made several statues of William III, including one formerly at Walton Hall, Lancashire, now in the Yale Center for British Art, and two others similar in design to that shown in this drawing, one now in Portsmouth Dockyard and another at Wrest Park, Bedfordshire. Nost's precedents seem to have been Grinling Gibbons's statues of Charles II, at the Royal Hospital, Chelsea, and James II, now outside the National Gallery, Trafalgar Square.

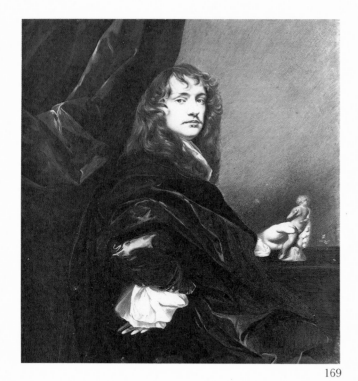

169

169 Sir Peter Lely (1618–1680), after a self-portrait

Watercolour on vellum; 194 × 169 mm (7⅝ × 6⅝ in)

Signed: *CB* (in monogram) *1679*

PROVENANCE: Horace Walpole (sale, Strawberry Hill, 6 May 1842, lot 15, bought by Gosling)

LITERATURE: ECM & PH 130; D. Foskett, *British Portrait Miniatures*, London, 1963, p. 146; D. Piper, *Catalogue of Seventeenth Century Portraits in the National Portrait Gallery 1625–1714*, London, 1963, p. 200; E. Walsh and R. Jeffree, *'The Excellent Mrs Mary Beale'*, exh. cat., Geffrye Museum, London, 1975, no. 50; Millar (1978) 29

The Victoria and Albert Museum

'Mr Lilly's own picture HL' was in the collection of Charles Beale's parents, Charles and Mary Beale, by 1661 (Vertue, IV, p. 174); it was probably the self-portrait recorded in the collection of Sir Francis Child in 1699, which later passed to the Earls of Jersey and is now in the National Portrait Gallery, London. Although Mary Beale was not in the formal sense a pupil of Lely's, both she and her husband were close friends of the artist and her painting style was to a great extent dependent on his.

Charles Beale the Younger was sent to study limning with another of his parents' friends, Thomas Flatman (1637–88) in 1677. The considerable skill he had developed by 1679 can be seen in this copy. Among the drawings by him in the British Museum is a red chalk study after the same Lely self-portrait (ECM & PH 130), and another copy in miniature, of the head and shoulders only, is at Welbeck Abbey.

The statuette of a Duquesnoy-like putto which Lely is holding was presumably in his collection; very similar examples seem also to have belonged to the Beales, since Charles Beale's sketchbooks include a number of studies of such figures (see ECM & PH 162–7).

170 Charles Beale's '3ᵈ Book 1680'

88 drawings chiefly in red chalk, some strengthened with black lead and black chalk, in a vellum-bound sketchbook containing 94 leaves; 261 × 203 mm (10¼ × 8 in)

Signed on first fly-leaf: *Charles Beale 3ᵈ Book. 1680* and inscribed on the second fly-leaf, probably in another hand, *Charles Beales Book Ano Domini 1721* and in another hand *J. Wakeford*

PROVENANCE: J. Wakeford; acquired by the Beale family in the late nineteenth century; Sir William Philipson Beale; Sir Samuel Beale

LITERATURE: E. Walsh, 'Charles Beale 3ᵈ Book. 1680', *Connoisseur*, CXLIX (1962), pp. 248–52; ECM & PH, pp. 151–2; E. Walsh and R. Jeffree, *'The Excellent Mrs Mary Beale'*, exh. cat., Geffrye Museum, London, 1975, no. 61

The British Museum (1981-5-16-15(1-94))

This sketchbook now contains eighty-eight drawings; originally, to judge from inscriptions in the hand of a later owner, J. Wakeford, there were ninety-seven. All the drawings are figure studies, apparently from the life, many of them being inscribed with the names of the sitters, several of whom also appear in Charles Beale's '1st Book, 1679', now in the Pierpont Morgan Library, New York, and among the 175 separately mounted sheets in the British Museum, which may originally have formed a further sketchbook. Replicas of sixty of the drawings in no. 170 are in a supposed 'fourth' book (also acquired by the British Museum in 1981), but these are so much coarser in quality that it is unlikely that they are by Charles Beale. The date of this sketchbook coincides with a notebook kept in 1680–81 by the artist's father, Charles Beale the Elder, who looked after the day-to-day organisation of Mary Beale's studio, noting her sitters and summarising her accounts. One list includes portraits painted by her for 'Studie and Improvement', mostly of the Beales themselves, their servants and pupils, including several of the subjects sketched by Charles Beale the Younger in this book. Another list of friends and relations from whom the Beales borrowed when in 'great straights and disappointment of money', and of those tradesmen and suppliers who would accept a portrait in lieu of payment, also includes various names that appear in one or other of the sketchbooks.

These studies by Charles Beale are unlike almost any other British drawings that have survived from the seventeenth century, with the possible exception of those by Samuel Cooper (nos 74–6 and 80). They are spontaneous and informal in character, free from the usual contemporary conventions of portraiture, and have more in common with Dutch genre scenes and figure studies. Among the most striking drawings is the study of one of the Beales'

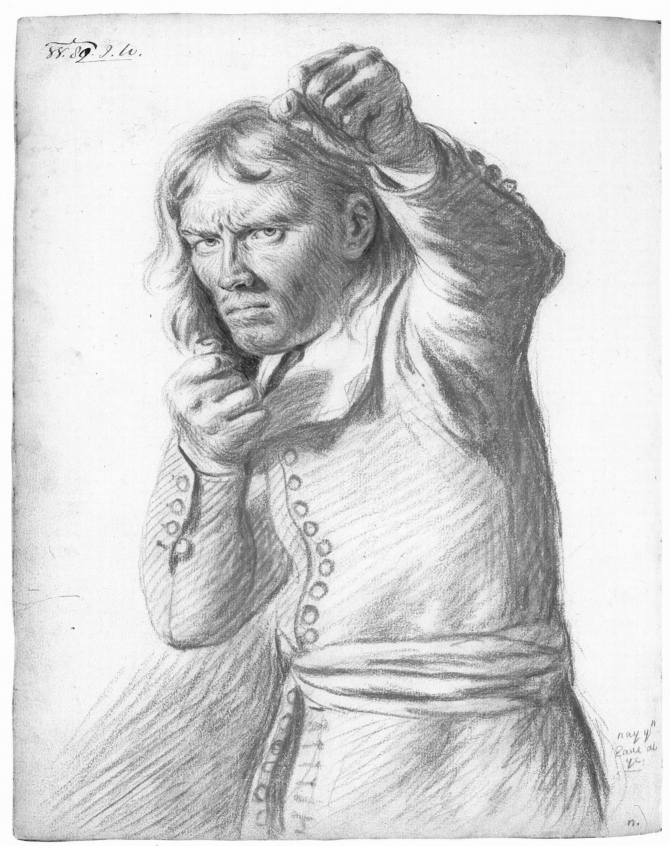

170a *Carter fighting: 'Nay yn / have at Ye'* (f.87v)

170b *Susan Gill* (f.34r)

170c *A young woman pouring chocolate or coffee* (f.35r)

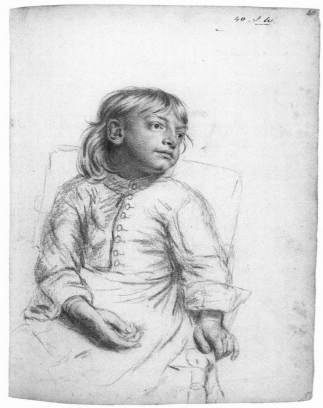

170d *A girl seated in a chair* (f.40r)

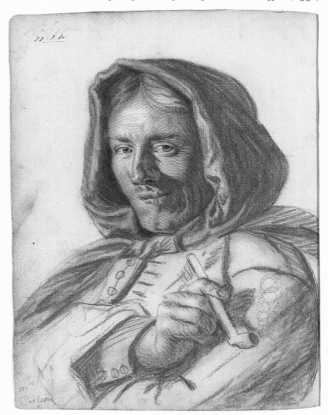

170e *Mrs Carter* (f.76v)

maidservants, Susan Gill, shown holding her broom. According to Charles Beale's 1677 notebook she was paid 17s. 6d. a quarter, but seems to have left their service by 1681. Other sitters included George Carter, the Colourman (supplier of pigments to Mary Beale), and his mother, shown smoking a clay pipe, and the children of Thompson Norris, the Beales' porter and general handyman.

171 Carter, the Colourman, looking over the back of a chair

Red and brown chalk, heightened with black lead and black chalk; 246 × 191 mm (9¹¹⁄₁₆ × 7½ in)

PROVENANCE: G. Steevens (before 1786); bequeathed by the Rev. C. M. Cracherode, 1799

LITERATURE: ECM & PH 28; E. Walsh and R. Jeffree, *'The Excellent Mrs Mary Beale'*, exh. cat., Geffrye Museum, London, 1975, no. 66

The British Museum (G.g.4 w.5-161)

According to Vertue, Carter the Colourman was 'intimate in the Beals family' (v, p. 14), and he or his father supplied many of the pigments used by Mary Beale. Four drawings in the '3ᵈ Book' (no. 170) are inscribed with his name, including a spirited study of him apparently preparing to fight, and he appears in many other drawings. His mother or grandmother, Mrs Carter, is the subject of a remarkable drawing in the same sketchbook. Vertue also noted

that Carter came into possession of Charles Beale the Elder's papers and notebooks, having 'above 30' 'in his Custody from 1711': he lent these 'to a Scrub painter to read. whose goods being seizd on. they were lost and sold away' (v, pp. 14–15). Of these, Vertue later made extracts from at least seven, 'bought at a book stall by a Friend of mine' (IV, p. 68), and probably five or six others owned by Dr Richard Rawlinson (v, pp. 172–6), who later left his collections to Oxford University. Carter was still alive about 1742, when Vertue noted his recollections of Mary Beale and her family.

This drawing is one of the 175 which probably formed a sketchbook which was broken up in the early nineteenth century.

CHÉRON, Louis
Paris 1660 – London 1725

The son of Henri Chéron, an enamel painter and etcher, and brother of Elisabeth-Sophie, a painter and poetess. Chéron studied at the Académie and won the Prix de Rome in 1676 and 1678, although there is no record that he actually went to Rome on this second occasion. In 1687 and 1690 he painted two altarpieces for the Goldsmiths' Guild which were presented to Notre-Dame (now in the Louvre), but his only known decorative work at this period was for his sister's house. Chéron was in England by 1693, when he joined the Huguenot congregation at the Savoy Chapel and was described as from Paris. His first patron was Ralph Montagu (1638–1709), 1st Earl and later 1st Duke of Montagu, who had been British Ambassador in France and was a leading patron of Huguenot artists and craftsmen. Chéron was employed at Montagu's country house, Boughton, in Northamptonshire, about 1693–5, and also carried out lesser commissions at Montagu's other houses, Ditton Park, Buckinghamshire, and Montagu House, London (demolished in the 1840s to make way for Smirke's new British Museum). Among his other decorative work were ceilings at Chatsworth and Burghley. In 1709 he was one of five artists invited to submit designs for the dome of St Paul's, the commission eventually going to Thornhill (q.v.).

Chéron was a teacher at the first official art academy in London (although he is not listed among the original members), which opened in 1711 in Great Queen Street and of which Kneller was the first Governor. According to Vertue, Chéron was 'much immitated by the Young people. & indeed on that account by all other lovers of Art much esteem'd & from thence rais'd his reputation'. In 1718, Kneller's academy split into two groups, one of which was managed by Chéron and met in a 'Great Room' in St Martin's Lane, about 1720–24, where Hogarth was a student. Chéron designed a number of book illustrations towards the end of his life, including those for Tonson's 1720 edition of Milton's works. He died unmarried, his will consisting largely of charitable bequests, and was buried in St Paul's, Covent Garden.

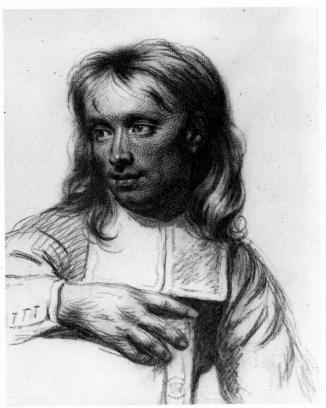

171

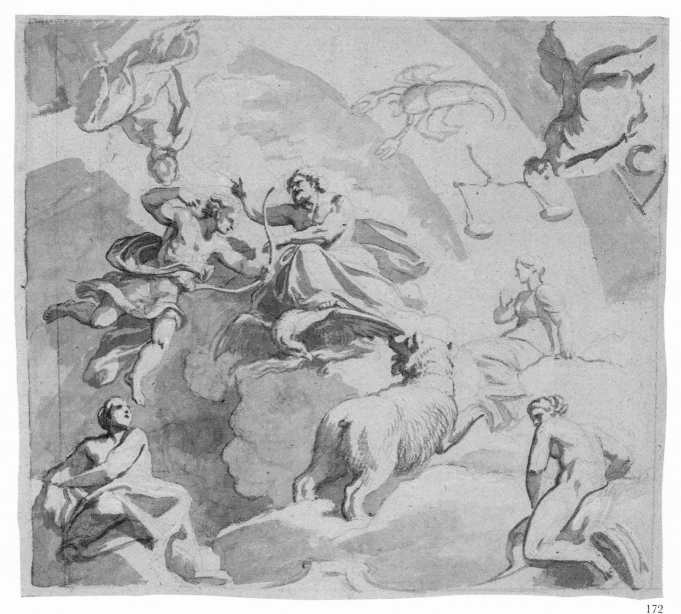

172

172 Jupiter restraining Arcas from shooting at his mother, the bear Callisto

Grey wash over black chalk, heightened with white, on grey paper; 455 × 483 mm (17⅞ × 19 in)

PROVENANCE: From an album of drawings by Chéron assembled by James, 10th Earl of Derby; by family descent; Edward, 18th Earl of Derby (sale, Christie, 19 October 1953, lot 1)

LITERATURE: ECM & PH 5(3); Croft-Murray, I, p. 244; J. Cornforth, 'Boughton House, Northamptonshire', *Country Life*, CXVIII (1970), pp. 564–8, 624–8, 684–7; T. Friedman and J. Linstrum, 'Country Houses through Georgian Eyes', *Country Life*, CLIII (1973), pp. 268–70

The British Museum (1953-10-21-11(3))

According to Vertue (III, p. 28), the 10th Earl of Derby (1664–1735/6), 'a great admirer of Cherons drawings', formed a large collection, acquiring 'most of his fine drawings he did in Italy after Raphael' a few years before the artist's death, for which he was said to have paid the considerable sum of £500, and another group of seventy-two drawings from Chéron's sale held in 1726, for which he paid 265 guineas.

Chéron's most important early commission in England was for the decoration of nine rooms in the newly built north range at Boughton, the principal country seat of his patron, Ralph Montagu, 1st Earl of Montagu. He probably began work at Boughton shortly after he arrived in England in 1693, perhaps finishing by the autumn of 1695

when William III visited the house. The present drawing, a study for the ceiling of the Fourth State Room, is one of a group of preliminary sketches for Boughton in the Museum's album. The subject is taken from Ovid, *Metamorphoses*, II, 496–505; Callisto, seduced by Jupiter, gives birth to a son, Arcas, but is turned into a bear by the enraged Juno. Fifteen years later, while hunting in the Arcadian forests, Arcas is unknowingly about to kill his mother, when Jupiter restrains him. In the final painting (which differs somewhat from this preliminary sketch, see below), Chéron includes the next episode in the narrative, where Jupiter transforms Callisto into a star to preserve her from the jealous Juno. At the corners of the composition Chéron places the Four Elements, and also represents various signs of the zodiac, including Scorpio and Libra.

The State Rooms were once said to be by Verrio, but Chéron's authorship of all the ceilings, with the possible exception of that in the Fifth State Room, is confirmed both by their style and by the drawings now in the British Museum, which are undoubtedly by him. Further confirmation is provided by a recently discovered manuscript travel journal (Friedman and Linstrum, op. cit.), compiled by an unidentified visitor to Boughton in 1724, who included a note that 'The Hall & all the Cielings are nobly painted by Charron a Frenchman, as also the rich Cornishes of the rooms, the Salloon & Staircase'.

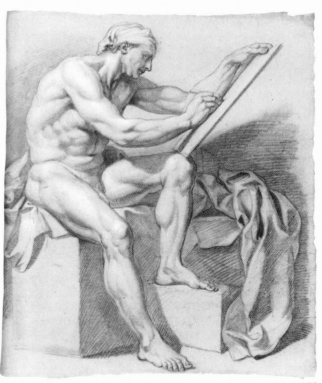

173

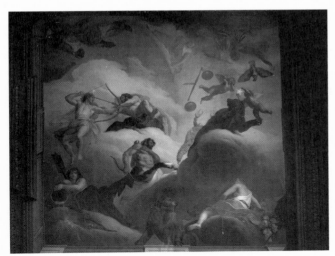

Louis Chéron:
Ceiling of the Fourth State Room, Boughton. Oil on plaster, about 1695.
The Duke of Buccleuch, Boughton

173 A life study

Black chalk, heightened with white, on grey paper; 648 × 562 mm (25½ × 22⅛ in)

PROVENANCE: As no. 172

LITERATURE: ECM & PH 5 (86)

The British Museum (1953-10-21-11(86))

174 A life study

Black chalk, heightened with white, on grey paper; 611 × 446 mm (24 × 17½ in)

PROVENANCE: As no. 172

LITERATURE: ECM & PH 5 (71)

The British Museum (1953-10-21-11(71))

Chéron attended the first official art academy in London, which opened in October 1711 in Great Queen Street, Covent Garden, and of which Godfrey Kneller was first Governor (see no. 146). Although based on the Académie Royale de Peinture et de Sculpture founded in Paris in 1648 (at which Chéron had studied in the 1670s, before going to Rome where he also drew at the Accademia di San Luca), the London academy was essentially an informal life class rather an ordered, hierarchical institution. Kneller was re-elected Governor annually until 1715, but as Vertue reported: 'There began some fractions encouraged by Sʳ James Thornhill Mr Cheron – which at last

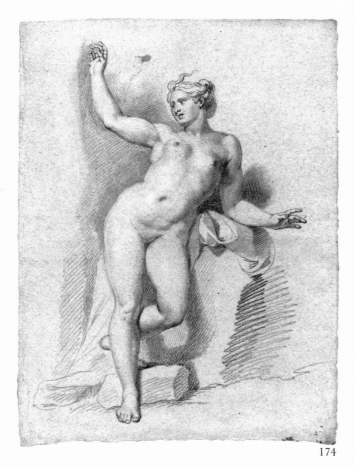

174

CRADOCK, Marmaduke

Somerton? 1660? – London 1716/17

A painter of animal and bird subjects in the manner of Barlow (q.v.) and Peter Casteels (1684–1749), highly thought of by Vertue (I, pp. 79–80). Few signed works by Cradock survive, although he apparently painted rapidly and left many pictures, which were said to have increased three- or fourfold in value after his death (a signed example, *Exotic Fowl*, is in the Yale Center for British Art). He was born in Somerset and went to London, where he was apprenticed as a house-painter; he seems to have taught himself to be an artist. Cradock's name is not recorded in the Painter-Stainers' minutes, but he presented the Company with a picture of dead game, and was presumably a member. Vertue notes that he worked chiefly 'for persons that pay'd him *p* diem, or that dealt in pictures'. The only recorded drawings by him are the three in the British Museum; another, untraced, was in the collection of Dr Barry Delany (Sotheby, 5 June 1872, lot 54). Vertue referred to him as Luke, but in the burial registers of St Mary Whitechapel for 24 March 1716/17 he is recorded as Marmaduke Cradock.

175 Studies of waterfowl

Watercolour with touches of bodycolour over black lead; 188 × 240 mm (7⅜ × 9⁷⁄₁₆ in)

Inscribed on the verso: *JH*, perhaps for John Henderson, but not recorded as a mark, and in a more recent hand, *Luke Cradock*

PROVENANCE: John Henderson (L 1256), by whom presented in 1863

LITERATURE: ECM & PH 2

The British Museum (1863-1-10-233)

Only four drawings by Cradock are recorded, three of which are in the British Museum. Cradock specialised in bird and animal subjects, and studies such as this may be related to his paintings. The birds shown in this drawing are, from left to right (1st row), little grebe and two unidentified birds; (2nd row) a teal and a mallard; (3rd row) a Brent goose (?) and a shelduck; (4th row) an adult and a young cormorant (?); (5th row) two shelducks and a pochard (information from Peter Carlill).

broke it up – and afterwards Thornhill got it under his management' (VI, pp. 268–9). Thornhill's regime lasted only a short time, and Chéron and John Vanderbank (*c.*1694–1739) set up another academy in an old presbyterian meeting house off St Martin's Lane, which opened in October 1720.

Both the drawings illustrated here are from a group of 35 large life studies by Chéron in the British Museum, preserved in an album of 126 drawings collected by the 10th Earl of Derby. Vertue praised 'Cherons drawings accademy figures . . . done with great exactness & skill will be always much Valued & esteemd amongst the Curious' (III, p. 22). It is difficult to date these studies, but no. 174 was probably drawn in 1720 or after, when a female model was first introduced, 'to make [the academy] the more inviting to subscribers', as Hogarth put it (rejected passage in *The Analysis of Beauty* (1753), ed. J. Burke, Oxford, 1955, p. 185).

See also no. 146 for an example of a figure study attributed to Kneller, no. 182 for a life drawing made in 1714 by Jonathan Richardson the Elder, who was a director of the Great Queen Street academy, and no. 197, a figure study by Hogarth.

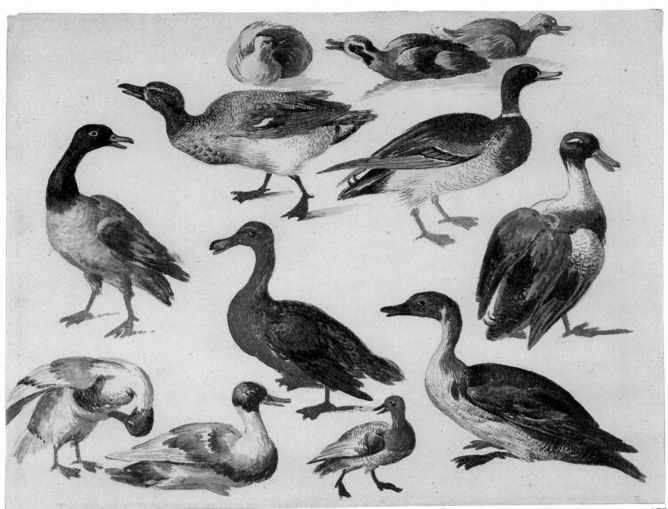

175

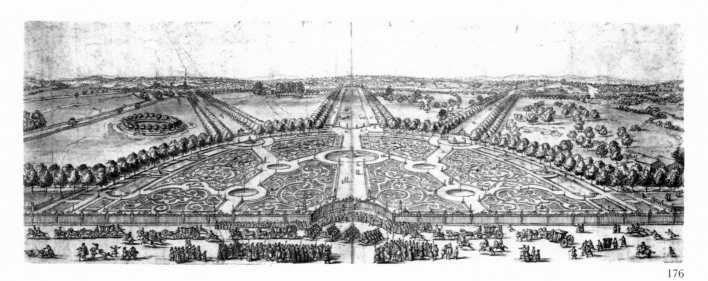

MAROT, Daniel

Paris 1661? – The Hague? 1752?

Marot probably received his training from his father Jean Marot (*c.*1617–79), the engraver and architect, and from the designer Jean Bérain (1640–1711). A Huguenot, he left France either in 1684 or immediately after the revocation of the Edict of Nantes in 1685, and went to the Netherlands, where he was soon in the employment of William, Prince of Orange and Stadholder, and his circle. Although he subsequently became an architect, it was as an interior designer that he was most successful and influential, and engravings of his designs for architectural details, ceilings, fireplaces and furniture popularised his distinctive style. He may have visited England in the 1680s and was certainly in London from about 1694 to 1696 (his children were baptised at the Huguenot Church in Leicester Fields in June 1695 and June 1696), where his chief patrons were William, then King of England, for whom he carried out a good deal of work at Kensington Palace and at Hampton Court, and Ralph Montagu, later 1st Duke of Montagu, by whom he was employed at Boughton House, Northamptonshire, and at Montagu House in London. His influence on English taste was considerable, and he was one of the first architects to consider the whole ensemble of an interior. Many of his designs were published from the 1690s onwards, and on the title-page of at least one collection, *Oeuvres du Sieur D. Marot . . .*, The Hague, 1702, he is described as *architecte de Guillaume III, roy de la Grande Bretagne*. By 1697 he was back in The Hague, and for the rest of his long life continued working in variations of the style he had developed in his youth, a style that went out of fashion in France in about 1715 but to which he remained faithful. His later buildings include the Paleis Schuijlenburg (1715), the Hôtel Wassenaar (1717) and the Hôtel Huguetan (1734, now the Royal Library), all in The Hague, whose façades are examples of his mature decorative style, combining in an impressive ensemble ornamental details that were strictly more appropriate for interior use.

176 Design for the parterre at Hampton Court

Pen and wash; 197 × 514 mm (7¾ × 20¼ in)

Inscribed: *Marot Fecit Aoust 1689*

PROVENANCE: A. W. M. Mensing (sale, Amsterdam, Frederik Muller, 28–29 November 1939, lot 706)

LITERATURE: A. Lane, 'Daniel Marot: Designer of Delft Vases and of Gardens at Hampton Court', *Connoisseur*, CXXIII (1949), pp. 19–24; *The Quiet Conquest: the Huguenots 1685–1985*, exh. cat., Museum of London, 1985, no. 264

Museum Boymans-van Beuningen, Rotterdam

Daniel Marot had first entered the service of William III (then Stadholder) in Holland in 1685/6, designing the interior and the park at Het Loo (1686–1700); his work in Holland during the following fifty years showed his thorough mastery of the contemporary French decorative style (see M. D. Ozinga, *Daniel Marot: De Schepper van den Hollandschen Lodewijk XIV-Stijl*, Amsterdam, 1938). In England, his chief patron was again William III, by whom he was employed at Kensington Palace and at Hampton Court, designing some of the interiors and their furnishings (see P. Thornton, *Seventeenth-Century Interior Decoration in England, France and Holland*, New Haven and London, 1978), and being consulted on the garden layout. This drawing, a preliminary design for the parterre on the east side of the palace, is dated 1689, and it is possible that Marot could have visited England in that year, when major rebuilding began under the direction of Wren. On 16 July 1689 John Evelyn noted, 'I went to Hampton Court about business . . . a spacious garden with fountaines was beginning in the park at the head of the canal'. However, the death of Queen Mary in 1694 brought activity at Hampton Court to a halt until 1698, when the disastrous fire at Whitehall Palace caused William to

177

return there. It was only in 1698 that Marot was eventually paid for his designs for the gardens: Arthur Lane (op. cit., p. 24) has suggested that he was at Hampton Court in that year, presumably supervising the work. Marot later published, together with other garden designs, an engraving inscribed, 'Parterre d'Amton Court inventé par D. Marot', and the view of Hampton Court drawn by Knyff and engraved by Kip in *Britannia Illustrata* (1707) shows that the parterre as executed was extremely close to Marot's design.

A drawing attributed to Knyff in the Yale Center for British Art (B1977.14.6212) has every appearance of being a copy after this drawing by Marot.

177 Designs for two painted panels

Pen and ink with black lead; 400 × 122 mm (15¾ × 4¹³/₁₆ in)

Inscribed by the artist with colour notes, identification of the subjects and various dimensions

PROVENANCE: E. Parsons; purchased 1879

LITERATURE: G. Jackson-Stops, 'Daniel Marot and the 1st Duke of Montagu', *Nederlands Kunsthistorisch Jaarboek*, 31 (1980), pp. 244–62; *The Quiet Conquest: the Huguenots 1685–1985*, exh. cat., Museum of London, 1985, no. 272

The Victoria and Albert Museum

Designs for two of the five surviving panels which probably formed the decoration of a state drawing-room or closet at Montagu House, the London home of Ralph Montagu (1638–1709), 1st Duke of Montagu, which housed the British Museum from 1754 (see no. 159); the paintings are now at Boughton, one of Montagu's country seats, in the collection of his descendant the Duke of Buccleuch (see Jackson-Stops, op. cit.). Montagu House was rebuilt after a serious fire in January 1685/6 and, as Vertue recorded in 1722, 'the late Duke Brought from France three excellent painters to adorn & beautify this House. Monsieur Lafosse [Charles de Lafosse, 1636–1716] History painter. Monsieur Rouseau [Jacques Rousseau, 1630–93] for Landskip & Architecture. & Baptist [Jean Baptiste Monnoyer, d. 1699] for fruit & flowers . . . these three great masters have happily united their thoughts & skill to a great perfection' (III, pp. 23–4). Vertue does not, however, mention Marot, who seems to have masterminded much of the decoration. The painted panels depicted scenes from the loves of the gods: Diana and Endymion, Venus and Adonis, Jupiter and Io, the Triumph of Galatea, and Apollo and Daphne, as shown here. The paintings were probably a collaborative effort, each artist working according to his speciality but carefully following Marot's designs.

LAGUERRE, Louis

Versailles 1663 – London 1721

The son of a servant in the French royal household (his Catalan-born father was keeper of the royal menagerie), Laguerre was a godson of Louis XIV. As a boy he was educated at a Jesuit school, with the intention of entering the priesthood, but an impediment of speech prevented this, and, showing a talent for drawing, he entered the Académie Royale. A pupil of Charles Le Brun (1619–90), Laguerre won third prize for painting in the Prix de Rome in 1682 and the same prize for sculpture in the following year. In 1683, for reasons that are unknown, he accompanied the architectural painter 'Monsieur Ricard' to England, where he settled for the rest of his life, working at first as an assistant to Verrio (q.v.) at Windsor and at Christ's Hospital where, according to Vertue, he was chiefly responsible for the large painting *James II receiving the Mathematical Scholars of Christ's Hospital* (see no. 132), about 1685–8. By 1687 Laguerre seems to have been independently established; his first major commission was at Chatsworth, where between 1689 and 1697 he carried out some of his finest work. He was to be employed by the Duke of Devonshire again in about 1704, when he painted a ceiling for his London house; this no longer survives, but there is a *modello* at Yale (B1976.7.50). Laguerre worked for a wide range of patrons, including William III at Hampton Court (where he was also employed to repair Mantegna's *Triumph of Julius Caesar*, with disastrous effect) and the Earl of Exeter at Burghley, where he took over from Verrio in 1698. On Verrio's retirement in about 1705 Laguerre became the leading decorative and history painter in England: his greatest rival was to be James Thornhill (q.v.), who, absorbing much from Verrio and from Laguerre himself, wrested one of the most important public commissions of the day from him, the decoration of St Paul's.

Laguerre's confident and stylish manner, although on occasion descending to mere competence, set high standards. He was a founder director of the Great Queen Street academy in 1711, which was modelled on the example of the French Académie, where he had trained. Vertue notes that he would have been chosen Governor after Godfrey Kneller (q.v.) in 1715, 'had he bin as forward for it as Mr Thornhill . . . he rather waited for honours done him on account of his works, than sought for them' (II, p. 125). Among notable later commissions was the grisaille decoration of St Lawrence Whitchurch, north London (recently restored), for the 1st Duke of Chandos, and his work for the Marlboroughs, first at their London house in 1713–14 where he depicted the Duke's campaigns, and then at Blenheim in about 1720 where he in turn supplanted Thornhill, who had been dismissed because the Duchess found his charges excessive. His decoration of the Saloon was based on one of Le Brun's most splendid schemes, the Escalier des Ambassadeurs at Versailles. As Whinney and Millar noted, 'it is a curious paradox that one of the grandest rooms in the Duke of

179

Marlborough's palace should be derived from the state staircase of the King whom he had beaten to his knees' (*English Art 1625–1714*, Oxford, 1957, p. 305).

Although a Catholic, Laguerre married Eleanor Tijou, the daughter of the celebrated Huguenot ironsmith; their son John (d. 1748) was an actor and minor artist, by whom there is a group of paintings at Yale (B1981.25. 392–395).

178 An Assembly of the Gods: a study for a ceiling at Chatsworth(?)

Pen and brown ink with grey wash over black lead; 390 × 285 mm (15⅜ × 11¼ in)

Inscribed on the old mount: *Original sketch of Legarde* and *For Chatsworth Chapel Derbyshire* and on the back of the old mount: *The original sketches of Legard for Chatsworth with an estimate and charge's of the work*

PROVENANCE: Prof. J. Isaac; Brod Gallery

LITERATURE: Croft-Murray, 1, p. 251; J. Simon, *English Baroque Sketches*, exh. cat., Marble Hill House, Twickenham, 1947, no. 8

Yale Center for British Art, Paul Mellon Collection (B1975.2.367)

Between 1689 and 1697 Laguerre and his assistants decorated a number of interiors at Chatsworth for William Cavendish (1640–1707), 1st Duke of Devonshire, including the Chapel (modelled on Verrio's work in the Royal

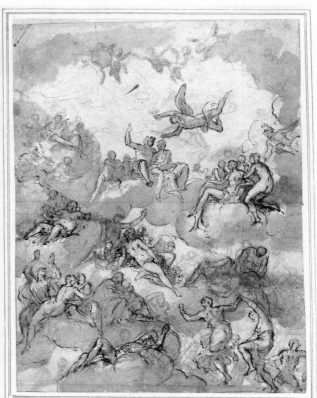

178

Chapel at Windsor), the Hall with the story of Julius Caesar and four state rooms with mythological scenes, among the finest of their kind in England. The splendour of these decorations, wholly in the style of Laguerre's master Le Brun, exceeded any other contemporary English interiors. The present drawing is not directly related to any of the Chatsworth ceilings as executed, but was perhaps an early idea for the Assembly of the Gods in the state drawing-room; it is drawn in the rather scratchy pen and ink style characteristic of Laguerre's preliminary sketches.

179 Design for the decoration of the staircase at Petworth

Pen and brown ink with grey wash over traces of black chalk, lightly squared in pencil; 242 × 379 mm (9½ × 14⅞ in)

PROVENANCE: Sale, Puttick and Simpson, 7 May 1936, lot 135, as by Thornhill; Sir R. Witt; sold by order of the Rev. F. N. Vavasour on behalf of a charitable trust (sale, Christie, 15 June 1971, lot 78); Baskett and Day

LITERATURE: G. Jackson-Stops, *National Trust Guide to Petworth*, London, 1973, p. 27; J. Simon, *English Baroque Sketches*, exh. cat., Marble Hill House, Twickenham, 1974, n.p., under 'Laguerre'

The British Museum (1971-7-24-3)

Laguerre was commissioned by Charles Seymour, 6th Duke of Somerset, to decorate the new Grand Staircase at Petworth, the old one having been destroyed by fire in 1714. The lower part is painted with scenes from the story of Prometheus – perhaps an allusion to the fire – the landing with the Muses, and the ceiling with a scene showing the Assembly of the Gods. This is a study for the painting that occupies the south wall: Elizabeth, Duchess of Somerset (1667–1722), the Percy heiress whose patrimony had included Petworth, rides in a triumphal chariot attended by her children and, in the painting, by her spaniel. Vertue considered the staircase at Petworth to be one of Laguerre's finest achievements, 'a noble great work' (II, p. 81).

In this drawing, Laguerre was principally concerned with the setting for the painting. The figures in the Triumph are only sketchily indicated, and he has drawn a detail of the staircase over the horses. The richly decorated columns, particularly the one on the right, are drawn in more detail. As executed, the *trompe l'oeil* and grisaille details are different.

VINNE, Jan van der
Haarlem 1663 – Haarlem 1721

The son and pupil of Vincent Laurensz. van der Vinne (1629–1702). At some time around 1686 he visited England, where he may have worked with Jan Wyck (q.v.), but subsequently returned to Haarlem, where he is said to have opened a silk-weaving factory with his brother Isaak, also an artist.

180 Oxford from the south-west

Black lead with brown wash; 236 × 398 mm (9¼ × 15¹¹/₁₆ in)

PROVENANCE: M. Janse

LITERATURE: Hind, IV, 3; ECM & PH, p. 577, no. 1

The British Museum (1879-3-8-1)

A view taken from rising ground, looking towards the city from a point near Wytham. Headington Hill is in the left background, and the slopes of Boar's Hill are on the right. In the foreground of the city is the Castle Mound, and, slightly to the right beyond, New College Tower and St Mary's Church. Further to the right is Tom Tower (the spire of the Cathedral is not shown), and beyond is the tower of Merton chapel. On the extreme left is the tower of Magdalen chapel.

Anonymous artist, c.1695

181 Interior of a London coffee house

Bodycolour; 147 × 220 mm (5¾ × 8⅝ in)

Inscribed (falsely): *A.S.1668*. There are various notices on the wall, one of which advertises: *Heare is / Right Irish / Usquebah*

PROVENANCE: Presented by R. Y. Ames

The British Museum (1931-6-13-2)

The costume of the figures suggests a date in the mid- or late 1690s: the inscription *A.S.1668* is certainly false. The scene might almost be taken as an illustration to Henri Misson's description of London coffee houses in his *Mémoires et Observations Faites par un Voyageur en Angleterre*, first published in The Hague in 1698 and reissued in an English translation in 1719, p. 39: 'These [Coffee] Houses, which are very numerous in *London*, are extreamly convenient. You have all Manner of News there: You have a good fire, which you may sit by as long as you please: You have a Dish of Coffee; you meet your Friends for the Transaction of Business, and all for a Penny, if you do not care to spend more.'

In style and technique this drawing has much in common with English fan-painting of the period, and it may be compared with the somewhat later examples by Thomas Loggon (1706–c.1780). Drawn in a rather charmingly naïve manner, this is a rare visual record of a late seventeenth-century coffee-house interior.

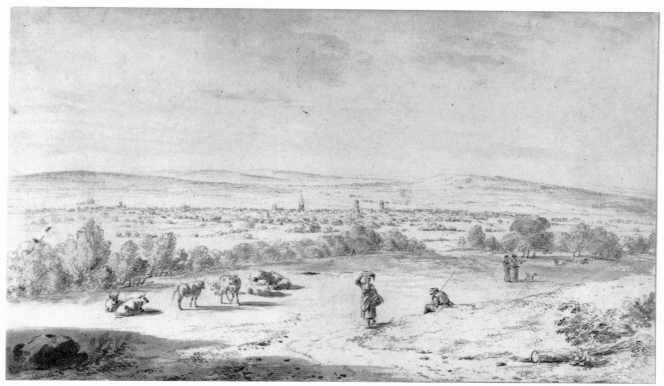

180

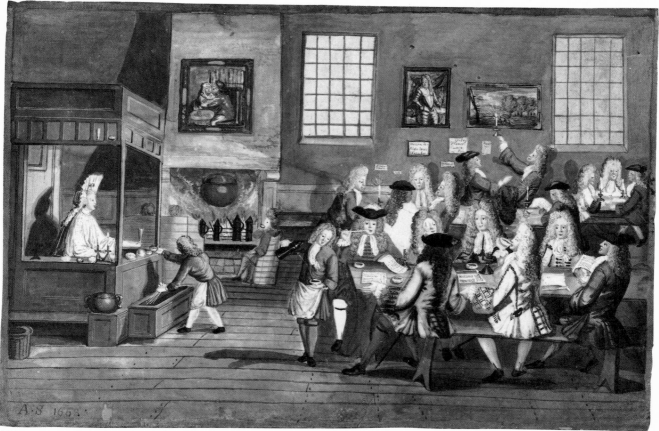

181

RICHARDSON the Elder, Jonathan

London 1665? – London 1745

According to most accounts, Richardson was born in 1665. Vertue noted that he was apprenticed to a 'Scrivener [defined in the *Oxford English Dictionary* as either a professional penman or copyist, which might account for his elegant script; a notary; or a money-lender], wch. he never much liked'. In the late 1680s he became the pupil of John Riley (1646–91), whose niece he married, inheriting part of his master's collection of paintings and drawings (the foundation of his own important collection), and also succeeding him in his style of portraiture. Richardson established a successful practice and was, apart from Charles Jervas (*c.*1675–1739), the busiest native-born painter of the day. In 1711 he was one of the founder directors of the Great Queen Street academy, of which Godfrey Kneller (q.v.) was the first Governor. He appears in Vertue's list of 'Living Painters of Note in London' (III, p. 12), compiled in 1723, and in 1731 was described as one of 'the three foremost Old Masters' (III, p. 54, with Jervas and Dahl (q.v.)). He was a prolific portrait draughtsman, Walpole noting that 'after his retirement from business the good old man seems to have amused himself with writing a short poem and drawing his own or his son's portrait every day' (*Anecdotes*, IV, 1827, p. 29). Richardson painted a number of distinguished portraits, including those of Sir Hans Sloane, founder of the British Museum, Dr Richard Mead, the collector, and Alexander Pope, the poet, but he is perhaps more important for the contribution he made towards the development in England of art theory. His main writings include *An Essay towards the Theory of Painting* (1715), *An Essay on the Whole Art of Criticism in Relation to Painting* and *An Argument on behalf of the Science of a Connoisseur* (both 1719). In collaboration with his son, he wrote the famous *Account of Some of the Statues, Bas-reliefs, Drawings and Pictures in Italy* (1722). These influential books, with their emphasis on the serious purposes of art, anticipated the high ambitions of the Royal Academy in the latter part of the century, and inspired the Academy's future first President, Sir Joshua Reynolds, when still a youth, with the desire to be something more than an ordinary painter. Richardson was also one of the most notable collectors of drawings of his day: the greater part of his collection was sold shortly after his death, the drawings from 22 January to 10 February 1746/7, the paintings in March, one of the chief purchasers being his son-in-law, Thomas Hudson, who was himself to form a distinguished collection of drawings. Among those owned by Richardson was Van Dyck's *View of Rye*, no. 53. Many of Richardson's own drawings were sold in 1772.

182 James Figg (d. 1734)

Black and white chalks on blue paper; 290 × 225 mm (11⅜ × 8⅞ in)

Inscribed by Jonathan Richardson the Younger: *Figg the Gladiator ad Vivum* and by the artist *14* and *1714*

PROVENANCE: Randall Davies; Sir Hugh Walpole (no. 59 in the dispersal of the Walpole collection at the Leicester Galleries, 1945); bought by the Ashmolean Museum (Hope Collection), 1945

LITERATURE: Brown (1982) 1532; Brown (1983) 20

The Ashmolean Museum, Oxford

James Figg was one of the most celebrated pugilists of his day. He ran an academy of arms, teaching sword-play, boxing and cudgelling, and promoted contests between leading fighters, both male and female: on one occasion Mrs Stokes, a well-known amazon, challenged the 'Hibernian heroines' to meet her at Figg's. He was chiefly famous, however, for various sensational bouts in which he took part himself; his skill and valour were legendary and he was apparently defeated only once. Captain John Godfrey described him in his *Treatise upon the Useful Science of Defence*, London, 1747, pp. 40–41: '[He] was the Atlas of the sword, and may he remain the gladiating statue. In him strength, resolution, and unparallel'd judgement conspired to form a matchless Master. There was a Majesty shone in his countenance and blazed in all his actions beyond all I ever saw.' Figg fought over 270 contests, the most spectacular being those with Ned Sutton (Thackeray used a contemporary description of their fight in April 1725 for a passage in *The Virginians*, 1859, ch. XXXVII). During the annual Southwark Fair, Figg kept a booth where he presented similar entertainments to eager audiences, and he is probably the broadsword fighter seated on his horse awaiting a challenge on the left of Hogarth's painting of *Southwark Fair*, 1733 (Art Museum, Cincinnati). He is also said to have been the model for the prostrate figure in Hogarth's *Midnight Modern Conversation*, about 1731 (Yale Center for British Art), and has traditionally been identified as the quarter-staff player in the second painting in *The Rake's Progress*, 1734 (Sir John Soane Museum, London). An admission ticket for Figg's establishment, about 1733, on which he is shown as a cudgel and back-sword fighter, has been reattributed to Joseph Sympson (R. Paulson, *Hogarth's Graphic Works*, New Haven and London, 1965, pp. 313–14).

As the inscription by Jonathan Richardson the Younger states, this drawing must have been made *ad vivum*: as well as being a most striking portrait, it has much in common with the life studies drawn at the Great Queen Street academy, of which Kneller was the first Governor and Richardson a founder member in 1711 (see nos 146 and 173–4). Figg may have sat as a model: with his muscular torso he would have been an ideal subject. The number *14* inscribed on the drawing suggests that it may have been one of a series of such studies.

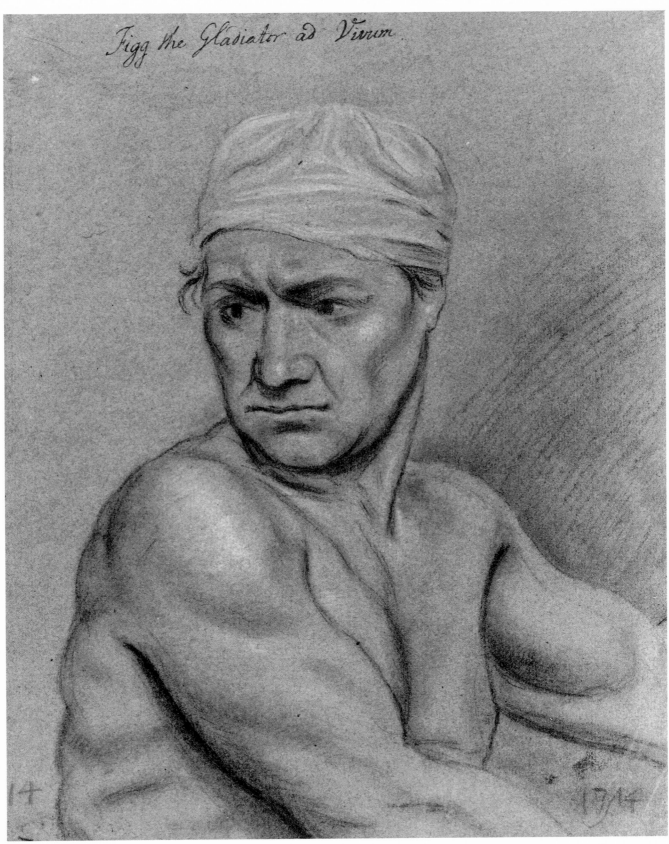

Figg the Gladiator ad Vivum.

182

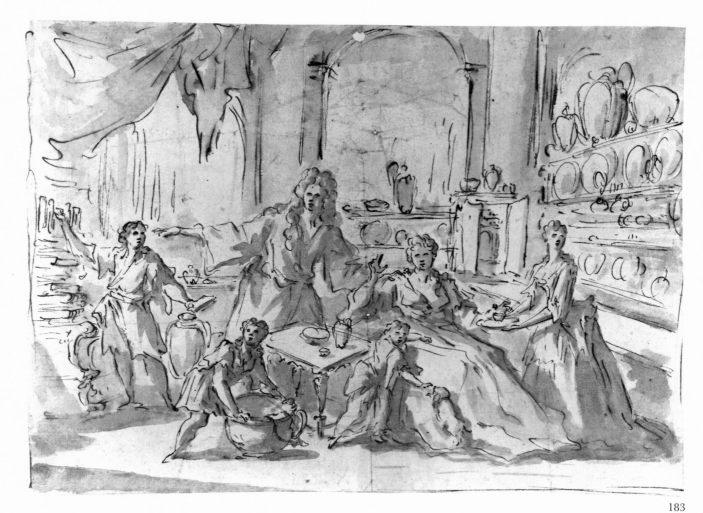

183

(*Right*) William Hogarth:
*The Industrious 'Prentice Married
and Furnishing his House.*
Pen and brown ink with grey
wash over black lead, about
1747.
The British Museum

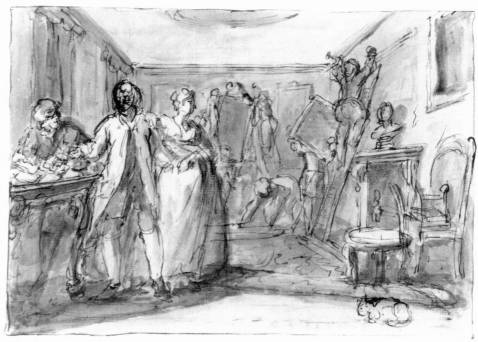

PELLEGRINI, Giovanni Antonio

Venice 1675 – Venice 1741

A leading exponent of Venetian rococo painting, Pellegrini spent much of his career abroad. He trained under the Milanese artist Paolo Pagani (1661–1716), with whom he was to work in Austria for six years from 1690, and under Sebastiano Ricci (1659–1734), and was influenced by the paintings of Jan Lys (1595–1629), who had settled in Venice in 1627. From 1696 he was back in Italy, but in 1708, together with Sebastiano's nephew, Marco Ricci, he was brought to England by the 4th Earl of Manchester, who had been ambassador extraordinary to Venice. Pellegrini's first and most important period in England was from 1708 to 1713, but he made a second visit in 1719: the chronology of his activity in England is confused by Vertue's somewhat inaccurate account and the fact that only three contemporary documents relating to his stay in England are known. In 1709 he was invited to submit designs for the decoration of St Paul's Cathedral, and is traditionally said to have been the artist favoured by Wren, but after much intriguing (including an invitation by Marco Ricci to his uncle to come to England in order to wrest the project from Pellegrini, with whom Marco had fallen out (Vertue, I, p. 39)), the commission eventually went to Thornhill (q.v.). Pellegrini's most important surviving work in England is the staircase for Lord Manchester at Kimbolton Castle, painted after 1710; he also worked at Castle Howard and at Narford Hall, Norfolk, as well as at a number of London houses and, early on during his first visit, collaborated with Marco Ricci in the painting of scenery for Italian opera productions. He was a director of the so-called Kneller (q.v.) Academy on its foundation in 1711, Vertue noting that 'he drew [there] very often. he had an extraordinary readynes in setting the model well' (I, p. 39). He was described by Vertue as 'a talle, proper man of a great deal of fire & vivacity' (I, p. 39). From 1713 to 1719 he worked in Germany and the Low Countries, returning to England in 1719 and then to Venice via Paris. From 1722 to 1730 he was again in Germany and Austria, where he painted the dome of the Salesianerinnenkirche, Vienna, 1725–7, which gives some idea of how he might have decorated St Paul's. After another period in Venice and Padua, 1730–36, he returned to Germany in 1736, and retired to Venice in 1737.

183 Peter Motteux (1660–1718) and his family

Pen and brown ink with grey wash over traces of black lead; 261 × 353 mm (10¼ × 13⅞ in)

Inscribed on the verso: *Peter Motteux & his family by Sig Pelegrini.*

PROVENANCE Hugh Howard; the Earls of Wicklow

LITERATURE: A. Bettagno, *Disegni e dipinti di Giovanni Antonio Pellegrini 1675–1741*, exh. cat., Fondazione Giorgio Cini, Venice, 1959, no. 71; *Italian Art and Britain*, exh. cat., Royal Academy, London, 1960, no. 644; Croft-Murray, II, p. 254

The British Museum (1874-8-8-43)

Peter Motteux, translator and playwright, was born in Rouen and moved to England on the revocation of the Edict of Nantes in 1685. He was a merchant, with an East India warehouse in the City, but soon began to exercise his literary talents, first as the editor of the *Gentleman's Journal* and then as a translator, most notably of Rabelais and Cervantes; he wrote a number of plays, masques and poems and contributed to the *Spectator*. For some years he held an appointment at the General Post Office, probably in connection with his abilities as a linguist, but by 1712 he seems to have resumed his business activities; he described himself in the *Spectator* of 30 January 1712 as 'an author turned dealer' and noted the large variety of goods which ladies would find at his warehouse, publishing later in the year *A Poem in Praise of Tea*. Motteux's friend Richard Steele described his 'spacious warehouses, filled with tea, China and Indian wares', and Pellegrini's drawing seems to show him and his family surrounded by the oriental porcelain in which he traded. Pellegrini and Motteux may have met each other through their mutual interest in the theatre, or perhaps through Pellegrini's patron, the 4th Earl (later 1st Duke) of Manchester, to whom Motteux had dedicated several works.

No painting of Motteux and his family is known; although Pellegrini was chiefly active in England as a decorative artist, he did paint portrait groups of the daughters of his chief patrons, Lord Carlisle and Lord Manchester. The present study, which must date from Pellegrini's first visit to England, 1708–13 (Motteux was murdered in 1718, the year before the artist's second visit), is particularly interesting as an anticipation of Hogarth's style in drawings such as those for *Industry and Idleness*, 1747 (opposite, below): he could have absorbed something of the Venetian artist's manner through his father-in-law Sir James Thornhill, Pellegrini's rival.

THORNHILL, Sir James
Woolland or Weymouth 1675/6 – Thornhill 1734

Descended from an old Dorset family, staunch Parliamentarians during the Civil War and the Protectorate, whose fortunes declined at the Restoration, Thornhill was apprenticed in 1689 to Thomas Highmore (d. 1720), a distant relative. By 1702 he seems to have been assisting Antonio Verrio (q.v.) with the decorations at Hampton Court, and in 1705 received his first independent commission, for the staircase, hall and overmantels at Stoke Edith in Herefordshire. He was a baroque decorative painter all his life, employing a style that owed most to Verrio's partner, the French artist Laguerre (q.v.), and working in competition with foreigners in a genre that enjoyed a relatively short vogue in England, from about 1690 to about 1725. His style was formed before he visited the Low Countries in 1711 and Paris in 1720, his only two visits abroad. As a draughtsman, Thornhill is seen at his most baroque and of a calibre to match his Continental rivals. Although he was employed at numerous country houses, his most important commissions were the Upper and Lower Hall and Vestibule at Greenwich Hospital (1707–27) and the dome of St Paul's Cathedral (1709–21). At St Paul's he was required to depict scenes from the life of the saint, for which he used motifs borrowed from the Raphael Cartoons, the greatest examples of Italian Renaissance painting in Britain, then at Hampton Court. At Greenwich Thornhill's approach was closer to that of Rubens in the latter's series of allegorical modern histories in the Banqueting House, Whitehall, and in the Palais du Luxembourg, Paris. Thornhill was appointed History Painter in Ordinary to the King in 1718, and Serjeant Painter in 1720. That same year he was knighted, the first British-born artist to receive that honour. In the mid-1720s he fell out of favour with the powerful clique that gathered around Lord Burlington – of whom William Kent was the favoured artist and architect – Vertue noting, 'tis certain that after so much reputation, friends & meritt as the most Excellent Native history painter, which is justly allowd at this present to be his character, he hath no great work, or imployment'. However, he had been successful enough to have recovered much of his family's fortune and from 1722 sat as MP for Weymouth and Melcombe Regis. In addition to large-scale decorative painting, Thornhill also designed theatre scenery and book illustrations, painted occasional portraits and, from 1711 onwards, was involved in the running of several short-lived academies of art, one of which was later taken over by his son-in-law, William Hogarth (q.v.).

184a

184 Sir James Thornhill's sketchbook

Drawings in a variety of media, in a sketchbook containing 149 leaves, in a late eighteenth-century diced russia binding; 356 × 231 mm (14 × 9⅛ in)

PROVENANCE: The artist's son, John Thornhill (sale, Christie, 11 June 1779, lot 64, bought Dawson); John Dawson, 1st Earl of Portarlington; by descent to the 3rd Earl (sale, Christie, 2 May 1884, lot 108)

LITERATURE: Croft-Murray, I, *passim*; J. Simon, *English Baroque Sketches*, exh. cat., Marble Hill House, Twickenham, 1974, n.p., under 'Thornhill'

The British Museum (1884-7-26-40)

Thornhill used this sketchbook at intervals between 1699, the date inscribed on the fly-leaf and title-page, and 1718, the year in which he painted scenery for the temporary theatre at Hampton Court, studies for which are included. It contains drawings related to several of his most important works, including the possible collaboration at the outset of his career with Verrio in the decoration of the Queen's Drawing Room at Hampton Court, and his work at Stoke Edith, Chatsworth, Eastwell Park, Easton Nes-

184b

184a *Design for the central oval of the ceiling of the Lower Hall at Greenwich.* Pen and brown ink over black lead (f.65r)
184b *Two early designs for the decoration of St Paul's Cathedral.* Pen and brown ink (f.111r)

ton, Kiveton, Wollaton Hall, Blenheim Palace, Greenwich Hospital and St Paul's Cathedral. It shows his activities not only as a history painter but also as a landscapist and portraitist. Although the drawings fall very roughly into chronological order, it is difficult to draw any conclusions about the dating of individual commissions because Thornhill seems to have been in the habit of jumping from one part of the sketchbook to another, and then filling in the gaps.

Sir James Thornhill at Greenwich

The decoration of the Painted Hall at Greenwich, a project which spanned twenty years, was Thornhill's greatest secular commission and the culmination of the Baroque style of decorative painting in England. Why the comparatively unknown Thornhill received the commis-

sion in about 1707 is uncertain: Laguerre, however, seems to have been his only serious competitor. Verrio's failing eyesight would have ruled him out (and he was to die in 1707), and Giovanni Antonio Pellegrini (q.v.) and Marco Ricci, the first of the Venetian artists who were to capture many of the most important commissions in the following thirty years, did not arrive in England until 1708. Thornhill combined two advantages: he was English, and at this stage in his career his services were likely to be cheap. Indeed, the Governors of the Hospital were later to pay him less than he claimed, stating that 'This was the first great work he ever undertook in England and served as an introduction to bring him into reputation'.

The Great Hall, which Thornhill painted between 1707 and 1714, is a glorification of King William and Queen Mary, founders of the Hospital (a home for retired sailors), and celebrates the Triumph of Peace and Liberty. The development of Thornhill's design for the ceiling can be seen in the numerous drawings he made, notably in the British Museum sketchbook (no. 184), ff. 49v, 61v, 64v, 65v, 66v, 90v and 91r, and in other related drawings and oil-sketches (see Croft-Murray, I, pp. 268–9). The Governors were not at first satisfied that Thornhill had included sufficient reference to maritime affairs, and the drawings show him modifying his composition to accord with their stipulation: indeed, perhaps the most striking element in the ceiling is the great ship's stern that appears under the feigned elliptical arch supported by atlantes at one end of the Hall (see Croft-Murray, I, p. 133).

Thornhill probably began to make drawings for the Upper Hall in about 1707 (see British Museum sketchbook, ff. 61v, 66r, 67r, and BM 1865-6-10-1327, 1335, 1336, 1348, 1353, as well as other studies listed in Croft-Murray, I, p. 268, and J. Simon, *English Baroque Sketches*, exh. cat., Marble Hill House, Twickenham, 1974, n.p., under 'Thornhill'). Two separate schemes can be traced, one prepared in Queen Anne's reign, the other after the accession of George I in 1714. Thornhill originally intended to make Queen Anne the central figure of both the ceiling and the main west wall. However, work on the decoration of the Upper Hall did not begin until 1717 and although Queen Anne and her husband, Prince George of Denmark, dominate the ceiling (completed in 1722) as rulers of the seas, the west wall is devoted to the new Hanoverian dynasty. Fame draws a curtain to reveal George I surrounded by his family (these portraits were painted by the Baltic Russian artist Dietrich André), with emblematic figures above them and St Paul's in the background. The walls were not completed until 1726, the north wall depicting the landing of George I at Greenwich in 1714 (see nos 185–6) and the south wall that of William III at Torbay in 1688; on the east wall are allegories on *Salus Publica* and *Securitas*. Thornhill's theme was essentially the triumph of the Protestant Succession in England.

A full account of Thornhill's work at Greenwich is to be found in Croft-Murray, I, pp. 71, 74–6 and 268–9.

185 George I landing at Greenwich in 1714

Pen and brown ink, with brown-grey wash, over black lead;
158 × 228 mm (6¼ × 9 in)

Inscribed by the artist in the margins around the design: *Objections y^t will arise from y^e plain representation of y^e K. Landing 7^{br}* [September] *18^{th} 1714 as it was in fact, & in y^e modern way & dress*. In the left margin: *1 first of all it was Night, w^{ch} to represent would be hard & ungracefull in Picture. No. * ships appearing, & boats make a small figure / 2 Then who shall be there to accompany him, if the Real Nobles that were there, then, some of them are in disgrace now. & so will be to much Party in Picture / 3 To have their faces & dresses as they Realy were, difficult. / 4 The Kings own dress then not Gracefull, nor enough worthy of him to be transmitted to Posterity / 5 There was a vast Crowd w^{ch} to represent would be ugly, & not to represent would be false*. In the right margin: *1 Answrd. Take Liberty of an evening sky, & torches. / 2 Make only 5 or 6 of y^e Chief Nobles y^e rest in y^e crowd. / 3 enquire their dresses y^e best you can & get their faces from y^e life / 4 Make y^e Kings dress as it now is & as it should have been then, rather than what it was / 5 Take y^e Liberty to lessen y^e Crowd as they ought to have been then*. Below the drawing: ** take y^e Liberty to bring in y^e yatch that brought over y^e King & y^e Barges. & Guns firing &c*.

PROVENANCE: Purchased from E. Daniell, 1865

LITERATURE: E. Wind, 'The Revolution in History Painting', *Journal of the Warburg Institute*, II (1938–9), pp. 123–4; C. Mitchell, 'Benjamin West's "Death of Wolfe" and the Popular History Piece', *Journal of the Warburg Institute*, VII (1944), pp. 25–6; Croft-Murray, I, p. 268; J. Simon, *English Baroque Sketches*, exh. cat., Marble Hill House, Twickenham, 1974, no. 29

The British Museum (1865-6-10-1327)

An early idea for the grisaille decoration of the north wall of the Upper Hall. This drawing is of particular interest because it shows Thornhill debating the arguments for and against a realistic treatment of a contemporary subject, a dilemma which later in the century was to arouse much feeling among artists and their public. After carefully noting the exact circumstances of George I's landing, Thornhill considers the possibility of modifying events. Should he, for example, 'Take Liberty of an evening sky, & torches' in place of 'Night, w^{ch} to represent would be hard & ungracefull in Picture'? Most of his arguments are derived from long-established aesthetic theory, although as Charles Mitchell has pointed out (op. cit., p. 25), the question of appropriate representation in this instance brought to the fore a current political consideration. Thornhill was concerned that if he included 'the Real Nobles that were there, then, some of them are in disgrace now. & so will be to much Party in Picture': should he 'Make only 5 or 6 of y^e Chief Nobles y^e rest in y^e crowd'? Aesthetic prejudice of the period against the representation of such historic events in modern dress, without the presence of allegorical elements, was barely conceivable (Laguerre's Marlborough House paintings and Blenheim tapestries, in which the Duke of Marlborough's campaigns were treated as contemporary battle-pieces, were rather exceptional in their omission of allegory). It is not surprising that Thornhill rejected the idea of a realistic interpretation (even if modified, as his notes suggest), and another drawing (no. 186) shows a more conventional treatment.

186 George I landing at Greenwich in 1714

Pen and brown ink, with brown-grey wash, over black lead;
175 × 228 mm (6⅞ × 9 in)

Inscribed by the artist in the margins around the design: *Anglorum spes magna Victoria fractae fidei ultimae Laetitia publica Felecissimus Regis in Urbem adventua Felicitas temporum / 1^{st} Fame flying before carry^d by Zephyrus, / 2 Apoll: & muses Sing Great Georges praise. / The Royal Cavalcade or Landing of K. George at Greenwich Sept:^{br} 18^{th} 1714 A View of y^e Hospital w^{th} y^e Royal flag put out. Thames and y^e Nymphs & Graces playing around him / 3 Tyrannick Power & despair fly before Liberty / 4 Liberty & / 5 Religion / 6 Comerce 7 Courage & 8 Justice / 9 The King in a triumphant Charriot / 10 Princely Prudence on his Right hand. An Eagle on y^e Charr: Shews y^e Power of Jove, as well as y^e German Ensign / 11 Brittanick power guards y^e King*. Also inscribed with notes of the scale, *21 ftt:, 17 ftt, is now but 19-11 long & 18-11 high*, and of the proposed treatment, *In Basso Relievo or Chiar-oscuro in Greenish heightnd w^{th} Gold*. Inscribed on the verso at the foot: *s^r James Thornhill*

PROVENANCE: Purchased from E. Daniell, 1865

LITERATURE: E. Wind, 'The Revolution in History Painting', *Journal of the Warburg Institute*, II (1938–9), p. 124; C. Mitchell, 'Benjamin West's "Death of Wolfe" and the Popular History Piece', *Journal of the Warburg Institute*, VII (1944), pp. 25–6; Croft-Murray, I, p. 268

The British Museum (1865-6-10-1353)

An alternative design for the *Landing of George I*, the subject chosen for the decoration of the north wall of the Upper Hall at Greenwich. Thornhill rejected a more realistic treatment (no. 185) in favour of an allegorical composition, in which the King is welcomed at Greenwich by Father Thames and Nymphs or Graces; Fame flies before him, Apollo and the Muses sing the King's praises, while Tyrannic Power and Despair flee, and Liberty and Religion, Commerce, Courage and Justice escort the King, Princely Prudence and Britannic Power attending him. The eagle that surmounts the chariot was regarded by Thornhill as a subtle compliment to the new Hanoverian monarch: not only does it 'shew the power of Jove' but it was also 'y^e German ensign'. So, as Charles Mitchell notes (op. cit), it would please those who favoured the German succession, yet would not gratuitously offend those who preferred to ignore this fact.

7 Gr. 18th. 1714.

Objections yt will arise from ye plain representation of ye K: Landing, as it was in fact, & in ye modern way & dress.

first of all it was Night, wch to represent would be hard & ungracefull in Picture.

No Ships appearing, & boats make a small figure

Then who shall be there to accompany him, if the Real Nobles, that were there, then some of them are in disgrace now. & so will be too much Party in Picture

3 To have their faces & dresses as they Realy were, dificult.

4 the King own Dress then not Gracefull, nor enough worthy of him to be transmitted to Posterity

There 5 was a vast Crowd wch to represent would be ugly, & not to represent would be false.

1 Answd.
Take Liberty of an evening sky, & torches.

2 Make only 5 or 6 of yr chief Nobles ye rest in ye croud

3 enquire their dresses yt best you can & get their faces from yr life

4 make ye King dress as it now is & as it should have been then, rather than what it was

5 Take ye Liberty to lessen ye Croud as they ought to have been then

* take ye Liberty to bring in ye yacht that brought over ye King & ye Barge. & Guns firing &c

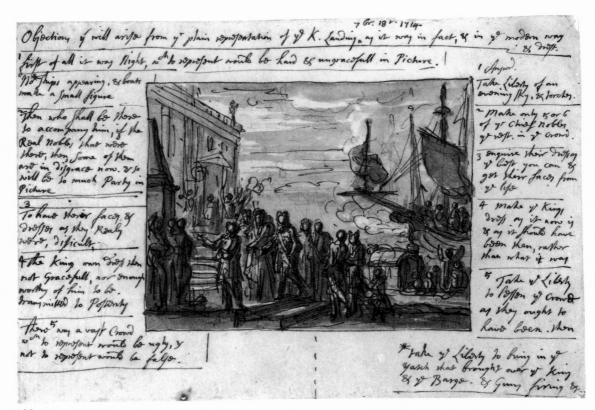

185

Anglorum Spes magna
Victoria fractæ fidei ultrix
Lætitia publica
Fœlicissimus Regis in urbem adventus
Fœlicitas temporum

1st Fame flys before carryd by Zephyrs,

2 Apollo & muses sing Great Georgs praise.

21 ft is now but 19-11 long & 18-11 high

The Royal Cavalcade or Landing of K: George at Greenwich Septr 18th 1714
A View of ye Hospital wth ye Royal flag put out.
with ye Trophys of Peace playing around him.

Tyrannick Power & Despair fly before Liberty.

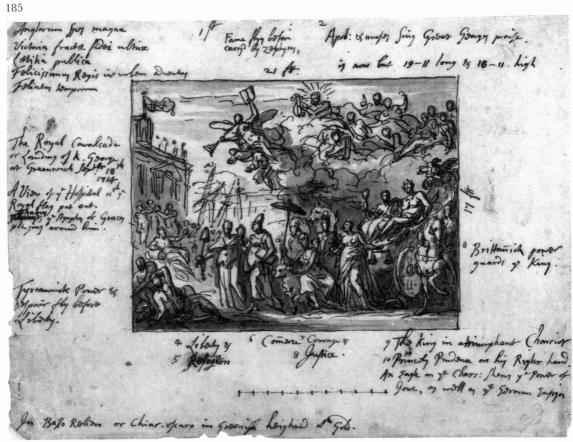

Brittanick power guards ye King.

2 Liberty & 5 Religion 6 Commerce Courage & 8 Justice. 9 The King in a triumphant Chariot 10 Princely Prudence on his Righer hand. An Eagle on ye Charr: shews ye Power of Jove, as well as ye German Ensigne

In Basso Relievo or Chiar-oscuro in Greenish heightned wth Gold.

186

235

Sir James Thornhill at St Paul's Cathedral

The decoration of the newly built St Paul's Cathedral was Thornhill's principal ecclesiastical commission of the period, as his main secular one was for the Painted Hall at Greenwich. Both – and especially St Paul's – were won at the expense of foreign rivals and after much intrigue and considerable indecision on the part of the Commissioners. The painting of the Dome, with figures 'confined to the Scripturall History taken from the Acts of the Apostles', was first contemplated soon after its completion in the autumn of 1708. Four painters in addition to Thornhill – the Frenchmen Pierre Berchet and Louis Chéron (q.v.), the obscure Neapolitan Giovanni Battista Catenaro and the brilliant Venetian Giovanni Antonio Pellegrini (q.v.) – were put forward for consideration by the Commissioners for the Fabric. In this initial competition Pellegrini and Thornhill were selected and a year later each was asked to paint 'a little cupolo' as a trial. An oil sketch of the *Trinity adored by saints and angels* by Pellegrini (who was said to have been Sir Christopher Wren's candidate, dated 1710 (Victoria and Albert Museum, P 24-1953), and three by Thornhill of scenes from the Acts of the Apostles (two of which are in St Paul's Cathedral Museum and a third in the Yale Center for British Art, B1981.25.627), may be connected with this stage of the project. No immediate steps, however, were taken to make a final appointment of an artist; and, indeed, two further candidates were to make their appearance: the Venetian Sebastiano Ricci, who arrived in England at the end of 1711, and the Frenchman Louis Laguerre (q.v.). According to Vertue, Laguerre actually received the commission, and made 'many approved sketches & designs for that purpose'. He had even started to 'draw & dispose the work in the Cupola', when he was suddenly supplanted by Thornhill. Thornhill was finally chosen to paint the Dome in June 1715, probably out of patriotic sentiment. As Archbishop Tenison, one of the Trustees of St Paul's, is reputed to have said: 'I am no judge of painting, but on two articles I think I may insist: first that the painter employed be a Protestant; and secondly that he be an Englishman'.

The decoration (which was 'to be done in Basso-Relievo' [monochrome imitating sculpture]) was carried out in three stages: the Cupola, or Dome proper, painted with eight scenes from the life of St Paul, in 1716–17 at a cost of £4,000; the Lantern, with feigned coffering enclosing rosettes, in 1718–19 at £450; and the Whispering Gallery, or Drum, with further scenes from the life of St Paul, in 1719–21 at £2,125. The project was also to include the decoration of the pendentives over the crossing, but this was not carried out. Today, the painting in the Cupola and Lantern survives, but not that in the Whispering Gallery. Thornhill made a large number of preparatory studies for his work at St Paul's, the three main groups of which are in the British Museum, the Victoria and Albert Museum and the Witt Collection of the Courtauld Institute. They include studies both for the general layout of the decoration, including the architectural ornament, and for the figure subjects alone. In the

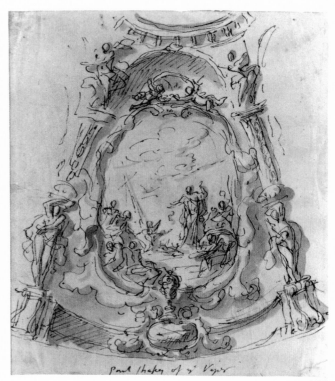

187

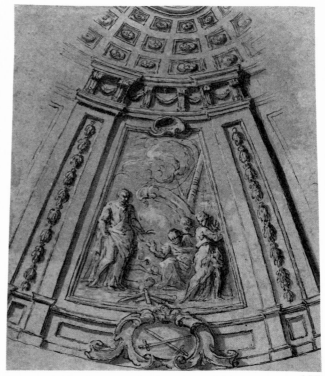

188

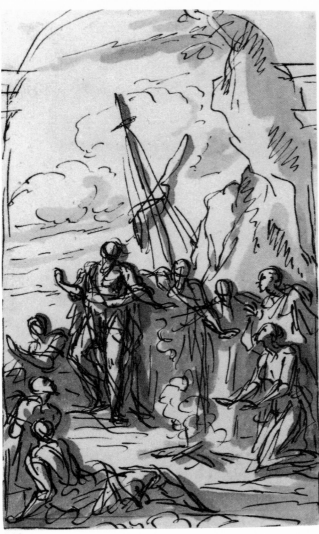

189

case of the latter, Thornhill seems to have prepared a number of separate sets of alternative treatments, some on a small, others on a larger scale: eight sequences of this kind can be identified, although not all are complete. What may be regarded as the earliest ideas are to be found in the British Museum sketchbook (no. 184), ff. 111v, 112r and 118r–119v. Over forty other designs, representing various stages of Thornhill's scheme, are in the British Museum, but for reasons of space it has only been possible to include a token representation here. A fuller discussion of the commission is to be found in Croft-Murray, I, pp. 71–4.

As has often been noted, Thornhill's work at St Paul's is less successful and certainly less dramatic in effect than that at Greenwich. This is largely due to the demand of the Commissioners that the decoration was to be carried out in grisaille, and partly because Thornhill depended too slavishly for his compositions on the Raphael tapestry Cartoons. Nevertheless, his achievements in decorative painting on the grand scale were of fundamental importance for the morale of British painters, undoubtedly firing the young Hogarth (Thornhill's son-in-law) with ambition: as he later noted, 'the paintings of St Pauls and Greenwich Hospital . . . were . . . running in my head'.

187 St Paul shipwrecked on Malta

Pen and brown ink with grey wash; 175 × 148 mm (6⅞ × 5¹³⁄₁₆ in)

Inscribed: *Paul Shakes of* [f] *yᵉ Viper*

PROVENANCE: Miss Harriet Sophia Imart

LITERATURE: Croft-Murray, I, p. 271, no. 33

The British Museum (1913-12-16-8)

188 St Paul shipwrecked on Malta

Pen and brown ink, heightened with yellow bodycolour, on buff paper; 270 × 224 mm (10⅝ × 8¹³⁄₁₆ in)

PROVENANCE: E. Daniell

LITERATURE: Croft-Murray, I, p. 271, no. 33

The British Museum (1872-10-12-3428)

189 St Paul shipwrecked on Malta

Pen and brown ink, with brown-grey wash; 163 × 98 mm (6⅜ × 3⅞ in)

PROVENANCE: David McIntosh (sale, Christie, 20 May 1857, lots 788-9); A. E. Evans

LITERATURE: Croft-Murray, I, p. 271, no. 33

The British Museum (1857-5-20-55)

Eight scenes from the life of St Paul were chosen for the decoration of the Cupola, starting with his *Conversion* nearest the altar and continuing anti-clockwise with *The Blinding of Elymas, Paul and Barnabas at Lystra, Paul and Silas in Prison, Paul preaching at Athens, The Ephesian Conjurors*

burning their Books, Paul before Agrippa and *Paul shipwrecked on Melita* (Malta). The drawings discussed here (nos 187–9) each represent different stages in the development of Thornhill's decorative scheme, one of the eight subjects – *Paul shipwrecked on Malta* – having been chosen to illustrate his method. Thornhill's text was taken from the Acts of the Apostles, chapter XXVIII, verses 3–6. Having been shipwrecked, Paul and his companions are treated kindly by the inhabitants of the island, who light a fire: 'And when Paul had gathered a bundle of sticks, and laid them on the fire, there came a viper out of the heat, and fastened on his hand. And when the barbarians saw the venomous beast hang on his hand, they said among themselves, No doubt this man is a murderer, whom, though he hath escaped the sea, yet vengeance suffereth not to live. And he shook off the beast into the fire, and felt no harm . . . after they had looked a great while and saw no harm come to him, they changed their minds, and said that he was a god.'

Four pages in the British Museum sketchbook (no. 184) show Thornhill's earliest ideas and list possible subjects. Having decided on the episodes to be treated, he began to work out the shape and design of the surrounds; in no. 187 (one of three similar studies), which is among the artist's liveliest sketches, he is experimenting with an elaborate curved and scrolled frame for each compartment. In no. 188 a more austere treatment is shown, the design being given straight edges. As finally painted (see no. 190), each scene had an arched top, which is anticipated in no. 189, a study which, however, is chiefly concerned with the possible placing of the figures rather than the shape of the surround (a further drawing in the British Museum, Crowle Pennant XI, no. 65, is close to the final composition).

190 St Paul shipwrecked on Malta

Pen and black ink, with oil-colours, on oiled paper; 380 × 250 mm (15 × 9⅞ in)

PROVENANCE: David McIntosh (sale, Christie, 20 May 1857, lots 788–9); A. E. Evans

LITERATURE: Croft-Murray, I, p. 271, no. 33

The British Museum (1857-5-20-56)

At some time before 1720, the year in which they appear to have been published, engravings were made (mostly in reverse) after the completed paintings of the life of St Paul. Thornhill provided a series of drawings, of which this is one, for the engravers (two of whom never visited England) to work from; several of these sketches are annotated in the artist's hand, indicating which engraver he wanted for that plate. The exact date of publication is not recorded, but the earliest reference is an entry in Humfrey Wanley's diary for 6 May 1720: 'Sir James Thornhill brought two Setts of Prints taken from his Paintings in St Paul's Cathedral, for my Lord [Harley]' (BL, Lansdowne MS 777, f.21). This drawing was engraved in reverse by Gerard van der Gucht.

191 Hanbury Hall, Worcestershire, from the bowling green

Pen and brown ink with grey wash over black lead; 283 × 443 mm (11⅛ × 17⁷⁄₁₆ in)

Inscribed: *Hanbury Hall from ye Bowling Green*

PROVENANCE: Purchased from W. B. Tiffin, 1864

LITERATURE: Croft-Murray, I, p. 270; Harris (1979), p. 259; M. Gibbon (rev. A. Mitchell), *National Trust Guide to Hanbury Hall*, London, 1979, p. 28

The British Museum (1864-5-14-272)

Hanbury Hall was built for Thomas Vernon (1654–1721), an eminent lawyer: the date 1701 is carved on the entrance façade. The architect of the house is unknown, but he is sometimes identified as William Talman, or, more probably, as the local architect William Rudhall of Henley-in-Arden. The design of the house also shares some characteristics with Ragley, eight miles away in Warwickshire, built in 1679–83 by Robert Hooke. At Hanbury Thornhill was commissioned to paint the hall, withdrawing-room, a bedchamber and the staircase, which is one of the finest surviving examples of his work. The staircase decoration can be dated about 1710 from the ceiling painting: an assembly of the gods, with Mercury holding the print of a portrait of Dr Henry Sacheverell which is set alight by the Furies – a reference to the recent trial of Sacheverell, a high-church clergyman who had preached a sermon of Tory bias in St Paul's Cathedral on Guy Fawkes day 1709. The Whig government (engaged in a costly war against Louis XIV, with the Duke of Marlborough as Commander in Chief) held that the sermon was contrary to the constitutional principles of the revolution settlement of 1688 and thus seditious. Sacheverell was impeached and found guilty of sedition but lightly punished by being forbidden to preach for three years. Although personally a dislikeable hypocrite, Sacheverell's trial (a political blunder by the Whigs) made him a popular martyr and temporarily the hero of the London populace. The Queen gradually dismissed her Whig ministers, replacing them with Tories who made peace with France. As a staunch Whig, Thomas Vernon doubtless regarded Sacheverell as a traitor, fit only to be torn to pieces by the Furies.

This drawing, which can also probably be dated about 1710, is an example of Thornhill's occasional house views. Hanbury Hall is seen from the south-east. The bowling green was a distinctive feature of the grounds, and is clearly shown in a perspective view of the house made by Joseph Dougharty in 1732 (Worcestershire County Record Office). The formal garden on the south side of the house was laid out by George London in the Dutch style, including walled enclosures (with espalier fruit trees on the south-east wall, which Thornhill shows) and parterres divided by straight paths and compartments of box and yew, shown here as still rather shapeless young hedges. Towards the end of the century, the formal gardens were swept away in favour of landscaping.

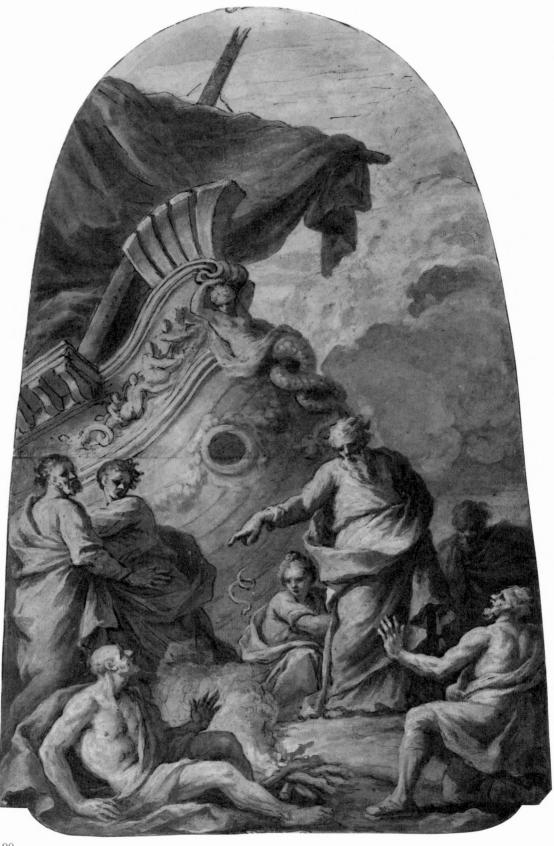

190

191

192 Design for the ceiling of the Great Hall at Moor Park, Hertfordshire

Pen and brown ink and wash over black lead, the scenes at the corners in grey ink and wash, half the central border circle in yellow wash; 428 × 353 mm (16⅞ × 13⅞ in)

Inscribed: *No 1* and with notes of the subjects taken from Ovid, Xenophon, Valerius Maximus and Plutarch. Centre: *Ceiling is the deifying of Herisilia, by the name of the Goddess Ora, for her fidelity to her husband Romulus. Ovid met. p. 272.* Top left: *Tuccia [Tutia] carrying water in a Sieve to prove her Innocence. Val: Max. p. 348.* Top right: *Chelonis' Piety and love to Leonidas her Father, and her Husband Cleombrutus. Plut. vol. 4, p. 261.* Bottom left: *Panthea, to avoid Cyrus embraces kills herself by Abradates her dead Husband. Xenoph: p. 105.* Bottom right: *Lucretia kills herself because she had been violated by Tarquin. Val: Max. p. 257*

PROVENANCE: Sir Thomas Lawrence; Colnaghi

LITERATURE: *Three Centuries of British Watercolours and Drawings*, exh. cat., Arts Council, 1951, no. 185; *European Masters of the Eighteenth Century*, exh. cat., Royal Academy, London, 1954–5, no. 609; *Sir James Thornhill*, exh. cat., Guildhall Art Gallery, London, 1958, no. 87; J. Simon, *English Baroque Sketches*, exh. cat., Marble Hill House, Twickenham, 1974, no. 60

Sir Brinsley Ford

At Moor Park, Thornhill was responsible not only for the decoration of the house, but also for its design (see T. Hudson, 'Moor Park, Leoni and Sir James Thornhill',

Burl. Mag., CXIII (1971), pp. 657–61). However, his decorations for the interior can be judged only from drawings, for Thornhill was sued by his dissatisfied patron, Benjamin Styles, who subsequently commissioned Giacomo Amiconi and Francesco Sleter to replace Thornhill's work, of which no trace remains. Styles, who had made his fortune out of the South Sea Company, bought Moor Park from the widow of the Duke of Monmouth in 1720, and seems to have engaged Thornhill to remodel the house shortly afterwards (see Hudson, op. cit.). The most important interior for which Thornhill was responsible was the Great Hall, for which several drawings survive, showing that he also designed the elaborate plasterwork. The lawsuits brought by Styles against Thornhill in 1728 and 1730 set out his grievances against the artist, who was (according to an agreement made in 1725) to paint 'the Great Circle in the Ceiling . . . being Twenty foot Diameter According to the Design Marked Number 4 with Basso Relievos in the Angles According to Number (1) also the Eight great Pictures on the sides of the same Great Hall According to the Designes Marked Number (2)'. This was to have been executed in 'the best Manner that [he] was Capable of . . . According to his best Skill and Judgement': in Styles's opinion, Thornhill's work was not only incomplete, but also badly executed, and he claimed that the painter had 'Entred into a Combinacon and Confederacy . . . to defeat and defraud him'. Thornhill's

192

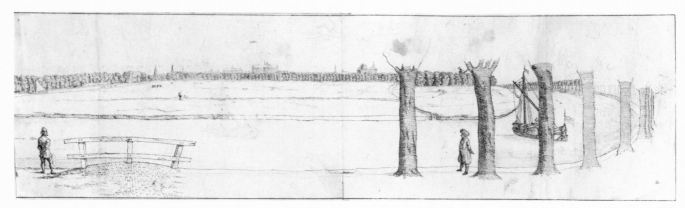

193

'Answer' shows that he finished the work 'to the seeming full and ample satisfaction of the Compl[ainan]t. on or about the Tenth day of November last [1727]'. The case was eventually settled out of court, Styles paying Thornhill in full and giving him 'an handsom present' in addition (Vertue, III, pp. 35, 46).

Vertue (III, p. 35) noted that Thornhill's eight canvases for the Hall represented '8 heroic Virtues taken from several stories of the Antients, Greeks, & Latins & Britons', each showing an act of self-sacrifice: in this drawing, a splendid example of Thornhill's draughtsmanship, the theme is illustrated from classical sources. The design for the stuccowork is close to that used on the ceiling of the Hall, while the four military trophies and their crouching slaves echo the decoration in the Saloon painted by Verrio about 1679–85 for the Duke of Monmouth.

This drawing was probably in the Thornhill sale in 1735, which included 'All the Designs of the Buildings and Pictures at Moor Park'.

TALMAN, John

London 1677 – Hinxworth 1726

The eldest son of the architect William Talman (1650–1719), who in 1698 sent him on the first of many foreign tours, partly to study architecture and partly to form a collection of prints and drawings. He was in Holland and Germany in 1698–9, then in Italy, returning to England by 1702; his letter-books (in the Bodleian Library, Oxford) show that he was again in Italy, travelling with William Kent, in 1709. There he commissioned draughtsmen to make studies of architectural details, ecclesiastical ornaments and regalia, which were of considerable antiquarian interest, and acted as an amateur dealer, negotiating the sale of the collection of drawings formed by Padre Resta from the Cavaliere Marchetti to Lord Somers. He was still in Rome in 1713, and although he was again in England in 1717 – the year in which he was appointed the first Director of the Society of Antiquaries – he was in Venice in 1719. Although he was primarily a connoisseur and collector, he made hundreds of extra-ordinary baroque designs which show his knowledge of Italian architecture, as well as schemes for sumptuous interior decoration inspired by his study of both medieval and contemporary sources. His extensive collection was dispersed through auctions held in 1725 and, after his death, in 1727; the most substantial remnants of the collection – which was described in January 1724/5 as consisting of about two hundred volumes – are in the British Museum, the Victoria and Albert Museum, the Ashmolean Museum, Westminster Abbey Library, the Sir John Soane Museum and the Courtauld Institute.

193 The Rhine outside Leiden

Pen and brown ink over black lead, on three conjoined pieces of paper; 180 × 623 mm (7⅛ × 24½ in)

Inscribed: *Rhÿn, Nieuw Rhÿn* and *Leyden* (arrows indicate the flow of the river) and on the verso, by Francis Douce: *Belonged to Jonathan Richardson / Q. by Hollar?* and in another hand: *105 Oct 2678*

PROVENANCE: J. Richardson sen. (L 2184); Francis Douce

LITERATURE: Brown (1982) 213

The Ashmolean Museum, Oxford

An album of drawings by John Talman in the collection of the Royal Institute of British Architects includes a group made in the Low Countries and Germany between August 1698 and May 1699. Talman went on to Rome, where he stayed until at least 1701. This drawing may have been made around 13 August 1698, the date inscribed on a view of Leyderdorp, which is near Leiden. Another drawing made during this journey, a view of Rheinberg dated 12 May 1699 (BM 1962-7-14-58), is in a style nearer to Hollar. The composition of the present drawing, while influenced by Hollar, is very striking and idiosyncratic.

The inscription *Nieuw Rhÿn* is probably a reference to a canal (*rijn* in Dutch), rather than to the river.

FORSTER, Thomas

*c.*1677 – after 1712

Very little is known of Forster's life; he is said to have been a native of Northumberland, his date of birth being inferred from Vertue's mention of a self-portrait drawing inscribed *aeta.31 1708.* He was one of the last practitioners of the seventeenth-century tradition of miniature portraiture in black lead, but at his best, as in the example at Yale (no. 194), he reveals a delicacy of handling that is of the greatest refinement and a sense of movement which anticipates full-scale rococo portraiture. Unlike most exponents of this medium, Forster was not an engraver, and few of his portraits were reproduced. His surviving works date from the mid-1690s to 1712.

194 Portrait of a man

Black lead on vellum; 111 × 85 mm (4⅜ × 3⅜ in)

Signed: *T. Forster Delin 1699*

PROVENANCE: Christopher Powney, 1970; John Baskett

LITERATURE: Noon (1979) 16

Yale Center for British Art, Paul Mellon Collection (B1975.4.322)

The verso of this drawing was originally inscribed: 'London Sep[?]: yo': Reall Lovein Thos: ffors', but no trace of this annotation remains. At one time thought to be a

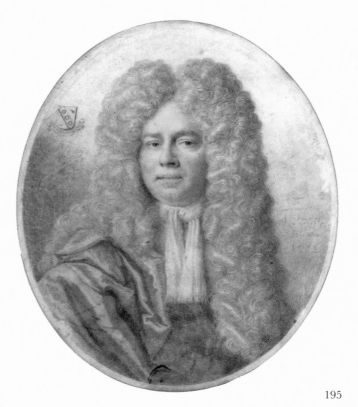

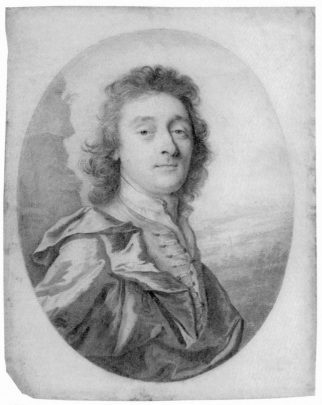

194

195

self-portrait by Forster, the features of this sitter bear little resemblance to those in another supposed self-portrait in the Ashmolean Museum (Brown (1982) 129), perhaps that seen by Vertue (IV, p. 114), 'head of Mr. Foster. done by himself on Vellum. aeta. 31. 1708'. A third putative self-portrait, *A man in a nightcap*, in the British Museum (ECM & PH 3), resembles neither of the two others.

As Patrick Noon has noted, this portrait – arguably one of the artist's finest drawings – is distinguished by its air of dignified simplicity and directness. The sitter is shown without a wig, and the combination of informal attire and draped shoulders *all'antica* results in a most arresting image.

195 George St Lo (1658–1718)

Black lead on vellum; oval 176 × 147 mm (6⅞ × 5¾ in)

Inscribed by the artist: *Geo. St Lo Esq: Commr. of His*[?] *Majis: Navy* and signed *T. Forster. delin– 1704.* The sitter's arms are shown, with his motto, PROTEO CONTRARIUS

PROVENANCE: Joseph Mayor (sale, Sotheby, 23 July 1887, lot 485); Dr John Percy (sale, Sotheby, 17 May 1890, lot 454)

LITERATURE: ECM & PH 2

The British Museum (1890-5-12-81)

A characteristic example of Forster's plumbago portrait drawings. George St Lo served in the Navy: he was captain of the *Portsmouth* when he was severely wounded and captured by the French in 1689. In 1693 he was

appointed a Commissioner of Prizes, and in the same year published a pamphlet, *England's Safety, or a Bridle to the French King*. He became a Commissioner at Plymouth in 1695, and in this capacity was directed in 1697 to guard those at work on the construction of the first Eddystone Lighthouse; however, through his negligence in omitting to station a protection vessel, they were carried off by a French privateer. St Lo was Resident Commissioner at Chatham from 1703 to 1712 and then Commander-in-Chief of ships in the Medway and at the Nore until the accession of George I.

TILLEMANS, Peter

Antwerp 1684? – Stowlangtoft 1734

Tillemans was trained in the studios of various minor landscape artists in Antwerp before accompanying his brother-in-law, the still-life and flower painter Peter Casteels (1684–1749) to England in 1708, where he was at first employed as a copyist of old master paintings. He quickly established himself as a versatile painter, receiving commissions for portrait groups (including *Queen Anne in the House of Lords* and *The House of Commons*, about 1709), history subjects, theatre scenery and decorative painting, as well as his particular specialities of country house views, enlivened in the Flemish style with figures and animals, and panoramic landscapes with sporting activities in the foreground. In 1711 Tillemans joined the newly established academy of which Kneller was the first Governor and Casteels one of twelve directors. He was also a member of the Society of St Luke, of which he became Steward in 1725, and of the convivial Rose and Crown Club. In 1719 Tillemans was living in the parish of St Margaret's, Westminster, and by 1730 somewhere in Marylebone, retiring in 1733 'into the Country on Account of his ill State of Health' (probably to Richmond, Surrey), according to the catalogue of his sale. His most important patron was Dr Cox Macro of Little Haugh Hall, Suffolk, where he was employed in decorative painting and where he was to die.

Few drawings by Tillemans have survived, although there is a group of around two hundred topographical drawings of Northamptonshire, intended to illustrate a county history by the antiquary John Bridges, dated 1719–21 (BL, Dept of Manuscripts, Add. MS 32467).

196 'From my Turit in Black friers Lambeth'

Watercolour on paper prepared with a pink wash; 198 × 369 mm (7¹³⁄₁₆ × 14½ in)

Inscribed on the verso: *From my Turit in Black friers Lambeth*

PROVENANCE: L. G. Duke; Sir Bruce Ingram; purchased through the Virtue-Tebbs Bequest Fund, 1963

LITERATURE: Brown (1982) 1815; Brown (1983) 18

The Ashmolean Museum, Oxford

Tillemans rarely dated his paintings or drawings, and his varied style makes it difficult to trace any chronological development. This watercolour has been tentatively dated in the early 1720s, a period in which Tillemans painted a number of Thames-side subjects, but although it can readily be identified as a view taken south-west across the river, looking towards Lambeth marsh (Lambeth Palace is on the right, in the distance), it is not primarily a topographical record. In his watercolours, which are rare (a comparable example, however, inscribed *from Gravesend the block tower in Essex*, is in the Yale Center for British Art), Tillemans reveals an unexpectedly sensitive observation of atmospheric effects, and uses watercolour in a way that anticipates the next generation of landscape artists, such as William Taverner (1703–72).

HOGARTH, William

London 1697 – London 1764

One of the most influential, striking and original of all British artists, whose career marks the end of the Baroque era and the beginning of a new phase, Hogarth was the son of a schoolmaster turned author of Latin textbooks who, during the artist's boyhood, was temporarily imprisoned for debt. This experience of the seamy side of life marked Hogarth permanently, while giving him material for his art, and he was haunted ever afterwards by the contrast between success and failure, which he saw as a moral issue. He was apprenticed in 1713 to a silver engraver, and by 1720 was independently established, continuing to practise engraving throughout his life. In the same year, he enrolled at the academy organised by Louis Chéron (q.v.) and John Vanderbank. During the 1720s he engraved and published a number of prints, chiefly satirical, which included the earliest examples of his much proclaimed xenophobia, attacking the Italian opera and the Palladian taste in architecture. His illustrations to *Hudibras* in the mid-1720s anticipated the genre which he invented and popularised: moral narratives. These were stories told in six or eight paintings, exposing the follies and vices of the age in theatrical but essentially realistic terms, which Hogarth engraved (or had engraved), published himself and sold by subscription (in 1734 he was a signatory of a petition to Parliament which resulted in an act prohibiting unauthorised copies of engravings for fourteen years after initial publication).

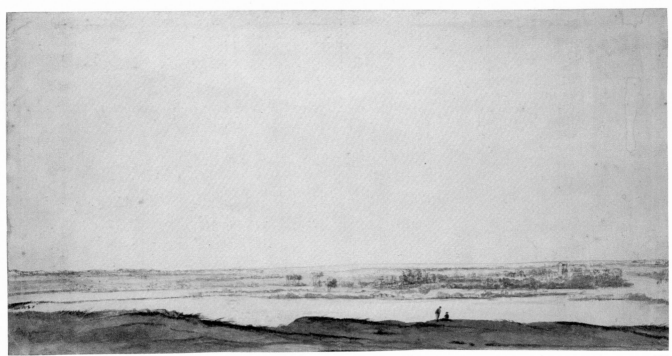

Among these celebrated series are *The Harlot's Progress* (1731), *The Rake's Progress* (1735), *Marriage à la Mode* (1743), and, conceived from the outset as a series of popular prints, *Industry and Idleness* (1747): all these were to some extent pictorial counterparts to the novels of his friend Henry Fielding.

In 1729 Hogarth married Jane, daughter of Sir James Thornhill (q.v.), without her father's consent, but the two artists seem later to have become reconciled; Hogarth admired and identified himself with his father-in-law, whom he saw as the pioneer of a genuinely British school. His own attempts at history painting, which include *Paul before Felix* (1748) for the Benchers of Lincoln's Inn and an altarpiece in the mid-1750s for St Mary Redcliffe, Bristol, are arguably too closely based on Raphaelesque prototypes and lack the idiosyncratic character of, for instance, *The Four Times of Day* (about 1737–8; Ancaster and Bearsted collections), *The March to Finchley* (1746; the Coram Foundation, London) or *Calais Gate* (1748; Tate Gallery, London). Hogarth's other main activity was portraiture: although he set little store by this work, he was in fact the finest and liveliest portraitist of the period, being especially successful with sitters from the same middle-class background as himself. His masterpiece in this genre in his portrait of *Captain Coram* (1740; the Coram Foundation, London), who was the moving spirit of the Foundling Hospital, a charity with which Hogarth was closely associated and which, largely through his efforts, became one of the first public showplaces for contemporary works of art.

Although Hogarth despised the stultifying effects of formal academic training and empty theory, he was close-ly connected with one of the most important and avant-garde drawing academies of the period, the St Martin's Lane academy, from 1734 to 1755, and made an important contribution to aesthetics, *The Analysis of Beauty*, published in 1753. He was appointed Serjeant Painter to the King in 1757 (a post earlier held by his father-in-law), and joined the newly formed Society of Artists in 1761, but did not exhibit. He died, as his late autobiographical writings reveal, embittered and pessimistic.

The drawings discussed here date from the earliest years of Hogarth's career, but already anticipate his later preoccupations. He was the first British-born artist of undeniable genius, and by his example paved the way for the elevated status that painting was to achieve in the next generation.

197 A life study

Black chalk heightened with white on grey paper; 486 × 287 mm (19⅛ × 11⁵⁄₁₆ in)

PROVENANCE: Colnaghi

The British Museum (1960-4-9-113)

This drawing was attributed to Hogarth when it was acquired by the British Museum, and there seems no reason to doubt the attribution. Like other comparable examples noted in A. P. Oppé, *The Drawings of William Hogarth*, London, 1948, nos 25 and 28, this life study was very probably drawn during Hogarth's membership of the academy founded by John Vanderbank and Louis Chéron in St Martin's Lane – Hogarth being one of the

initial subscribers in October 1720 – and is among his earliest surviving drawings. The cross-hatched shading shows the influence of Chéron (see nos 173–4), although Hogarth's drawing is softer in execution.

Hogarth later recalled that at the academy he had begun 'copying in the usual way and had learnt by practice to do it with tolerable exactness', until 'it ocur'd to me that there were many disadvantages attended going on so well continually copying Prints and Pictures . . . nay in even drawing after the life itself at academys . . . it is possible to know no more of the original when the drawing is finish'd than before it was begun'. As he observed, in his opinion the best artist was one whose visual memory was so highly developed that he could reproduce complicated forms at will, without the original in front of him, and thus concentrate on his proper business, that of invention: 'Whoever can conceive part [of] a Human [figure] with all its circumstances variation[s] when absent as distinct as he doth the 24 letters with their combination[s] is perhaps a greater painter sculptor than ever yet existed' (M. Kitson, 'Hogarth's "Apology for Painters"', *Walpole Society*, XLI (1966–8), p. 106). Nevertheless, his early training in drawing from the life was to be valuable to him and he seems never to have entirely abandoned the practice.

198 Hudibras: the frontispiece

Black lead, with grey-black ink, brown and grey washes and splashes of green, indented for transfer; 239 × 339 mm (9⅜ × 13⅜ in)

PROVENANCE: Mr Brent, from whom acquired (with other drawings for *Hudibras*) by Samuel Ireland; in the Royal Collection by 1833

LITERATURE: S. Ireland, *Graphic Illustrations of Hogarth*, II, London, 1799, p. 20; J. B. Nichols, *Anecdotes of William Hogarth*, London, 1833, p. 391; A. P. Oppé, *The Drawings of William Hogarth*, London, 1948, no. 5; Oppé 332; R. Paulson, *Hogarth: His Life, Art and Times*, I, New Haven and London, 1971, pp. 146–57

Lent by gracious permission of Her Majesty The Queen

Samuel Butler's *Hudibras: Written at the Time of the Late Wars* (the Civil War) is a comic pseudo-chevaleresque poem, a satire on puritanical life under the Commonwealth, owing some of its inspiration – as far as its central characters, Sir Hudibras and his squire Ralpho, are concerned – to *Don Quixote*. The work was first published, in its three separate parts, between 1662/3 and 1678, and enjoyed great popularity during the Restoration period and on into the eighteenth century. The earliest illustrations to it were by Francis Le Piper (1648–94), who painted twelve small pictures of scenes from the poem, and in 1710 two crudely illustrated editions of *Hudibras* were issued.

Hogarth first turned his attention to illustrating the poem in about 1720; this venture, the 'small *Hudibras*', was to consist of seventeen small plates. His illustrations,

however, did not appear until 1726. In the meantime, in 1724–5 he embarked on a more ambitious project, the 'large *Hudibras*', a series of eleven illustrations preceded by an emblematic frontispiece (R. Paulson, *Hogarth's Graphic Works*, New Haven and London, 1965, nos 73–84). Of his twelve original designs for the 'large *Hudibras*', six, including the present drawing for the frontispiece, belonged to Samuel Ireland (d.1800) and are now in the Royal Library at Windsor Castle; one is in the National Gallery of Canada, Ottawa; one is in the British Museum (1980-5-10-20), and another was sold at Christie's on 10 July 1984, lot 80. The techniques in which they are drawn vary considerably, and, indeed, constitute an epitome of the different styles to be used by Hogarth in later years, while the combination of satire with narrative anticipates the modern moral histories of his own invention which he was to develop in the 1730s.

The drawing for the frontispiece is one of Hogarth's most baroque designs, but introduces, in place of the idealised figures one might expect in a conventional book illustration of the period, the almost ludicrous figures of Hudibras and his squire. Butler's portrait (see also no. 153) surmounts a sarcophagus on which a putto sculpts a parody of a triumphal procession: Hudibras and Ralpho are hitched to the scales of Justice and draw the chariot in which a satyr ('Mr Butler's Genious', according to the lettering on the print) is seated, lashing three figures – Rebellion, Hypocrisy and Ignorance – 'the Reigning Vices' of the period satirised in *Hudibras*. The satyr on the left, playing a square viola da gamba, was replaced in the print by the figure of Britannia, to whom a baby satyr holds up a mirror which reflects an undistorted image, perhaps a suggestion that England under the Hanoverians no longer resembles Butler's description (the drawing for this portion must at one time have been superimposed, for part of Britannia's spear is drawn in pen on the present sheet).

Even at this fairly early stage in Hogarth's career, his juxtaposition of comic-grotesque and heroic elements is distinctive.

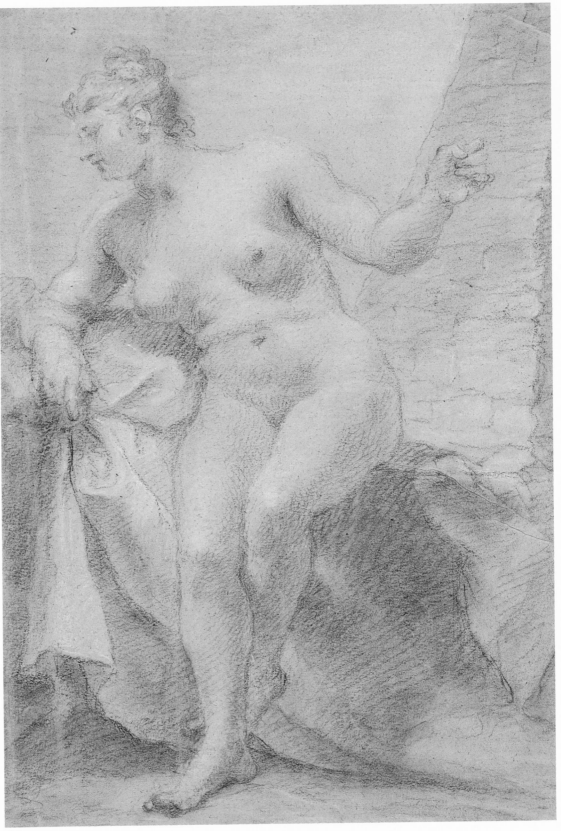

197

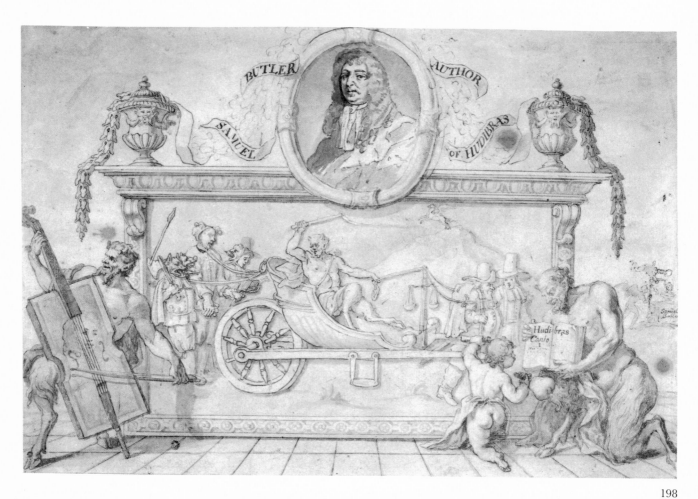

198

(*Right*) William Hogarth:
*Frontispiece to Samuel Butler's
'Hudibras'.*
Etching and engraving,
1725/6 (Paulson 73)

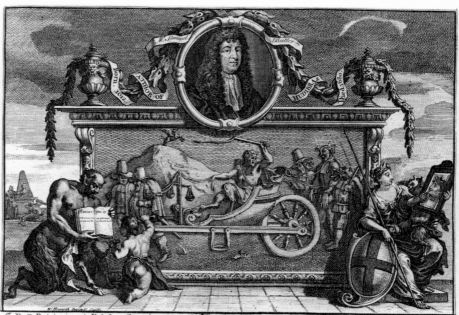

199 Study for a christening, called 'Orator Henley christening a child'

Oil on canvas, prepared with a grey ground; 319 × 233 mm (12⁹⁄16 × 9³⁄16 in)

PROVENANCE: Mrs Hogarth, until 1780; Samuel Ireland (sale, Christie, 6 March 1797, lot 141; Richard Payne Knight Bequest, 1824

LITERATURE: S. Ireland, *Graphic Illustrations of Hogarth*, I, London, 1794, pp. 134–8; J. Nichols and G. Stevens, *The Genuine Works of William Hogarth*, II, London, 1810, p. 273; *Catalogue of the Payne Knight Collection of Prints and Drawings*, 1845 (MS preserved in the British Museum, Dept of Prints and Drawings), p. 176, no. 3; A. Dobson, *William Hogarth*, London, 1902, pp. 263–4; R. E. Beckett, *Hogarth*, 1949, p. 64; R. Paulson, *Hogarth's Graphic Works*, I, New Haven and London, 1965, pp. 310–11; R. Paulson, *Hogarth: his Life, Art, and Times*, I, New Haven and London, 1971, p. 226

The British Museum (O.o. 5-3)

This fluent, lively oil sketch is a study for the central group of figures in Hogarth's painting of the same title (Private Collection), which has been dated about 1729. The clergyman is said to be 'Orator' John Henley, a notorious figure whose eccentric manner forced him to resign from the Church of England. He officiated at a private chapel, to which he charged admission as for a theatrical performance, and attracted large congregations. Alexander Pope denounced him in the *Dunciad*:

> Oh great Restorer of the good old Stage,
> Preacher at once, and Zany of the age !

Henley was the butt of several of Hogarth's satirical prints. Here, while he is supposed to be officiating at a christening, he is ogling the girl at the right of the composition. In the finished painting and the related mezzotint by Joseph Sympson (Paulson, op. cit., 1965), a young man pays court to the mother of the baby being christened, while the father ignores both his wife and the ceremony to admire himself in a mirror. As Paulson has pointed out, *The Christening* foreshadows the first scene of *Marriage à la Mode* (1743–5). This preparatory sketch also anticipates Hogarth's delicately responsive portraits, which culminate in the study of his servants (about 1750–55; Tate Gallery, London).

200 A harlot in her garret attended by her bunter

Red chalk, touched with black chalk, squared; 250 × 359 mm (9⅞ × 14⅛ in)

PROVENANCE: In the British Museum by 1837

LITERATURE: A. P. Oppé, *The Drawings of William Hogarth*, London, 1948, no. 32; R. Paulson, *Hogarth: His Life, Art and Times*, I, New Haven and London, 1971, p. 238; *Hogarth*, exh. cat., Tate Gallery, London, 1972, no. 13

The British Museum (z.1-3)

Acquired by the British Museum before 1837, this drawing was unattributed until Edward Croft-Murray recognised that it might be a preliminary study connected with Hogarth's *Harlot's Progress*, his first sequence of paintings devoted to a modern moral subject, completed in 1731 but now known only through engravings (the paintings were destroyed by fire in 1755). It is possible that this drawing may be connected with the 'small picture' which, according to Vertue, who was writing in 1732 (III, p. 58), Hogarth painted in 1730: '. . . a common harlot, supposed to dwell in drewry lane [Drury Lane]. just riseing about noon out of bed. and at breakfast. a bunter [originally a woman who picks up rags in the street; hence a low, vulgar servant] waiting on her – this whore's desabillé careless and a pretty Countenance . . . then other thoughts increased and multiplied by his fruitful invention. till he made six'. The subject depicted here is an anticipation of Plate III of the *Harlot's Progress* (see p. 251), 'Apprehended by a Magistrate'. However, in this drawing Hogarth treats the subject in an even more squalidly realistic manner: the whore is scrawny and disease-ridden, her garret utterly sordid, and the vividly descriptive details are immediately apparent. The harlot is bandaging her arm, having perhaps injected herself with the syringe that lies on the rough wooden table, alongside a broken-toothed comb, a mirror, prophylactic sheaths and a beer-mug. In the foreground, a birch-rod lies beside an open book inscribed *Aristotle on F.*, and a mangy cat gnaws some pieces of food. Washing is hanging from a line suspended across the middle of the room, and below the window is a close-stool, while the wooden-legged bunter approaches carrying a leaky jar.

The squaring-up suggests that Hogarth intended to use the composition either for an engraving or for a painting. He was painting the *Harlot's Progress* in 1730–31, and this drawing must represent his earliest ideas for the subject, suggesting a date no later than 1730.

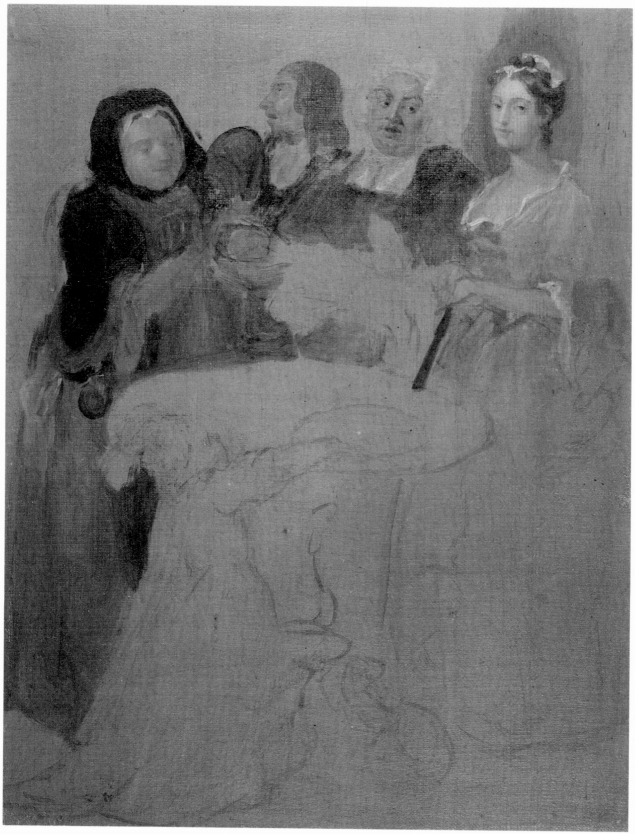

199

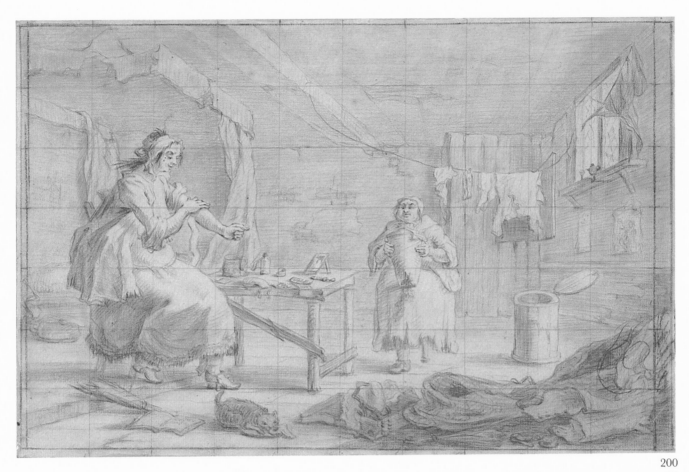

200

William Hogarth:
A Harlot's Progress, Plate III,
'Apprehended by a
Magistrate'.
Etching and engraving, 1732
(Paulson 123)

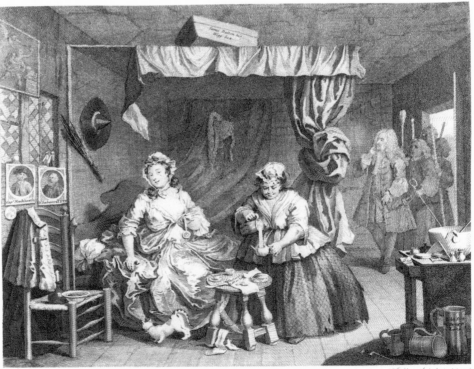

Select Bibliography

Works referred to in abbreviated form

Auerbach
Erna Auerbach, *Nicholas Hilliard*, London, 1961

Beckett
R. B. Beckett, *Lely*, London, 1951

BMQ
The British Museum Quarterly, London, 1926–73

BM Satires
F. G. Stephens and Dorothy M. George, *Catalogue of Political and Personal Satires . . . in the British Museum, to 1832*, 11 vols, London, 1870–1954

Brown (1982)
D. B. Brown, *Ashmolean Museum, Oxford: Catalogue of the Collection of Drawings, Volume IV: Early English Drawings*, Oxford, 1982

Brown (1983)
D. B. Brown, *Early English Drawings from the Ashmolean Museum*, exh. cat., Morton Morris & Co., London, 1983

Burl. Mag.
The Burlington Magazine, London, from 1902

Chaloner Smith
John Chaloner Smith, *British Mezzotinto Portraits*, 4 vols, London, 1878–83

Connoisseur
The Connoisseur, London, from 1901

Croft-Murray, I
Edward Croft-Murray, *Decorative Painting in England 1537–1837, Volume I: Early Tudor to Sir James Thornhill*, London, 1962

Croft-Murray, II
Edward Croft-Murray, *Decorative Painting in England 1537–1837, Volume II: The Eighteenth and Nineteenth Centuries*, London, 1970

ECM & PH
Edward Croft-Murray and Paul Hulton, *Catalogue of British Drawings* [in the British Museum] *Volume I: XVI & XVII Centuries*, 2 vols, London, 1960

Edmond (1980)
Mary Edmond, 'Limners and Picturemakers – New light on the lives of miniaturists and large-scale portrait painters working in London in the sixteenth and seventeenth centuries', *Walpole Society*, XLVII (1980)

Finsten
Jill Finsten, *Isaac Oliver: Art at the Courts of Elizabeth I and James I*, 2 vols, New York and London, 1981

Foskett (1974a)
Daphne Foskett, *Samuel Cooper 1609–1672*, London, 1974

Foskett (1974b)
Daphne Foskett, *Samuel Cooper and his Contemporaries*, exh. cat., National Portrait Gallery, London, 1974

Griffiths and Kesnerová
A. V. Griffiths and Gabriela Kesnerová, *Wenceslaus Hollar: Prints and Drawings*, exh. cat., British Museum, London, 1983

Harris
John Harris, *The Artist and the Country House*, London, 1979

Harris and Tait
John Harris and A. A. Tait, *Catalogue of the Drawings by Inigo Jones, John Webb and Isaac de Caus at Worcester College, Oxford*, Oxford, 1979

Haverkamp-Begemann, Lawder and Talbot
E. Haverkamp-Begemann, S. Lawder and C. Talbot, *Drawings from the Clark Art Institute*, New Haven and London, 1964

Hayes
John Hayes, 'Claude de Jongh', *Burl. Mag.*, XCVIII (1956), pp.3–11

Held
J. S. Held, *Rubens Selected Drawings*, 2 vols, London, 1959, 2nd ed., 1986

Hind (1922)
A. M. Hind, *Wenceslaus Hollar and his Views of London and Windsor in the Seventeenth Century*, London, 1922

Hind, II
A. M. Hind, *A Catalogue of Drawings by Dutch and Flemish Artists preserved in the Department of Prints and Drawings, The British Museum*, vol. II, London, 1923

Hind, III
Ibid., vol. III, London, 1926

Hind, IV
Ibid., vol. IV, London, 1931

H, O & S
John Harris, Stephen Orgel and Roy Strong, *The King's Arcadia: Inigo Jones and the Stuart Court*, exh. cat., Arts Council of Great Britain, 1973

Hodnett (1978)
Edward Hodnett, *Francis Barlow: First Master of English Book Illustration*, London, 1978

Hollstein
F. W. H. Hollstein, *Dutch and Flemish Etchings, Engravings and Woodcuts, c. 1450–1700*, Amsterdam, 1947– (in progress)

Huemer
F. Huemer, *Corpus Rubenianum Ludwig Burchard Part XIX: Portraits I*, Brussels, 1977

KdK
Gustav Glück, *Van Dyck, Des Meisters Gemälde, Klassiker der Kunst*, XII, 2nd. ed., Stuttgart and Berlin, 1931

Kenyon
John Kenyon, *The Popish Plot*, rev. ed., London, 1984

L
Frits Lugt, *Les marques de collections de dessins et d'estampes*, Amsterdam, 1921

Millar (1960)
Oliver Millar, 'Abraham van der Doort's Catalogue of the Collection of Charles I', *Walpole Society*, XXXVII (1960)

Millar (1972)
Oliver Millar, *The Age of Charles I: Painting in England 1620–1649*, exh. cat., Tate Gallery, London, 1972

Millar (1978)
Oliver Millar, *Sir Peter Lely*, exh. cat., National Portrait Gallery, London, 1978

Millar (1982)
Oliver Millar, *Van Dyck in England*, exh. cat., National Portrait Gallery, London, 1982/3

Nicoll
A. Nicoll, *Stuart Masques and the Renaissance Stage*, London, 1937

Noon (1979)
Patrick J. Noon, *English Portrait Drawings & Miniatures*, exh. cat., Yale Center for British Art, New Haven, 1979

O & S
Stephen Orgel and Roy Strong, *Inigo Jones: The Theatre of the Stuart Court*, 2 vols, London and University of California, 1973

Oppé
A. P. Oppé, *English Drawings – Stuart and Georgian Periods – in the Collection of H.M. The King at Windsor Castle*, London, 1950

P
Gustav Parthey, *Wenceslaus Hollar, Beschreibendes Verzeichniss seiner Kupferstiche*, Berlin, 1853

Pennington
Richard Pennington, *A descriptive Catalogue of the etched Work of Wenceslaus Hollar*, Cambridge, 1982

Reynolds
Graham Reynolds, *Nicholas Hilliard and Isaac Oliver*, Victoria and Albert Museum, London, 1947, 2nd ed., 1971

Roberts
Jane Roberts, *Master Drawings in the Royal Collection*, exh. cat., The Queen's Gallery, London, 1986

S & B
P. Simpson and C. F. Bell, 'Designs by Inigo Jones for Masques and Plays at Court', *Walpole Society*, XII (1923–4)

Schreiber
F. M. O'Donoghue, *Catalogue of the Collection of Playing Cards bequeathed to the Trustees of the British Museum by the late Lady Charlotte Schreiber*, London, 1901

Sprinzels
F. Sprinzels, *Hollar Handzeichnungen*, Prague and Vienna, 1938

Stainton (1985)
Lindsay Stainton, *British Landscape Watercolours 1600–1860*, exh. cat., British Museum, London, 1985

Stewart (1971)
J. Douglas Stewart, *Sir Godfrey Kneller*, exh. cat., National Portrait Gallery, London, 1971

Stewart (1983)
J. Douglas Stewart, *Sir Godfrey Kneller and the English Baroque Portrait*, Oxford, 1983

Strong and Murrell
Roy Strong and V. J. Murrell, *Artists of the Tudor Court*, exh. cat., Victoria and Albert Museum, London, 1983

Vertue
George Vertue, 'Note Books I–VI', *Walpole Society*, XVIII (1930), XX (1932), XXII (1934), XXIV (1936), XXVI (1938), Index to vols I–V: XXIX (1947), XXX (1955)

Vey
H. Vey, *Die Zeichnungen Anton van Dycks*, 2 vols, Brussels, 1962

Wayland
Virginia and Harold Wayland, *Francis Barlow's Sketches for the Meal Tub Plot Playing Cards*, Pasadena, 1971

Whinney (1964)
Margaret Whinney, *Sculpture in Britain 1530–1830*, Harmondsworth, 1964

Whinney and Millar
Margaret Whinney and Oliver Millar, *English Art 1625–1714*, Oxford, 1957

White (1977)
Christopher White, *English Landscape 1630–1850: Drawings, Prints & Books from the Paul Mellon Collection*, exh. cat., Yale Center for British Art, New Haven, 1977

Willshire
W. H. Willshire, *A Descriptive Catalogue of Playing and other Cards in the British Museum*, London, 1876

Woodward
John Woodward, *Tudor and Stuart Drawings*, London, 1951